A Short Guide to Writing about Art

ELEVENTH EDITION

SYLVAN BARNET
Tufts University

Boston Columbus Indianapolis New York San Francisco Upper Saddle River
Amsterdam Cape Town Dubai London Madrid Milan Munich Paris Montreal Toronto
Delhi Mexico City São Paulo Sydney Hong Kong Seoul Singapore Taipei Tokyo

Editor-in-Chief: Sarah Touborg
Editorial Assistant: Victoria Engros
Director of Marketing: Brandy Dawson
Executive Marketing Manager: Kate Stewart
Assistant Marketing Manager: Paige Patunas
Senior Managing Editor: Melissa Feimer
Production Project Manager: Joe Scordato
Senior Operations Supervisor: Mary Fischer
Operations Specialist: Diane Peirano
Creative Director (cover): Jayne Conte

Cover Designer: Suzanne Behnke
Cover Art: Album/Oronoz/Newscom
Senior Digital Media Director: David Alick
Senior Media Project Manager:
 Rich Barnes
Full-Service Project Management:
 PreMediaGlobal
Composition: PreMediaGlobal
Printer/Binder: Edwards Brothers
Cover Printer: Edwards Brothers

Credits and acknowledgments borrowed from other sources and reproduced, with permission, in this textbook appear on the appropriate page within text.

Library of Congress Control Number: 2013954456

3 16

PEARSON

Student Edition
ISBN 10: 0-205-88699-X
ISBN 13: 978-0-205-88699-9

Instructor's Review Copy
ISBN 10: 0-205-93349-1
ISBN 13: 978-0-205-93349-5

To the memory of my brother, Howard

I saw the things which have been brought to the King from the new golden land: a sun all of gold a whole fathom broad, and a moon all of silver of the same size, also two rooms full of the armour of the people there, and all manner of wondrous weapons of theirs, harness and darts, wonderful shields, strange clothing, bedspreads, and all kinds of wonderful objects of various uses, much more beautiful to behold than prodigies. These things were all so precious that they have been valued at one hundred thousand gold florins. All the days of my life I have seen nothing that has gladdened my heart so much as these things, for I saw amongst them wonderful works of art, and I marvelled at the subtle talents of men in foreign lands. Indeed, I cannot express all that I thought there.

> —Albrecht Dürer, in a journal entry of 27 August 1520, writing about Aztec treasures sent by Motecuhzoma to Cortés in 1519, and forwarded by Cortés to Charles V

Painting cannot equal nature for the marvels of mountains and water, but nature cannot equal painting for the marvels of brush and ink.

> —Dong Qichang (1555–1636)

What you see is what you see.

> —Frank Stella, in an interview, 1964, published 1966

The surface bootlessness of talking about art seems matched by a depth necessity to talk about it endlessly.

> —Clifford Geertz, 1976

Contents

Preface

Another book for the student of art to read? Well, everyone knows that students today do not write as well as they used to. Probably they never did, but it is a truth universally acknowledged (by English teachers) that the cure is *not* harder work from instructors in composition courses; rather, the only cure is a demand, on the part of the entire faculty, that students in all classes write decently. But instructors outside of departments of English understandably say that they lack the time—and perhaps the skill—to teach writing in addition to, say, art.

This book may offer a remedy: Students who read it—and it is short enough to be read in addition to whatever texts the instructor regularly requires—should be able to improve their essays

- by getting ideas—both about works of art and about approaches to art, from the first five chapters ("Writing about Art," "Writing about Art: The Big Picture," "Formal Analysis and Style," "Analytic Thinking," and "Writing a Comparison,")—and from Chapter 12 ("Some Critical Approaches")
- by studying the principles of writing—principles of effective description, narration, and especially persuasion—explained in Chapter 10 "Style in Writing" (e.g., on tone, paragraphing, and concreteness), and Chapters 11, 13, and 14 ("Art-Historical Research," "Writing a Research Paper," and "Manuscript Form")
- by studying the short models throughout the book, which give the student a sense of some of the ways in which people talk about art

As Robert Frost said, writing is a matter of having ideas. This book tries to help students to have ideas by suggesting questions they may ask themselves as they contemplate works of art. After all, instructors want papers that *say* something, papers with substance, not papers whose only virtue is that they are neatly typed and that the footnotes are in the proper form.

Consider a story that Giambologna (1529–1608) in his old age told about himself. The young Flemish sculptor (his original name was Jean de Boulogne), having moved to Rome, went to visit the aged Michelangelo. To show what he could do, Giambologna brought with him a carefully finished, highly polished wax model of a sculpture. The master took the

model, crushed it, shaped it into something very different from Giambologna's original, and handed it back, saying, "Now learn the art of modeling before you learn the art of finishing." This story about Michelangelo as a teacher is harrowing, but it is also edifying (and it is pleasant to be able to say that Giambologna reportedly told it with delight). The point of telling it here is not to recommend a way of teaching; the point is that a highly finished surface is all very well, but we need substance first of all. A good essay, to repeat, *says* something, and it says it persuasively.

A *Short Guide to Writing about Art* contains notes and sample essays by students and numerous model paragraphs by students and by published scholars such as Albert Elsen, Mary D. Garrard, Anne Hollander, and Leo Steinberg. These examples, as well as the numerous questions that are suggested, should help students to understand the sorts of things people say, and the ways they say them effectively, when writing about art. After all, people *do* write about art, not only to satisfy a college requirement but also to communicate ideas in learned journals, catalogs, and even in newspapers and magazines.

A NOTE ON THE ELEVENTH EDITION

> I have been in love with painting ever since I became conscious of it at the age of six. I drew some pictures which I thought fairly good when I was fifty, but really nothing I did before the age of seventy was of any value at all. At seventy-three I have at last caught every aspect of nature—birds, fish, animals, insects, trees, grasses, all. When I am eighty I shall have developed still further, and will really master the secrets of art at ninety. When I reach one hundred my art will be truly sublime, and my final goal will be attained around the age of one hundred and ten, when every line and dot I draw will be imbued with life.
>
> —Hokusai (1760–1849)

Probably all artists share Hokusai's self-assessment. And so do all writers of textbooks. Each edition of this book seemed satisfactory to me when I sent the manuscript to the publisher, but with the passing not of decades but of only a few months I detected inadequacies, and I wanted to say new things. This eleventh edition, therefore, not only includes eleventh thoughts about many topics discussed in the preceding editions but it also introduces new topics. (All writers—professors as well as undergraduates—should post

at their desks the words from *Westward Ho* that Samuel Beckett posted at his: "Try again. Fail again. Fail better.")

The emphasis is still twofold—on seeing and saying, or on getting ideas about art (Chapters 1–8) and presenting those ideas effectively in writing (Chapters 9–15)—but this edition includes new thoughts about these familiar topics, as well as thoughts about new topics. Small, but I think important, revisions—here a sentence or two, there a paragraph or two—have been made throughout the book, as well as some extensive additions. Topics that are either treated at greater length or are entirely new include

- additional checklists
- seeing writing as a social act, notably by taking into account the likely responses of readers, and by being aware that most good writing about art seeks to be *persuasive,* not merely descriptive or analytic
- writing about virtual exhibitions
- thinking about non-Western art
- synthesizing material and duly acknowledging all sources
- using, in research, library catalog and discovery and delivery services. The local library online catalog is giving way to "one-stop" search and retrieval systems that look for books, journal articles, and digitized materials from both local and remote sources. Some of the new matters discussed here are:

1. **Library on your iPad**

 Access to the library's online catalog and resources can be from any electronic device with an internet connection. (It should be noted that copyright issues regarding illustrations in books are retarding the publication of art books in electronic format. Most books on art are still in print only and require going to the physical library. This, of course, will change with time.)

2. **Online reference collections**

 Art dictionaries and encyclopedias are now available online in collections such as Oxford Reference Online, which has 18 titles of previously published reference works that can be searched individually or collectively.

3. **Print indexes to periodicals are gone**

 Very few libraries retain print indexes—they take up precious shelf space and are tedious to search. Online databases with links to available full text have replaced them. Art and architecture databases, both indexes and reference works, can be searched as a group with cross-searching programs such as MetaLib.

ACKNOWLEDGMENTS

I am fortunate in my many debts: James Cahill, Sarah Blick, Madeline Harrison Caviness, Robert Herbert, Naomi Miller, and Elizabeth de Sabato Swinton generously showed me some of their examinations, topics for essays, and guidelines for writing papers. Amy Ingrid Schlegel provided advice about writing labels. I have received invaluable help also from those who read part or all of the manuscript of the first edition, and to those who made suggestions while I was preparing the revised editions.

Several students—they are named in the text—allowed me to reprint essays they wrote in various introductory courses. I chose these essays because of their excellence—they are thoughtful and clear—but I want to say, emphatically, that almost all students can produce comparable work if they spend adequate time preparing *and then revising* their material. Some of these essays benefited, I think, from small suggestions that I made after the essays had been submitted, but these suggestions—here the correction of a spelling error, there a small change in the title or the addition of a transitional word or phrase—were all of the sort that any peer reviewer might have suggested, or the authors themselves might have thought of the changes had they reread their final draft once more.

The following people called my attention to omissions, excesses, infelicities, and obscurities, and out-and-out errors: Jane Aaron, Mary Clare Altenhofen, Howard Barnet, Peter Barnet, Mark H. Beers, Pat Bellanca, Katherine Bentz, Morton Berman, Sarah Blick, Peggy Blood, Sarah E. Bremser, Lisa Buboltz, William Burto, Ruth Butler, Rebecca Butterfield, James CahilL William E. Cain, Richard Carp, Janet Carpenter, Perry Chapman, Charles Christensen, Fumiko Cranston, Whitney Davis, Margaret Fields Denton, Eugene Dwyer, Karl Fugelso, Glenn Goldman, Gail Geiger, Diane Goode, Carma R. Gorman, Louise K. Greiff, Elizabeth ten Grotenhuis, Anna Hammond, Maxwell Hearn, Julius Held, Leslie Hennessey, Heidi J. Hornik, Anna Indych-Lopez, Joseph M. Hutchinson, Eugene J. Johnson, Deborah Martin Kao, Laura Kaufman, Samantha Kavky, Leila Kinney, Jane Kromm, Jason Kuo, Susan Kuretsky, Thomas Larose, Jennifer Lerclerc, Annette LeZotte (and her students), Arturo Lindsay, Yukio Lippit, Sara J. MacDonald, Charles Mack, Janice Mann, Jody Maxmin, Elizabeth Anne McCauley, Andrew McClellan, Melissa McCormick, Sarah E. McCormick, Robert D. Mowry, Robert Munman, Julie Nicoletta, Willow Partington, Jennifer Purtle, Sheryl Reiss, Patricia Rogers, John M. Rosenfield, Leland Roth, James M. Saslow, Allison Sauls, Amy Schlegel, John M. Schnorrenberg, Diana Scott, Annie Shaver-Crandell, Jack J. Spector, Virginia Spivey, Connie Stewart, Marcia Stubbs, Anne Swartz, Helen Taschian, Ruth Thomas, Gary Tinterow, Stephen K. Urice, Stephen Wagner, Jonathan Weinberg, Cole H. Welter, Tim Whalen, and Paul J. Zelanski. I have adopted many of their suggestions verbatim.

I also wish to thank the reviewers whose comments helped me to revise this edition: Janet Carpenter, City College of San Francisco; Surana Singh-Bischofberger, East Los Angeles College; Melissa Dabakis, Kenyon College; Carey Rote, Texas A & M University—Corpus Christi; Rebecca Trittel, Savannah College of Art and Design (SCAD); Erika Schneider, Framingham State University; Marjorie Och, University of Mary Washington; Johanna Movassat, San Jose State University.

The extremely generous contributions of Noah Daniels, Glenn Goldman, Anne McCauley, James Saslow, Anne Stameshkin, and Ruth Thomas must be further specified. Noah Daniels provided information concerned with computer programs. Goldman significantly improved the discussion of architecture (I have adopted his suggestions verbatim); McCauley wrote the material on photography, Saslow wrote the material on gay and lesbian criticism, Stameshkin on citing electronic sources, and Thomas on library resources. In each instance the job turned out to be more time-consuming than they or I had anticipated, and I am deeply grateful to them for staying with it. I am also indebted to Erika Doss, who kindly read and improved my comments on writing about a public monument, and to Pat Bellanca, William E. Cain, and Marcia Stubbs, who let me use some material that had appeared in books we collaborated on.

The library staff of the Harvard Art Museum has been unfailingly helpful, but I must especially thank Mary Clare Altenhof, Amanda Bowen, Abigail Smith, and Emily Weinrich, who have put up with my pestering.

Finally, I am grateful to Paula Bonilla for her expert copyediting, to Lindsay Bethoney and Melissa Sacco of PreMedia Global, and equally grateful to Lynne Breitfeller, Joe Scordato, Kate Stewart and Sarah Touborg at Pearson, who were always receptive, always encouraging, and always helpful.

1

WRITING ABOUT ART

Art for art's sake.

—Anonymous translation of *L'art pour l'art*

What is art that it should have a sake?

—Samuel Butler

Isn't it a man's name?

—Andy Warhol, responding to the question, "What is art?"

Art is culturally significant meaning, skillfully encoded in an affecting, sensuous medium.

—Richard L. Anderson

Art is the objectification of feeling.

—Suzanne K. Langer

Every so often a painter has to destroy painting. Cézanne did it and then Picasso did it again with Cubism. Then Pollock did it—he busted our idea of a picture all to hell. Then there could be a new pictures again.

—Willem de Kooning

If someone calls it art, it's art.

—Donald Judd

WHAT IS ART?

Perhaps most nonspecialists would say that art consists of "Beautiful pictures and statues. Things like the *Mona Lisa, The Thinker,* and Monet's paintings of his garden, and van Gogh's *The Starry Night.* And Greek statues of naked gods." Presumably "beautiful" things evoke some sort of special response, an "aesthetic response," and we call these things—if they are not works of nature such as sunsets and daffodils—works of "art."

The first paragraph of a book on contemporary art, however, includes these sentences:

Ordinary viewers of today, hoping for coherence and beauty in their imaginative experiences, confront instead works of art declared to exist in

1

arrangements of bare texts and unremarkable photographs, in industrial fabrications revealing no evidence of the artist's hand, in mundane commercial products merely transferred from shopping mall to gallery, or in ephemeral and confrontational performances in which mainstream moral values are deliberately travestied.

–Thomas Crow, *The Rise of the Sixties: American and European Art in the Era of Dissent 1955–1969* (1996), 7°

Again, what is art? Perhaps we can say that art is anything that is said to be art by people who ought to know. Who are these people? They are the men and women who teach in art and art history departments, who write about art for newspapers and magazines and scholarly journals, who think of themselves as art collectors, who call themselves art dealers, and who run museums.

At the Dia Center for the Arts in Chelsea, Tracey Moffatt's video of surfers in a parking lot changing into swimwear, shielded by towels, created excitement. At the New Museum, Mona Hatoum's videos of the inside of her body—she sends a microvideo through one bodily orifice or another to create a video self-portrait—still get lots of attention. The people who run art museums show these videos, and the people who visit the museums enjoy them, so presumably the videos are art. (For more on video art, see pages 129–30.) In 2007 Damien Hirst exhibited some thirty dead sheep, a dead shark, hundreds of sausages, and thousands of empty boxes with labels of medicines. According to the *New York Times* (December 23, 2007, Arts 39) Hirst said it was his "most mature work." Cai Guo-Qiang, who uses gunpowder explosions to produce burns on panels of paper, in 2008 was given a retrospective exhibition at the Guggenheim Museum. And also in 2008 the comic-book artist R. Crumb was given an exhibition at the Institute of Contemporary Art in Philadelphia.

This idea that something—anything at all and not only objects that are said to be "beautiful"—is art if artists and the public (or a significant part of the public, the "art world") say it is art is called the **Institutional Theory** of art. Philosophically speaking, in this view artworks do not possess properties (let's say "beauty" or "truth") that are independent of their historical and cultural situations; they are artworks because people in certain institutions that are called the art world (museums, universities, art galleries, auction houses, publishing houses, government bureaus, etc.) interpret them as artworks. Thus, Picasso's ownership of (and presumably serious interest in) a northwest African mask designed for use in agricultural fertility ceremonies removes the object from its original context and makes it a work of "art" rather than a ritual object. The fact that there is such a theory and that it has an impressive name should not deter you from asking "Does this theory

°Reprinted by permission of Laurence King Publishing Ltd.

make sense?" and "Even if this theory helps us to see that X and Y are works of art, does the theory help us to know if X and Y are good or bad?"°

Of course, museum curators, museum-goers, art teachers, and all the rest change their ideas over time. Until fairly recently, say the latter part of the eighteenth century, the West did not sharply distinguish the *Fine Arts* (painting and sculpture) from now what are called the *decorative arts* (utilitarian objects such as dinnerware, furniture, and carpets). The painter and the sculptor, like the potter and the cabinetmaker and the weaver, were artisans. Furthermore, until two or three decades ago, such Native American objects as blankets, headdresses, beaded clothes, and horn spoons were regarded as artifacts, not art, and consequently they were found not in art museums but in ethnographic museums, and they were said to be "interesting" and "informative." Today curators of art museums are eager to acquire and display such Native American objects, and these objects are said to be "beautiful" and "imaginative." Similarly, although sculptures from sub-Saharan Africa have been found in art museums since the early twentieth century, other African works—for instance, textiles, pottery, baskets, and jewelry—did not move from ethnographic museums to art museums until about 1970.

Even today, however, the African objects most sought by art museums are ones that show no foreign influence. Objects showing European influence or objects made for the tourist trade are rarely considered art by those who run art museums. The museums (and the museum-goers) of tomorrow, however, may have a different idea about such objects. Maybe only our present cultural prejudice keeps most museum curators from regarding airport art or tourist art (contemporary objects made for tourists) as worth serious consideration. These curators argue that such objects do not embody indigenous values and are only responses to a foreign market. But are these curators merely perpetuating a colonialist (exploitive) relationship by refusing to recognize that colonized people can respond creatively to colonialization?°° After all, nobody dismisses

°See George Dickie, *Art and the Aesthetic* (1974) and Arthur C. Danto, *The Transfiguration of the Commonplace* (1981).

°°On tourist art, see Ruth B. Phillips and Christopher B. Steiner, eds., *Unpacking Culture: Art and Commodity in Colonial and Postcolonial Worlds* (Berkeley: University of California Press, 1998), and also "Marketing Culture" in Howard Morphy and Morgan Perkins, eds., *The Anthropology of Art: A Reader* (Oxford: Blackwell, 2006). For an especially vigorous presentation of the idea that indifference to (i.e., contempt for) airport art reveals "a continuing exploitative power relation," see Larry Shiner in the *Journal of Aesthetics and Art Criticism* 52 (1994): 225–234. For a discussion of the criteria that governed the selection of non-Western pieces for display in museums, see Shelly Errington, "What Became of Authentic Primitive Art?," in Errington's *The Death of Authentic Primitive Art and Other Tales of Progress* (1998), 70–101.

a Western artist who borrows from another culture: Van Gogh derived ideas from Japanese prints, and Picasso from African sculpture. Why then do some Westerners dismiss as "degenerate" those African or Aboriginal Australian artists who show an awareness of European and American culture?

In listening to people who talk about art, let's not forget the opinions of the people who consider themselves artists. If someone with an established reputation as a painter says of a postcard she has just written, "This is a work of art," well, we probably have to be very careful before we reply, "No, it isn't." In 1917, when the Society for Independent Artists gave an exhibition in New York, Marcel Duchamp submitted for display a porcelain urinal, standing on its back, titled *Fountain,* and signed "R. Mutt" (the urinal had been manufactured by Mutt Works). The

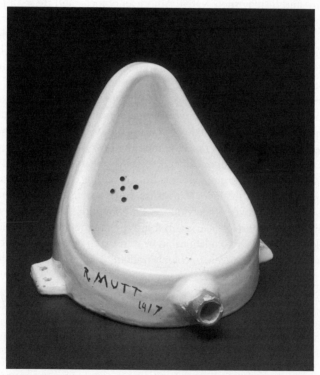

Marcel Duchamp (American, b. France 1887–1968). "Fountain (Second Version)". 1950. 12" × 15" × 18". Readymade: Glazed Sanitary China with Black Paint. Philadelphia Museum of Art/Art Resource, NY. Photograph by Graydon Wood, 1998. © 2013 Artists Rights Society (ARS), New York/ ADAGP, Paris/Succession Marcel Duchamp.

exhibition was supposed to be open to anyone who wished to exhibit in it, but the organizers rejected Duchamp's entry, saying in a press release that it was "a very useful object, but its place is not in an art exhibition." The press release went on to say, "It is by no definition a work of art." Today, however, it is illustrated in almost every history of art on the grounds that an artist of undoubted talent took an object and forced its viewers to consider it as an aesthetic object (something to be contemplated in an art museum) rather than as a functional one (something to be used for the disposal of men's urine). In Duchamp's words, "Whether Mr. Mutt with his own hands made the fountain or not has no importance. He chose it. He took an ordinary article of life, placed it so that its useful significance disappeared under the new title and point of view—created a new thought for that object." And in 1991, noticing that *Fountain* resembles the hood-like niche that sometimes surrounds a sacred image, the artist Sherrie Levine created two polished bronze versions, *Fountain (Madonna)* and *Fountain (Buddha)*. These, too, have found their way into exhibitions and into books about art—and into the art marketplace, where one sold at auction in 2008 for $ 440,000. (Duchamp's *Fountain* nicely illustrates the Institutional Theory (summarized on page 2), which claims that an object is a work of art if the art world (for instance someone who is widely regarded as an artist) says it is.

A common definition today is "Art is what artists do," and they do a great many things that do not at all resemble Impressionist paintings. Listen to Claes Oldenburg, sculptor and designer of an environmental work, *The Store,* that exhibited works constructed from such untraditional materials as burlap and cardboard: "I am for an art that is political-erotic-mystical, that does something other than sits on its ass in a museum" (quoted in Charles Harrison and Paul Wood, eds., *Art in Theory: 1900–2000* [Malden, Mass.: Blackwell, 2003], 744).

But artists also may be uncertain about what is art. An exhibition catalog, *Jackson Pollock: Black and White* (1969), reports an interesting episode. Pollock's wife, Lee Krasner, a painter herself, is quoted as saying, "In front of a very good painting . . . he asked me, 'Is this a painting?' Not is this a good painting, or a bad one, but a *painting!* The degree of doubt was unbelievable at times" (page 8).

Sculptors, too, have produced highly innovative work, work that may seem not to qualify as art. Take, for instance, **earthworks** or *Earth Art* or *land art* (or more recently, *green art*), large sculptural forms made of earth and rocks. An example is Robert Smithson's *Spiral Jetty*, created in 1970. Smithson supervised the construction of a jetty—if a spiral can be regarded as a jetty—some 15 feet wide and 1,500 feet long, in Great Salt

Lake, Utah. Because the water level rose, *Spiral Jetty* became submerged, though the work still survived—under water, in a film Smithson made during the construction of the jetty, and in photographs taken before the water level rose. Beginning in 1999 drought lowered the water level, and by the middle of 2003 *Spiral Jetty* again became visible. Is a combination of mud, salt-encrusted rocks, and water art? Smithson said it was art, and the writers of books on recent art agree, since they all include photographs of *Spiral Jetty*. And if it is art, should we tamper with it? The black basalt rocks that once made a strong contrast with the pinkish surrounding water (the color of the water is due to bacteria and algae) now are white with the encrusted salt, so that the whole looks rather like a snowfield, very different from the work that Smithson created.

Let's look briefly at a work produced in 1972 by a student in the Feminist Art Program at the California Institute of the Arts and exhibited again at the Bronx Museum of the Arts in 1995. Two instructors and some twenty students in the class decided to take an abandoned house and turn it into a work of art, *Womanhouse*. Each participant took some part of the house—a room, a hallway, a closet—and transformed it in accord with her dreams and fantasies. The students were encouraged to make use of materials considered trivial and associated with women, such as dolls, cosmetics, sanitary napkins, and crocheted material. One student, Faith Wilding, constructed a crocheted rope web, thereby creating what she called (in 1972) *Web Room* or *Crocheted Environment* and (in the 1995 version) *Womb Room* (see page 7). Traditionally, a work of art (say, a picture hanging on the wall or a statue standing on a pedestal) is set apart from the spectator and is an object to be looked at from a relatively detached point of view. But *Womb Room* is a different sort of thing. It is an *installation*—a construction or assemblage that takes over or transforms a space, indoors or outdoors, and that usually gives the viewer a sense of being not only a spectator but also a participant in the work. With its nontraditional material—who ever heard of making a work of art out of rope and pieces of crochet?—its unusual form, and its suggestions of the womb, a nest, and rudimentary architecture, Wilding's installation would hardly have been regarded as art before, say, the mid-twentieth century.

We have been talking about the idea that something is a work of art if its creator—whether a person or a culture—says it is art. But some cultures do not want some of their objects to be thought of as art. For example, although curators of American art museums have exhibited Zuni war god figures (or *Ahayu:da*), the Zuni consider such figures to be embodiments of sacred forces, not aesthetic objects, and therefore *un*suitable for exhibition.

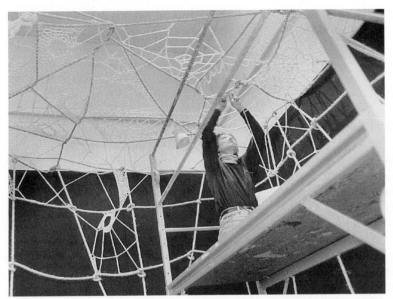

Faith Wilding crocheting the *Womb Room* installation (1995) at the Bronx Museum of the Arts. Photographer: CM Hardt/CM Pictures.

The proper place for these figures, the Zuni say, is in open-air hillside shrines.° (A question: Can we call something *art* if its creator did not think of it as art?)

What sorts of things you will write about will depend partly on your instructor, partly on the assignment, partly on what the museums in your area call art, and partly on what you call art.

Here is a definition that, as you look at works of art, may help you get ideas for writing.

°See Steven Talbot, "Desecration and American Indian Religious Freedom," *Journal of Ethnic Studies* 12:4 (1985): 1–8; T. J. Ferguson and B. Martza, "The Repatriation of Zuni *Ahayu:da*," *Museum Anthropology* 14:2 (1990): 7–15. For additional discussions of the social, political, and ethical questions that face curators, see Moira Simpson, *Making Representations: Museums in the Post-Colonial Era* (1996); *Exhibiting Dilemmas: Issues of Representation at the Smithsonian*, ed. Amy Henderson and Adrienne L. Kaeppler (1997). Some authors of books go so far as not to reproduce certain images in deference to the wishes of the community. Example: Janet C. Berlo and Ruth B. Phillips, in *Native North American Art* (1998), inform readers that a certain kind of Iroquois mask, representing forest spirits, is not illustrated because these masks "are intended only to be seen by knowledgeable people able to control these powers" (page 11). The heart of the issue perhaps may be put thus: Is it appropriate for one culture to take the sacred materials of another culture out of their context and to exhibit them as aesthetic objects to be enjoyed?

[We use] the term "art" to refer to an object whose form is elaborated (in its etymological sense of "worked") to provide visual and tactile pleasure and to enhance its rhetorical power as a visual representation.

> Janet C. Berlo and Ruth B. Phillips, *Native North American Art*
> (New York: Oxford UP, 1998), p. 7

WHY WRITE ABOUT ART?

We write about art in order to clarify and to account for our responses to works that interest or excite or frustrate us. In putting words on paper we have to take a second and a third look at what is in front of us and at what is within us. Picasso said, "To know what you want to draw, you have to begin drawing"; similarly, writing is a way of finding what you want to write, a way of learning.

The last word is never said about complex thoughts and feelings—and works of art, as well as our responses to them, embody complex and even contradictory thoughts and feelings. Still, when we write about art we hope to make at least a little progress in the difficult but rewarding job of talking about and clarifying our responses. As Arthur C. Danto says in the introduction to *Embodied Meanings* (1994), a collection of essays about art:

> Until one tries to write about it, the work of art remains a sort of aesthetic blur. . . . After seeing the work, write about it. You cannot be satisfied for very long in simply putting down what you felt. You have to go further. (14)

When we write, *first of all we teach ourselves*; by putting down words and by thinking about what we are writing (for instance by looking for evidence to support a response) we get to learn what our multiple responses—our likes, our dislikes, our uncertainties—add up to. When we write and review what we have written, each of us is something like a committee of one, trying to work out a statement that is acceptable to all of our selves. Writing is thus a way of learning. *Second, we hope to interest our readers* by communicating our mulled-over responses to material that is worth talking about.

But to respond sensitively to anything and then to communicate responses, we must possess

- some understanding of the thing and
- some skill at converting responses into words.

This book tries to help you deepen your understanding of art—what art does and the ways in which it does it—and the book also tries to help you convert your responses into words that will let your reader share your perceptions, your enthusiasms, and even your doubts. This sharing is, in effect, teaching. An essay on art is an attempt to help your reader to see the work as you see it.

> ✍️ **A RULE FOR WRITERS:**
> You may think you are writing for the teacher, but this view is a misconception; when you write, *you* are the teacher.

THE IMAGINED READER AS THE WRITER'S COLLABORATOR

If you are not writing for the instructor, for whom are you writing? To repeat,

- At first, when you take notes and even when you write your first draft, you are writing *for yourself*—you are trying to clarify your ideas, trying to know what you think—but
- when you begin to revise a draft you are also writing *for an imagined reader*, an imagined audience. All writers need to imagine some sort of audience: Writers of self-help books keep novices in mind, writers of articles for *Time* keep the general public in mind, writers of papers for legal journals keep lawyers in mind, and writers of papers for *The Art Bulletin* keep art historians in mind.

An imagined audience in some degree determines what the writer will say—for instance, it determines the degree of technical language that may be used and the amount of background material that must be given. No principle of writing is more important than this one:

When you are revising, keep your audience in mind.

Who is *your* audience, your actual or implied reader? In general (unless your instructor suggests otherwise) think of your audience as your classmates. If you keep your classmates in mind as your audience,

- you will not write, "Leonardo da Vinci, a famous Italian painter," because such a remark offensively implies that the reader does not know Leonardo's nationality or trade.
- You might, however, write, "Leonardo da Vinci, a Florentine by birth," because it's your hunch that your classmates do *not* know that Leonardo was born in Florence, as opposed to Rome or Venice.
- And you will write, "John Butler Yeats, the expatriate Irish painter who lived in New York," because you are pretty sure that only specialists know about Yeats.

Similarly, you will not explain that the Virgin Mary was the mother of Jesus—you can probably assume that your reader has at least this much knowledge of Christianity—but if you mention St. Anne, you probably will explain that St. Anne was the mother of Mary.

Further, assume that your reader may tend not to agree with you— that is, assume a somewhat skeptical reader. Why? Because with such an audience in mind, you will be prompted to support your assertions with evidence.

In short, if you imagine that your reader is looking over your shoulder when you are revising, your imagined audience becomes your collaborator, helping you to decide what you need to say—in particular, helping you to decide

- how much background you need to give
- which terms you need to define
- what kinds of evidence you need to offer in order to convince the reader
- what degree of detail you need to go into.

If, for instance, you are offering a psychoanalytic interpretation, you can assume that your audience is familiar with the name Freud and with the Oedipus complex, but you probably cannot assume (unless you are addressing psychoanalysts) that your audience is familiar with the contemporary psychoanalyst D. W. Winnicott and his concept of the pre-Oedipal mother–infant dyad as a source of creativity. If you are going to make use of Winnicott, you will have to identify him and briefly explain his ideas.

✍ A RULE FOR WRITERS:

When you draft, and especially when you revise, keep your audience in mind. (Your imagined audience for a course paper probably will be your classmates.) Tell these imagined readers (a) what they need to know, (b) in an orderly way, and (c) in language that they will understand.

A successful essay, whether a brief review of an art exhibition in a newspaper or a twenty-page essay in *Art History*, begins with where the readers are and then goes on to take the readers further. (See also "A Note on Technical Language," pages 197–200.)

✔ A Checklist: Imagining a Reader

❏ Do I have a sense of what the reader probably *knows* about the issue?
❏ Do I have a sense of what the reader probably *thinks* about the issue?
❏ Have I stated my thesis clearly and sufficiently early in the essay?
❏ How much common ground do we probably share?
❏ Have I, in the paper, tried to establish common ground and then moved on to advance my position?
❏ Have I supported my arguments with sufficient details?
❏ Have I used the appropriate language (for instance, defined terms that are likely to be unfamiliar)?
❏ Have I indicated *why* my readers should care about the issue and should accept or at least take seriously my views?
❏ Is the organization clear?
❏ Have I used transitions ("furthermore," "on the other hand") where they are needed?
❏ Have I presented myself as a person who is (a) fair, (b) informed, and (c) worth listening to?

THE FUNCTIONS OF CRITICAL WRITING

In everyday language the most common meaning of *criticism* is "finding fault," and to be critical is to be censorious. But a critic can see excellences as well as faults. Because we turn to criticism with the hope that the critic has seen something we have missed, the most valuable criticism is not that which shakes its finger at faults but that which calls our attention to interesting matters going on in the work of art. Critical writing, in short, educates the reader, chiefly by offering *evidence* in support of opinions.

In the following statement W. H. Auden suggests that criticism is most useful when it calls our attention to things worth attending to. He is talking about works of literature, but we can easily adapt his words to the visual arts.

> What is the function of a critic? So far as I am concerned, he can do me one or more of the following services:
> 1. Introduce me to authors or works of which I was hitherto unaware.
> 2. Convince me that I have undervalued an author or a work because I had not read them carefully enough.
> 3. Show me relations between works of different ages and cultures which I could never have seen for myself because I do not know enough and never shall.
>
> —W. H. Auden, *The Dyer's Hand* (1963), 8–9

The emphasis on introducing and showing suggests that the chief function of critical writing is not very different from the common view of the function of literature or art. The novelist Joseph Conrad said that his aim was "before all, to make you *see*," and the painter Ben Shahn said that in his paintings he wanted to get right the difference between the way a cheap coat and an expensive coat hung.

Take Auden's second point, that a good critic can convince us—can gain our agreement by calling attention to evidence supporting a thesis—that we have undervalued a work. Although you probably can draw on your own experience for confirmation, an example may be useful. Rembrandt's self-portrait with his wife (see below), now in Dresden, strikes many viewers as one of his least attractive pictures: The gaiety seems forced, the presentation a bit coarse and silly. Paul Zucker, for example, in *Styles in Painting*, finds

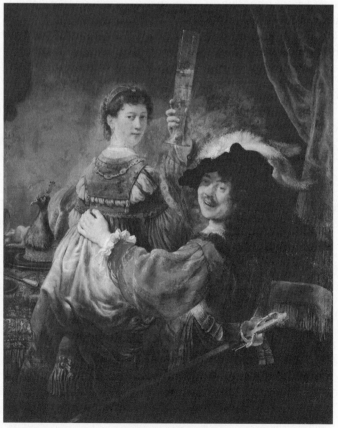

Rembrandt Harmensz van Rijn (1606–1669). Rembrandt *Self-Portrait with Saskia* in the parable of the Prodigal Son. 1635–39. Oil on canvas, 131 × 161 cm. Photographer: Erich Lessing. Art Resource, N.Y.

it "over-hearty," and John Berger, in *Ways of Seeing,* says that "the painting as a whole remains an advertisement for the sitter's good fortune, prestige, and wealth. (In this case Rembrandt's own.) And like all such advertisements it is heartless." But some scholars have pointed out, first, that this picture may be a representation of the Prodigal Son, in Jesus' parable, behaving riotously, and, second, that it may be a profound representation of one aspect of Rembrandt's marriage. Here is Kenneth Clark on the subject:

> The part of jolly toper was not in his nature, and I agree with the theory that this is not intended as a portrait group at all, but as a representation of the Prodigal Son wasting his inheritance. A tally-board, faintly discernible on the left, shows that the scene is taking place in an inn. Nowhere else has Rembrandt made himself look so deboshed, and Saskia is enduring her ordeal with complete detachment—even a certain hauteur. But beyond the ostensible subject, the picture may express some psychological need in Rembrandt to reveal his discovery that he and his wife were two very different characters, and if she was going to insist on her higher social status, he would discover within himself a certain convivial coarseness.
>
> —Kenneth Clark, *An Introduction to Rembrandt* (1978), 73

After reading these words, we may find that the appeal of the picture grows—and any analysis that increases our enjoyment in a work surely serves a useful purpose. Clark's argument, of course, is not airtight—one rarely can present an airtight argument when writing about art—but notice that Clark does more than merely express an opinion or report a feeling. In his effort to persuade us, he offers evidence (the tally-board and the observation that no other picture shows Rembrandt so "deboshed"), and the evidence is strong enough to make us take another look at the picture. After looking again, we may come to feel that we have undervalued the picture.

SOME WORDS ABOUT CRITICAL THINKING

Again, the word *critical* commonly implies a negative, fault-finding spirit, and *thinking* can include mere daydreaming ("During Art History 101 I kept thinking about lunch"), but the term *critical thinking* suggests careful analysis. *Critical* comes from a Greek word, *krinein,* meaning "to separate," "to choose"; it implies conscious, deliberate inquiry, and especially it implies a skeptical state of mind, but a skeptical state of mind is *not* a negative, self-satisfied, fault-finding state of mind. Quite the reverse; because critical thinkers wish to draw sound conclusions, they apply their skepticism to *their own* assumptions, to *their own* evidence, and indeed toward all aspects of *their own* thinking as well as toward that of others. When they read a draft, they read it with a skeptical mind, seeking to improve the thinking that has gone into it.

A SAMPLE CRITICAL ESSAY

Let's look at a student's short essay on a famous picture by James McNeill
Whistler (1834–1903).

<div align="right">

Douglas Lee

Fine Arts 101

February 7, 2013

</div>

<div align="center">

Whistler's Japanese Mother

</div>

The painting commonly known as *Whistler's Mother* (Figure 1) is
full of surprises. First of all, its title—the title that Whistler gave it—is
Arrangement in Grey and Black No. 1: The Artist's Mother. Once we
are aware of the title, we look at it in a way different from the way
we look at it under the popular title, *Whistler's Mother.* The word

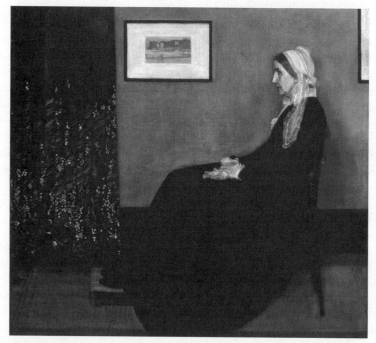

Figure 1. James Abbott McNeill Whistler, American (1834–1903). *Arrangement
in Black and Gray: The Artist's Mother.* 1871, oil on canvas, 57" × 64 ½". Louvre.
RMN-Grand Palais/Art Resource, NY.

"Arrangement" in Whistler's title forces us to think about the work (at least for a while) as a composition, not as a picture of a particular mother, and certainly not as a picture of the idea of motherhood.

Whistler has done a good deal to prevent us from seeing the picture as an image of motherhood. The subject, of course, is a Caucasian woman (in fact, Whistler's mother), but we do not see her with a child or with grandchildren, and we do not even see her engaged in some sort of action that might suggest motherhood, let's say setting the table or hanging out the clothes to dry. Rather, she is alone, and motionless. She does not even look in our direction. Because we see her in profile, she seems somewhat aloof, taking no notice of others, hardly a quality we associate with motherliness. Further, her black dress, appropriate enough for an older woman in the late nineteenth century, does not help to establish her as an individual with a warm or tender personality. If it says anything about her, it may say only that she is a widow. When we let our mind stray a bit, and we think of the brightly colored vibrant women depicted by some of Whistler's contemporaries such as Renoir (1841–1919), van Gogh (1853–90), and Gauguin (1848–1903), we realize that we should take his title seriously, *Arrangement in Grey and Black,* and should look for a pattern rather than for an engaging personality.

By the time he painted *Arrangement in Grey and Black* Whistler had become deeply interested in Japanese prints. True, Japanese prints are colorful and their subject matter is often a beautiful young woman wearing an elaborately decorated kimono, whereas Whistler's rather drab picture shows a plainly dressed older woman. One of the qualities, however, of Japanese prints that interested Whistler was the flatness of the colors; most early Japanese prints did not use shading, so the colors are unmodulated within any given area bounded by lines. Further, Japanese prints often did not use perspective, and they often did not include a background, so the figures

are not set within a recognizable space; they exist in empty space. If there is in these prints a background, it usually is indicated with relatively few details, such as a picture on a wall or a bamboo blind (Figure 2), and the space seems very shallow. Whistler's background here is not empty—clearly the woman is in a room, with two pictures hanging on the wall behind her, and a curtain hanging at the left—but the wall and the floor are relatively blank, as they are in the Japanese print. Furthermore, because the seated woman is close to the wall (as

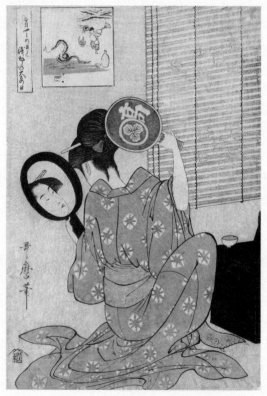

Figure 2. Kitagawa Utamaro I, Japanese, (?–1806). *Takashima Ohisa,* Edo Period, about 1795 (Kansei 7). Woodblock print (nishiki-e); ink and color on paper. Vertical oban; 36.3 × 25 cm (14 5/16 × 9 13/16 in.). Museum of Fine Arts, Boston. William S. and John T. Spaulding Collection, 21.6410. Photograph © 2013 Museum of Fine Arts, Boston.

in Japanese prints) and we are close to her, Whistler does not convey a sense of depth or of a person who moves within a clearly defined setting. Rather than directing us to think about the loving actions of a particular mother, Whistler invites us to enjoy the pattern, for instance to contrast the curved lines that define the woman with the rectangles that constitute the pictures (again compare Whistler's painting with Figure 2), the drapery, and the footstool where the drapery touches the ground. In short, we are invited to see the picture as a design, an "arrangement." Speaking of the first part of the title, *Arrangement in Grey and Black,* Whistler said, "Now, that is what it is. To me it is interesting as a picture of my mother; but what can or ought the public to care about the identity of the picture?"[1]

If we want to confirm the fact that the picture is a picture, a design rather than an evocation of motherliness, we can contrast it with an ugly postage stamp that the United States issued in 1934 (Figure 3). Whistler's handsome painting is severely cropped at the bottom, the pictures on the wall are gone (probably Whistler put them there to help us to understand that this is a painting about the art of painting, not about the revelation of maternal character), and a vase with flowers replaces the drapery, doubtless in order to show that the woman in the painting likes pretty things, and maybe even that she has a green thumb. The post office's heavy-handed message

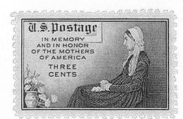

Figure 3. Commemorative U.S. postage stamp, 1934. Courtesy of the Library of Congress Prints and Photographs Division.

[1] Quoted in Anne Koval, *Whistler in His Time* (London: Tate Gallery, 1994), 6.

further demolishes Whistler's picture: "U.S. postage/in memory/and in honor/of the mothers/of America/three cents."

The common title, *Whistler's Mother,* sounds as though the picture must be as American as apple pie, a close relative of Gilbert Stuart's *George Washington* or maybe of Grant Wood's *American Gothic,* but a careful look at this justly famous painting, coupled with an awareness of Whistler's title and a familiarity with the fact that Whistler was much interested in Japanese prints, brings a viewer to see that this painting owes less to America or to motherhood than to Japan.

The Essay Analyzed

Douglas Lee's essay includes evaluation, or judgment, as well as analysis of what is going on in the painting. As for **evaluation,** it is enough for us to notice that Lee judges Whistler's painting as worth talking about. (Newspaper and magazine criticism is largely concerned with evaluation—think, for instance, of film reviews, which exist chiefly to tell the viewer whether a film is worth seeing—but most academic criticism assumes the value of the works it discusses, and it is chiefly analytic and interpretive. For a more detailed comment on evaluation, see pages 40–42, 229–43.)

Although Lee explicitly praises the work ("handsome painting"), most of his evaluation is implicit in and subordinate to the **analysis** of what he sees. (For the moment we can define analysis as the systematic separation of the whole into its parts; the fourth chapter of this book is devoted to the topic.) Lee sees things and calls them to our attention as worthy of note, for instance:

- the flatness of the figure,
- its detachment from us because it is presented in profile,
- the lack of any action that suggests motherliness,
- the lack of any other figure that would help to confirm the woman's motherliness, and
- the shallowness of the space.

It is clear that Lee values the picture but he does not worry about whether Whistler is a better artist than van Gogh or Grant Wood. He is content to help us to see what is going on in the picture.

Or at least Lee seems to be content to help us see. In fact, he is advancing a **thesis** (a central point, a main idea that will be supported by evidence—in short a claim, an argument). His argument is that the picture is not about motherliness but about the importance of design in art.

A good thesis is

- *not* the assertion of a mere undisputed fact ("Whistler's mother was his model in this picture" or "Whistler was an American who lived chiefly in London")
- *nor* is a good thesis a broad generalization that cannot interestingly be supported (*"Whistler's Mother* is widely admired").

Such statements are true, but they can hardly be argued. Normally a **thesis statement**

- names the topic (here, a particular painting) and
- makes an arguable assertion about it that the writer will support with details later in the essay.

✔ A Checklist for a Thesis Statement

Have I asked myself the following questions?

❑ Does the sentence make a claim rather than merely offer a description?
❑ Is the claim arguable rather than self-evident, universally accepted, and of little interest?
❑ Can evidence be produced to support the claim?
❑ Is the claim narrow enough to be convincingly supported in a paper written within the allotted time and of the assigned length?

This student's thesis statement, appropriately in the first sentence, is

> The painting commonly known as *Whistler's Mother* (Figure 1) is full of surprises.

True, this statement is not specific, for instance, not nearly as specific as

> *Whistler's Mother* is indebted to Japanese prints,

or

> *Whistler's Mother* owes more to Japanese prints than it does to any traditional concept of motherhood

but it qualifies as a thesis sentence because it offers an arguable asser-
tion, and the writer goes on to clarify it and to support it effectively. The
essay is largely an effort to *persuade* us by offering an argument—a rea-
soned account, consisting of evidence offered in support of the thesis—that
indeed the thesis is valid, that the picture is not as simple as it looks or as the
common title suggests.

It is not enough for writers to see things and to report to readers what
they have seen. Writers have to present their material in an orderly fash-
ion, so that readers can take it in and can follow a developing argument.
In short, writers must organize their material. Each paragraph must serve
a purpose, and the sequence of paragraphs must serve the writer's basic
purpose—to communicate clearly.

- **The opening paragraph** asserts the thesis (the picture is "full
 of surprises") and gives us some essential information (the origi-
 nal title and the suggestion that this title ought to help us to think
 about the picture). Notice that the thesis is introduced without a
 tedious announcement such as "In this paper I will demonstrate,"
 or "This paper seeks to prove that . . ."

- **The second paragraph** helps us to see the picture; it points out
 that by presenting the woman without other figures, and by pre-
 senting her in profile, Whistler diminishes her motherliness. The
 comparison with his contemporaries—strictly speaking a contrast
 rather than a comparison—helps us to see the distinctiveness of this
 painting.

- **The third paragraph** explains in large part why the picture looks
 the way it does: It is indebted to Japanese prints, which tend to
 emphasize flat designs rather than the illusion of depth, and for
 Whistler these works of art were chiefly "arrangements," designs
 rather than revelations of character.

- **The next-to-last paragraph** introduces a comparison (strictly
 speaking, a contrast) to the postage stamp, which, by showing us
 what Whistler's picture is *not*, helps to show us what it *is*. (The act
 of comparing—especially of contrasting—similar things is an excel-
 lent way of seeing distinctive traits.)

- **The final paragraph** reinforces the thesis, not by the obvious
 device of saying "Thus we have seen," or "In conclusion," but by
 making explicit what until now has been implicit: "This painting
 owes less to America or to motherhood than to Japan." Like most
 good concluding paragraphs, while recapitulating the main point it
 enlarges the vision, in this instance by including references to two
 other American painters.

A Note on Outlining

If Lee prepared an outline to help him draft the essay, it may have looked something like this or, rather, something like this after he arranged and rearranged it:

> Begin with where reader is, "Whistler's Mother," then inform reader of real title
> Significance of real title
> *Not* maternal
> no children present
> no action suggesting motherliness
> profile: sort of cold, remote
> Infl. of Japanese prints
> flat (uniform) colors
> little sense of depth; no perspective
> emphasis on pattern rather than on character
> Contrast with U.S. stamp
> ridiculous flower pot to feminize her
> Contrast with other American portraits, reaffirm Japanese influence

An outline—nothing elaborate, even just a few notations in a sequence that seems reasonable—can be a great help in drafting an essay. The very act of putting a few ideas down on paper will usually stimulate you to think of additional ideas, just as when you jot down "tuna fish" on a shopping list, you are reminded that you also need to pick up bread. Outlining, in short, is not merely a way of organizing ideas but is also a way of *getting* ideas.

If, however, you feel that you can't make a preliminary outline for a draft, write a draft and *then* outline it. Why? An outline of your draft will let you easily examine your organization. That is, when in the course of reviewing your draft you brush aside the details and put down the chief point or basic idea of each paragraph, you will produce an outline that will help you to see if in your draft you have set forth your ideas in a reasonable sequence, a sequence that will help rather than confuse your readers. By studying this outline of your draft, you may find, for instance, that your third point would be better used as your first point. (Outlining is discussed in more detail on pages 44–45 and especially pages 59–60.)

✍️ A RULE FOR WRITERS:

Organize your essay so that your readers can easily follow the argument you use—the reasons you give—to support your thesis.

WHAT IS AN INTERPRETATION—AND ARE ALL INTERPRETATIONS EQUALLY VALID?

Interpretation and Interpretations

An interpretation sees the work of art as *representing* something, or *expressing* something, or *doing* something. In short, an interpretation tries to make sense of a work by setting forth its meaning, or, better, as the setting forth of one of the meanings of the work. (*Meaning* is variously defined, but probably most people would agree that meaning in art implies that the work calls attention to something other than itself, that is, that there is more to it than meets the eye. What claim does it seem to make, or, we might even ask, What claim does it have on us?) This issue of *meaning* versus *meanings* deserves a brief explanation. Although some art historians still believe that a work of art has a single meaning—the meaning it had for the artist—most historians today hold that a work has several meanings:

- the meaning it had for the artist
- the meaning(s) it had for its first audience
- the meaning(s) it had for later audiences, and
- the meaning(s) it has for us today.

Michelangelo's *David* (page 70), for instance, in sixteenth-century Florence seems to have "meant" freedom from tyranny—the Florentines twice drove out the Medici and established republics—but most of today's viewers, unaware of the history of Florence, do not find this meaning in a sculpture of the youth who killed the giant Goliath.

Similarly, a portrait by Goya probably meant one thing to the artist, another to the sitter, yet another to the sitter's descendants when they viewed it in their ancestral house, and it means something else to us when we view it in a museum. In fact, it probably meant several things to the artist as he worked on it. Picasso offers a relevant comment about changes in meaning:

> A picture is not thought out and settled beforehand. While it is being done it changes as one's thoughts change. And when it is finished, it still goes on changing, according to the state of mind of whoever is looking at it. A picture lives a life like a living creature, undergoing the changes imposed on us by our life from day to day. This is natural enough, as the picture lives only through the man who is looking at it.
>
> —Conversation with Christian Zervos, 1935, reprinted in
> *Picasso on Art*, ed. Dore Ashton (1972), 8

Although viewers usually agree in identifying the subject matter of a work of art (the martyrdom of St. Catherine, a portrait of Napoleon, a bowl of apples), disputes about subject matter are not unknown. Earlier in the chapter, for example, we saw that one of Rembrandt's paintings can be identified as *Self-Portrait with Saskia* or—a very different subject—as *The Prodigal Son;* similarly, on pages 264–65, we will see that Rembrandt's painting of a man holding a knife has been variously identified as *The Butcher, The Assassin,* and *St. Bartholomew.* Of course, an interpretation usually goes further than identifying the subject. We have already seen that Kenneth Clark interprets the picture with Saskia not only as an illustration of the story of the Prodigal Son but also as Rembrandt's expression of an insight into his relationship with his wife. Similarly, in Millet's famous painting, *The Gleaners,* an interpretation may begin by saying that Millet's picture shows poor women gleaning (gathering what the harvesters have left behind), and it may go on to argue that it shows (or asserts, or represents, or expresses) some sort of theme, such as the dignity of labor, or the oppression of the worker, or the bounty of nature, or whatever.

Who Creates "Meaning"—Artist or Viewer?

Artists themselves sometimes offer interpretations of their works. For instance, writing of his *Night Café* (1888, Yale University Art Gallery), van Gogh said in a letter (8 September 1888):

> The room is blood-red and dark yellow with a green table in the middle; there are four lemon-yellow lamps with a glow of orange and green. Everywhere there is a clash and contrast of the most disparate reds and greens . . . in the empty, dreary room. . . . I have tried to express the idea that the café is a place where one can ruin oneself, run mad, or commit a crime. So I have tried to express, as it were, the powers of darkness. . . .

Many viewers find this comment helpful, but what do we make of his comment (in a letter to Gauguin, in October 1888) that the picture of his bedroom expresses an "absolute restfulness" and (in a letter to his brother, Theo, in October 1888) that the "color is to . . . be suggestive here of *rest* or of sleep in general"? Probably most viewers find the heightened perspective and the bright red coverlet on the bed disturbing rather than restful. (In the letter to Gauguin, van Gogh himself speaks of the coverlet as blood-red.)

Does the artist's **intention** limit the meaning of a work? (Earlier in this chapter we touched on intention: If Zuni creators of war god figures did not intend them to be works of art, are we not allowed to discuss these creations as works of art?) Surely one can argue that the creators of artworks may not always be consciously aware of what they are including in a work. Or their motives may

be irrelevant to their accomplishments: A painter may chiefly intend to produce a work to make money and yet may produce a masterpiece, or a painter may intend to produce a masterpiece and may produce nothing of interest. Further, artists may be consciously deceptive when they tell us about their intentions. Roy Lichtenstein told an interviewer, "I wouldn't believe anything I tell you."

Some modern critical theory holds that to accept the artist's statement about what he or she intended is to give the artist's intention an undeserved status. In this view, a work is created not by an isolated genius—the isolated genius is said to be a romantic invention—but by the political, economic, social, and religious ideas of a society that uses the author or artist as a conduit. Hence, we hear about "the social production of art." Most obviously, artists such as Rembrandt, Rubens, and Titian (and in our own time, Andy Warhol, who presided over a site of production called The Factory) worked with circles of assistants and apprentices and provided objects that responded to the demands of the market.

The idea that the creator of the work cannot comment definitively on it is especially associated with Roland Barthes (1915–1980), author of "The Death of the Author," in *Image-Music-Text* (1977), and with Michel Foucault (1926–1984), author of "What Is an Author?" in *The Foucault Reader* (1984). For instance, in "The Death of the Author" Barthes says, "The text [we can substitute "the work of art" for "the text"] is a tissue of quotations drawn from the innumerable centers of culture" (page 142). Similarly in "What Is an Author?" Foucault assumes that the concept of the author (we can say "the artist") is the invention of a society fascinated by personality, an invention that impedes the free circulation of ideas. In Foucault's view, the work does not belong to the alleged maker, who, to repeat, is a conduit for the ideas of the period. The artist is a team player; the work is the production of a society, not of an individual.

Further, it is sometimes argued, the work belongs—or ought to belong—to the *perceivers,* who of course interpret it variously, according to their historical, social, and psychological states. A proper history of art, in this view, examines works in the light of what they have meant over the years. Their past meanings are recognized as part of our present experience. Works of art, James Elkins argues in *Critical Theory* 22 (1996), page 591, have nothing to say except what we say to them. They do not speak for themselves; viewers speak for the works, that is, viewers put meanings—depending on their experiences—into the works they look at. This position, called **reception theory,** holds that art is not a body of works but is, rather, an activity of perceivers making sense of images. A work does not have meaning "in itself"; it can mean something only to someone in a context. The meaning is not inherent in the work, but is in the spectator's response. In this view, meaning is not in things that, so to speak, are behind the work, such as the artist's intention and the patron's demands; rather, meaning is in front of the work, in the spectator's response. What counts is, what kind of response did the work evoke?

To put the matter into almost comically oversimplified terms, in the eyes of a moralist a picture of a female nude may primarily be an obscene threat to decency, in the eyes of an aesthetician it may be a beautiful life-enhancing work of art, and in the eyes of a cultural historian it may be an interesting document revealing the exploitation of women. In the witty formulation of the novelist Penelope Fitzgerald, in *The Gates of Angels* (1990), "No two people see the external world in exactly the same way. To every separate person a thing is what he thinks it is—in other words, not a thing but a think" (page 49).

✍ A RULE FOR WRITERS:

Because most artists have not told us of their intentions, and because even those artists (or patrons or agents) who have stated their intentions may not be fully reliable sources, and because we inevitably see things from our own points of view, *think twice before you attribute intention to the artist* in statements such as "The designers of the stained glass windows at Chartres were trying to show us . . . ," or "Mary Cassatt in this print is aiming for . . . ," or "In his most recent photographs Hiroshi Sugimoto seeks to convey. . . ."

If one agrees that the beholders make or create the meaning, one can easily dismiss the statements that artists make about the meaning of their work. For example, although Georgia O'Keeffe on several occasions insisted that her paintings of calla lilies and of cannas were not symbolic of human sexual organs, we can (some theorists hold) ignore her comments. If *we* see O'Keeffe's lilies with their prominent stamens as phallic, and her cannas as vulval, that *is* their meaning—for us.

Much can be said on behalf of this idea—and much can be said (and in later pages *will* be said) against it. On its behalf one can say, first, that we can never reconstruct the artist's intentions and sensations. Van Gogh's *Sunflowers,* or his portrait of his physician, can never mean for us what they meant for van Gogh. Second, the boundaries of the artwork, it is said, are not finite. The work is not simply something "out there," made up of its own internal relationships, independent of a context (*decontextualized* is the term now used). Rather, the artwork is something whose internal relationships are supplemented by what is outside of it—in the case of van Gogh, by a context consisting of the artist's personal responses to flowers and to people, and by his responses to other pictures of flowers and people, and by our responses to all sorts of related paintings, and (to give still another example) by our understanding of van Gogh's place in the history of art. Because we now know something of his life and something of the posthumous history of his paintings, we cannot experience his work in the same way or ways—in the same context—that its original audience experienced it.

A Note about the Word "Art"

Anthropologists have often commented that this or that culture does not have a word that corresponds to our word *art*, or to our *fine arts*, they have sometimes said that therefore certain works that we put into art museums—let's say a sculpture of a deity—do not belong there. But the truth is, the word art, in the sense of "something valued chiefly for its aesthetic merit," is relatively new in English. Let's step back, however, and begin with the ancient Greeks. The Greek did not have a word for *art*. They merely had the word *techne* (which gives us our word "technology"), a word meaning something like *craft, skill, know-how*. The Greeks did not distinguish between the *know-how* of, say, the men who made sandals, and the know-how of the men who made the sculptures for the Parthenon, the famous Elgin Marbles, some of which are now regarded as the most glorious art treasures in the British Museum.

Nor—even though our word *art* comes from the Latin word *ars*—did the Romans have a word for "art," in our sense of the word—an object created chiefly for aesthetic enjoyment, For the Romans, *ars* was, like the Greek *techne*, a matter of skill. There was the art of public speaking, the art of the charioteer, and, notoriously, the art of love—Ovid's *Ars amatoria*, a book instructing men how to seduce women, and instructing women how to be attractive to men. Ovid includes passages describing sexual positions.

Nor did the Middle Ages have any word to define what we call the Fine Arts. Not until the Renaissance did the idea begin to develop that certain men— almost always men, not women—were supremely gifted creators of some special sorts of things that were valuable in themselves, valuable just to be looked at, or just to be heard. These inspired creators were artists. Others—let's say weavers and potters—were mere *artisans*, craftsmen—not "artists." Often works of craftsmanship—however handsome—are said to be distinguished from works of art by the fact that the products of craftspersons are essentially functional— chairs are to be sat on, textiles are to be worn, ceramics are for tea, and so forth— whereas works of art are primarily valued simply as things to be perceived. But of course many works of art served highly specific purpose—religious images, for instance, were usually regarded as possessing power that could be transferred to the worshipper. Perhaps a more helpful way to distinguish between art and craft is to say that (1) works of art have meaning—one does not ask a chair or a macrame pot-holder to have meaning—and that (2) works of art are more evidently "original," more "creative." Indeed, if a craft product is conspicuously "original" or "creative," its utility may be diminished. After all, the quality we value most in a chair is that it provide a comfortable seat, not that it be imaginative. But there really is no need to police the borders here; we need not insist that X is a work of art, and that Y is a work of craft. Many traditional works of art have been highly crafted—this gets us back to Greek *techne*—and many works of craft provide so much visual and tactile pleasure that it seems churlish to insist they are not art.

When We Look, Do We See a Masterpiece— or Ourselves?

Writing an essay of any kind ought not to be an activity that you doggedly engage in to please an instructor; rather, it ought to be a stimulating, if taxing, activity that educates you and your reader. The job is twofold—seeing and saying—because these two activities are inseparable:

- If you don't see clearly, you won't say anything interesting and convincing.
- If you don't write clearly, your reader won't see what you have seen, and perhaps you haven't seen it clearly either.

What you say, in short, is a device for helping the reader *and yourself* to see clearly.

But what do we see? It is now widely acknowledged that when we look, we are not looking objectively, looking with what has been called an **innocent eye.** That is, we are not like the child who, uncorrupted by the ways of fawning courtiers, accurately saw that the emperor was wearing no clothes. Inevitably, we see from a particular point of view (even if we are not aware of it)—for instance, the view of an aging middle-class white male, or of a second-generation Chinese-American, or of a young Chicana feminist in the early years of the twenty-first century. Our interpretations of experience certainly feel like our own independent, rational responses, but, far from being objective, they are (it is widely believed) largely conditioned by who we are—and who we are depends partly on the cultures that have shaped us. The idea is ancient: Eight hundred years ago St. Thomas Aquinas said, "Whatever is received is received according to the nature of the recipient."

Most people would probably agree with the philosopher Nelson Goodman, who in *The Languages of Art* (1968) says that what the eye sees "is regulated by need and prejudice. It selects, rejects, organizes, discriminates, associates, classifies, analyzes, constructs. It does not so much mirror as take and make" (pages 7–8). Thus, in contrast to the view that the mind simply perceives (the position of the innocent eye), the **constructionist view** holds that the eye is selective and creative. In Degas's words, "One sees as one wishes to see." Some recent critics, influenced by Claude Lévi-Strauss's *The Savage Mind* (1966), have pushed this idea even further: Perceiving and interpreting are, they say, a form of **bricolage** (from the French *bricole,* meaning "trifle")—a form of spontaneously creating something new by assembling bits and pieces of whatever happens to be at hand or, in this case, whatever happens to be in the viewer's mind.°

°*Art Journal* 67:1 (Spring 2008) is devoted to several artists who work in this manner.

These ideas have engendered distrust of the traditional concepts of *meaning*, *genius*, and *masterpiece*. The arguments, offered by scholars who belong to a school of thought called the *New Historicism*, run along these lines: Works of art are not the unique embodiments of profound meanings set forth by individual geniuses; rather, the artist is "desacralized" and works of art are regarded as the embodiments of the ideology (ways of understanding the world) of the age that produced them. To talk of genius is to fetishize the individual. Works of art, in this view, are produced not so much by exceptional individuals as by the "social energies" of a period, which somehow find a conduit in a particular artist.° The old idea of a masterpiece—a work demonstrating a rare degree of skill, embodying a profound meaning, and exerting a universal appeal—thus is called into question, and is replaced by an idea summarized as "the social production of art." Theorists of the New Historicism argue that to believe in masterpieces is to believe, wrongly, that a work of art embodies an individual artist's fixed, transcendent achievement, whereas in fact (they argue) the work originally embodied the politics of the artist's age and it is now interpreted by the politics of the viewer's age. (The word *masterpiece* is also sometimes regarded as objectionable because of its alleged sexist implications.) In any given period, art dealers, museum personnel, professors of art history, self-styled artists, collectors, and so on, may speak of masterpieces, but all such talk is simply the talk of people associated with particular cultural institutions in a particular age, mistakenly thinking that they are describing objective, eternal values. (We have already looked at the "Institutional Theory of art," on pages 2–3.)

According to this way of thinking, the **canon**—the body of artworks that supposedly have stood the test of time because of their inherent quality—is not in fact a body of work of inherently superior value but is largely a construction made for political reasons by a self-serving elite. Thus, eighteenth-century landscapes of country estates with ploughed fields or with grazing cattle, it is argued, are in effect propaganda on behalf of landowners, intended to suggest that the landowners are benevolent stewards of their property. Or to take an even more obvious case, we can think about a body of work that until recently was regularly excluded from the canon: The work of women artists has been scandalously neglected because patriarchal values have determined the canon. (For additional remarks about analyses that see art as material that does "cultural work," see the discussion of cultural materialism on page 250.)

The idea of a universal appeal—an appeal in a work that transcends the historical circumstances of its production—thus is said to be a myth created by a coterie (chiefly dead white males) that has succeeded in imposing its patriarchal tastes and values on the rest of the world. The claim that, say, ancient

°See, for example, Griselda Pollock, "Artists, Mythologies, and Media—Genius, Madness, and Art History," *Screen* 21:3 (1983): 57–96.

Greece produced masterpieces of universal appeal, with the implication that all people *should* feel uplifted or enlightened or moved by these works of genius, is, according to some writers, the propaganda of European colonialism. In this view, individualism—the idea underlying the cult of genius—is merely another bourgeois value.

But the matter need not be put so bluntly, so crudely. We can hardly doubt that our perceptions are influenced by who we are, but we need not therefore speak dismissively of our perceptions or of the objects in front of us. True, talk about "universal appeal" is a bit highfalutin, but some works of art have so deeply interested so many people over so many years that we should hesitate before we dismiss these objects as nothing but the expression of the values of a particular class. Further, we should recognize that the traditional canon consists of works by very different kinds of artists. Botticelli, Poussin, Rembrandt, Vermeer, van Gogh, Cézanne, Munch, Klee, Pollock, and Rothko, for instance, do have something in common— they are all dead white males—but their works are amazingly different.

The Relevance of Context: The Effect of the Museum and the Picture Book

Chapter 7, "Writing a Review of an Exhibition," offers suggestions about what to look for in preparing to write not about a particular work but about a curator's choice and presentation of many works, but here we can glance at a few underlying issues.

We can look at ancient Greek sculptures or at Olmec sculptures in a museum—or at pictures of them in a book—but we cannot experience them as the Greeks or the Olmecs did in their social and religious contexts. (Indeed, most of the Greek sculptures that we see today are missing limbs or heads and have lost their original color, so we aren't really looking at what the Greeks looked at.)

Historians may think that they can recreate the **context**—the requirements of the patrons, the studio conditions of the sculptors, the religious beliefs of the viewers, and the churches or temples in which the objects were situated—but inevitably the historians (or, rather, all of us) unwittingly project current attitudes into a constructed past. Norman Bryson and Mieke Bal, in "Semiotics and Art History," *Art Bulletin* 73 (1991), 175, put it this way: "What we take to be positive knowledge is the product of interpretive choices. The art historian is always present in the construct she or he produces." We cannot even become mid–twentieth-century Americans contemplating American paintings whose meaning in part was in their apparently revolutionary departure from European work. (Even those of the original viewers who are still living now see the works somewhat differently from the way they saw them in the 1950s.)

Meaning, the argument goes, is indeterminate. Further, one can add that when a museum decontextualizes the work or deprives it of its original context—for instance, by presenting on a white wall an African mask that once was worn by a costumed dancer in an open place, or by presenting in a vitrine with pinpoint lighting a Japanese tea bowl that had once passed from hand to hand in a humble teahouse—the museum thereby invites the perceivers to project their own conceptions onto the works that may seem to be independent and free-standing but that in fact were part of an ensemble (the mask was part of a costume, the tea bowl was part of an arrangement of several tea utensils) used in a ritual context. The object—the African mask or the Japanese tea bowl or whatever—is now, in the museum, removed from its original context and thus is decontextualized, or, more accurately, it is put into a *new* context, a context that has its own meaning and that influences the viewer's interpretation of the object.

One can even argue that the museum makes invisible ("appropriates") the social forces that created a culture. One might ask, What is Christian art—designed to inspire faith and to assist believers in their worship—doing in a museum rather than church? Speaking of Piero della Francesca's *The Baptism of Christ* (mid-fifteenth century), which is in the National Gallery, London, the Archbishop of Westminster said (quoted in the *New York Times,* Nov 29, 2008, p. C2), it should be treated not as a work of art but rather as "a work of faith and piety."

The idea that the museum erases the social forces that created the work is especially heard with reference to African art. Thus, an exhibition called *Africa: The Art of a Continent,* displayed in London in 1995 and in New York in 1997, evoked considerable criticism on the grounds that the title was a European construction that minimized or homogenized the art of what in fact are numerous independent cultures. After all, the people who created these objects did not think of themselves as "African," nor, for that matter, did the people who carved ritual masks or who wove textiles think of themselves as artists. In short, it is the Western exhibitors who chose to call these objects "African art," who, so to speak, transformed cult objects into cultural objects. In an anthropological museum the emphasis is on function, but in an art museum the emphasis is on form.*

An example: A well-intentioned liberal effort to present Chicano art in an art museum met with opposition from the radical Left, which said that the proposed exhibition was an attempt to depoliticize the Mexican-

*For information about the debate surrounding *Africa: The Art of a Continent,* see Elsbeth Court, "Africa on Display," in Emma Barker, ed., *Contemporary Cultures of Display* (1999), 147–73.

American works and to appropriate them into bourgeois culture. In other words, it was argued that by framing (so to speak) the works in a museum rather than in their storefront context, the works were drained of their political significance and were turned into art—mere aesthetic objects in a museum in a capitalistic society. The frame (the context) is not neutral; it is not a meaningless container, but rather it becomes part of what it frames. (For further discussion of the museum as a frame, see page 113.)

This decontextualization or, to use a fairly new word, aestheticization has especially troubled some students of photography. Photographs that were intended to stir the viewer to social action—for instance, photographs of the homeless—become something else when they are displayed in a museum. What do they become? They become objects presented for our aesthetic enjoyment, and our interest shifts from the ostensible subject to the skill of the photographer. (For a student's comment along these lines with reference to Dorothea Lange's *Migrant Mother*, see page 122–23.)

Much of what has been said about "white box" (or "white cube") museum displays—windowless rooms with uncluttered white walls—with their implication that museums are repositories of timeless values that transcend cultural boundaries, also can be said about the illustrations of art objects in books. Here works of art are presented (at least for the most part) in an aesthetic context, rather than in a social context of, say, economic and political forces. Indeed, we have already seen that some objects—Zuni war god figures—are sometimes taken out of their cultural context and then are presented (by a sort of benevolent colonialism, it is said) as possessing a new value: artistic merit. Some critics argue that to take a non-Western object out of its cultural context and to regard it as an independent work of art by discussing it in aesthetic terms is itself a Eurocentric (Western) colonial assault on the other culture, a denial of that culture's unique identity.*

Conversely, it has been objected, when a book or a museum takes a single art object and surrounds it with abundant information about the cultural context, it demeans the object, reducing it to a mere cultural artifact—something lacking inherent value, something interesting only as part of a culture that is "the Other," remote and ultimately unknowable. Fifty years ago it was common for art historians to call attention to the aesthetic properties within a work and for anthropologists to try to tell us "the meaning" of a work; today, with a concern for global art history, it is common for art historians to borrow ideas from a new breed of anthropologists, who tell us that we can never grasp the meaning of an object from another culture and that we can understand

*On issues concerning the exhibition of objects in museums, see (in addition to Emma Barker's book cited in the preceding note) Victoria Newhouse, *Art and the Power of Placement* (2005), and Andrew McClellan, *The Art Museum from Boullée to Bilbao* (2007).

only what it means in *our* culture. That is, we study it to learn what economic forces caused us to wrest the work from its place of origin and what psychological forces cause us to display it on our walls. The battle between, on the one hand, providing a detailed context (and thus perhaps suggesting that the work is alien, "Other") and, on the other hand, decontextualizing (and thus slicing away meanings that the work possessed in its own culture, thereby implying it is part of our culture, or of a universal culture) is still going on.*

For some words about writing a review of an exhibition of nonwestern art, see pages 159–60.

Arguing an Interpretation: Supporting a Thesis

Against the idea that works of art have no inherent core of meaning and that what viewers see depends on their class or gender or whatever, one can argue that competent artists shape their work so that their intentions or meanings are evident to competent viewers (perhaps after some historical research). Most people who write about art make this assumption, and indeed such a position strikes most people as being supported by common sense.

It should be mentioned, too, that even the most vigorous advocates of the idea that meaning is indeterminate do not believe that all discussions of art are equally significant. Rather, they usually agree that a discussion is offered against a background of ideas—shared by writer and reader—as to what constitutes an effective argument, an effective presentation of a thesis. (As we saw on page 13, Kenneth Clark's thesis—or, because his thesis is tentative, we can call it a hypothesis—is that Rembrandt's *Self-Portrait with Saskia* "may express some psychological need in Rembrandt to reveal his discovery that he and his wife were two very different characters. This thesis, in effect, is that the work meant one thing to Rembrandt and it means another thing to the modern viewer.") When good writers offer a thesis, they do so in an essay that is

- **plausible** (reasonable because the thesis is supported with *evidence*)
- **coherent** (because it is clearly and reasonably organized)
- **rhetorically effective** (for instance, the language is appropriate to the reader; technical terms are defined if the imagined audience does not consist of specialists)

*For online reviews of exhibitions, see *CAA reviews* <*www.caareviews.org*>.

✍ A RULE FOR WRITERS:

Support your thesis—your point—with evidence. Assume that your readers are skeptical and show them that details support your interpretation.

This means that the writer cannot merely set down random expressions of feeling or even of unsupported opinions. To the contrary, the writer

- assumes a reasonable but skeptical reader and, therefore,
- tries to persuade the reader by *arguing* a case—by pointing to evidence that will cause the reader to say, in effect, "Yes, I see just what you mean, and what you say makes sense."

For many people, the verb *to argue* has unpleasant connotations; it suggests those nasty exchanges on televised debates. But to argue a case—and this is what your instructor expects you to do—is not to engage in a shouting match or to exchange insults; it is, again, to engage in self-criticism and to offer evidence in support of a thesis.

As readers, when do we say to ourselves, "Yes, this makes sense"? And what makes us believe that one interpretation is better than another? What makes some interpretations better than others? Probably

- the interpretations that strike us as better than other interpretations are the ones that are more *inclusive*; they are more convincing because they account for more details of the work.
- The less satisfactory, less persuasive interpretations of supposed meaning(s) are less inclusive; they leave a reader pointing to some aspects of the work—to some parts of the whole—and saying, "Yes, but your explanation doesn't take account of . . ." or "our explanation is in part contradicted by. . . ."

We'll return to the problem of interpreting meaning when we consider the distinction between subject matter and content in Chapter 4 (pages 74–75).*

*For a good introduction to the topic, see Terry Barrett, *Interpreting Art: Reflecting, Wondering, and Responding* (New York: McGraw-Hill, 2002).

EXPRESSING OPINIONS: THE WRITER'S "I"

The study of art is not a science, but neither is it the expression of random feelings loosely attached to works of art. You can—and must—come up with statements that seem true to the work itself, statements that almost seem self-evident (like Clark's words about Rembrandt) when the reader of the essay turns to look again at the object.

Of course, works of art evoke emotions—not only nudes but also, for example, the sprawled corpse of a rabbit in a still life by Chardin, or even the jagged edges or curved lines in a nonobjective painting by Kandinsky. It is usually advisable, however, to reveal your feelings not by continually saying "I feel" and "this moves me," but by pointing to *evidence*, by calling attention to qualities in the object that shape your feelings. Thus, if you are writing about Picasso's *Les Demoiselles d'Avignon* (see page 35), instead of saying, "My first feeling is one of violence and unrest," it is better to call attention (as John Golding does in *Cubism,* page 47) to "the savagery of the two figures at the right-hand side of the painting, which is accentuated by the lack of expression in the faces of the other figures." Golding cites this evidence in order to *support* his assertion that "the first impression made by the *Demoiselles* . . . is one of violence and unrest."

✍ A RULE FOR WRITERS:

If in an analysis you wish to make use of your feelings, you need to *explain* them, not merely describe them.

The point, then, is not to repress or to disguise one's personal response but to *account* for it (usually by pointing to supporting evidence) and to suggest that the response is not eccentric and private. Golding can safely assume that his response is tied to the object and that we share his initial response because he cites evidence that compels us to feel as he does—or at least evidence that explains why we feel this way. Here, as in most effective criticism, we get what has been called "persuasive description." It is persuasive largely because it points to evidence, but also because most of us have been taught—rightly or wrongly—to respect the authority of an apparently detached point of view.

✍ A RULE FOR WRITERS:

When you use terms such as *forceful, moving, stirring,* or *vivid,* you probably are talking not about the work but about your response to it. If you hope to persuade your reader, you need to point to the evidence—the features in the work that cause you to respond in such a way.

Most readers probably would rather be alerted to the evidence in the work of art than be informed about the writer's feelings, but to say that a writer should not keep repeating "I feel" is not to say that "I" cannot be used. Nothing is wrong with occasionally using "I." Conversely, noticeable avoidances of "I"—such as "one sees that," "the author," "this writer," "we," and the like—may suggest sham modesty.

By the way, the use of *one*, as in "One sees that," easily gets one— oops—easily gets a writer into sounding like a goose honking, or into some other trouble. Consider:

One sees when one looks closely
(better: One sees on close inspection)

One sees when you look
(annoying shift in subject)

One sees when he looks
(sexist)

One sees when he or she looks
(awkward)

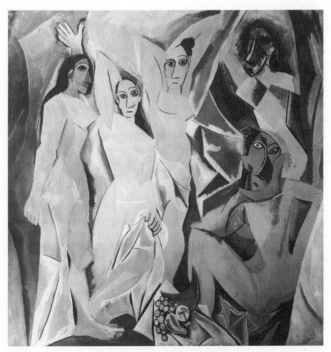

Pablo Picasso, Spanish (1881–1973). *Les Demoiselles d'Avignon,* Paris (June– July, 1907). Oil on canvas, 8' × 7' 8" (243.9 × 233.7 cm). The Museum of Modern Art/Licensed by SCALA/Art Resource, NY. Acquired through the Lillie P. Bliss Bequest. Photograph © 2001 The Museum of Modern Art, New York. © 2011 Estate of Pablo Picasso/Artists Rights Society (ARS), New York.

In short, when you revise you draft, think twice before you let *one* stand. Finally, it must be admitted that the preceding paragraphs make it sound as if writing about art is a decorous business. In fact, it is often a loud, contentious business, filled with strong statements about the decline of culture, revolution, pornography (or a liberating sexuality), the destruction of the skyline, fraud, new ways of seeing, beauty. In 1846 Charles Baudelaire called for a criticism that was "partial, passionate, and political," and much of what is written today fits this description. Examining the conflicting critical assumptions and methodologies will be part of your education, and if you find yourself puzzled, you will also find yourself stimulated. An energetic conversation about art has been going on for a long time, and it is now your turn to say something.

2

WRITING ABOUT ART: THE BIG PICTURE

Writing is exploration. You start from nothing and learn as you go.

> —E. L. Doctorow

I write what I would like to read.

> —Kathleen Norris

What can be said at all can be said clearly.

> —Ludwig Wittgenstein

The next few chapters amplify the assertions offered in this chapter, and Chapter 8 ("How to Write an Effective Essay") provides a review, but for a start, here is a brief introduction to what composition instructors call the writing process. In fact, no single process works for all writers—indeed, most writers use different processes for different kinds of assignments—but the following advice may help you to get going, especially on a short paper that draws chiefly on your own responses to a work.

STANDING BACK: KINDS OF WRITING (INFORMING AND PERSUADING)

Most writing about art seeks to do one or both of two things:

- **to inform** ("This picture was painted in 1980"; "The anchor in the picture symbolizes hope"; "Conceptual Art favors intellectual over visual pleasure")
- **to persuade** ("This early picture is one of her best"; "Despite the widespread view that the anchor symbolizes hope, I will argue that here the anchor has no symbolic meaning"; "Most exhibitions of Conceptual Art are tedious because there is so little sensuality, so little visual pleasure")

Recall Auden's comments on the function of criticism (page 11), when he said that a critic might "introduce" him to a work of which he had been

unaware (here information would be dominant) or might "convince" him that he had undervalued a work (here persuasion would be dominant). Most writing, of course, seeks both to inform *and* to persuade—Kenneth Clark's paragraph (page 13) interpreting a painting by Rembrandt certainly tries to do both—though one purpose or the other usually dominates.

Whether you are chiefly concerned with informing or with persuading (and the two purposes are often indistinguishable, because writers usually want to persuade readers that the information is significant),

Giovanni Bologna, *Mercury*, 1580. Bronze, 69". Photographer: Alinari. Art Resource, N.Y. R. Museo Nazionale, Firenze.

you ought to be prompted by a strong interest in a work or a body of work. This interest usually is a highly favorable response to the material (essentially, "That's terrific"), but an unfavorable response ("Awful!") or a sense of bafflement ("Why would anyone care for that?") may also motivate writing. We can guess that Kenneth Clark, puzzled by the fact that "Nowhere else has Rembrandt made himself look so deboshed," set his mind to work and came up with some tentative explanations. In any case, stimulated by a work, you put words onto paper, perhaps first by jotting down observations in no particular sequence. Later you will organize them for the benefit of an imagined reader, offering what the novelist D. H. Lawrence calls "a reasoned account of the feelings" produced by a work. Don't be embarrassed if a work produces strong feelings in you, pleasant (van Gogh wanted the picture of his bedroom to induce restful feelings in the viewer) or unpleasant (Damien Hirst says he wants his work to make viewers feel "uncomfortable").

Most academic writing about art, such as the material that you will read in courses in art history, is chiefly explanatory, or, we can say, **analytic:** It is concerned with examining relationships (for instance, of the parts to the whole within a work, or of historical causes and effects), and indeed your instructors probably will ask you to write papers that are largely analytic. The next chapter is devoted entirely to analysis, but writing about art includes a range of kinds of writing:

- **description,** such as might be given if one is reporting a stolen object ("Giovanni da Bologna's *Mercury* [page 38] is a bronze statue, 69 inches tall, of a male who is nude except for his hat; his hat and his heels are winged, and he holds a staff with wings at the top.")
- **interpretation** ("A youthful male figure with winged sandals and a winged hat can be identified as Mercury, a messenger of the gods.") When you interpret, *you make sense of what you see,* as, for instance in "W is about classical heroism," or "X expresses the artist's response to the new challenge of Pop Art," or "Y reveals, unintentionally, the sexism of the period," or "Z is aesthetically pleasing because" Thus, depending on the writer's aim, many sound interpretations are possible. It does *not* follow, however, that because a particular work may generate more than one sound interpretation—that because there is no single interpretation that is *the* proper interpretation for a work—therefore all interpretations are equally sound. A sound interpretation must be in accord with the facts of the work and of history.

- **analysis** or **explanation** of the internal relationships—the structure—of the work, that is, explanation of *why* the artist ("The slender outstretched limbs suggest flight, but the sense of motion is countered by the strong vertical of the body and the left leg, which makes the figure seem stable.")
- **personal report,** or what might be called "confession," a report of one's immediate response and perhaps of later responses ("Unlike some sculpture which is interesting only when viewed from the front, *Mercury* is equally interesting when viewed from the sides and the rear.")
- **evaluation** ("The work is masterfully executed not only by the sculptor but also by the craftsmen who cast the image.")

To take a brief example: In a classic essay on Jackson Pollock's *Blue Poles,* Ellen Johnson in *Studio International,* Number 185 (June 1973), 261, calls attention to "the bam-bam-bam of the bright red, blue and yellow, flung and dripped along with the white, black and aluminum, to the powerful beat of the blue poles as they swing across the canvas." We get description (the information about the colors of the painting), but surely we also get personal report—the writer's response—when Johnson speaks of the "bam-bam-bam" of the bright colors. The entire sentence implies a favorable evaluation.

Again, your instructors will probably ask you to write papers that are chiefly analytic, though some description, personal report, and evaluation almost surely will be implicit (if not explicit) in your analyses.

Caution: Bear in mind that although description is essential, **prolonged description** will probably become boring, especially if you include a reproduction of the work of art in your essay: "On the table there is a white tablecloth; at the left is a pitcher, and to the right of the pitcher are six pieces of fruit, including two lemons, two red apples, one green apple, and one pear. The background consists of a wall, partly obscured by drapery." Why, your reader will rightly wonder, are you bothering to tell me all this, when I can see it for myself at a glance? (On the other hand, readers welcome a description that calls attention to what is *not* evident in a reproduction, such as a view of a sculpture from a different angle, or a description of the texture of the brush strokes in a painting.)

As for a **prolonged personal report,** it will be of little interest unless you can connect your responses with your reader's. An excellent way to connect responses, and perhaps even to create them in the reader, is to point to *evidence* in the work. We have already seen (page 34) an example: In talking about Picasso's *Les Demoiselles d'Avignon,* John Golding does

not merely say, "My first feeling is one of violence and unrest"; rather, he points to "the savagery of the two figures on the right-hand side of the painting." We can look at the picture and examine the evidence; if we agree, we understand why Golding says he experiences violence and unrest. Or we can look and disagree; perhaps we will want to reply to Golding that he confuses an unfamiliar form of sensuous beauty with savagery, but at least we know where Golding stands, why he takes his position, and we know why we are taking a different position.

Personal report often implies **evaluation** ("We are shocked, but we cannot look away," or, on the contrary, "There is simply nothing here that holds our interest"), and in Chapter 11 we will discuss some critical principles that underlie evaluation. Here it is enough to say that the two most common sources for judging are

- a principle alleged to be widely held ("A picture ought to be unified," "A building should not disguise its purpose"), and
- a spontaneous personal response ("This picture of a blind beggar is deeply disturbing").

Although personal responses can hardly be argued about in rational terms, they can and must be set forth clearly and interestingly, so that the reader understands—because the writer points to things in the work that evoke the responses—*why* the writer experiences these responses and *why* the writer evaluates the work as he or she does.

Again, most writing about art is of a mixed sort. Let's look at part of another paragraph from Ellen Johnson's essay on Jackson Pollock. Johnson says that in Pollock's work

> the material nature of the paint insistently demands our sensory response to its enormous variety. This is true even when the paint is thin and stains the canvas—becoming one with it—in this sense also the ground is eliminated and the homogeneity of the surface is further emphasized. In some pictures, Pollock enriched the already sensuous surface by adding bits of other matter; *Full Fathom Five* is especially rich in this regard. Several foreign objects are embedded in its oil and aluminum paint; but the thumb tacks, pennies, cigarettes, paint tube tops, matches, etc., are only discovered with very close scrutiny. Lost in the life of the painting, they "suffer a sea-change into something rich and strange." Pollock's grand scale paintings are curiously intimate and public in what they give—and what they ask of us.
>
> —"Jackson Pollock and Nature," in *Studio International*, Number 185 (June 1973), 260

In talking about Pollock's work, Johnson gives us

- some relatively objective **description** (she tells us that thumbtacks, pennies, and other objects are embedded in the paint), and she gives us a
- **personal report** (she tells us what "being in their actual presence is . . . like"). She also give us
- **analysis** (she tells us *how* Pollock gets his effects, for instance, by enriching the surfaces), and she gives us
- **evaluation** (it is clear that Johnson admires the pictures). The metaphoric word *enriched*—used of a surface that has thumbtacks and pennies stuck to it!—strongly implies a favorable evaluation. By the way, Johnson's quotation ("suffer a sea-change") comes from a song in Shakespeare's *The Tempest,* the very song that provided Pollock with his title, *Full Fathom Five.* The quotation thus itself enriches Johnson's writing, lending it weight or authority.

Earlier in this chapter I said that most academic writing about art is chiefly analytic. The statement is true—but equally true is the statement that most writing about art is not merely analytic but is also *persuasive,* which is to say that

- it makes a claim, offers a thesis
- it seeks to persuade readers that its thesis is valid
- it supports its thesis with evidence (facts and reasons)

You may want to reread Johnson's paragraph and evaluate her ways of talking about Pollock. Do you imagine that, if you were standing in the presence of a work by Pollock, her paragraph would help you to understand and enjoy the work? If the paragraph shows ways of talking that you like, consider incorporating them into your own essay; and if it shows ways of talking that displease you, try to banish them from your own writing.

CLOSE-UP: DRAFTING THE ESSAY

Generating Ideas

1. **Consider the writing situation:** Is the specific topic assigned, or do you choose your own topic?
 - If the choice is yours, choose a work you like, but
 - allow plenty of time (you may find, once you get to work, that you want to change your topic).

How long will the essay be? (Allow an appropriate amount of time.) What kinds of sources are you expected to use?

- Only your own insights, supplemented by conversations with friends, and perhaps familiarity with your textbooks?
- Some research?
- Substantial research?

Again, allow the appropriate amount of time.
Who are the readers?

- Classmates?
- The general public (e.g., readers of *Time* magazine)? Awareness of the audience—the imagined readers—will help you to determine the amount of detail you need to provide. Unless you are told otherwise, assume that your classmates are your audience; they are intelligent adults, but they have not thought as deeply as you have about the particular topic you are writing about. (More about the audience in a moment, under Revising a Draft, page 45–46.)

When is the essay due? Allow time

- to write, type, and revise the draft several times,
- to proofread, and
- to check any sources.

2. **Jot down at least a few ideas *before* you write a first draft:** You can immediately generate some ideas by thinking about the impact the work makes on you.

- *Why* does it please, displease, or puzzle, or even anger you?
- What relevant assertions have you heard in lectures or read in books, for instance, concerning male representations of women, or concerning colonial influences on tribal art (or conversely, African influences on Western art), or concerning the criteria for judging a public building?
- How convincing *are* these ideas? Now that you are looking closely at a particular work or works, do these criteria really apply without modification? What modifications now suggest themselves? (In your final version, be sure to give credit for any ideas that you borrow.)

Jot down whatever comes to mind—key phrases will do—and you probably will find that these jottings, this mixture of assertions and

questions, will engender further ideas. Writing at this stage is not only the setting forth of ideas; it is largely the *discovering* of ideas you didn't know were in you.

Sometimes it is helpful to give yourself prompts to develop and define a thesis. For example:

- During class discussion a student said . . . but I disagree because
- During class discussion a student said. . . . I agree, but I would also add. . . .
- The lecture focused on . . . , but I think we should also consider
- The most important thing about X is It is important because

3. **Rearrange these jottings into a scratch outline (i.e., a tentative plan for a draft):** A list of a few phrases indicating the topics you plan to address (e.g., "historical context," "symbolic use of color," "woman is nude but not man") and the sequence will help you to get going. In such an outline

- probably the first paragraph will name the artists or the works of art and will specify the general approach (e.g., biographical or comparative) or scope (an early and a late work by an artist) of the paper
- additional jottings, in sequence, will indicate the gist of each paragraph

4. **Start writing without worrying about correctness.** Yes, you have been putting down words, but those preliminary jottings were what composition instructors call "prewriting." Now you are writing a draft—not yet a first draft but a zero draft, so don't worry about mechanical matters such as spelling and punctuation and stylistic elegance. Such things will be important when you revise and edit, but at the moment you are trying to find out what your ideas are and how much sense they make. Don't be afraid to set forth your hunches. As E. M. Forster put it, "How do I know what I think until I see what I say?" Write in a spirit of confidence, and if you are using a computer, be sure to save your material.

If you have jotted down an outline,

- begin by following the outline, but remember,
- the outline is a helpful guide to get you going; it is not a road map that must be followed.

Write freely and get your ideas down on paper or up on the screen. At this stage, you are still wrestling with ideas, trying things out, clarifying things *for yourself,* engaging in a search and discovery operation.

Later, of course, you will read and reread with a critical (skeptical) mind what you have said—you will want to make sure that assertions are supported by evidence—but for now, follow your instincts.

Revising a Draft

1. **Print, reread, and revise the material,** preferably after an interval of a few hours or even a day.

You are now prepared to write a serious draft. Your tentative or working thesis has evolved to a point in which you have confidence. Revisions will be of two sorts:

- global (large scale, such as reorganization) and
- local (the substitution of a precise word for an imprecise one or a spelling correction).

Do not try to revise on the screen. Print a hard copy; you need to see your essay in the form that your reader will see it.

Generally speaking, try to begin by making the necessary global revisions. You may, for instance, decide that introductory background material is or is not needed, or that background material should be distributed throughout the essay rather than given all at once at the start, or that you are too colloquial, too chatty (or, on the other hand, too formal, too stuffy). But, of course, if you spot a spelling error, or realize that a particular word is not the best word, there is no harm in pausing to make such a correction when you first see the need.

Now is the time to keep asking yourself,

- What will my audience—my readers—make of this paragraph, this sentence, this word?
- Does this word need to be defined?
- Do I offer adequate support for this generalization?
- Is my point clear, and is it expressed effectively?
- Do I offer helpful transitions (signposts) such as "moreover," "on the other hand," and "for example," so that readers know where I am taking them?

Put yourself in your reader's shoes; ask yourself if readers will be aware of where they are going. Yes, your instructor or your section leader is in fact your reader, but do *not* write for this specific person. Invent (imagine) a friendly but skeptical reader; if you write for this

imagined reader, you will have created a silent but helpful collabora-
tor, someone who will tell you that you need a transition, a definition,
or a concrete detail.

2. **Reread and revise the draft again,** asking yourself what your
 reader will make out of each sentence.

 - Again, work from a paper copy, not from the computer screen.

3. **Make certain that the mechanics are according to specifications:**
 Here you are acting not so much as an author but as an *editor.*

 - It is appropriate for an author, in the heat of drafting material,
 to be indifferent to mechanical details, but
 - it is appropriate for an editor to be cool, detached, finicky—in
 short, for the editor to tell the author to come down to earth
 and to package the essay correctly.
 - Margins, spacing, page numbering, and labeling of illustrations
 should follow the instructor's requirements.
 - Documentation should be according to the system of the
 Chicago Manual of Style, given in this book.

4. **If possible, get a classmate or a friend to read your essay and
 to make suggestions.** This representative of your audience should
 not, of course, rewrite the essay for you, but he or she can call your
 attention to

 - paragraphs that need development
 - unclear organization
 - unconvincing arguments
 - awkward sentences
 - errors in punctuation and spelling.

5. **Consider the reader's suggestions and revise where you
 think necessary.** If your reader finds some terms obscure or an
 argument unsubstantiated, you will almost surely want to revise,
 clarifying the terms and providing evidence for the argument. As
 before, in the process of revising, try to imagine yourself as your
 hypothetical reader.

6. **Print out a copy of the revised draft, read it, and revise again—**
 and again—as needed.

> ✍ **A RULE FOR WRITERS:**
>
> You are not knocking off an assignment; you are *writing an essay*, engaging in a process that, first, will teach *you* and, second, will ultimately engage the interest of your readers and will teach them.

It all adds up to *seeing* and *saying*, to seeing (discovering) in the works of art things that you will then want to communicate to your reader (this is a matter of getting ideas) and to saying effectively the things you want to say. Chapters 1–8 offer suggestions about getting ideas, about finding things that, once found, you will want to communicate to others, and Chapters 9–13 offer suggestions about the art of writing, from developing effective opening and concluding paragraphs to such technical matters as using the accepted forms in documenting print and electronic sources.

✔ Checklist of Basic Matters

Have I asked myself the following questions?

❑ Is my title engaging?
❑ Does the introduction provide essential information (artist, work, topic, or approach of the essay)?
❑ Does the paper have a thesis, a point?
❑ Do I support my argument with sufficient persuasive detail?
❑ Have I kept the needs of my audience in mind—for instance, have I defined unfamiliar terms, and have I provided transitions ("for instance," "on the other hand") so that the readers know where I will be taking them?
❑ Have I set forth my views effectively and yet not come across as an egotist?
❑ Does the essay fulfill the assignment (length, scope)?

❑ Have I given credit to my sources of information?

3

FORMAL ANALYSIS
AND STYLE

It seems to me that the modern painter cannot express this age, the air-
plane, the atom bomb, the radio, in the old forms of the Renaissance or of
any other past culture. Each age finds its own technique.

—Jackson Pollock

He has found his style when he cannot do otherwise.

—Paul Klee

All art is at once surface and symbol.

—Oscar Wilde

WHAT FORMAL ANALYSIS IS

The word *formal* in **formal analysis** is not used as the opposite of *informal*, as
in a formal dinner or a formal dance. Rather, a formal analysis—the result of
looking closely—is an analysis of the *form* the artist produces; that is, an analysis
of the work of art, which is made up of such things as line, shape, color, texture,
mass, composition. These things give the stone or canvas its form, its expression,
its content, its meaning. Rudolph Arnheim's assertion, in *Art and Visual
Perception* (1974), pages 458–60, that the curves in Michelangelo's *The Creation
of Adam* convey transmitted, life-giving energy is a brief example. Similarly, one
might say that a pyramid resting on its base conveys stability, whereas an inverted
pyramid—one resting on a point—conveys instability or precariousness.

Even if we grant that these forms may not universally carry these mean-
ings, we can perhaps agree that at least in our culture they do. That is,
members of a given *interpretive community* perceive certain forms or lines
or colors or whatever in a certain way.

Formal analysis assumes that clear-sighted minds agree that a work of art is

1. a constructed object,
2. with a stable meaning, and
3. that can be ascertained by studying the relationships between the
 elements of the work.

If the elements "cohere," the work is "meaningful." That is, a work of art is an independent object that possesses certain properties, and (according to those who practice formal analysis) if we think straight, we can examine these properties and can say what the work represents and what it means. We are (so to speak) in the artist's studio, looking over the artist's shoulder, seeing and explaining *why* the elements in the work cause us to respond to it the way we do. The work speaks directly to us, and we understand its language—we respond appropriately to its characteristics (shape, color, texture, and so on), at least if we share the artist's culture. Formal critics assume that a work of art *says* something, has a meaning, and that when they interpret a work they are helping their readers to grasp the meaning that its creator put into it.

FORMAL ANALYSIS VERSUS DESCRIPTION

Is the term *formal analysis* merely a pretentious substitute for *description?* Not quite. A **description** is an impersonal inventory, dealing with the relatively obvious, reporting what any eye might see: "A woman in a white dress sits at a table, reading a letter. Behind her . . . " A description can also comment on the artistic medium and on the execution of the work ("thick strokes of paint," "a highly polished surface"), but unlike an analysis, a description does not offer inferences, and it does not evaluate.

A highly detailed description that seeks to bring the image before the reader's eyes—a kind of writing fairly common in the days before illustrations of artworks were readily available in books—is sometimes called an *ekphrasis* or *ecphrasis* (plural: *ekphraseis*), from the Greek word for "description" (*ek* = out, *phrazein* = tell, declare). Such a description may be set forth in terms that also seek to convey the writer's emotional response to the work. That is, the description praises the work by seeking to give the reader a sense of being in its presence, especially by commenting on the presumed emotions expressed by the depicted figures. Here is an example: "We recoil with the terrified infant, who averts his eyes from the soldier whose heart is as hard as his burnished armor."

Writing of this sort is no longer common; a description today is more likely to tell us, for instance, that

> The head of this portrait sculpture faces front; the upper part of the nose and the rim of the right earlobe are missing. . . . The closely cropped beard and mustache are indicated by short, random strokes of the chisel

These statements, from an entry in the catalog of an exhibition, are all true, and they can be useful, but they scarcely reveal the thought, the

reflectiveness, that we associate with analysis. When the entry in the cata-
log goes on, however, to say

> The surfaces below the eyes and cheeks are sensitively modeled to suggest
> the soft, fleshy forms of age

we begin to feel that now indeed we are reading not merely a description
but an **analysis**, because the writer is explaining how things function— is in
effect arguing a thesis.

Similarly, although the statement that "the surface is in excellent condi-
tion" is purely descriptive (despite the apparent value judgment in "excellent"),
the statement that the "dominating block form" of the portrait contributes to
"the impression of frozen tension" can reasonably be called analytic. One rea-
son we can characterize this statement as analytic (rather than descriptive) is
that it offers an argument, in this instance an argument concerned with cause
and effect: The dominating block form, the writer argues, produces an effect—
causes us to perceive a condition of frozen tension.

Much of any formal analysis will inevitably consist of description ("The pupils
of the eyes are turned upward"), and accurate descriptive writing itself requires
careful observation of the object and careful use of words. But an essay is a formal
analysis rather than a description only if it connects effects with causes, thereby
showing *how* the described object works. For example, "The pupils of the eyes
are turned upward" is a description, but the following revision is an analytic state-
ment: "The pupils of the eyes are turned upward, suggesting a heaven-fixed gaze,
or, more bluntly, suggesting that the figure is divinely inspired."

In short, when one writes a formal analysis one takes a "look under the
hood," in the words of Professor Rosalind Krauss. Another way of putting it
is to say that analysis tries to answer the somewhat odd-sounding question,
"*How* does the work mean?"

Opposition to Formal Analysis

Formal analysis, we have seen, assumes that artists shape their materials so
that a work of art embodies a particular meaning and evokes a pleasurable
response in the spectator. The viewer today does not try to see the historical
object with "period" eyes but, rather, sees it with an aesthetic attitude. The
purpose of formal analysis is to show *how* intended meanings are communi-
cated in an aesthetic object.

For the past few decades, however, these assumptions have been
strongly called into question. Interest has markedly shifted from the work as
a thing whose meaning is contained within itself—a decontextualized object
to be looked at enjoyed—to the work of as a thing whose meaning largely

or even entirely consists of its context, its relation to things outside of itself, such as institutions or individuals for whom the work was produced. Thus, in this newer view, the first thing (and the chief thing) to say about a statue of King Khafre (see page 98)—a statue that a modern viewer might think is lacking in naturalness, lacking in the revelation of any personality—is that it was designed to impress viewers with the king's *im*personality, his lack of ordinary mortality, the closeness his nature to the gods. It served a political function.

In short, there has been a shift from viewing an artwork as a thing of value in itself—or as an object that provides pleasure and that conveys some sort of profound and perhaps universal meaning—to viewing the artwork as an object that reveals the power-structure of a society. The work is brought down to earth, so to speak, and is said thereby to be "demystified." Thus the student does not look for a presumed unified whole. On the contrary, the student "deconstructs" the work by looking for "fissures" and "slippages" that give away—reveal, unmask, debunk— the underlying political and social realities that the artist sought to cover up with sensuous appeal.

A discussion of an early nineteenth-century idyllic landscape painting, for instance, today might call attention not to the elegant brushwork and the color harmonies (which earlier might have been regarded as sources of aesthetic pleasure), or even to the neat hedges and meandering streams (meant to evoke a pleasing sensation) but, rather, the analysis might be chiefly concerned with what significant issues of its day the picture hides from us. An analysis of this sort might call attention to such social matters as

- the painter's unwillingness to depict the hardships of rural life, as well as the cruel economic realities of landownership in an age when poor families could be driven from their homes at the whim of a rich landowner who wanted a pleasant view.
- Such a discussion might even argue that when we demystify the picture—when (in this view) we turn from relatively trivial talk about aesthetic matters to serious talk about what the picture *really does*, we can see that what the picture's true function is, by means of its visual seductiveness, to legitimize social inequalities.

We will return to the matters of demystification and deconstruction in Chapter 12, when we look at the social historian's approach to artworks, on pages 248–49.)

We can grant that works of art are partly shaped by social and political forces (these are the subjects of historical and political approaches,

discussed in Chapter 12); and we can grant that works of art are partly shaped by the artist's personality (the subject of psychoanalytical approaches, discussed in Chapter 12). But this is only to say that works of art can be studied from several points of view; it does not invalidate the view that these works are also, at least in part, shaped by conscious intentions, and that the shapes or constructions that the artists (consciously or not) have produced convey a meaning.

STYLE AS THE SHAPER OF FORM

It is now time to define the elusive word **style.** The first thing to say is that the word is *not* used by most art historians to convey praise, as in "He has style." Rather, it is used neutrally: Everyone and everything made has a style—good, bad, or indifferent. The person who, as we say, "talks like a book" has a style (probably an annoying one), and the person who keeps saying, "Uh, you know what I mean" has a style too (different, but equally annoying).

Similarly, whether we wear jeans or gray flannel slacks, we have a style in our dress. We may claim to wear any old thing, but in fact we don't; there are clothes we wouldn't be caught dead in. The clothes we wear are expressive; they announce that we are police officers or bankers or tourists or college students—or at least they show what we want to be *thought* to be. It is not silly to think of our clothing as a sort of art that we make. Once we go beyond clothing as something that merely serves the needs of modesty and that provides protection against heat and cold and rain, we get clothing whose style is expressive.

To turn now to our central topic—style in art—we can all instantly tell the difference between a picture by van Gogh and one by Norman Rockwell or Walt Disney, even though the subject matter of all three pictures may be the same (e.g., a seated woman). How can we tell? By the style—that is, by line, color, medium, and all of the other things we talked about earlier in this chapter. Walt Disney's figures tend to be built up out of circles and ovals (think of Mickey Mouse), and the color shows no modeling or traces of brush strokes; Norman Rockwell's methods of depicting figures are different, and van Gogh's are different in yet other ways. Similarly, a Chinese landscape, painted with ink on silk or on paper, simply cannot look like a van Gogh landscape done with oil paint on canvas, partly because the materials prohibit such identity and partly because the Chinese painter's vision of landscape (usually lofty mountains) is not van Gogh's vision. Their works "say" different things.

"We're in Japanese waters, that's for sure." Anatol Kovarsky/Cartoon Bank.

We recognize certain *distinguishing characteristics* (from large matters, such as choice of subject and composition, to small matters, such as kinds of brush strokes) that mark an artist, or a period, or a culture, and these constitute the style. Almost anyone can distinguish between a landscape painted by a traditional Chinese artist and one painted by van Gogh. But it takes considerable familiarity with van Gogh to be able to say of a work, "Probably 1888 or maybe 1889," just as it takes considerable familiarity with the styles of Chinese painters to be able to say, "This is a Chinese painting of the seventeenth century, in fact the late seventeenth century. It belongs to the Nanking School and is a work by Kung Hsien—not by a follower, and certainly not a copy, but the genuine article."

Style, then, is revealed in **form;** an artist creates form by applying certain techniques to certain materials in order to embody a particular vision or content. In different ages people have seen things differently:

- the nude body as splendid, or the nude body as shameful;
- Jesus as majestic ruler, or Jesus as the sufferer on the cross;
- landscape as pleasant, domesticated countryside, or landscape as wild nature.

So the chosen subject matter is not only part of the content but also part of that assemblage of distinguishing characteristics that constitutes a style.

All of the elements of style, finally, are expressive. Take ceramics as an example. The kind of clay, the degree of heat at which it is baked, the decoration or glaze (if any), the shape of the vessel, the thickness of its wall, all are elements of the potter's style, and all contribute to the expressive form. But not every expressive form is available in every age; certain visions, and certain technologies, are, in certain ages, unavailable. Porcelain, as opposed to pottery, requires a particular kind of clay and an extremely high temperature in the kiln, and these were simply not available to the earliest Japanese potters. Even the potter's wheel was not available to them; they built their pots by coiling ropes of clay and then, sometimes, they smoothed the surface with a spatula. The result is a kind of thick-walled, low-fired ceramic that expresses energy and earthiness, far different from those delicate Chinese porcelains that express courtliness and the power of technology (or, we might say, of art).

SAMPLE ESSAY: A FORMAL ANALYSIS

The following sample essay, written by an undergraduate, includes a good deal of description (a formal analysis usually begins with a fairly full description of the artwork), and the essay is conspicuously impersonal (another characteristic of a formal analysis). But notice that even this apparently dispassionate assertion of facts is shaped by a **thesis.** If we stand back from the essay, we can see that the basic point or argument is this: The sculpture successfully combines a highly conventional symmetrical style, on the one hand, with mild asymmetry and a degree of realism, on the other.

Put thus, the thesis does not sound especially interesting, but that is because the statement is highly abstract, lacking in concrete detail. A writer's job is to take that idea (thesis) and to present it in an interesting and convincing way. In drafting and revising an essay, good writers keep thinking, "I want my readers to see. . . ." The idea will come alive for the reader when the writer supports it by calling attention to specific details—the evidence—as the student writer does in the following essay.

Notice, by the way, that in his first sentence the students refers to "Figure 1," which is a photograph of the work he discusses. (The images in an essay or book are called figures, and they are numbered consecutively.) This illustration (page 55) originally appeared on a separate page at the end of the paper, but here it has been put before the essay.

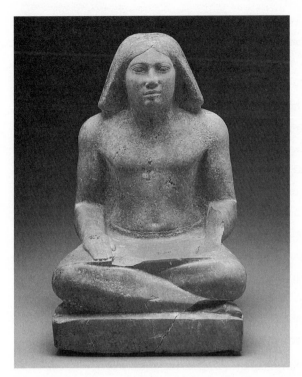

Figure 1. Seated Statue of Prince Khunera as a Scribe. Egyptian, Old Kingdom, Dynasty 4, reign of Menkaure, 2490–2472 B.C. Egypt (Giza, Menkaure Cemetery, MQ1). Limestone, Height × width × depth: 30.5 × 21.5 × 16 cm (12 × 8 7/16 × 6 5/16 in.) Museum of Fine Arts, Boston, Harvard University–Boston Museum of Fine Arts Expedition, 13.3140. Photograph © 2013 Museum of Fine Arts, Boston.

Stephen Beer

Fine Arts 10A

September 10, 2013

Formal Analysis: *Prince Khunera as a Scribe*

Prince Khunera as a Scribe, a free-standing Egyptian sculpture
12 inches tall, now in the Museum of Fine Arts Boston (Figure 1), was
found at Giza in a temple dedicated to the father of the prince, King
Mycerinus. The limestone statue may have been a tribute to that Fourth
Dynasty king.[1] The prince, sitting cross-legged with a scribal tablet on
his lap, rests his hands on his thighs. He wears only a short skirt or kilt.

The statue is in excellent condition although it is missing its
right forearm and hand. Fragments of the left leg and the scribe's

[1] Museum label.

tablet also have been lost. The lack of any difference in the carving between the bare stomach and the kilt suggests that these two features were once differentiated by contrasting paint that has now faded, but the only traces of paint remaining on the figure are bits of black on the hair and eyes.

The statue is symmetrical, composed along a vertical axis which runs from the crown of the head into the base of the sculpture. The sculptor has relied on basic geometric forms in shaping the statue on either side of this axis. Thus, the piece could be described as a circle (the head) within a triangle (the wig) which sits atop a square and two rectangles (the torso, the crossed legs, and the base). The reliance on basic geometric forms reveals itself even in details. For example, the forehead is depicted as a small triangle within the larger triangular form of the headdress.

On closer inspection, however, one observes that the rigidity of both this geometric and symmetric organization is relieved by the artist's sensitivity to detail and by his ability as a sculptor. None of the shapes of the work is a true geometric form. The full, rounded face is more of an oval than a circle, but actually it is neither. The silhouette of the upper part of the body is defined by softly undulating lines that represent the muscles of the arms and that modify the simplicity of a strictly square shape. Where the prince's naked torso meets his kilt, just below the waist, the sculptor has suggested portliness by allowing the form of the stomach to swell slightly. Even the "circular" navel is flattened into an irregular shape by the suggested weight of the body. The contours of the base, a simple matter at first glance, actually are not exactly four-square but rather are slightly curvilinear. Nor is the symmetry on either side of the vertical axis perfect: Both the mouth and the nose are slightly askew; the right and left forearms originally struck different poses; and the left leg is given prominence over the right. These departures from symmetry and from geometry enliven the statue, giving it both an individuality and a personality.

Although most of the statue is carved in broad planes, the sculptor has paid particular attention to details in the head. There he attempted to represent realistically the details of the prince's face. The parts of the eyes, for example—the eyebrows, eyelids, eyeballs, and sockets—are distinct. Elsewhere the artist has not worked in such probing detail. The breasts, for instance, are rendered in large forms, the nipples being absent. The attention to the details of the face suggests that the artist attempted to render a lifelikeness of the prince himself.

The prince is represented in a scribe's pose but without a scribe's tools. The prince is not actually *doing* anything. He merely sits. The absence of any open spaces (between the elbows and the waist) contributes to the figure's composure or self-containment. But if he sits, he sits attentively: There is nothing static here. The slight upward tilt of the head and the suggestion of an upward gaze of the eyes give the impression that the alert prince is attending someone else, perhaps his father the king. The suggestion in the statue is one of imminent work rather than of work in process.

Thus, the statue, with its variations from geometric order, suggests the presence, in stone, of a particular man. The pose may be standard and the outer form may appear rigid at first, yet the sculptor has managed to depict an individual. The details of the face and the overfleshed belly reveal an intent to portray a person, not just an idealized member of the scribal profession. Surely when freshly painted these elements of individuality within the confines of conventional forms and geometric structure were even more compelling.

Behind the Scene: Beer's Essay, from Early Responses to Final Version

This essay is good because it is clear and interesting and especially because it helps the reader to see and enjoy the work of art. Now let's go backstage, so to speak, to see how Stephen Beer turned his notes into an effective final draft.

Beer's Earliest Responses. After studying the object and reading the museum label, Beer jotted down ideas in the SuperNoteCard application from Mindola Software, although he could just as easily have used several other applications. What historical information does the label provide? (Beer recorded the material on a virtual note card.) Can the sculpture be called realistic? Yes and no. (Beer typed his responses, on another virtual note card.) What is the condition of the piece? (Again he put his responses on their own cards.) A day later, when he returned to work on his paper, stimulated by another look at the artwork and by a review of his notes, Beer made additional notes.

Organizing notes. When the time came to turn the notes into a draft and the revised draft into an essay, Beer reviewed the notes and added further thoughts. Next, he organized the notes, assigning them to categories so that whatever notes he had about (for instance) realism were grouped together. Reviewing the notes in each section, and, on the basis of the review (after making a backup copy), deleting a few cards that no longer seemed useful, as well as reassigning an occasional card to a different category, Beer started to think about how he might organize his essay.

As a first step in settling on an organization, he arranged the note cards into a sequence that seemed reasonable to him. It made sense, he thought, to begin with some historical background and a brief description, then to touch on Egyptian sculpture in general (but he soon decided *not* to include this general material), then to go on to some large points about the particular piece, then to refine some of these points, and finally to offer some sort of conclusion. This organization, he felt, was reasonable and would enable his reader to follow his argument easily.

Preparing a Preliminary Outline. In order to get a clearer idea of where he might be going, Beer then typed an outline—the gist of what at this stage seemed to be the organization of his chief points in the OmniOutliner (Omni Group), although he could just as easily have used the Outline view in Microsoft Word. In short, he prepared a map or rough outline so that he could easily see, almost at a glance, if each part of his paper would lead coherently to the next part.

In surveying his outline, Beer became aware of points that he should have included but that he had overlooked.

A tentative outline, after all, is not a straitjacket that determines the shape of the final essay. To the contrary, it is a preliminary map that, when examined, helps the writer to see not only pointless detours—these will be eliminated in the draft—but also undeveloped areas that need to be worked up. As the two versions of Beer's outline indicate, after drafting his map he made some important changes before writing a first draft.

Writing a Draft. Working from his thoughtfully revised outline, Beer wrote a first draft, which he then revised into a second draft. The truth of the matter is that when we write a first draft—even after we have jotted down notes and thought about rearranging and amplifying them—we are still writing to clarify our ideas *for ourselves;* we are still getting ideas, still learning, still teaching ourselves. Probably it is only after we have written a first draft that we can seriously begin to revise our thoughts *for a reader.*

Word processing programs, such as Microsoft Word, allow you to track the revisions made to a document and look at different versions of a document. However, many writers find comfort in having a printed copy of each draft to go over with a pen; the desired changes can then be made (and kept track of) on the computer.

The word *draft*, by the way, comes from the same Old English root that gives us *draw*. When you draft an essay, you are making a sketch, putting on paper (or screen) a sketch or plan that you will later refine.

Outlining a Draft. A good way to test the coherence of a final draft—to see if indeed it qualifies as an essay rather than as a draft—is to outline it, paragraph by paragraph, in *two* ways, indicating

 (a) what each paragraph *says*
 (b) what each paragraph *does*

Here is a double outline of this sort for Beer's seven-paragraph essay. In (a) we get a brief summary of what Beer is *saying* in each paragraph, and in (b) we get, in the italicized words, a description of what Beer is *doing*.

Reminder: An outline of this sort is *not* intended as a device that will help a writer produce a first draft; rather, it is a way of checking a *final* draft. Probably the best way to produce a first draft is, after doing some thoughtful looking, to jot down a few phrases, think about them, add and rearrange as necessary, and then start drafting.

1. a. Historical background and brief description
 b. *Introduces* the artwork
2. a. The condition of the artwork
 b. *Provides further overall description, preparatory* to the analysis
3. a. The geometry of the work
 b. *Introduces the thesis,* concerning the basic, overall geometry
4. a. Significant details
 b. *Modifies (refines) the argument*
5. a. The head
 b. *Compares* the realism of head with the breasts, in order to make the point that the head is more detailed

6. a. The pose
 b. *Argues* that the pose is not static
7. a. Geometric, yet individual
 b. *Concludes*, largely by *summarizing*

✍🏻 A RULE FOR WRITERS:

You may or may not want to sketch a rough outline before drafting your essay, but you certainly should outline what you hope is your final draft, to see (a) if it is organized and (b) if the organization will be evident to the reader.

An outline of this sort, in which you force yourself to consider not only the content but also the function of each paragraph, will help you to see if your essay

- says something and
- says it with the help of an effective structure.

If the structure is sound, your argument will flow nicely.

POSTSCRIPT: THOUGHTS ABOUT THE WORDS "REALISTIC" AND "IDEALIZED"

In his fifth paragraph (page 57) Beer uses the word "realistically," and in his final paragraph he uses "idealized." These words, common in essays on art, deserve comment. Let's begin a bit indirectly. Aristotle (384–322 B.C.) says that the arts originate in two basic human impulses, the impulse to imitate (from the Greek word *mimesis*, imitation) and the impulse to create patterns or harmony. In small children we find both (1) the impulse to imitate in their mimicry of others and (2) the impulse to harmony in their fondness for rocking and for strongly rhythmic nursery rhymes. Most works of art, as we shall see, combine imitation (mimicry, a representation of what the eye sees, realism) with harmony (an overriding form or pattern produced by a shaping idea). "We can imagine," Kenneth Clark wrote, "that the early sculptor who found the features of a head conforming to an ovoid, or the body conforming to a column, had a deep satisfaction. Now it looks as if it would last" (Introduction to *Masterpieces of Fifty Centuries*, 1970, page 15). In short, artists have eyes, but they also have ideas about basic patterns that underlie the varied phenomena around us.

For an extreme example of a body simplified to a column—a body shaped by the *idea* that a body conforms to a column—we can look at Constantin Brancusi's *Torso of a Young Man* (1924). Here the artist's *idea*

has clearly dominated his eye; we can say that this body is **idealized**. (Some writers would say that Brancusi gives an **abstract** version of the body, gives the essence of form.) Looking at this work, we are not surprised to learn that Brancusi said he was concerned with the "eternal type [i.e., the prototype] of ephemeral forms," and that "What is real is not the external form, but the essence of things. . . . It is impossible for anyone to express anything essentially real by imitating its exterior surface." The real or essential form represented in this instance is both the young man of the title and also the phallus.

The idea underlying works that are said to be idealized usually is the idea of beauty. Thus, tradition says that Raphael, seeking a model for the beautiful mythological Galatea, could not find one model who was in all respects beautiful enough, so he had to draw on several women (the lips of one, the hair of another, and so on) in order to paint an image that expressed

Figure 2. Constantin Brancusi, *Torso of a Young Man*, 1924. Polished brass, 18"; with original wood base, 58 ½". Photographer: Lee Stalsworth. The Hirshhorn Museum and Sculpture Garden, Smithsonian Institution. Gift of Joseph H. Hirshhorn, 1966. © 2013 Artists Rights Society.

the ideally beautiful woman. Examples of idealized images of male beauty are provided by many portrait heads of Antinous (also Antinoös), the youth beloved by the Roman emperor Hadrian. Writing in the *Bulletin* of the Metropolitan Museum of Art, Elizabeth J. Milleker calls attention to the combination of "actual features of the boy" and "an idealized image" in such a head (see the head of Antinoos on this page):

> This head is a good example of the sophisticated portrait type created by imperial sculptors to incorporate what must have been actual features of the boy in an idealized image that conveys a godlike beauty. The ovoid face with a straight brow, almond-shaped eyes, smooth cheeks, and fleshy lips is surrounded by abundant tousled curls. The ivy wreath encircling his head associates him with Dionysos, a guarantor of renewal and good fortune.
>
> —Metropolitan Museum of Art *Bulletin* (Fall 1997): 15

Realism has at least two meanings in writings about art:

1. a movement in mid–nineteenth-century Western Europe and America, which emphasized the everyday subjects of ordinary life, as opposed to subjects drawn from mythology, history, and upper-class experience;
2. fidelity to appearances, the accurate rendition of the surfaces of people, places, and things.

Figure 3. 1996.141, *Portrait Head of Antinous,* Roman, Mid-Imperial, Late Hadrianic, ca. A.D. 130–138. Marble, overall 9½ × 9¼ in. (24.1 × 21 cm). The Metropolitan Museum of Art, Gift of Bronson Pinchot in recognition of his mother Rosina Asta Pinchot, 1996 (1996.401). Image © The Metropolitan Museum of Art/Art Resource, NY.

In our discussion of realism, we will be concerned only with the second definition. *Naturalism* is often used as a synonym for *realism;* thus, a work that reproduces surfaces may be said to be realistic, naturalistic, or illusionistic; *veristic* is also used, but less commonly. The most extreme form of realism is *trompe-l'oeil* (French: deceives the eye), complete illusionism—the painted fly on the picture frame, the waxwork museum guard standing in a doorway, images created with the purpose of deceiving the viewer. But of course most images are not the exact size of the model, so even if they are realistically rendered, they do not deceive. When we look at most images, we are aware that we are looking not at reality (a fly, a human being) but at the product of the artist's gaze at such real things. Further, the medium itself may prohibit illusionism; an unpainted stone or bronze head, however accurate in its representation of cheekbones, hair, the shape of the nose, and so forth, cannot be taken for Abraham Lincoln.

Idealism, like realism, has at least two meanings in art: (1) the belief that a work conveys an idea as well as appearances and (2) the belief—derived partly from the first meaning—that it should convey an idea that elevates the thoughts of the spectator, and it does this by presenting an image, let's say of heroism or of motherhood, loftier than any real object that we can see in the imperfect world around us. (Do not confuse *idealism* as it is used in art with its everyday meaning, as in "despite her years, she retained her idealism," where the word means "noble goals.") The story of Raphael's quest for a model for Galatea (mentioned on page 61) is relevant here, and somewhat similarly, the Hadrianic sculptors who made images of Antinous, as the writer in the Metropolitan Museum's *Bulletin* said, must have had in mind not a particular youth but the idea of "godlike beauty."

By way of contrast, consider Sir Peter Lely's encounter with Oliver Cromwell (1599–1658), the English general and statesman. Cromwell is reported to have said to the painter, "Mr. Lely, I desire you would use all your skill to paint my picture truly like me, and not flatter me at all; but remark [i.e., take notice of] all these roughnesses, pimples, warts, and everything as you see me." Cromwell was asking for a realistic (or naturalistic, or veristic) portrait, not an idealized portrait like the sculpture of Antinous. What would an idealized portrait look like? It would omit the blemishes. Why? Because the blemishes would be thought to be mere trivial surface details that would get between the viewer and the artist's *idea* of Cromwell, Cromwell's essence as the artist perceives it—for instance, the nobility that characterized his statesmanship and leadership. What distinguishes the idealizing artist from the ordinary person, it is said, is the artist's imaginative ability to penetrate the visible (the surface) and set forth an elevating ideal.

In short, *realism* is defined as the representation of visual phenomena as exactly—as realistically—as the medium (stone, bronze, paint on paper or canvas) allows. At the other extreme from illusionism we have idealism, for instance, in the representation of the torso of a young man by a column. A realistic portrait of Cromwell will show him as he appears to the eye, warts and all; an idealized portrait will give us the idea of Cromwell by, so to speak, airbrushing the warts, giving him some extra stature, slimming him down a bit, giving him perhaps a more thoughtful face than he had, setting him in a pyramidal composition to emphasize his stability, thereby stimulating our minds to perceive the nobility of his cause.

Both realism and idealism have had their advocates. As a spokesperson for realism we can take Leonardo, who in his *Notebooks* says that "the mind of the painter should be like a looking-glass that is filled with as many images as there are objects before him." Against this view we can take a remark by a contemporary painter, Larry Rivers: "I am not interested in the art of holding up mirrors." Probably most artists offer the Aristotelian combination of imitation and harmony. The apparently realistic (primarily mimetic) artist is concerned at least in some degree with a pattern or form that helps to order the work and to give it meaning, and the apparently idealistic artist—even the nonobjective artist who might seem to deal only in harmonious shapes and colors—is concerned with connecting the work to the world we live in, for instance, to our emotions. An artist might deliberately depart from surface realism—mimetic accuracy—in order to "defamiliarize" or "estrange" our customary perceptions, slowing us down or shaking us up, so to speak, in order to jostle us out of our stock responses, thereby letting us see reality freshly. Although this idea is especially associated with the Russian Formalist school of the early twentieth century, it can be traced back to the early-nineteenth-century Romantic writers. For instance, Samuel Taylor Coleridge praised the poetry of William Wordsworth because, in Coleridge's words, it removed "the film of familiarity" that clouded our usual vision.

Somewhere near the middle of the spectrum, between artists who offer highly mimetic representations and at the other extreme those who offer representations that bear little resemblance to what we see, we have the sculptor, hypothesized by Kenneth Clark, who saw the head as an ovoid and said to himself, "Now it looks as if it would last." Here the "idea" that shapes the features of the head (for instance, bringing the ears closer to the skull) is the idea of perfection and endurance, stability, even eternity, and surely some such thoughts cross our minds when we perceive works that we love. One might almost write a history of art in terms of the changing proportions of realism and idealism during the lifetime of a culture.

✍ A RULE FOR WRITERS:

There is nothing wrong with using the words *realistic* and *idealized* in your essay, but keep in mind that it is not a matter of all-or-nothing; there are degrees of realism and degrees of idealization.

It is easy to find remarks by artists setting forth a middle view. In an exhibition catalog (1948), Henri Matisse said, "There is an inherent truth which must be disengaged from the outward appearances of the object to be represented. . . . Exactitude is not truth." And most works of art are neither purely realistic (concerned only with "exactitude," realistic description) nor purely idealistic (concerned only with "an inherent truth"). Again we think of Aristotle's combination of the impulse to imitate and the impulse to create harmony. We might think, too, of a comment by Picasso: "If you want to draw, you must first shut your eyes and sing."

We can probably agree that *Prince Khunera as a Scribe* (page 55) shows a good deal of idealism, but it also shows realistic touches. Stephen Beer's analysis calls attention to its idealized quality, in its symmetry and its nearly circular head, but he also says that the eye is rendered with "descriptive accuracy." Or look at Michelangelo's *David* (page 70). It is realistic in its depiction of the veins in David's hands, but it is idealized in its color (not flesh color but white to suggest purity), in its size (much larger than life, to convey the ideal of heroism), and in its nudity. Surely Michelangelo did not think David went into battle naked, so why is his David nude? Because Michelangelo, carving the statue in part to commemorate the civic constitution of the Florentine republic, wanted to convey the ideas of justice and of classical heroism, and classical sculptures of heroes were nude. We can, then, talk about Michelangelo's idealism, and—still talking of the same image—we can talk about his realism.

Consider the three pictures of horses shown on page 66. Han Gan's painting (upper left) is less concerned with accurately rendering the appearance of a horse than with rendering its great inner spirit, hence the head and neck that are too large for the body, and the body that is too large for the legs. The legs, though in motion to show the horse's grace and liveliness, are diminished because the essence of the horse is the strength of its body, communicated partly by juxtaposing the arcs of its rump and its (unreal) electrified mane with the stolid hitching post. In brief, the painting shows what we in the West probably would call an idealized horse, although the Chinese might say that by revealing the spirit the picture captures the "real" horse. (It once had a tail, but the tail has been largely eroded by wear, and the vestiges have been obscured by an owner's seal.)

Leonardo's drawing (upper right) is largely concerned with anatomical correctness, and we can call it realistic. Still, by posing the horse in profile, Leonardo calls attention to the animal's geometry, notably the curves of the neck, chest, and rump, and despite the accurate detail the picture seems to represent not a particular horse but the essential idea of a horse. (Doubtless the blank background and the absence of a ground plane here, as in the Chinese painting, contribute to this impression of idealizing.)

Figure 4. Chinese paintings. *Night-Shining White,* Tang Dynasty (618?–907), 8th century. Attributed to Han Gan (Chinese, act. 742?–756) China Handscroll; ink on paper; 12 ⅛ × 13 ⅜ in. (30.8 × 34 cm.). The Metropolitan Museum of Art. Purchase, The Dillon Fund, 1977 (1977.78). Photographer: Malcom Varon. 1990. Art Resource.

Figure 5. Leonardo Da Vinci, *A Horse in Profile to the Right, and its Forelegs,* c. 1490. Silverpoint on blue prepared surface, 8 ½" × 6 ⅜". The Royal Library of Windsor. Alinari Archives/The Image Works.

Figure 6. Great Britain, County Down, Mount Stewart House & Garden—*Hambletonian* by George Stubbs c. 1800. Oil on canvas 82 ½" × 144 ¾". Photographer: NTPL/The Image Works.

George Stubbs's painting of Hambletonian (previous page), who had recently won an important race, surely is an accurate representation of a particular horse, but even here we can note an idealizing element: Stubbs emphasizes the animal's heroic stature by spreading its image across the canvas so that the horse dwarfs the human beings and the buildings.

If your instructor asks you to compare two works—perhaps an Egyptian ruler and a Greek athlete, or an Indian Buddha and a Chinese Buddha— you may well find one of them more realistic than the other, but remember, even a highly realistic work may include idealized elements, and an idealized work may include realistic elements.

Cautionary Words about Digital Images

Drawings and Paintings. The colors of images, reproductions in books, and images on the World Wide Web range from pretty accurate to very poor.

- Even if the color is good, reproductions give little if any sense of the texture of the original drawing or painting. They lose, for instance, the roughness or smoothness of the paper of a drawing, or the three-dimensionality and juiciness of thickly applied oil paint.
- Reproductions in books normally indicate the size of the original, but many viewers nevertheless do not mentally transform the reproduction into the size of the original drawing or painting. A life-size portrait makes an effect utterly different from a miniature, and standing in front of a Japanese screen that is 5½ feet tall and 12 feet long differs from looking at a reproduction 5½ inches tall and 12 inches long.
- Frames, even when they are designed by the painter, are rarely reproduced in textbooks or catalogs.

If possible, therefore, write only about works that you have actually seen— works that you have actually experienced by standing in their presence. If you can't see the original, ask your instructor to recommend the books or Web sites with the best reproductions of the works that you are writing about, but even with good reproductions the sense of scale is lost.

Sculpture. Photographs of works of sculpture are an enormous aid; we can see details of a work that, even if we were in its presence, might be invisible because the work is high above us on a wall or because it is shrouded in darkness. The sculptural programs on medieval buildings, barely visible *in situ,* can be analyzed (e.g., for their iconography and their style) by means of photographs. But keep in mind the following points:

- Because a photograph is two-dimensional, it gives little sense of a sculpture in the round. Fortunately, some Web sites do offer 360-degree panoramas of sculpture.

- A photograph may omit or falsify color, and it may obliterate distinctive textures.
- The photographer's lighting may produce dramatic highlights or contrasts, or it may (by even lighting) eliminate highlights that would normally be evident. Further, a bust (say, a Greek head in a museum) when photographed against a dark background may seem to float mysteriously, creating an effect very different from the rather dry image of the same bust photographed, with its mount visible, against a light gray background. In short, photographs of sculpture are highly interpretative.
- A photograph of a work even in its original context (to say nothing of a photograph of a work in a museum) may decontextualize the work, for example by not taking account of the angle from which the work was supposed to be seen. The first viewers of Michelangelo's *Moses* had to look upward to see the image, but almost all photographs in books show it taken straight on. Similarly, a photo of Daniel Chester French's *Lincoln* can convey almost nothing of the experience of encountering the work as one mounts the steps of the Lincoln Memorial.
- Generally, photographs do not afford a sense of scale (relative size); for example, one may see Michelangelo's *David* (about 13 feet tall) as no bigger than a toy soldier, unless the photograph includes human viewers.

Architecture. Though for some purposes photographs of buildings are indispensable, try to write about buildings that you have visited. If you must rely on photographs, try to imagine yourself moving within the building. Remember, architecture is not a large sculpture, an object that one looks at; rather, it is a distinct place, a space in which one moves.

- Photographs tell us something about what the façades look like, but they tell us little or nothing about how well a building functions and little or nothing about how well it is built.
- Photographs rarely tell us how the building relates visually to its neighbors. (Eugene J. Johnson could not have said what he says on page 112 about the Seagram building if he had been working only from a photograph.)
- Human beings are rarely shown in architectural photographs, especially in photographs of interiors, which are likely to be neatly composed pictures rather than images of lived-in spaces. And without people, it is hard to sense the scale of the rooms.

4

ANALYTIC THINKING

A painting must be a feast for the eyes, but that does not mean there is no place for reason.

—Eugéne Delacroix

[After attending a performance of Wagner's *Tannhäuser*] I set out to discover the *why* of it, and to transform my pleasure into knowledge.

—Charles Baudelaire

SEEING AND SAYING

An **analysis** is, literally, a separating into parts in order to understand the whole. (Beer's essay [55] on an Egyptian sculpture is a clear example.) When you analyze, you are seeking to account for your experience of the work. (Analysis thus includes **synthesis,** the combination of the parts into the whole.) You might, for example, analyze Michelangelo's marble statue *David* (see page 70), the youth who with a slingshot killed the heavily armed giant Goliath, by considering:

- Its sources (in the Bible, in Hellenistic sculpture, in Donatello's bronze *David,* and in the political and social ideas of the age—for example, David as a civic hero, the enemy of tyranny, and David as the embodiment of Fortitude)
- Its material and the limitations of that material (marble lends itself to certain postures but not to others, and marble has an effect—in texture and color—that granite or bronze or wood does not have)
- Its pose (which gives the statue its outline, its masses, and its enclosed spaces or lack of them)
- Its facial expression
- Its nudity (a nude Adam is easily understandable, but why a nude David? Statues of Greek heroes and gods were nude, so Michelangelo dressed—so to speak—his David in heroic or even godlike nudity. Further physical beauty can serve as a metaphor representing spiritual strength)

- Its size (here, in this over-life-size figure, man as hero)
- Its context, especially its site in the sixteenth century (today it stands in the rotunda of the Academy of Fine Arts, but in 1504 it stood at the entrance to the Palazzo Vecchio—the town hall—where it embodied the principle of the citizen-warrior and signified the victory of republicanism over tyranny)

Consider as well anything else you think the sculpture consists of—or does not consist of—for Michelangelo, unlike his predecessor Donatello, does not include the head of the slain Goliath; thus, Michelangelo's image is not explicitly that of a conquering hero. Or you might confine your attention to any one of these elements.

Analysis is not a process used only in talking about art. It is commonly applied in thinking about almost any complex matter. Venus Williams plays a deadly game of tennis. What makes it so good? What does her backhand contribute? What does her serve do to her opponents? The relevance of such questions is clear. Similarly, it makes sense, when you are writing about art, to try to see the components of the work.

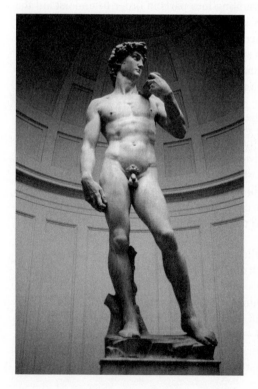

Michelangelo's Statue of
David, 1501–1504. Marble,
13"5". Accademia, Florence.
Photographer: David Buffington.
Getty Images, Inc.–Photodisc/
Royalty Free.

A SAMPLE STUDENT ESSAY

Here is a short essay written by a student, analyzing Michelangelo's *David*. Of course

- students were at the great disadvantage of not being able to see the object itself, in Florence, Italy, but
- for images, the instructor referred her students to Stanford University's "Digital Michelangelo Project," website at https://graphics.stanford.edu/projects/mich/ where they could see enlarged views of the whole sculpture as well as details of the head and neck (right side and left side) and a detail of each hand. Still, however good the images, the experience of looking downward at a sheet of paper is very different from the experience of craning one's neck and looking upward at an enormous statue.
- The students were told to consider only the object itself, not (for instance) its site, though its site—or at least its original site, in front of the seat of government in Florence—of course contributed to its meaning, just as, for instance, a statue of Abraham Lincoln in Springfield, Illinois, means something a bit different from a statue of Lincoln in Washington, D.C.
- Because a subsequent assignment required students to compare two works—the act of comparing is a very good way of seeing exactly what something is and is not—for the paper on *David* the instructor told students to discuss only this one piece, *not* to compare it to any other sculptures of David.
- Students were given the text from the Hebrew Bible in which the story of David and Goliath is told, 1 Samuel 17, and
- they were told, both by their instructor and by their textbook, that David's nudity was derived from the nudity of Greek gods, a sign of their ideal nature. If they made use of this information, the instructor explained, there was no need to give credit in a footnote since such information is regarded as "common knowledge" (see page 331).

Jessica Emkay

Professor Gomes

English 101A

November 18, 2013

Michelangelo's *David:* An Analysis

According to the King James Version of the Bible, when David

offered to fight against Goliath, King Saul

armed David with his armor, and he put an helmet of brass
upon his head; also he armed him with a coat of mail, . . . and
David said unto Saul "I cannot go with these. . . ." And David
put them off him. And he took his staff in his hand, and
chose him five smooth stones out of the brook, and put them in a
shepherd's bag which he had, even in a scrip [i.e. pouch], and his
sling was in his hand, and he drew near to the Philistines.

(1Samuel 17: 38-40)

The Bible does not tell us that after David removed the armor Saul had
given him and then "took his staff in his hand" he also put on his usual
clothes, but readers can rightly assume this to be the case, though
from Michelangelo's point of view it was entirely appropriate to depict
David the warrior—the youth who heroically killed Goliath—nude,
like the sculptural image of a Greek hero or a Greek god.

Exactly what does Michelangelo show us? We do not see David
placing the stone in the sling, about to engage in battle, nor do we see
Goliath dead at David's feet, but somehow we are in no doubt that we
are looking at David shortly before his triumph. The sling is over his
left shoulder, and presumably David's right hand holds the stone that
he will place within the sling, though in fact the stone is not visible—
and David is not encumbered with the "bag" or "scrip" that the Bible
says held additional stones. Michelangelo gives us only David and his
weapon; *this* majestic, god-like David will need only a single stone. In
fact, since the stone is invisible—Michelangelo could have shown it,
if he wanted to—and since the slingshot is scarcely emphasized, we
can reasonably say that Michelangelo puts all of his emphasis on the
heroic youth; it will be *David*, not a weapon, that kills the enemy.

How can we be confident that Michelangelo is showing us David
before the battle? First, the face: It is not smiling in triumph, nor is
it is relaxed after victory. Rather, the pronounced muscles above
and between the prominent eyebrows, the unsmiling mouth, and
the tendons in the neck all show intense concentration. Second, the
limbs. The muscles in the arms—even though the right arm is merely

hanging down—and the bulging veins in the right hand—suggest a power that will soon be released. The positions of the legs, too, are significant: David's weight is entirely on his right leg, but, because we are familiar with the story, we know that he soon will raise one leg, will twist his body, and will hurl the stone with all the force that is within him. In short, although at this instant David's head, limbs, and torso are not in motion—he is not hurling the stone, not running up to the fallen Goliath, not cutting off Goliath's head with Goliath's own sword—David's entire *inner* body is filled with potential action that soon will become the physical action for which David is famous.

The Analysis Briefly Analyzed

1. Jessica Emkay's title is not especially engaging—certainly readers would want a livelier title for a research paper—but, given the facts that the title is informative and that the assignment was meant to be something of a basic exercise, it is acceptable.

2. The essay begins, perhaps surprisingly but certainly engagingly, with a brief quotation. One can hardly go wrong by quoting from the King James Version of the Bible. Everyone knows that the story of David and Goliath comes from the Bible but few people have actually read it, and probably all are glad to hear a bit of the story told in slightly quaint English.

3. Emkay ends her first paragraph by pointing out that although the Bible says that after David removed Saul's armor he was equipped with "a shepherd's bag"—and thus implies gear and clothing—Michelangelo gives us not a Hebrew shepherd but a nude figure comparable to a Greek hero or god.

4. The second paragraph is largely devoted to the contrast between the Bible's specification of five stones, in a pouch, and Michelangelo's invisible single stone and barely perceived slingshot. The student's point is that Michelangelo puts all of the emphasis on the godlike hero himself, not on the equipment.

5. The final paragraph picks up, and develops, a point raised in the first sentence of the preceding paragraph, where the writer had said that the sculpture shows David not *in* action, and not *after* the action, but shortly *before* the action. "How can we be confident," she asks, that the image is of David before killing Goliath. And she now provides the evidence—Michelangelo's treatment of the face, the neck, the arms, the legs. Her evidence may not convince every reader but it probably will convince most readers. In short, she does

not merely make assertions; rather, *she advances a thesis, argues a case, offers evidence* such as the prominent eyebrows, the unsmiling mouth, the visible tendons in the neck.

6. Jessica Emkay does not give us a "concluding paragraph," and we probably do not feel that she has deprived us of anything. The essay ends nicely, and emphatically (notice the repetition in "not hurling . . ., not running, . . ., not cutting"); we do *not* need anything like "In conclusion," or "As I have now demonstrated."

SUBJECT MATTER AND CONTENT

Before we go on to analyze some of the ways in which art communicates, we can take a moment to distinguish between the *subject matter* of a work and the *content* or *meaning*. (Later in this chapter, on pages 74–76, we will see that the content or meaning is expressed through the *style* or *form*.)

The study of artistic images and the cultural thoughts and attitudes that they reflect is called iconography (see pages 264–69). Two sculptures of the same subject matter—for instance, the Crucifixion—can express different meanings:

- Christ's conquest of death (head high, eyes open, face composed, arms horizontal, body relatively straight and self-possessed, fully clothed with an ankle-length tunic of a king).
- Christ's painful death (head drooping to one side, eyes closed, brows and mouth contorted, arms pulled into a V by the weight of the body, body twisted into an S-shape, body vulnerable because clothed only with a loincloth).

The subject matter in both is the same—the Crucifixion—but the meaning or content (conquest of death in one image, painful death in the other) is utterly different. The image of Christ Triumphant—Christ as Divine Ruler and Judge—was common in the twelfth and early thirteenth centuries; the Suffering Christ, emphasizing the humanity or mortal aspect of Jesus, was common in the late thirteenth and fourteenth centuries.

To turn to another genre, if we look at some nineteenth-century landscapes we may see (aided by Barbara Novak's *Nature and Culture: American Landscape and Painting, 1825–1875*) that the *subject matter* of skies streaked with red and yellow embodies a *content* that can be described, at least roughly, as the grandeur of God. Perhaps Paul Klee was trying to turn our attention from subject matter to content when he said, "Art does not reproduce the visible; rather, it makes visible," or (in a somewhat freer translation), "Art does not reproduce what we see; rather, it makes us see."

The content, one might say, is the subject matter transformed or recreated or infused by intellect and feeling with meaning—in short, the content is a meaning made visible. This is what Henri Matisse was getting at when

he said that drawing is "not an exercise of particular dexterity but above all a means of expressing intimate feelings and moods."

Even abstract and nonobjective works of art probably make visible the artist's inner experiences and, thus, have a subject matter that conveys a meaning. Consider Picasso's words:

> There is no abstract art. You must always start with something. Afterward you can remove all traces of reality. There is no danger then, anyway, because the idea of the object will have left an indelible mark. It is what started the artist off, excited his ideas, and stirred up his emotions. Ideas and emotions will in the end be prisoners in his work.
> —*Picasso on Art,* ed. Dore Ashton (1972), 64

This seems thoroughly acceptable. Perhaps less acceptable at first, but certainly worth pondering, is Wassily Kandinsky's remark: "The impact of an acute triangle on a sphere generates as much emotional impact as the meeting of God and Adam in Michelangelo's *Creation.*" In this exaggeration Kandinsky touches on the truth that a painting conveys more than the objects that it represents. Still, lest we go too far in searching for a content in or behind or under the subject matter, we should recall a story. In the 1920s the poet Paul Eluard was eloquently talking to Joan Miró about what Eluard took to be a solar symbol in one of Miró's paintings. After a decent interval Miró replied, "That's not a solar symbol. It is a potato."

FORM AND CONTENT

The meaning or content of a work of art is not the opposite of form. To the contrary, the *form*—including such things as the size of the work, the kinds of brush strokes in a painting, and the surface texture of a sculpture—is part of the meaning. For example, a picture with short, choppy, angular lines will "say" something different from a picture with gentle curves, even though the subject matter (let's say a woman sitting at a table) is approximately the same.

When Paul Klee spoke of "going for a walk with a line," he had in mind a line's ability (so to speak) to move quickly or slowly, assertively or tentatively. Thus, a line not only indicates form (for instance, a nose on the drawing of a face) but may also create a mood. Of course, many of the words we use in talking about lines—or shapes or colors—are metaphoric. If, for instance, we say that a jagged line is "agitated" or "nervous" or a thick line is "bold," we are not implying that the line is literally alive and endowed with feelings. We are really talking about the way in which we perceive the line, or, more precisely, we are setting forth our inference about what the artist intended or in fact produced.

Are the lines of a drawing thick or thin, curved or straight, broken or unbroken? A soft pencil drawing on pale gray paper will say something different from a pen drawing made with a relatively stiff reed nib on bright

white paper; at the very least, the medium and the subdued contrast of the one are quieter than those of the other. Similarly, a painting such as Jean-François Millet's *The Winnower* (1848), with a rough surface built up with vigorous or agitated brush strokes, will not say the same thing—and will not have the same meaning—as a painting with a smooth, polished surface that gives no evidence of the brush. If nothing else, the painting that gives evidence of brush strokes announces the presence of the painter, whereas the polished surface seems to eliminate the painter from the painting. In an age when most paintings had smooth surfaces, Millet's style as well as his content was revolutionary. The critic Théophile Gautier said that Millet "trowels on top of his dishcloth of a canvas, without oil or turpentine, vast masonries of paint so dry that no varnish could quench its thirst."

For obvious examples of artists who use contrasting media, compare a work by an Action painter of the 1940s and the 1950s such as Jackson Pollock with a work by a Pop artist such as Andy Warhol or Robert Indiana. Whereas Pollock executed apparently free, spontaneous, self-expressive nonfigurative paintings, the marks on the canvas almost let us see the painter in the *act* of brushing or dribbling or spattering the pigment—Pop artists tended to favor commonplace images (e.g., Warhol's Campbell's soup cans) and impersonal media such as the serigraph. Pop works call to mind not the individual artist but anonymous commercial art and the machine, and these commercial, mechanical associations are part of the meaning of the works. Such works express what Warhol said in 1968: "The reason I'm painting this way is because I want to be a machine."

Let's think about the "meaning" of Andy Warhol's *Gold Marilyn Monroe* (1962), a work produced—we can even say manufactured—shortly after Monroe's death. (You can find it via Google or a comparable search engine.) Warhol used a publicity photograph of 1952 or 1954 and made a silk-screen print. In this process, a stencil is applied to a screen of silk or nylon or polyester with a fine mesh that has been stretched on a frame, or an impermeable substance such as glue is applied to some areas of the fabric. Warhol in fact used a later variant of the process: A photographic stencil is produced by attaching light-sensitive gelatin to the screen. Ink or paint is pressed with a squeegee through the part of the fabric that is not protected by the stencil or the hardened glue or gelatin; thus, the image appears on the printing surface, usually paper or canvas, that is beneath the mesh.

This method of printing is hardly suited to subtle details, and the lack of subtlety is part of the meaning: Ordinarily we assume that a portrait artist wishes, by looking intently at the subject, to reveal that subject's appearance and personality by means of minute touches, but Warhol began with a publicity photo rather than a live model, and he used assistants in a studio that he called the Factory, producing an image that inevitably is a bit crude,

rather like a colored image in a newspaper, where the colors are sometimes misaligned. The critic Adam Gopnik shrewdly described Warhol's character- istic use of pink, red, lemon, turquoise, and so on as his "lipstick-and-perox- ide palette" (*New Yorker,* April 10, 1989, page 109). The image of Monroe— just her head—is printed on a canvas that is almost 7 feet tall and almost 5 feet wide, to which gold paint has been applied in a somewhat slapdash manner. Marilyn is a star in heaven, yes, but in a tacky tinsel-town heaven, a Hollywood heaven, a place manufactured by publicity departments. As Marshall McLuhan famously put it, "The Medium is the Message." Warhol's medium—a publicity photograph transferred into silk-screen print with slightly misaligned garish colors, printed by assistants on an unusually large surface—cannot be separated from the meaning of the work. *Gold Marilyn Monroe* means or says that Marilyn was and is a manufactured image.

In short, to get at the content or meanings of a work we usually need to interpret

- the subject matter,
- the material and the form (size, shape, texture, color, and the like),
- the sociohistoric context, and
- perhaps the artist's intentions (if known).

We also have to recognize that our own sociohistoric context—including our gender, economic background, political convictions, and so forth— will to some degree determine the meanings we see in a work. Nelson Goodman, you may recall from Chapter 1 (page 26–27), says that because the perceiver's eye "is regulated by need and prejudice" the eye "does not so much mirror as take and make." One also hears that all interpre- tations—all discussions of content—are misinterpretations and that no standards (e.g., common sense or the artist's intention) can guide us in evaluating different interpretations.

GETTING IDEAS FOR ESSAYS: ASKING QUESTIONS TO GET ANSWERS

The painter Ad Reinhardt once said that "Looking is not as simple as it looks." Not until one has learned to look at art can one have useful ideas, material for writing. As Robert Frost said (with some understatement), "All there is to writing is having ideas." But how do you get ideas? As the next few pages will indicate, the best way to get ideas is to confront puzzling questions.

What are some of the basic things to look for in trying to acquire an understanding of the languages of art—that is, in trying to understand what a work of art expresses?

Basic Questions

One can begin a discussion of the complex business of expression in the arts almost anywhere, but let's begin with some questions that can be asked of almost any work of art—whether a painting or a drawing or a sculpture or even a building. These are not naive questions, questions asked only by inexperienced viewers. They are questions that occupy the minds of professional art historians and critics. For instance, Evelyn Welch in her *Art and Society in Italy 1350–1500* (1997) says,

> Part I of this book asked questions about what an object was made from, how it was made, for whom, and by whom. It finished by asking how . . . posthumous fame was guaranteed for a number of Renaissance artists. Part II, which looks particularly at art in sacred settings, asks to what purpose this effort was directed.
>
> To attempt an answer, however partial, we need to know something about the original function and meaning of the works illustrated in this book. For example, where were they located? Who could have seen them and when? How were viewers supposed to behave in front of such objects and how did they actually behave? (133)

Here, then, are some basic questions:

What is my first response to the work? Amusement? Awe? Bafflement? Erotic interest? Annoyance? Shock? Boredom? Later you may modify or even reject this response, this feeling, but begin by trying to study it. Jot down your responses—even your free associations. And *why* do you have this response? The act of jotting down a response, and of *accounting for it analytically*, may help you to deepen the response, or even to move beyond it to a different response.

When, where, and why was the work made? By whom, and for whom? In short, **What is the cultural context?** Was the purpose to stimulate religious devotion? To impress the viewer with the owner's power? To enhance family pride? To teach? To delight? To express the artist's feelings? Does the work present a likeness, or express a feeling, or illustrate a mystery? Does it reveal the qualities or values that your textbook attributes to the culture? (Don't assume that it does: Works of art have a way of eluding easy generalities.)

What did the work originally look like? Paper and silk darken, paintings crack, sculptures—even of marble or bronze—change color over the centuries, buildings decay and are renovated.

Where would the work originally have been seen? Perhaps in a church or a palace, or a bourgeois house, or (if the work is an African mask) worn by a costumed dancer, but surely not in a textbook and not (unless it is a contemporary work) in a museum. For Picasso, "The picture-hook is the ruination of a painting. . . . As soon as [a painting] is bought and hung on a wall, it takes on quite a different significance, and the painting is done for." If the work is now part of an exhibition in a museum, how does the museum's presentation of the work affect your response?

What do the physical properties and the form contribute? Take account of (a) *the material* (for instance, polished marble vs. unpainted wood, or transparent watercolor vs. opaque oil paint, or oil paint thinly applied vs. oil paint so thickly applied that it gives the canvas a rough texture); (b) *the size* (a larger-than-life image will have an impact different from a miniature); (c) *the color* (realistic or symbolic?); (d) *the composition* (balanced or asymmetrical? highly patterned or not?).

What does the work express? What meanings and values does it convey, and what does it say about its creator and its social context?

What is the *title*? Does it help to illuminate the work? Picasso called one of his early self-portraits *Yo Picasso* (i.e., "I Picasso"), rather than, say, *Portrait of the Artist,* and indeed his title goes well with the depicted self-confidence. Charles Demuth called his picture of a grain elevator in his hometown of Lancaster, Pennsylvania, *My Egypt,* a title that nicely evokes both the grandeur of the object (the silo shafts and their cap resemble an Egyptian temple) and a sense of irony (Demuth, longing to be in New York or Paris, was "in exile" in Lancaster). On the other hand, the sculptor Donald Judd stopped giving titles to his works, or rather, he called many of them untitled—because he thought titles distracted the viewer.

Note, too, that many titles were not given to the work by the artist (for instance, Michelangelo's *The Dying Slave* received its title long after the sculptor's death.), and some titles are positively misleading. Rembrandt's *Night Watch* was given that name at the end of the eighteenth century, when the painting had darkened; it is really a daytime scene, so it is now called *The Militia Company of Captain Frans Banning Cocq.* And we have already noticed, on page 13, that one's response to a Rembrandt painting may differ, depending on whether it is titled *Self-Portrait with Saskia* or *The Prodigal Son.*

When you ask yourself such basic questions, answers (at least tentative answers) will come to mind. In short, you will have some ideas, material that you will draw on and will take shape when you are called on to write. And these

ideas will get you going: They will give you confidence that you have something to say, and you therefore will not suffer from the self-doubt that engenders writer's block.

Following are additional questions to ask, first on drawing and painting, then on sculpture, architecture, photography, and video art. An unanswered question is an essay topic in disguise.

In brief, most of these questions require you to engage in one or the other of two kinds of examination:

- an analysis of properties that you see in the work and
- an analysis of your responses to these properties.

Drawing and Painting

What is the **subject matter?** *Who* or *what* can we identify in the picture? What (if anything) is happening?

If the picture is a **figure painting,** what is the relation of the viewer's (and the artist's) **gaze** to the gaze of the figure(s)? After all, the viewer— the bearer of the gaze—is looking at an "Other." Does this Other return the viewer's gaze, thereby asserting his or her identity and power, or does the subject look elsewhere, unaware of the voyeur viewer-painter? It has been argued, for instance, that in his pictures of his family and friends, Degas gives his subjects a level stare, effectively placing them on the same social level as the viewer; in his pictures of working women (laundresses, dancers), he adopts a high viewpoint, literally looking down on his unaware subjects; in his pictures of prostitutes, he looks either from below or from above, gazing as a spy or voyeur might do, with unsuspecting and, there-fore, vulnerable victims.

Concern with the "gaze"—and the idea that (in art) males look actively, whereas women are to-be-looked-at—was perhaps first set forth at length in English by Laura Mulvey in "Visual Pleasure and Narrative Cinema," in the journal *Screen* 16:3 (1975): 6–18, reprinted in her book *Visual and Other Pleasures* (1989). Today much art criticism concerns gaz-ing, and the implication is that the person who gazes is in fact a voyeur, who derives both pleasure and power from the act of looking.[*] In Mary Cassatt's *Woman in Black at the Opera* (c. 1878; also called *In the Loge* and *At the Français, a Sketch*), page 80, however, there is not so simple a dichotomy as male-looker and female-looked-at. True, the woman in the foreground is being looked at by the man in the upper left, but the

[*]For a brief survey of concepts of the gaze, see Marita Sturken and Lisa Cartwright, *Practices of Looking,* 2nd ed. (2009), 120–36. See also Margaret Olin's essay in Robert S. Nelson and Richard Shiff, eds., *Critical Terms for Art History,* 2nd ed. (2003), 318–29.

woman herself is very actively looking, and she is a far more dominating figure (severe profile, dark garments, large size, angular forms) than the small and somewhat comically sprawling man who is looking at her (and in effect at us). These two figures are looking; does the person who is looking at the picture—yet another, the viewer—see power as located in the woman rather than in the man—or does the man's voyeuristic activity undermine the woman's apparent power?

If more than one figure is shown, what is the relation of the figures to each other?

If there is only one figure, is it related to the viewer, perhaps by the gaze or by a gesture? If the figure seems posed, do you agree with those theoreticians who say that posing is a subordination of the self to the gaze of another and the offering of the self (perhaps provocatively or shamefully) to the viewer?

Let's now consider **portrait** painting. The old idea was that a good portrait not only describes the face but also characterizes the personality of the sitter. The face was said to be the index of the personality; thus, an accurate portrait of King X showed his cruelty (it was written all over his face), and accurate portraits of Pope Y and of Lady Z showed, respectively, the pope's piety (or worldliness) and the lady's tenderness (or arrogance). The set jaw of Gilbert Stuart's unfinished portrait of Washington (the basis of the image on the one-dollar bill) shows resolute firmness, and the ruddy cheeks show his energy; Lincoln's craggy face shows the burden on a leader during the Civil War. It usually turns out, however, that those who see such traits in particular portraits already know what traits to expect. When the portrait is of an unidentified sitter, the commentaries vary greatly.

Mary Stevenson Cassatt (American, 1844–1926), *In the Loge*, 1878. Oil on canvas, 32 × 26 in. (81.28 × 66.04 cm.). Museum of Fine Arts, Boston. The Hayden Collection – Charles Henry Hayden Fund, 10.35. Photograph © 2013 Museum of Fine Arts, Boston.

It is now widely held that a portrait is not simply a representation of a face that reveals the inner character; a portrait is also a presentation or a construction created by the artist and the sitter. Sitters and artists both (so to speak) offer interpretations of the sitter. In the words of the photographer Richard Avedon, "A portraits are performances" (*Richard Avedon Portraits* [2002], unpaginated). A portrait supposedly reproduces a surface (the sitter's face) but it also probably reveals states of mind of both the sitter and the painter.

How are the sitter's and the painter's minds conveyed? Consider such matters as these:

- How much of the figure does the artist show (just the face, or the face and bust, or the full figure?), and how much of the available space does the artist cause the figure to occupy? What effects are thus gained? For instance, if the figure occupies almost all of the pictorial space, it probably will seem commanding, even aggressive, threatening to move into the viewer's space.
- If the face is not treated realistically in a culture that made use of realism, what does the lack of realism convey? For instance, Renaissance and Baroque portraits of monarchs often show an unshadowed and rather flat face, the uniform lighting and the mask-like face presumably implying an unchanging—almost immortal—status, whereas farm laborers, on the other hand, usually are depicted much more realistically.
- What has the artist done with the subject's hands? Does a gesture simply a state of mind?
- What do the clothing, furnishings, accessories (horses, swords, dogs, clocks, business ledgers, and so forth), background, angle of the head or posture of the head and body, direction of the gaze, and facial expression contribute to our sense of the figure's social identity (monarch, clergyman, trophy wife) and personality (intense, cool, inviting)? A Renaissance equestrian portrait—the rider controlling a powerful horse—evokes images of Roman emperors and of dominance. Is the sitter portrayed in a studio setting or in his or her own surroundings? At this point, then, we can say that although a portrait is supposedly about an *individual,* it often relies on standard props, or *conventions.* A crown, scepter, and bejewelled costume obviously denote a monarch. If accessories and suggestions of a particular setting are absent, does the absence suggest timelessness—as when, for instance, a saint is depicted against a uniform gold background? The lack of setting in Gilbert Stuart's portrait of Washington probably helps to take

Washington out of a quaint remote period and establishes him as a figure for all times.

- Does the picture advertise the sitter's *political* importance, or does it advertise the sitter's *personal* superiority? A related way of thinking is this: What sort of identity is presented—social or psychological? That is, does the image present a strong sense of social class, for instance, king (the image evokes the principles implicit in kingship, notably absolute power), soldier, merchant, or (as in many Renaissance portraits) beautiful-wife-of-a-wealthy-man; or, on the other hand, does the image present a strong sense of psychology—a sense of an independent inner life (as is usual in portraits by Rembrandt)?

- Is the picture in large measure an image not only of an individual but also of a particular society? For instance, German portraits of the 1920s, by Max Beckman, Otto Dix, and George Grosz seem to capture the bitterness and desperation of the time and place.

- Is the picture largely an advertisement of the sitter (as is common in pictures commissioned by sitters or members of their family), or is it largely concerned with the painter's response to the sitter (as is common since the late nineteenth century, when artists working with dealers had a larger market)?

- If *frontal,* does the figure seem to face us in a godlike way, as if observing everything before it? If *three-quarter,* does it suggest motion, a figure engaged in the social world? If *profile,* is the emphasis decorative or psychological? (Generally speaking, a frontal or, especially, a three-quarter view lends itself to the rendering of a dynamic personality, perhaps even interacting in an imagined context, whereas a profile is relatively unexpressive and seems apart from any social interaction. If a profile does reveal a personality, it is that of an aloof, almost unnaturally self-possessed, sitter.)

- If the picture is a double portrait—for instance, of a married couple—does the artist reveal what it is that ties the two figures together? (A sixteenth-century double portrait by Lorenzo Lotto shows Cupid hovering behind the couple; he holds a yoke above them.) Do the figures look at each other? If not, what is implied by the lack of eye contact?

- Is the figure (or are the figures) allegorical (turned into representations of, say, liberty or beauty or peace or war)? Given the fact that female sitters are more often allegorized than males, do you take a given allegorical representation of a female to be an act of appropriation—a male forcing a woman into the role of "Other"?

- If the picture is a self-portrait, what image does the artist project? Van Gogh's self-portraits in which he wears a felt hat and a jacket show him as the bourgeois gentleman, whereas those in which he wears a straw hat and a peasant's blouse or smock show him as the country artist.
- To what extent does the artist's style—let's say, fine wiry lines, or vigorous brush strokes, or flat colors—create the alleged character of the sitter?
- It is sometimes said that every portrait is a self-portrait. (In Leonardo's formula, "the painter always paints himself." In the words of Dora Maar, Picasso's mistress in the 1930s and 1940s, "All his portraits of me are lies. They're all Picassos. Not one is Dora Maar.") Does this portrait seem to reveal the artist in some way?
- Some extreme close-up views of faces, such as those of the contemporary photo-realist painter Chuck Close, give the viewer such an abundance of detail—hairs, pores, cracks in lips—that they might be called landscapes of faces. Do they also convey a revelation of character or of any sort of social relationship, or does this overload of detail prevent the viewer from forming an interpretation?
- Does the portrait, in fact, reveal anything at all? Although George Orwell said that by the age of fifty everyone has the face he or she deserves, Max Beerbohm took the opposite view: "So few people look like themselves." The critic Roger Fry took Beerbohm's view; looking at John Singer Sargent's portrait titled *General Sir Ian Hamilton,* Fry said, "I cannot see the man for his likeness." Sargent, by the way, said that he saw an animal in every sitter.

For a student's discussion of two portraits by John Singleton Copley, see pages 138–45. For a professional art historian's discussion of Anthony Van Dyck's portrait of Charles I, see pages 213–15. For a brief, useful survey of the topic, see Joanna Woodall's introduction to a collection of essays, *Portraiture: Facing the Subject,* edited by Joanna Woodall (Manchester: Manchester University Press, 1997). For another short book on the topic with suggestions for further reading, see Shearer West, *Portraiture* (Oxford: Oxford University Press, 2004). Also useful on matters of portraiture and gender is Gill Perry, ed., *Gender and Art* (New Haven: Yale University Press, 1999).

Let's now consider a **still life** (plural: *still lifes,* not *still lives*)—a depiction of inanimate objects in a restricted setting, such as a tabletop.

- What is the chief interest? Is it largely in the skill with which the painter captures the transparency of glass, the reflection of light on

silver, the textures of ham and cheese and a lemon rind? Or is the interest chiefly in the relationships between the shapes? Or is it in the symbolic suggestions of opulence (a Dutch seventeenth-century painting, showing a rich tablecloth on which are luxurious porcelain bowls and expensive foods) or, on the other hand, is the interest in humble domesticity and the benefits of moderation (a seventeenth-century Spanish painting, showing a simple wooden table on which are earthenware or dented pewter vessels)?

- Does the picture give us realism or "seeming realism," "disguised realism," "symbolic realism"? That is, by means of realism does it offer allegorical implications? For instance, does it imply transience, perhaps by a burnt-out candle or a clay pipe (in the Hebrew Bible, Psalm 102 says, "For my days are consumed like smoke") or even merely by the perishable nature of the objects (food, flowers) displayed? Other common symbols of *vanitas* (Latin for "nothing" or "emptiness," particularly the emptiness of earthly possessions and accomplishments) are a mouse nibbling at food, an overturned cup or bowl, and a skull. If the picture shows a piece of bread and a glass of wine flanking a vase of flowers, can the bread and wine perhaps be Eucharistic symbols, the picture as a whole representing life everlasting achieved through grace?

- Is there a contrast (and a consequent evocation of *pathos*) between the inertness and sprawl of a dead animal and its vibrant color or texture? Does the work perhaps even suggest, as some of Chardin's pictures of dead rabbits do, something close to a reminder of the Crucifixion?

- Is the picture—let's say one of van Gogh's paintings of sunflowers—a sort of disguised autobiography, an expression of the artist's emotional life?

- Is all of this allegorizing irrelevant? Does the picture merely call our attention to things? Or call attention to the artist's almost unbelievable ability to imitate things?

- Consult Margit Rowell, *Objects of Desire: The Modern Still Life* (1997); Sybille Ebert-Schifferer, *Still Life: A History* (1999); Erika Langmuir, *Still Life* (2001); and, on Dutch still life, several essays in a journal, *Art History*, 35.5 (November 2012).

When the picture is a **landscape,** you may want to begin by asking the following questions:

- What is the relation between human beings and nature? Are the figures at ease in nature (e.g., happy shepherds—perhaps

picnicking or flirting beside their flocks—or aristocrats loung-
ing complacently beneath the mighty oaks that symbolize their
ancient power and grandeur), or are the figures dwarfed by
nature's awe-inspiring sublimity? Are they earthbound, beneath
the horizon, or (because the viewpoint is low) do they stand out
against the horizon and perhaps seem in touch with the heavens,
or at least with open air? Remember: The representation of the
natural world is not wholly objective.

- What do human constructions in the landscape—for instance,
cottages, or crumbling ruins, or fortifications—say about the rela-
tion of human beings to the countryside?
- Do the natural objects in the landscape (e.g., billowy clouds or dark
clouds, gnarled trees or airy trees) somehow reflect the emotions of
the figures?
- What does the landscape say about the society for which it was
created? Even if the landscape seems realistic, it may also express
political or spiritual forces. Does it, for instance, reveal an aris-
tocrat's view of industrious, well-clad peasants toiling happily in
a benevolently ordered society? Does it convey an imperialistic
(colonial) view of an exotic land with allegedly uncivilized migrant
figures such as Bedouins on camels? Does it—literally—put
the rural poor in the shade, letting the wealthy people get the
light? (This view is set forth in John Barrell, *The Dark Side of
the Landscape: The Rural Poor in English Painting, 1730–1840*
[1980].)
- If there are no signs of people—not even ruins of ancient buildings—
does the picture say something about the grandeur of God, the region
as an unspoiled paradise, or perhaps a heroic, ordered, highly struc-
tured world of ideal beauty?

In short, a picture showing a landscape nicely fits Emile Zola's definition of
a work of art as "a corner of nature seen through a temperament." Such a
work is not just an objective presentation of earth, rocks, greenery, water,
and sky. The artist presents what is now called a social construction of
nature—for instance, nature as a place made hospitable by the wisdom of
the landowners, or nature as an endangered part of our heritage, or nature
as a world that we have lost, or nature as a place where the weary soul can
find rest and nourishment.[*]

[*]For a readable discussion of how art turns or constructs land into landscape, see
Malcolm Andrews, *Landscape and Western Art* (1999). Andrews's book includes an especially
valuable "Bibliographic Essay."

We have been talking about particular subjects—figure painting, still life, landscape—but other questions concern all kinds of painting and drawing. Are the **contour lines** (outlines of shapes) strong, wiry, and hard, isolating each figure or object? Or are they irregular, indistinct, fusing the subjects with the surrounding space? Do the lines seem (e.g., in an Asian ink painting) calligraphic—that is, of varied thicknesses that suggest liveliness or vitality—or are the lines uniform and suggestive of painstaking care?

What does the medium (the substance on which the artist acted) contribute?

- If the drawing was made with a wet medium (e.g., ink applied with a pen or washes applied with a brush), what did the degree of absorbency of the paper contribute? Are the lines of uniform width, or do they sometimes swell and sometimes diminish, either abruptly or gradually? (Quills and steel pens are more flexible than reed pens, but almost all pen lines seem harder—move wiry—than brush lines.)
- If the drawing was made with a dry medium (e.g., silverpoint, charcoal, chalk, or pencil), what did the smoothness or roughness of the paper contribute? (When crayon is rubbed over textured paper, bits of paper show through, suffusing the dark with light, giving vibrancy.)

In any case, a drawing executed with a wet medium, where the motion of the instrument must be interrupted in order to replenish the ink or paint, will differ from a drawing executed with a dry medium such as graphite.[*]

If the work is a painting, is it in **tempera** (pigment dissolved in egg, the chief medium of European painting into the late fifteenth century), which usually has a somewhat flat, dry appearance? Because the brush strokes do not fuse, tempera tends to produce forms with sharp edges—or, we might say, because it emphasizes contours, it tends to produce colored drawings. Or is the painting done with **oil paint**, which (because the brush strokes fuse) is better suited than tempera to give an effect of muted light and blurred edges? Thin layers of translucent colored oil glazes can be applied so that light passing through these layers reflects from the opaque ground colors, producing a soft, radiant effect; or oil paint can be put on heavily

[*]For well-illustrated, readable introductions to the physical properties of drawings, see Susan Lambert, *Reading Drawings* (1984) and Julian Brooks, *Master-Drawings Close-Up* (2010). For a more detailed but somewhat drier account, see James Watrous, *The Craft of Old-Master Drawings* (1957).

(*impasto*), giving a rich, juicy appearance. Impasto can be applied so thickly that it stands out from the surface and catches the light. Oil paint, which lends itself to uneven, gestural, bravura handling, is thus sometimes considered more painterly than tempera or, to reverse the matter, tempera is sometimes considered to lend itself to a more linear treatment, to define forms by outline rather than by light and shadow.°

To return to general remarks about paints: **Acrylic paint**, a synthetic developed in the mid-twentieth century, has been widely used for abstract expressionism, pop art, and color field painting. Highly versatile, it can be brushed, poured, sprayed, or applied with a sponge onto unsized canvas. It soaks into the canvas, dries quickly, and can give a sort of watercolor look, but (like oil and unlike watercolor) it can be reworked.

The material value of a pigment—that is to say, its cost—may itself be expressive. For instance, Velázquez's lavish use of expensive ultramarine blue in his *Coronation of the Virgin* in itself signifies the importance of the subject. Ultramarine—"beyond the sea"—made of imported ground lapis lazuli, was more expensive than gold; its costliness is one reason why, like gold, it was used for some holy figures in medieval religious paintings, whereas common earth pigments were used for lesser mortals.

Caution: Reproductions in books usually fail to convey the texture of brush strokes.

In looking at a picture, ask yourself if

- the **colors** are related by bold contrasts or by gradual transitions, and ask if
- the colors are imitative of appearances or symbolically expressive, or both.

An example of **symbolic color** is the uniform gold background of some medieval Christian painting, which is meant to represent heaven and to convey the beauty, unity, and (because gold is impervious to change) the unchanging nature of God. (In Buddhist art, the flesh of the Buddha is gold, symbolizing his illumination or enlightenment, i.e., his perfect knowledge.) Blue is conventionally used for the cloak of the Virgin Mary, signifying her heavenly nature. But artists may, so to speak, invent their own symbolic conventions: Picasso used white, grays, and black for *Guernica*, when in fact the fascists bombarded the Basque town on a sunny day. Perhaps he wanted to evoke the reality of newsprint and of the black-and-white newsreels of the era.

°The contrast between "painterly" and "linear" pictures derives from translations of works by the Swiss art historian Heinrich Wölfflin (1864–1945), who distinguished between the "painterly" (German: *Malerische*) work of the baroque and the "linear" (*Lineare*) work of the Renaissance.

Vincent van Gogh, speaking of his own paintings, said he sought "to express the feelings of two lovers by a marriage of two complementary colors, their mixture and their oppositions, the mysterious vibrations of tones in each other's proximity . . . to express the thought behind a brow by the radiance of a bright tone against a dark ground." As this quotation may indicate, comments on the expressive value of color often seem highly subjective and perhaps unconvincing. One scholar, commenting on the yellowish green liquid in a bulbous bottle at the right of Manet's *Bar aux Folies-Bergère,* suggested that the color of the drink—probably absinthe—is oppressive. A later scholar pointed out that the distinctive shape of the bottle indicates that the drink is crème de menthe, not absinthe and, therefore, he found the color not at all disturbing.*

Caution: It is often said that *warm colors* (red, yellow, orange) come forward and produce a sense of excitement, (yellow is said to suggest warmth and happiness, as in the smiley face), whereas *cool colors* (blue, green) recede and have a calming effect. Experiments, however, have proved inconclusive; the response to color—despite clichés about seeing red or feeling blue—is highly personal, highly cultural, highly varied.

Still, a few things can be said, or at least a few terms can be defined. *Hue* gives the color its name—red, orange, yellow, green, blue, violet. *Value* (also called *lightness* or *darkness, brightness*) refers to relative lightness or darkness of a hue. When white is added, the value becomes "higher"; when black is added, the value becomes "lower" or "deeper." The highest value is white; the lowest is black. Light gray has a higher value than dark gray. *Saturation* (also called *intensity*) is the strength or brightness of a hue—one red is redder than another; one yellow is paler than another. A vivid hue is of high saturation; a pale hue is of low saturation. But note that much in a color's appearance depends on context. Juxtaposed against green, red will appear redder than if juxtaposed against orange. A gray patch surrounded by white seems darker than the same shade of gray surrounded by black.

When we are armed with these terms, we can say, for example, that in his South Seas paintings Paul Gauguin used *complementary colors* (colors opposite on the color wheel: orange and blue, yellow and violet, red and green, i.e., hues that when mixed absorb almost all white light, producing a blackish hue) at their highest values, but it is harder to say what this adds up to. (Gauguin himself said that his use of complementary colors was "analogous to Oriental chants sung in a shrill voice," but one may question whether the analogy is helpful.)

*See a four-volume series called *Artists' Pigments: A Handbook of Their History and Characteristics,* ed. Robert L. Feller (1986). For a more philosophic analysis, see John Gage, *Color and Meaning: Art, Science and Symbolism* (1999), and also Gage's shorter book, *Color in Art* (2007). See, too, Josef Albers, *Interaction of Color,* revised and expanded edition (2006) and Andrea Kirsh and Rustin S. Levenson, *Seeing through Paintings: Physical Examination in Art Historical Studies* (2000).

For several reasons our nerve may fail when we try to talk about the effect of color. For example:

- Light and moisture cause some pigments to change over the years, and the varnish customarily applied to Old Master paintings inevitably yellows with age, altering the appearance of the original. Modern pigments to can be unstable; the bluish trees of Edward Hopper's *Cape Cool Evening* (1939) were originally green but the yellow in the mixture has faded.
- The colors of a medieval altarpiece illuminated by flickering candlelight or by light entering from the yellowish translucent (not transparent) glass or colored glass of a church cannot have been perceived as the colors that we perceive in a museum, and, similarly, a painting by van Gogh done in bright daylight cannot have looked to van Gogh as it looks to us on a museum wall.
- Different cultures use color-symbolism differently. For instance, white in China is associated with funerals, but in the West white is associated with purity.

The moral? Be cautious in talking about the effect of color. Keep in mind the remark of the contemporary painter Frank Stella: "Structural analysis is a matter of describing the way the picture is organized. Color analysis would seem to be saying what you think the color does. And it seems to me that you are more likely to get an area of common agreement in the former."

What is the effect of **light** in the picture? Does it produce sharp contrasts, brightly illuminating some parts and throwing others into darkness, or does it, by means of gentle gradations, unify most or all of the parts? Does the light seem theatrical or natural, disturbing or comforting? Is light used to create symbolic highlights? In Rembrandt's *Adoration of the Shepherds* (1646) the careful viewer sees that the light does *not* come from the lanterns held by the shepherds but miraculously comes from the manger. Something of the same idea is seen in an early nineteenth-century magazine illustration (see page 91), where the light has no visible source; rather, it is a spiritual force indicating the union (in an otherwise dark world) of the praying child with God.

Do the objects or figures share the **space** evenly, or does one overpower another, taking most of the space or the light? What is the focus of the composition? The **composition** or **design**—the ordering of the parts into a whole by line, color, and shape—is sometimes grasped at an

initial glance and at other times only after close study. For instance, is the composition:

- symmetrically balanced (and perhaps therefore monumental, or quiet, or rigid and oppressive)?
- diagonally recessive and perhaps, therefore, as in Munch's *The Scream* (see page 91),° dramatic or even melodramatic, conveying swift recession or a disturbing thrust into the viewer's space.

Are figures harmoniously related, perhaps by a similar stance or shared action, in which case they can be said to balance or echo each other, or are they opposed, perhaps by diagonals thrusting at each other? Speaking generally—very generally—**diagonals** may suggest motion or animation or instability, except when they form a triangle resting on its base, which is a highly stable form. **Horizontal lines** suggest tranquility or stability—think of plains or of reclining figures. **Vertical lines**—tree trunks thrusting straight up, or people standing, or upright lances as in Velázquez's *Surrender of Breda*—may suggest a more vigorous stability. **Circular lines** are often associated with motion and sometimes—perhaps especially by men—with the female body and with fertility. It is even likely that Picasso's *Still-Life on a Pedestal Table*, with its rounded forms, is, as he is reported to have called it, a "clandestine" portrait of one of his mistresses. These simple formulas, however, must be applied cautiously, for they are not always appropriate. Probably it is fair to say, nevertheless, that when a *context* is established—for instance, by means of the title of a picture—these lines may be perceived to bear these suggestions if the suggestions are appropriate.

Caution: The sequence of eye movements with which we look at a picture has little to do with the compositional pattern. That is, the eye does not move in a circle when it perceives a circular pattern. The mind, not the eye, makes the relationships. It is therefore inadvisable to say things like "The eye follows the arrow and arrives finally at the target."

Does the picture convey **depth,** that is, **recession in space?** If so, how? If not, why not? (Sometimes space is flattened—e.g., to convey a sense of otherworldliness or eternity.) Among the chief ways of indicating depth are the following:

- **Overlapping** (the nearer object overlaps the farther object)
- **Foreshortening** (as in the recruiting poster *I Want You*, where Uncle Sam's index finger, pointing at the viewer, is represented

°For a further comment on *The Scream*, see pages 211–12.

Image of a boy praying, from *American Sunday School Teacher's Magazine* (July 1824, p. 257). Courtesy of the Library of Congress Prints and Photographs Division.

Edvard Munch (1863–1944). *The Scream.* 1896. Lithograph, printed in black composition: 13 ¹⁵/₁₆ × 10". Digital Image © The Museum of Modern Art/Licensed by Scala/Art Resource, NY. Art © 2013 The Munch Museum/The Munch-Ellison Group/Artists Rights Society.

chiefly by its tip, and, indeed, the forearm is represented chiefly by a cuff and an elbow)

- **Contour hatching** (lines or brush strokes that follow the shape of the object depicted, as though a net were placed tightly over the object)
- **Shading** or **modeling** (representation of shadows on the body)
- Representation of **cast shadows**

- **Relative position from the ground line** (objects higher in the picture are conceived of as farther away than those lower)
- **Perspective** (parallel lines seem to converge in the distance, and a distant object will appear smaller than a near object of the same size.* Some cultures, however, use a principle of *social perspective*, based on *hierarchic scale.* In such a system a king, for instance, is depicted as bigger than a slave not because he is nearer but because he is more important; similarly, the Virgin in a nativity scene may be larger than the shepherds even though she is behind them. Indeed, in Leonardo's *The Last Supper*, perspective is used to emphasize Jesus—the lines converge on his head—but hierarchic scale is also used, because he is slightly larger than the other figures. For an example of hierarchic scale, see the sculpture by Olowe of Ise, on page 268, where the senior queen is the largest figure, the king the second largest, and the two attendants, at the king's feet, are the smallest because they are the least important.)
- **Aerial** or **atmospheric perspective** (remote objects may seem—depending on the atmospheric conditions—slightly more bluish than similar near objects, and they may appear less intense in color and less sharply defined than nearer objects. The illusion of distance is created by decreased clarity. In Leonardo's *Mona Lisa,* for instance, the edges of the distant mountains are blurred. *Caution:* Aerial perspective does *not* have anything to do with a bird's-eye view.)

Does the picture present a series of planes, each parallel to the picture surface (foreground, middle ground, background), or does it, through some of the means just enumerated, present an uninterrupted extension of one plane into depth?

What is the effect of the **shape** and **size** of the work? Because, for example, most still lifes use a horizontal format, perhaps thereby suggesting restfulness, a vertical still life may seem relatively towering and monumental. Note too that a larger-than-life portrait—Chuck Close's portraits are 8 or 9 feet high—will produce an effect different from one 8 or 9 inches high. A colossal image normally implies a subject of great importance, a miniature may imply delicacy and preciousness and perhaps an especially intimate relationship between the depicted object (usually a person) and the viewer

*In the Renaissance, perspective was used chiefly to create a coherent space and to locate objects within that space, but later artists have sometimes made perspective expressive. Giorgio de Chirico, for example, often gives a distorted perspective that unnerves the viewer. Or consider van Gogh's *Bedroom at Arles.* Although van Gogh said that the picture conveyed "rest," viewers find the swift recession disturbing. Indeed, the perspective in this picture is impossible: If one continues the diagonal of the right-hand wall by extending the dark line at the base, one sees that the bed's rear right foot would be jammed into the wall.

for whom it was made. If you are working from a reproduction, be sure, therefore, to ascertain the size of the original. If you are writing about a work that you know only from a reproduction in a book, be sure to check the caption for information about its size and then try to visualize the original.

What is the **scale,** that is, the relative size? A face that fills a canvas will produce a different effect from a face of the same size that is drawn on a much larger canvas; probably the former will seem more expansive or more energetic, even more aggressive.

A Note on Nonobjective or Nonrepresentational Painting. We have already noticed (page 75) Wassily Kandinsky's comment that "The impact of an acute triangle on a sphere generates as much emotional impact as the meeting of God and Adam in Michelangelo's *Creation.*" Kandinsky (1866–1944), particularly in his paintings and writings of 1910–1914, has at least as good a title as anyone else to being called the founder of twentieth-century **nonobjective art** (also called **nonrepresentational art**). Nonobjective art, unlike figurative art, depends entirely on the emotional significance of color, form, texture, size, and spatial relationships rather than on representational forms.

The term *nonobjective art* includes **abstract expressionism**—a term especially associated with the work of New York painters in the 1950s and 1960s, such as Jackson Pollock (1912–1956) and Mark Rothko (1903–1970), who, deeply influenced by Kandinsky, sought to allow the unconscious to express itself. Nonobjective art is considered synonymous with **pure abstract art,** but it is *not* synonymous with "abstract art," since in most of what is generally called abstract art, forms are recognizable though simplified.

In several rather mystical writings, but especially in *Concerning the Spiritual in Art* (1910), Kandinsky advanced theories that exerted a great influence on American art after World War II. For Kandinsky, colors were something to be felt and heard. When he set out to paint, he wrote, he "let himself go. . . . Not worrying about houses or trees, I spread strips and dots of paint on the canvas with my palette knife and let them sing out as loudly as I could."

Nonobjective painting is by no means all of a piece; it includes, to consider only a few examples, not only the lyrical, highly fluid forms of Kandinsky and of Jackson Pollock but also the pronounced vertical and horizontal compositions of Piet Mondrian (1872–1944) and the bold, rough slashes of black on white of Franz Kline (1910–1962). Nonobjective painting is not so much a style as a philosophy of art: In their works, and in their writings and their comments, many nonobjective painters emphasized the importance of the unconscious and of chance. Their aim in general was to convey feelings with little or no representation of external forms; the work on the canvas conveyed not images of things visible in the world, but intuitions of spiritual realities. Notice that this is *not* to say that the paintings are "pure form" or that subject matter is unimportant in nonobjective art. To the contrary, the artists often insisted that their

works were concerned with what really was real—the essence behind appearances—and that their works were not merely pretty decorations. Two Abstract Expressionists, Mark Rothko and Adolph Gottlieb (1903–1974), emphasized this point in a letter published in the *New York Times* in 1943:

> There is no such thing as good painting about nothing. We assert that the subject is crucial and only that subject-matter is valid which is tragic and timeless. That is why we profess spiritual kinship with primitive and archaic art.
>
> —Quoted in *American Artists on Art from 1940 to 1980*,
> ed. Ellen H. Johnson (1982), 14

Similarly, Jackson Pollock, speaking in 1950 of his abstract works created in part by spattering paint and by dribbling paint from the can, insisted that the paintings were not mere displays of a novel technique and were not mere designs:

> It doesn't make much difference how the paint is put on as long as something has been said. Technique is just a means of arriving at a statement.
>
> —Quoted in *American Artists on Art from 1940 to 1980*,
> ed. Ellen H. Johnson (1982), 10

The **titles** of nonobjective pictures occasionally suggest a profound content (e.g., Pollock's *Guardians of the Secret*, Rothko's *Vessels of Magic*), occasionally a more ordinary one (Pollock's *Blue Poles*), and occasionally something in between (Pollock's *Autumn Rhythm*), but one can judge a picture by its title only about as well as one can judge a book by its cover (i.e., sometimes well, sometimes not at all). Richard Serra (b. 1939) says that the titles of his prints (for instance, *Bessie Smith*, *Malcolm X*, and *Screech*) are meaningless, and maybe they are, or maybe he is now trying to cover his tracks.

In writing about the work of nonobjective painters, you may get some help from their writings, though of course you may come to feel in some cases that the paintings do not do what the painters say they want the pictures to do. Good sources for statements by artists are *Theories of Modern Art* (1984), ed. Herschel B. Chipp; *American Artists on Art from 1940 to 1980* (1982), ed. Ellen H. Johnson; *Art in Theory: 1900–2000* (2002), ed. Charles Harrison and Paul Wood; and *Theories and Documents of Contemporary Art: A Sourcebook of Artists' Writings* (1996), ed. Kristine Stiles and Peter Selz. (In reading the comments of artists, however, it is often useful to recall Claes Oldenburg's remark that anyone who listens to an artist talk should have his eyes examined.)

Finally, here is a comment about a severely geometric nonobjective picture by Frank Stella (b. 1936) (see page 96). The picture, one of Stella's Protractor series, is 10 feet tall and 20 feet wide. Robert Rosenblum writes:

> Confronted with a characteristic example, *Tahkt-i-Sulayman I*, the eye and the mind are at first simply dumbfounded by the sheer multiplicity

of springing rhythms, fluorescent Day-Glo colors, and endlessly shifting planes—all the more so, because the basic components (circles and semi-circles; flat bands of unmodulated color) and the basic design (here a clear bilateral symmetry) are so lucid. But again, as always in Stella's work, the seeming economy of vocabulary is countered by the elusive complexities of the result. At first glance, the overriding pattern is of such insistent symmetrical clarity that we feel we can seize predictable principles of organization and bring to rest this visual frenzy. But Stella permits no such static resolution, for the overall symmetries of the design are contradicted by both the interlace patterns and the colors, which constantly assert their independence from any simple-minded scheme. In a surprising way, this tangle of gyrating energies, released and recaptured, provides a 1960s ruler-and-compass equivalent of the finest Pollocks, even in terms of its engulfing scale (here 20 feet wide), which imposes itself in an almost physical way upon the spectator's world. In this case, the springing vaults of the arcs, some reaching as high as 4 feet above one's head, turn the painting into something that verges on the architectural, a work that might rest on the floor and be subject to natural physical laws of load and support. Seen on this immense scale, the thrusts and counterthrusts, the taut and perfect spanning of great spaces, the razor-sharp interlocking of points of stress all contrive to plunge the observer into a dizzying tour-de-force of aesthetic engineering.

—*Frank Stella* (1971), 48–49[*]

What brief advice can be given about responding to nonobjective painting? Perhaps only this (and here is something of a repetition of what has already been said about representational drawings and paintings): As you look at the work, begin with your responses to the following:

- The dynamic interplay of colors, shapes, lines, textures (of pigments and of the ground on which the pigments are applied)
- The size of the work (often so large that you may have to crane your neck to see it). The works of some Abstract Expressionists, notably Jackson Pollock and Mark Rothko, tend to be large, and you might think you ought to view a Pollock or a Rothko from a distance, but both painters said they wanted their viewers to stand close to the paintings, to be engulfed by the paintings, to be immersed by colors and lines.
- The shape of the work (most are rectangular or square, but especially in the 1960s many are triangular, circular, chevron-shaped, diamond-shaped, and so on, with the result that, because they depart from the traditional shape of paintings, they seem almost to be objects—two-dimensional (or even three-dimensional) sculptures attached to a wall rather than paintings)

[*]*Penguin New Art 1: Frank Stella* by Robert Rosenblum, Penguin Books Ltd, 1971. Reprinted by permission.

Tahkt-I-Sulayman Variation II, 1969 (acrylic on canvas). Stella, Frank (b.1936). Dimensions 304.8 × 609.6 cms. Location: Minneapolis Institute of Arts, MN, USA. Gift of Bruce B. Dayton / The Bridgeman Art Library. Art © 2013 Frank Stella/Artists Rights Society (ARS), New York.

- The degree to which the artist's hand ("touch") is evident (in the Color Field paintings of a stain painter such as Helen Frankenthaler, where unprimed canvas soaked up spilled acrylic paint, touch is almost completely absent)
- The title

Later, as has been suggested, you may want to think about the picture in the context of statements made by the artist—for instance, Pollock's "My concern is with the rhythms of nature, the way the ocean moves. I work inside out, like nature." Useful sources include the four collections of comments mentioned on page 95.

Finally, remember that making a comparison is one of the most effective ways of seeing things. How does this work differ from that work, and what is the effect of the difference?

Sculpture

For what **purpose** was this object made? To edify the faithful? To commemorate heroism? What is expressed through the representation? What, for instance, does the highly ordered, symmetrical form of *King Chefren* (also called Khafre; Egyptian, third millennium B.C.; see page 98) suggest about the man? What is the relationship of naturalism to idealism or abstraction? If the sculpture represents a deity, what ideas of divinity are expressed? If it represents a human being as a deity (e.g., Alexander the Great as Herakles, or King Chefren as the son of an Egyptian deity), how are the two qualities portrayed?

If the work is a **portrait,** many of the questions suggested earlier for painted portraits (pages 81–84) may be relevant. Consider especially whether

the work presents a strong sense of an individual or, on the other hand, of a social type (e.g., military leader, philanthropist). Paradoxically, a work may do both: Roman portraits from the first to the middle of the third century are (for the most part) highly realistic images of the faces of older men, the conservative nobility who had spent a lifetime in public office. Their grim, wrinkled faces are highly individualized, and yet these signs of age and care indicate a rather uniform type, supposedly devoted and realistic public servants who scorn the godlike posturing and the feigned spontaneity of such flashy young politicians as Caesar and Pompey. That is, although the model might not in fact have been wrinkled, it apparently was a convention for a portrait bust to show signs of wear and tear, such as wrinkles, thereby indicating that the subject was a hardworking, mature leader. Odd though it sounds, the representation of signs of age in Roman sculpture was a way of idealizing the subject.

In other societies such signs of mortality may be removed from leaders. For instance, sub-Saharan African portrait sculpture of leaders tends to present idealized images. Thus, in Ife bronzes from the twelfth century, rulers show a commanding stance and a fullness of body, whereas captives (shown in order to say something not about themselves but about their conqueror) may be represented with bulging eyes, wrinkled flesh, and bones evident beneath the skin. In keeping with the tradition of idealizing, commemorative images of elders usually show them in the prime of life.

What does the **pose** imply? Effort? Rest? Arrested motion? Authority? In the Lincoln Memorial, Lincoln sits; in the Jefferson Memorial, Jefferson stands, one foot slightly advanced. Lincoln's pose and face suggest weariness, while Jefferson's pose and his faintly smiling face suggest confidence and action. In the Martin Luther King Jr. Memorial (p. 107), the pose has been criticized for being combative rather than contemplative. How relevant to a given sculpture is Rodin's comment that "The body always expresses the spirit for which it is the shell"?

What kinds of **volumes** are we looking at? Geometric (e.g., cubical, spherical) or irregular? Is the **silhouette** (outline) open or closed? In Michelangelo's *David* (page 70), David's right side is said to be closed because his arm is extended downward and inward; his left side is said to be open because the upper arm moves outward and the lower arm is elevated toward the shoulder. Still, although the form of *David* is relatively closed, the open spaces—especially the space between the legs—emphasize the potential expansion or motion of the figure. The unpierced, thoroughly closed form of *King Khafre* (see above), in contrast to the open form of *Mercury* (page 38), implies stability and permanence, a kinship with the gods and a deliberate lack of ordinary mortality. Put it this way: A closed form seems balanced and self-contained, whereas an open form seems unbalanced and reacting to the space around it.

Statue of Khafre. Giza Valley Temple
of Khafre. Dynasty 4 c. 2520–2494 B.C.
The Egyptian Museum, Cairo.
Photographer: DeAgostini/SuperStock.

Are certain bodily features or forms distorted? If so, why? (In most
African equestrian sculpture, the rider—usually a chief or an ancestor—
dwarfs the horse in order to indicate the rider's high status.)

If the sculpture is a bust, what sort of **truncation** (termination of the
image) has the sculptor used? Does a straight horizontal line run below the
shoulders, or does the bare or draped chest end in a curve in imitation of an
ancient bust? Does the sitter's garment establish the termination, perhaps
with flowing draperies that lend animation? Or is the termination deliberately
irregular, perhaps emphasizing the bust as a work of art rather than as a real-
istic reproduction of the subject? Does the head seem to emerge from a base
of uncarved stone or wood?

What do the **medium** and the **techniques** by which the piece was
shaped contribute?° Clay is different from stone or wood, and stone or wood
can be rough or they can be polished. Would the statue of Khafre have the
same effect if it were in clay instead of in highly polished diorite? Because
diorite is hard, it requires a great deal of work to carve it; thus, a statue of

°Media and techniques are lucidly discussed by Nicholas Penny in *The Materials of
Sculpture* (New Haven: Yale University Press, 1994). Also useful is a brief treatment, Jane
Bassett and Peggy Fogelman, *Looking at European Sculpture: A Guide to Technical Terms*
(Los Angeles: J. Paul Getty Museum, 1997).

diorite expressed wealth and enduring power. Can one imagine Daniel Chester French's marble statue of Lincoln, in the Lincoln Memorial, done in stainless steel? What are the associations of the material? For instance, early in the twentieth century welded iron suggested heavy-duty industry, in contrast with bronze and marble, which suggested nobility, the classical world, and great wealth. In the late twentieth century, many sculptors used fragile nontraditional material—in a moment we will discuss such a work by Eva Hesse that uses bedsheets and cord—partly to mock the idea that art is precious and enduring. Perhaps the extreme example is Dieter Roth's sculpture made of dirt and rabbit feces at Harvard's Busch-Reisinger Museum.

Even more important, what is the effect of the **tactile qualities,** for example, polished wood versus terra cotta? Notice that the tactile qualities result not only from the medium but also from the **facture**—that is, the process of working on the medium with certain tools, the manu-*facture* (hand-*making*) of the work. An archaic Greek *kouros* ("youth") may have a soft, warm look not only because of the porous marble but also because of traces left, even after the surface was smoothed with abrasives, by the sculptor's bronze punches and (probably) chisels.

Consider especially the distinction between **carving,** which is subtractive, and **modeling,** which is additive; that is, the difference between cutting away, to release the figure from the stone, wood, or ivory, and, on the other hand, building up or modeling, to create the figure out of a pliable material such as lumps of clay, wax, or plaster.° Rodin's *Walking Man* (see page 216), built up by modeling clay and then cast in bronze, recalls in every square inch of the light-catching surface a sense of the energy that is expressed by the figure. Can one imagine Michelangelo's *David* (see page 70), carved in marble, with a similar surface? Even assuming that a chisel could imitate the effects of modeling, would the surface thus produced catch the light as Rodin's does? And would such a surface suit the pose and the facial expression of *David?*

Compare *King Khafre* (see page 99) with Giovanni da Bologna's *Mercury* (see page 38). *King Khafre* was carved; the sculptor, so to speak, cut away from the block everything that did not look like Khafre. *Mercury* was modeled—built up—in clay or wax and then cast in bronze. The massiveness or stability of *King Khafre* partakes of the solidity of stone, whereas the elegant motion of *Mercury* suggests the pliability of clay, and wax, and the tensile strength of bronze.

In looking at any sculpture depicting a clothed figure, consider the extent to which the **drapery** is independent of the body. Does it express or diminish the **volumes** (enclosed spaces, e.g., breasts, knees) that it covers?

°"Modeling" is also used to refer to the treatment of volumes in a sculpture. Deep modeling, characterized by conspicuous projections and recesses, for instance, in drapery, creates strong contrasts in highlights and shadows. On the other hand, shallow modeling creates a relatively unified surface.

Does it draw attention to specific points of focus, such as the head or hands? Does it indicate bodily motion, or does it provide an independent harmony? What does it contribute to whatever the work expresses? If the piece is a wall or niche sculpture, does the pattern of the drapery help to integrate the work into the façade of the architecture?

What is the effect of **color,** either of the material or of gilding or paint? Is color used for realism or for symbolism? Why, for example, in the tomb of Urban VIII, did Gian Lorenzo Bernini use bronze for the sarcophagus (coffin), the pope, and Death, but white marble for the figures of Charity and Justice? The whiteness of classical stone sculpture is usually regarded as suggesting idealized form (though in fact the Greeks tinted the stone and painted in the eyes), but what is the effect—the emotional resonance—of the whiteness of George Segal's plaster casts (see page 102) of ordinary figures in ordinary situations, in this instance of a man sitting on a real stool and a woman standing beneath a real fluorescent light and behind a real counter, set off by a deep-red panel at the back wall? Blankness? Melancholy? Alienation?

What is the **scale** (size in relation to something else, usually to the subject in real life, or to the viewer)? Obviously the impact of a larger-than-life image differs from the impact of a miniature.

What was the original **location** or **site** or physical context (e.g., a pediment, a niche, a public square)?

Is the **pedestal** or **base** something added by a museum in order to let viewers see the piece, or is it a part of the sculpture (e.g., rocks, or a tree trunk that helps to support the figure), and, if so, is it expressive as well as functional? George Grey Barnard's *Lincoln—the Man,* a bronze figure in a park in Cincinnati, stands not on the tall classical pedestal commonly used for public monuments but on a low boulder—a real one, not a bronze copy—emphasizing Lincoln's accessibility, his down-to-earthness. Almost at the other extreme, the flying *Mercury* (see page 38) stands tiptoe on a gust of wind, and at the very extreme, Marino Marini's *Juggler* is suspended above the base, emphasizing the subject's airy skill.

Notice, too, that some sculpture does not have a base. George Segal's *The Diner* (page 102) is an example of what has come to be called "environmental sculpture," an image or images placed within a specific location. Talking about his own work, Segal said: "What was considered revolutionary about it was taking sculpture off the old plywood box and making it the center of a specifically constructed installation." Similarly, Richard Serra has said that getting rid of the pedestal was "the biggest move of the century." For a sculpture without a pedestal, see the work by Eva Hesse (page 104).

Where is the best place (or where are the best places) to stand in order to experience the work? Do you think that the sculpture is intended to be seen from multiple views, all of which are equally interesting and important? Or is the work strongly oriented toward a single viewpoint, as is the case with a sculpture set within a deep niche? If so, are frontality,

George Segal, *The Diner*. 1964–1966.
Plaster, wood, chrome, laminated
plastic, masonite, fluorescent
lamp, glass, paper. 9 ¾ × 144 ¼ ×
96 inches. Collection Walker Art
Center, Minneapolis. Gift of the
T. B. Walker Foundation, 1966.
Art © The George and Helen Segal
Foundation / Licensed by VAGA,
New York, NY.

rigidity, and stasis important parts of the meaning? Or does the image seem
to burst forward from the niche?° Keep in mind, too, the effect of the loca-
tion of the work; a freestanding sculpture placed in the middle of a room
may seem more active than a sculpture placed against a wall.

How close do you want to get? Why?

A Note on Nonobjective or Nonrepresentational Sculpture. Until the
twentieth century, sculpture used traditional materials—chiefly stone, wood,
and clay—and was representational, imitating human beings or animals by
means of masses of material. Sometimes the masses were created by cutting
away (as in stone and wooden sculpture), sometimes they were created by
adding on (as in clay sculpture, which then might serve as a model for a work
cast in bronze), but in both cases the end result was a representation.

Twentieth-century sculpture, however, is of a different sort. For one
thing, it is often made out of industrial products—Plexiglas, celluloid, fluo-
rescent lights, cardboard, brushed aluminum, galvanized steel, wire, and so
forth—rather than made out of traditional materials, notably wood, stone,
clay, and bronze. Second, instead of representing human beings or animals or

°Many older works of sculpture were placed relatively high, for example in temples and
cathedrals. Sometimes the sculptors took account of this placement, elongating the torsos
and enlarging the heads so that the figures look "natural" when seen from below. If such a
sculpture is placed at eye level, it may seem ineptly carved.

perhaps ideals such as peace or war or death (ideals that in the past were often represented allegorically through images of figures), much twentieth-century sculpture is concerned with creating spaces. Instead of cutting away (carving) or building up (modeling) material to create representational masses, the sculptors join material (**assemblage**)° to explore spaces or movement in space. Unlike traditional sculpture, which is usually mounted on a pedestal, announcing that it is a work of art, something to be contemplated as a thing apart from us, the more recent works we are now talking about may rest directly on the floor or ground, as part of the environment in which we move, or they may project from a wall or be suspended by a wire.

Let's look at a nonrepresentational work, Eva Hesse's *Hang-Up* (1966), shown on page 104. Hesse, who died of a brain tumor in 1970 at the age of thirty-four, began as a painter but then turned to sculpture, and it is for her work as a sculptor that she is most highly regarded. Her materials were not those of traditional sculpture; Hesse used string, balloons, wire, latex-coated cloth, rubber tubing, and other "nonart" materials to create works that (in her words) seem "silly" and "absurd." Only occasionally did Hesse create the sense of mass and sturdiness common in traditional sculpture; usually, as in *Hang-Up*, she creates a sense that fragile things have been put together, assembled only temporarily. In *Hang-Up,* a wooden frame is wrapped with bedsheets, and a half-inch metal tube, wrapped with cord, sweeps out (or straggles out) from the upper right and into the viewer's space, and then returns to the frame at the lower left. The whole, painted in varying shades of gray, has an ethereal look.

Taking a cue from Hesse, who in an interview with Cindy Nemser in *Artforum* (May 1970) said that she tried "to find the most absurd opposites or extreme opposites" and that she wanted to "take order versus chaos, stringy versus mass, huge versus small," we can see an evident opposition in the rigid, rectangular frame and the sprawling wire. There are also oppositions between the hard frame and its cloth wrapping or bandaging, and between the metal tubing and its cord wrapping. Further, there is an opposition or contradiction in a frame that hangs on a wall but that contains no picture. In fact, a viewer at first wonders if the frame *does* contain a panel painted the same color as the wall, and so the mind is stimulated by thoughts of illusion and reality. And although the work does not obviously represent any form found in the real world, the bandaging, the tubing, and perhaps our knowledge of Hesse's illness, may put us in mind of the world of hospitals, of bodies in pain. (The materials that Hesse commonly used, such as latex and fiberglass, often suggest the feel and color of flesh.) In *Hang-Up*, the tube, connected at each end to opposite extremes of the swathed frame, may suggest a life-support system.

°*Art Journal* 67.1 (Spring 2008) has several essays on artworks of this kind.

Eva Hesse, American,
b. Germany, 1936–1970.
Hang Up. 1966. Acrylic paint
on cloth over wood; acrylic
paint on cord over steel tube,
182.9 × 213.4 × 198.1 cm.
Through prior gifts of Arthur
Keating and Mr. and Mrs.
Edward Morris, 1988.130,
The Art Institute of Chicago.
Photograph © the Art
Institute of Chicago.
Courtesy of Hauser Wirth.

The title, too, provides a clue; *Hang-Up* literally hangs on a wall, but the title glances also at psychological difficulties—anyone's, but especially those of the artist, who was experiencing a difficult marriage and who was trying to create a new form of sculpture. If we go back to the idea of oppositions, we can say that the work itself has a hang-up: It seems as though it wants to be a painting (the frame), but the painting never materialized and now the work is a sculpture.

In looking at nonobjective sculpture, consider the following:

- the scale (e.g., is it massive, or is it on a domestic scale, like *Hang-Up*?)
- the effects of the materials (e.g., soft or hard, bright or dull?)
- the relationships between the parts (e.g., is the emphasis on masses or on planes, on closed volumes or on open assembly? If the work is an assembly, are light materials lightly put together, or are massive materials industrially joined?)
- the site (e.g., if the work is in a museum, does it hang on a wall or does it rest without a pedestal on the floor? If it is in the open, what does the site do to the work, and what does the work do to the site?)

- the title (e.g., is the title playful? enigmatic? significant?)
- comments by the sculptor, such as may be found in the four collections of statements by artists, mentioned on page 95.

A Note on Memorials and Other Public Monuments. Let's consider a bit further this matter of nonrepresentational sculpture, paying attention to public **memorials,** though we will also glance at representational monuments.° Think of a traditional war memorial—for instance, a statue of a local general in a park, or the Iwo Jima Monument representing marines raising an American flag—and then compare these essentially vertical figurative works with Maya Lin's Vietnam Veterans Memorial, dedicated in 1982 (page 106). Lin's pair of 200-foot granite walls join to make a wide V, embracing a gently sloping plot of ground. On the walls, which rise from ground level to a height of about 10 feet at the vertex, are inscribed the names of the 57,939 Americans who died in the Vietnam War—not in alphabetic sequence but in the sequence in which they died. The wall thus offers a sort of chronological narrative of the war. As visitors descend the slope to approach the wall with the names of the dead—a sort of descent into the grave—they experience a powerful sense of mortality, a sense heightened by the fact that visitors see their own reflection in the polished walls that list the dead.

Because this monument did not seem in any evident way to memorialize the heroism of those who died in the war, it stirred a great deal of controversy, and finally, as a concession to veterans groups, the Federal Fine Arts Commission came up with a compromise: A bronze sculpture of three larger-than-life armed soldiers (done by Frederick Hart) was placed nearby, thereby celebrating wartime heroism in a traditional way.

Although Lin's environmental sculpture has been interpreted as representational—the V-shaped walls have been seen as representing the chevron of the foot soldier, or as the antiwar sign of a V made with the fingers, and the black stone has been interpreted as suggesting that the war is a black mark in our history—clearly these interpretations are eccentric, far-fetched. The memorial is not an object representing anything, nor is it an object that (set aside from the real world and showing the touch of the

°Consult Harriet F. Senie, *Contemporary Public Sculpture* (1992). For a well-illustrated useful discussion of some thirty older works, with valuable bibliographic suggestions, see Judith Dupré, *Monuments: America's History in Art and Memory* (New York: Random House, 2007). For contemporary and older American monuments, see Erika Doss, *Memorial Mania* (Chicago: University of Chicago, 2010). Doss points out (page 38) that "Despite their interchangeability, the word 'memorial' is [now] used more often and has greater chachet than 'monument.'" Doss quotes Maya Lin: "I consider the work I do memorials, not monuments; in fact, I've often thought of them as anti-monuments."

Maya Lin, Vietnam Veterans Memorial, 1980–1982, walkway. Washington, D.C., January 20, 1997. Black granite. Each wall 10' 1" × 246' 9". Photographer: James P. Blair. © James P. Blair/Corbis/NY.

artist's hand) is meant to be looked at as a work of art, in the way that we look at a sculpture on a pedestal or at a picture in a frame. Rather, it is a *site*, a place for contemplation.

Vietnam Veterans Memorial belongs to a broad class of sculptures called *primary forms*. These are massive constructions, often designed in accordance with mathematical equations and often made by industrial fabricators. Until the middle of the twentieth century, however, most public monuments were representational, for instance showing military leaders on horses, or statesmen gesticulating. In recent years, things have changed: Many works of art in public spaces have been abstract, partly because of the prestige of abstract painting and partly because memorials now are less likely to commemorate individual heroes than they are to commemorate numerous victims, such as those of the Holocaust or of September 11, 2001.

Further, and paradoxically, some realistic monuments have seemed almost abstract partly because there is no immediately clear connection between *what* is represented and the site where the image stands. Take, for instance, Claes Oldenburg's *Clothespin* (1976), a rust-colored forty-five-foot Cor-Ten steel sculpture that stands in front of the City Hall (1871–1901), in Philadelphia, Pennsylvania. What is being memorialized? The commonplace? Perhaps yes, but perhaps there is also more. Behind *Clothespin* stands a bronze statue of William Penn, thirty-seven feet tall, mounted on a tower

atop the City Hall. In this context, *Clothespin* with its two leg-like prongs, can almost seem like a standing heroic figure. (Incidentally, although *Clothespin* soars elegantly, if it were a realistic image of a person, wouldn't the forty-five-foot figure seem uncomfortably gigantic to nearby spectators?) *Clothespin* may include additional meanings, additional associations: Robert Hughes has suggested in *American Visions* (1997) that "The shape of the spring [that holds the two halves of the clip] combines the numbers '7' and '6,' evoking 1776, the year of the American Revolution, in which Philadelphia played such a part" (532). And there is more: Some people, including Oldenburg himself, have seen in *Clothespin* two figures in profile, pressing against each other, thereby connecting the sculpture with Constantin Brancusi's *The Kiss*, a work nearby in the Philadelphia Museum of Art. *Clothespin* can thus be seen as both heroic and sensuous. Was Oldenburg playing with the idea that such an image is appropriate for a city whose name is Greek for "brotherly love"?

In looking at a monument, consider the following:

- Who or what is represented, is remembered? Is the representation appropriate? (Some critics of the Martin Luther King Jr. monument in Washington, D.C., complained that the sculpture, based on a photograph, loses the contemplative quality of the photo and instead presents an unattractively authoritarian personality. Your view?)

Left: Martin Luther King, Jr., in Atlanta SCLC office, with Gandhi print on wall. Source: Bob Fitch. © Bob Fitch, www.bobfitchphoto.com. *Right:* The model sculpture (by Lei Yixin) for the Martin Luther King Jr. National Memorial. Photographer: Jacquelyn Martin. © AP Images. The monument was in fact approved, built, and in 2011 dedicated.

- Does the monument honor the achievements of an individual (for instance by the realistic depiction of the face) and at the same time suggest timelessness (for instance by traditional symbols such as a classic garment or a torch signifying enlightenment)? If so, how successful is the combination?
- Is the monument representational, like the Statue of Liberty, or is it nonrepresentational, like the Vietnam Veterans Memorial? Or is it sculptural and architectural, like the Lincoln Memorial?
- Is it elevated on a pedestal or atop a flight of stairs, emphasizing its importance, or is it—democratically?—at ground-level?
- If nonrepresentational, is it symbolic? Of what? And how do the elements convey the symbolic meaning? Color? Scale? Material? Does—for instance—marble imply endurance, or does flowing water imply the passage of time? Do trees imply new life? Does a reflecting pool—or the black reflecting marble of the Vietnam Veterans Memorial—implicate the viewer? Maya Lin (quoted in *Art in America,* April 1983, page 123) said she chose black for the Memorial because she "wanted something that would be soft on the eyes, and turn into a mirror if you polished it. The point is to see yourself in the names." Does the AIDS quilt, by its medium, imply family values?
- Does the monument include any relics? (In New York City, the monument dedicated to *The Maine,* the ship that exploded in Havana Harbor in 1898, includes a tablet cast with metal recovered from the destroyed ship.) With such material, we may find we are less concerned with the beautiful than with the sacred or with the sublime (usually defined as the awe-inspiring). An example: Buckled steel columns from the Twin Towers are now objects of contemplation in the National September 11 Memorial and Museum at Ground Zero.
- Does the location of the monument contribute to its meaning, and does the monument contribute to the meaning of the location? The Statue of Liberty is in New York Harbor, the site where until recently most immigrants entered the United States. In Richmond, Virginia, Monument Avenue is the site of an equestrian statue (1890) of Robert E. Lee and of five later statues of Confederate heroes. In 1995 the nature of the site—in effect, a memorial for the Lost Cause—was changed when a statue of the African-American tennis star and civil-rights activist, Arthur Ashe (1943–93), was added.
- Does the monument include words? The Lincoln Memorial includes texts by Lincoln; the Vietnam Memorial and the AIDS Quilt record the names of the dead. If words are present, do they seem integral or merely tacked on?

- Has the monument been altered in any way, thereby reflecting a change in public taste? The Custer National Battlefield in 1991 was renamed the Little Bighorn National Battlefield. The original monument consisted of an obelisk dedicated to the memory of Lieutenant Colonel Custer and the 270 soldiers and the Crow Indian scouts of the 7th Cavalry who in 1876 were killed by Sioux and Cheyenne Indians in Southern Montana near a stream called the Little Bighorn. The revised monument includes an Indian Memorial, dedicated to all the Indians who fought, on either side, to preserve their land and their culture. An earthen enclosure is marked with a cut or a "weeping wound"; two large posts flank the gap, forming a "spirit gate" that welcomes all of the dead, who now possess the wisdom they did not have when alive.
- Is the monument intended merely to be looked at from a distance, or is the visitor invited to establish some sort of closer relationship, for instance, by entering it?
- What is the name of the monument? Consider again the change from Custer National Battlefield to Little Bighorn National Battlefield. In Cambridge, Massachusetts, the John Fitzgerald Kennedy Park, by using "park" instead of "monument" or "memorial," puts the emphasis on Kennedy as a living force.
- Is the monument aesthetically pleasing?
- Is it intellectually stimulating?
- Does it matter who designed the memorial? The monumental sculpture (page 17) of Dr. King in the Martin Luther King Jr. National Memorial (in Washington, between the Lincoln and the Jefferson Memorials) was carved by Lei Yixin, a Chinese sculptor. Many critics believe it should have been carved by an African American. The Statue of Liberty was created by a French sculptor, and in New York the memorial garden for the Museum of Jewish Heritage was designed by a non-Jewish British artist, Andy Goldsworthy. Do the works gain or lose anything because of the color or nationality of the creator?

Architecture

You may recall from Chapter 1 (page 12) Auden's comment that a critic can "throw light upon the relation of art to life, to science, economics, religion, and so on." Works of architecture, because they are created for use, especially can be considered in the context of the society that produced them. As the architect Louis Sullivan (1856–1924) said, "Once you learn to look upon architecture not merely as an art, more or less well or badly done, but

as a social manifestation, the critical eye becomes clairvoyant, and obscure, unnoted phenomena become illumined."

The Roman architect Vitruvius suggested that buildings can be judged according to their

- *firmitas* (firmness, structural soundness)
- *utilitas* (commodity, function, fitness for their purpose, utility)
- *venustas* (delight, beauty, design)

Firmitas gets us thinking about the structure and durability of the materials: The building should stand up in a given physical context (climate, prevailing winds, seismic zone, freeze-thaw cycles, sun angles for a particular latitude, and so on). *Utilitas* gets us thinking about how suitable (convenient, functional, usable) the building is for its purposes. Does the building work as, say, a bank, a church, a residence, a school? *Venutas* gets us thinking about the degree to which it offers delight when we look at it or move through it. Much (though not all) of what follows is an amplification of these three topics.

What did the client want? What was or is the **purpose** of the building? For instance, does it provide a residence for a ruler, a place of worship, or a place for legislators to assemble? Was this also its original purpose? If not, what was the building originally used for? Consider Le Corbusier's maxim, "A house is a machine for living in" (*Une maison est une machine-à-habiter*). Architecture is generally considered a useful art, and all architecture is designed to help us to live—even a tomb is designed to help the living to cope with death, perhaps by assuring them that the deceased lives in memory. Churches, museums, theaters, banks, zoos, schools, garages, residences, all are designed to facilitate the business of living.

Does the building appear today as it did when constructed? Has it been added to, renovated, restored, or otherwise changed in form?

What does the building say? "All architecture," wrote John Ruskin, "proposes an effect on the human mind, not merely a service to the human frame." One can distinguish between function as housing and function as getting across the patron's message—or the architect's. In Frank Lloyd Wright's formula, "Architecture is the scientific art of making structure express ideas."

- Sometimes the idea conveyed by the structure is grotesquely obvious as, for instance, when a frankfurter eatery is shaped like a frankfurter or a seafood restaurant is shaped like a ship or a fish, but
- Sometimes the relationship between structure and idea is more profound. A Gothic cathedral such as Chartres said, by virtue of its cross shape, that it was a house of Jesus. It also said, by virtue of the light coming through stained glass windows with their holy images, that it was a house of God (the Gospel according to John describes Jesus as the Light of the World) and the image of Heaven. In brief,

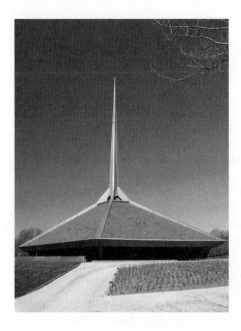

North Christian Church (Disciples
of Christ) in Columbus, Indiana.
Architect Eero Saarinen. Dedicated in
1964. Photographer: Cathy Melloan.
© Cathy Melloan/Alamy Images.

Chartres Cathedral is an earthly representation of the Heavenly
Jerusalem, the eternal city, and visitors to the church presumably are
elevated—at least temporarily. Some nineteenth-century libraries
look like Romanesque churches, implying that books free the spirit.
Eero Saarinen's North Christian Church (completed in 1964, after
his death) has a central spire that, like the traditional steeple, suggests
a connection between the earth and the heavens, but this rocket-like
spire especially suggests both tremendous energy and a God who
dwells in outer space. The position of the altar, in the center of the
sanctuary and surrounded by curved rows of pews, is also meaning-
ful: Religion is the center of life. To turn from churches to banks, we
can note that a nineteenth-century bank said, by means of its bulk, its
bronze doors, and its barred windows, that your money was safe. It also
said, since it had the facade of a Greek temple, that money was holy. A
modern bank, full of glass and color, is more likely to say that money is
fun, and that it is insubstantial—just numbers sent electronically.
• The J. Edgar Hoover FBI Building in Washington, D.C., with its
 masses of precast concrete, looks like a fortress, uninviting, menac-
 ing, impregnable—the very image of the FBI.
• Collegiate architecture often speaks an obvious language: Brick
 buildings in a Georgian style suggest the nation's earliest colleges;
 stone buildings in Collegiate Gothic (pointed arches, narrow

windows), common around 1900, are supposed to suggest a pre-industrial world of spirituality and scholarship. The chapel at the Military Academy at West Point, evoking a medieval fortress, suggests spirituality and also an appropriate militancy.

In Winston Churchill's words, "We shape our buildings: thereafter they shape us."

What, then, are the architectural traditions behind the building that contribute to the building's expressiveness? The Boston City Hall (see page 115), for all its modernity and (in its lower part) energetic vitality, is tied together in its upper stories by forceful bands of windows, similar in their effect to a classical building with columns. Classical façades, with columns, pediments, and arches, are by no means out of date. One can see versions of them, often slightly jazzed up, as the entrances to malls and high-style retail shops that wish to suggest that their goods are both timeless and in excellent taste. The classical tri-partite expression of base, middle, and top may be looked at another way as well. The repetitive windows at the top are dedicated to, and symbolic of, the bureaucracy of municipal government. The one-off expressive spaces in the middle indicate the presence of special places like the council chambers. And the base is open as the brick paving of the plaza climbs up the lower portion of the walls symbolically inviting the public into the building.

Here is how Eugene J. Johnson sees (or hears) Mies van der Rohe's Seagram Building (1954–1957):[*]

Austere, impersonal, and lavishly bronzed, it sums up the power, personality, and wealth of the modern corporation, whose public philanthropy is symbolized by the piazza in front, with its paired fountains—private land donated to the urban populace. If the piazza and twin fountains call to mind the Palazzo Farnese in Rome, so be it, particularly when one looks out from the Seagram lobby across an open space to the Renaissance-revival façade of McKim, Mead and White's Racquet Club which quotes the garden façade of Palazzo Farnese! Mies set up a brilliant conversation between two classicizing buildings, bringing the nineteenth and twentieth centuries together without compromise on either part. Mies was in many ways *the* great classicist of this century. One might say that one of his major successes lay in fusing the principles of the great classical tradition of Western architecture with the raw technology of the modern age.

—"United States of America," in *International Handbook
of Contemporary Developments in Architecture,* ed. Warren
Sanderson (1981), 506

[*]Eugene J. Johnson. Quotation in *International Handbook of Contemporary Developments in Architecture,* edited by Warren Sanderson. Copyright 1981 by Warren Sanderson. Reproduced with permission of Greenwood Publishing Group.

Notice how Johnson fuses *description* (e.g., "lavishly bronzed") with interpretive *analysis* (he sees in the bronze the suggestion of corporate power). Notice, too, how he connects the building with history (the debt of the piazza and twin fountains to the Palazzo Farnese) and how he connects it with its site (the "conversation" with a nearby building).

We have already seen (pages 29–32) that, like other buildings, **museums and the exhibition spaces** within museums make statements. This is true whether the museum resembles a Greek temple and is entered only after a heavenward ascent up a great flight of steps, or whether it is a Renaissance palace or a modern imitation of one, or whether it is insistently high-tech. When the Museum of Modern Art opened in New York in 1939, with an entrance consisting of a revolving door on ground level, it was making the radical statement that an art museum was more like a department store than it was like a temple.°

Do the forms and materials of the building relate to its neighborhood? What does the building contribute to the **site?** What does the site contribute to the building? Does the building contrast with the site or complement it? How big is the building in relation to the neighborhood and in relation to human beings; that is, what is the **scale?** A building larger than its neighbors, or elevated above them by a platform, suggests it is of greater importance. The Cambridge City Hall (1889; page 114), atop a slope above the street, crowns the site and announces—especially because it is in a Romanesque style—that it is a bastion of order, even of piety, giving moral significance to the neighborhood below. The Boston City Hall (1968; page 115), its lower part in brick, rises out of a brick plaza—the plaza flows into spaces between the concrete pillars that support the building—and seems to invite the crowds from the neighboring shops, outdoor cafés, and marketplace to come in for a look at government of the people by the people, and yet at the same time the building announces its importance.

How do you **approach** the building, and how do you enter it?

Does **form** follow **function?** For better or for worse? For example, does the function of a room determine its shape? Are there rooms with geometric shapes irrelevant to their purposes? Louis Sullivan, in rejecting the nineteenth-century emphasis on architecture as a matter of style (in its most extreme form, a matter of superficial decoration), said, "Form ever follows function." Sullivan's comment, with its emphasis on structural integrity—the appearance of a building was to reveal the nature of its construction as well as the nature of its functions or uses—became the slogan for many

°For an examination of many museums built in recent decades, see Victoria Newhouse, *Toward the New Museum,* expanded edition (2006). Among the topics Newhouse considers are "The Museum as Sacred Space," "The Museum as Entertainment," and "The Museum as Environmental Art."

Cambridge City Hall, Massachusetts Avenue, Cambridge, Mass. c. 1910. Longfellow, Alden, & Harlow Architects. Photograph by Thomson & Thomson. Library of Congress Prints and Photographs Division.

architects working in the mid-twentieth century. But there were other views. For instance, Philip Johnson countered Sullivan with "form always follows forms and not function." In looking at a building, ask yourself if the form serves a **symbolic function;** recall the "lavishly bronzed" Seagram building, which Eugene J. Johnson sees as summing up "the power, personality, and wealth of the modern corporation." Equally symbolic or expressive is Eero Saarinen's Trans World Airlines Terminal at Kennedy Airport, where the two outstretched wings suggest flight. Consider, too, Frank Gehry's Solomon R. Guggenheim Museum (1997) in Bilbao, built by the side of a river in a Basque port city in northern Spain, whose economy was based on shipbuilding. Viewed from across the river, the titanium-sheathed design evokes a ship, expressing such ideas as the history of the city, grandeur, and elegance.

Boston City Hall, City Hall Plaza Center, 1961–1968. jiawangkun/Shutterstock.

What **materials** are used? How do the materials contribute to the building's purpose and statement? The Bilbao Guggenheim, (see page 116) in addition to using titanium (a material chiefly used in aeronautics), uses a pale Spanish limestone that is evident in Bilbao's old university across the river, and so in its materials the museum embraces the past as well as the present. Or, as another example, take the materials of some American college and university buildings. Adobe may work well at the University of New Mexico, but would it be right for the Air Force Academy in Colorado? (The Academy uses different materials—notably aluminum, steel, and glass.)

Each building material has associations or, at least, potential associations.

- **Marble:** The Sam Rayburn House Office Building in Washington, D.C., is clad in marble veneer (costing many millions of dollars) because marble is thought to suggest dignity and permanence—though in fact marble is a rather soft stone. Marble is highly versatile: White or black marble, common in expensive jewelry shops, can seem sleek or aloof; pink or creamy marble, in a boutique with goods for women, can seem soft and warm.

- **Brick** often suggests warmth or unpretentiousness and hand-craftsmanship.
- **Wood,** like marble, is amazingly versatile. In its rough-bark state it suggests the great outdoors; trimmed and painted it can be the clapboard and shingles of an earlier America; smooth and sleek and unpainted it can suggest Japanese elegance.
- **Glass** can be transparent, translucent, or even opaque, as in I. M. Pei's John Hancock Building in Boston. The exterior walls of the Hancock building reflect the sky and clouds, thereby animating and softening the building, which towers above its neighbors.

Do the **exterior walls** seem hard or soft, cold or warm? Is the sense of hardness or coldness appropriate? (Don't simply assume that metal must look cold. A metal surface that reflects images can be bright, lively, and playful. Curves and arches of metal can seem warm and "soft.") Does the material in the interior have affinities with that of the exterior? If so, for better or for worse? (Our experience of an interior brick wall may be very different from our experience of an exterior brick wall.)

Does the **exterior** stand as a massive sculpture, masking the spaces and the activities within, or does it express them? The exterior of the Boston City Hall (see page 115) emphatically announces that the building harbors a variety of activities; in addition to containing offices, it contains conference rooms, meeting halls, an exhibition gallery, a reference library, and

Frank Gehry, Solomon R. Guggenheim Museum, 1997, Bilbao. Exterior view. The titanium-sheathed design evokes a ship, an apt form for a building in a city whose economy was largely based on shipbuilding and steel. Photographer: David Heald. © The Solomon R. Guggenheim Foundation, New York.

other facilities. Are the spaces continuous? Or are they static, each volume capped with its own roof?

What is the function of **ornament** or of any **architectural statuary** (for instance, personifications of industry, justice, or agriculture) in or near the building? To conceal the joins of a surface? To embellish a surface, and to suggest a meaning? (At Cornell University, the John Henrik Clarke African Library is clad with multicolor brick in patterns suggestive of African textiles. At West Point, above the main entrance to the chapel, is a cross in the form of a sword-hilt.) To emphasize importance? (The east end of a Christian church, where the altar is, sometimes is more elaborately decorated than the rest of the building.)

Does the **interior** arrangement of spaces say something—for example, is the mayor's office in the city hall on the top floor, indicating that he or she is above such humdrum activities as dog licensing, which is on the first floor?

In a given room, what is the function of the **walls?** To support the ceiling or the roof? To afford privacy and protection from weather? To provide a surface on which to hang shelves, blackboards, pictures? If glass, to provide a view in—or out?

What is the effect of the **floor** (wood, tile, brick, marble, carpet)? Notice especially the effect if you move from a room floored with one material (say, wood) to another (say, carpet).

Is the building inviting? The Cambridge City Hall has one public entrance, approached by a flight of steps; the Boston City Hall, its lower floor paved with the brick of the plaza, has many entrances at ground level. What are the implications in this difference?

What is the role of **color?** To clarify form? To give sensuous pleasure? To symbolize meaning? (Something has already been said, on page 00, about the effects of the colors of marble.) Much of the criticism of the *Vietnam Veterans Memorial* centered on the color of the stone walls. One critic, asserting that "black is the universal color of shame [and] sorrow," called for a white memorial.

What part does the changing **daylight** play in the appearance of the exterior of the building? Does the interior make interesting use of natural light? And how light is the interior? (The Lincoln Memorial, open only at the front, is somber within, but the Jefferson Memorial, admitting light from all sides, is airy and suggestive of Jefferson's rational—sunny, we might say—view of life. Similarly, the light in places of worship differs. A New England colonial church, with lots of clear windows and white walls, is full of light; a neo-Gothic cathedral, with narrow stained glass windows and dark woodwork, is subdued, mysterious, perhaps in some minds gloomy.)

As the preceding discussion suggests, architectural criticism usually is based on a finite number of topics that usually include the following:

- the building or monument as an envelope or object (its purpose, structural system, materials, sources of design, history, design [articulation of the façade, including all the arrangement of the windows and doors, ornamentation, color, formal composition/ sculptural properties and massing])
- the interior (spatial organization and hierarchy), circulation (flow of traffic), connection with or separation from the exterior
- the building's response to context—both physical (built and natural) and cultural
- the place of the building in the history of the architect's work (in other words, what aspects of a project are consistent with those aspects commonly found in other examples of the architect's work), the philosophy of the architect and how the building does or does not reflect it.
- Criticism of contemporary architecture asks if the building is a green building (also called a sustainable building), that is a building whose design, siting, construction, and operation (lighting, heating and cooling, disposal of waste) do as little damage as possible to the environment and to the building's inhabitants.

If you are writing about the first or second of these topics—the building as an envelope or the enclosed spaces through which one moves—you may have only your eyes and legs to guide you when you study the building of your choice, say, a local church or a college building. But if the building is of considerable historical or aesthetic interest, you may be able to find a published *plan* (a scale drawing of a floor, showing the arrangement of the spaces) or an *elevation* (a scale drawing of an external or internal wall). Plans and elevations, often available in printed sources, are immensely useful as aids in understanding buildings. For a helpful introductory discussion of architecture that makes excellent use of plans and elevations, see Simon Unwin, *Analysing Architecture* (1997).

A few words about the organization of an essay on a building may be useful. Much will depend on your purpose and on the building, but consider the possibility of using one of these three methods of organization:

1. You might discuss, in this order, *utilitas, firmitas,* and *venustas*— that is, function, structure, and design (see page 110).
2. You might begin with a view of the building as seen at a considerable distance, then at a closer view, and then go on to work from the ground up, since the building supports itself this way.

3. You might take, in this order, these topics:
 - the materials (smooth or rough, light or dark, and so on)
 - the general form, perceived as one walks around the building (e.g., are the shapes square, rectangular, or circular, or what? Are they simple or complex?)
 - the façades, beginning with the entrance (e.g., is the entrance dominant or recessive? How is each façade organized? Is there variety or regularity among the parts?)
 - the relation to the site, including materials and scale

Photography

A *photograph* is literally an image "written by light." Although most people today think of a photograph as a flat work on paper produced from a *negative* (in which tones or colors are the opposite from what we normally see) made in a camera, none of these qualities is necessary.[*] Photographs can be made without cameras (by exposing a light-sensitive material directly to light), can be generated without negatives (color slides and Polaroid prints are familiar examples of what are known as *direct positives*), and can be pieces of fabric, leather, glass, metal, or even a still image on a computer screen. All that you need to have a photograph is a substance that changes its color or tone under the influence of light and that can subsequently be made insensitive to light so that it can be viewed.

Inherent in this requirement that the image be created by light is the fundamental distinction between photography and prior ways of making pictures. Instead of having the hand drag oil paint across a stretched piece of linen or incise lines into a metal plate to generate an engraving, nature itself, with the help of some manufactured lenses and chemically coated sheets of glass, paper, or film, became the artist. Early photographic viewers marveled at the seemingly limitless details that magically appeared on the metal plate used for one of the first processes, the *daguerreotype*. Thus was born the idea that the camera cannot lie and that the image it produced depended on chemistry and optics, not on human skills.

At the same time, photographers and critics who were familiar with the craft realized that there was a huge gap between what the eye saw and

[*]This discussion of photography is by Elizabeth Anne McCauley, David H. McAlpin Professor of the History of Photography and Modern Art, Princeton University. This "Photography" section was written for this text and used by permission of the author.

the finished photograph. Human beings have two eyes that are constantly moving to track forms across and into space; they perceive through time, not in fixed units; their angle of vision (the horizontal span perceived when holding the eye immobile) is not necessarily that of a lens; their eyes adjust rapidly to read objects in both bright sun and deep shadows. As Joel Snyder and Neil Allen observed in *Critical Inquiry* (Autumn 1975), "A photograph shows us 'what we would have seen' at a certain moment in time, *from* a certain vantage point *if* we kept our head immobile *and* closed one eye *and if* we saw with the equivalent of a 150-mm or 24-mm lens *and if* we saw things in Agfacolor or in Tri-X developed in D-76 and printed on Kodabromide #3 paper" (page 152). And, they point out, if the eye and the camera saw the world in the same way, then the world would look the way it does in photographs.

Photographers also intervene in every step of the photographic process. They pose sitters; select the time of day or artificial light source; pick the camera, film, exposure time, and amount of light allowed to enter the camera (the lens *aperture*); position the camera at a certain height or distance from the subject; focus on a given plane or area; develop the film to bring out certain features; choose the printing paper and manipulate the print during enlargement and development; and so forth. By controlling the world in front of the camera, the environment within the camera, and the various procedures after the light-sensitive material's initial exposure to light, the photographer may attempt to communicate a personal interpretation or vision of the world. If he or she succeeds, we may begin to talk about a photographic "style" that may be perceptible in many images made over several years.

Since its invention in the early nineteenth century, photography has taken over many of the functions of the traditional pictorial arts while satisfying new functions, such as selling products or recording events as they actually happen. Because early photography seemed close to observed reality, it was rapidly used any time factual truth was required. Photographs have been taken of ancient and modern architecture, engineering feats, criminals' faces, biological specimens, astronomical phenomena, artworks, slum conditions, and just about anything that needed to be classified, studied, regulated, or commemorated. Because the validity of these images depended on their acceptance as truth, their creators often downplayed their role in constructing the photographs. The photojournalist Robert Capa, talking about his famous views of the Spanish Civil War, said, "No tricks are necessary to take pictures in Spain. . . . The pictures are there, and you just take them. The truth is the best picture, the best propaganda."

While statements such as Capa's reveal what photographers once wanted the public to believe about their images, we now no longer accept

photographs, even so-called documentary ones, as unmanipulated truth. All photographs are representations, in that they tell us as much about the photographer, the technology used to produce the image, and their intended uses as they tell us about the events or things depicted. In some news photographs, we now know that the event shown was in part staged. For example, the British photographer Roger Fenton, who was one of the first cameramen to record a war, moved the cannonballs that litter the blasted landscape in his famous *Valley of the Shadow of Death,* a photograph taken in 1855 during the Crimean War. Does this make a difference when we look at the picture as evidence of how a battleground appeared? Perhaps not. But we should be careful about ever assuming that from photographic evidence we can always draw valid conclusions about the lives of people, the historical meaning of events, and the possible actions that we should take.

Let's look now at a photograph (page 122) by Dorothea Lange, an American photographer who made her reputation with photographs of migrant farmers in California during the Depression that began in 1929. Lange's *Migrant Mother, Nipomo, California* (1936) is probably the best-known image of the period. A student made the following entry in a journal in which he regularly jotted down his thoughts about the material in an art course he was taking. (The student was given no information about the photograph other than its title and date.)

> This woman seems to be thinking. In a way, the picture reminds me of a statue called *The Thinker,* of a seated man who is bent over, with his chin resting on his hand. But I wouldn't say that this photograph is really so much about thinking as it is about other things. I'd say that it is about several other things. First (but not really in any particular order), fear. The children must be afraid, since they have turned to their mother. Second, the picture is about love. The children press against their mother, sure of her love. The mother does not actually show her love—for instance, by kissing them, or even hugging them—but you feel she loves them. Third, the picture is about hopelessness. The mother doesn't seem to be able to offer any comfort. Probably they have very little food; maybe they are homeless. I'd say the picture is also about courage. Although the picture seems to me to show hopelessness, I also think the mother, even though she does not know how she will be able to help her children, shows great strength in her face. She also has a lot of dignity. She hasn't broken down in front of the children; she is going to do her best to get through the day and the next day and the next.

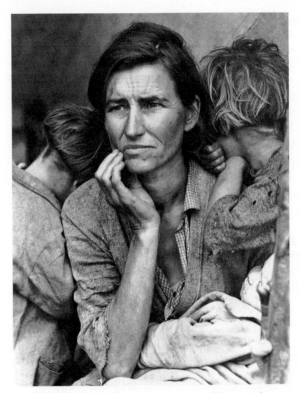

Dorothea Lange, *Migrant Mother, Nipoma, California.* February 1936. Gelatin-silver print, 12 ½" × 9 ⅞". Courtesy of the Library of Congress Prints and Photographs Division.

Another student wrote:

> Is this picture sentimental? I remember from American Lit that good literature is not sentimental. (When we discussed the word, we concluded that "sentimental" meant "sickeningly sweet.") Some people might think that Lange's picture, showing a mother and three little children, is sentimental, but I don't think so. Although the children must be upset, and maybe they even are crying, the mother seems to be very strong. I feel that with a mother like this, the children are in very good hands. She is not "sickeningly sweet." She may be almost overcome with despair, but she doesn't seem to ask us to pity her.

A third student wrote:

> Why does this picture bother me? It's like those pictures of the homeless in the newspapers and on TV. A photographer sees some

man sleeping in a cardboard box, or a woman with shopping bags sitting in a doorway, and he takes their picture. I suppose the photographer could say that he is calling the public's attention to "the plight of the homeless," but I'm not convinced that he's doing anything more than making money by selling photographs. Homeless people have almost no privacy, and then some photographer comes along and invades even their doorways and cardboard houses. Sometimes the people are sleeping, or even if they are awake they may be in so much despair that they don't bother to tell the photographer to get lost. Or they may be mentally ill and don't know what's happening. In the case of this picture, the woman is not asleep, but she seems so preoccupied that she isn't aware of the photographer. Maybe she has just been told there is work for her, or maybe she has been told she can't stay if she keeps the children. Should the photographer have intruded on this woman's sorrow? This picture may be art, but it bothers me.

All of these entries are thoughtful, interesting, and helpful—material that can be the basis of an essay—though, of course, even taken together they do not provide the last word. Far from being a neutral document, this photograph encapsulates Lange's sympathy for displaced migrant workers and her belief that they need government assistance. As comparisons between this justly famous image and other prints Lange took at the same time reveal, only this photograph is symmetrical and contrasts the strained face of the mother with the two bedraggled but anonymous children and the almost hidden baby in her lap. Although the clothing, place, and people are real, in the sense that Lange found them in this condition, she perhaps encouraged this pose, which echoes traditional representations of the Madonna and child. The tow-headed but grimy children become all children; the mother, seeming to look searchingly off to her right while raising her worn hand tentatively to her chin, could be any American mother worried about her family. The most effective social document, as Lange herself would readily admit, is not necessarily the spontaneous snapshot taken without the photographer's intervention in the scene. It is the careful combination of subject matter and composition that grabs our attention and holds it.

Some photographs are more obvious in the ways that they reveal the point of view of the person behind the camera and the manipulation of observed reality. Many of these images are intended to be sold and appreciated as aesthetic documents. In other words, the formal properties of the image—its composition, shades of tone or color, quality of light, use of blurs and grain—become as important as or more important than the depicted subject in inspiring feelings or ideas in the viewer. Edward

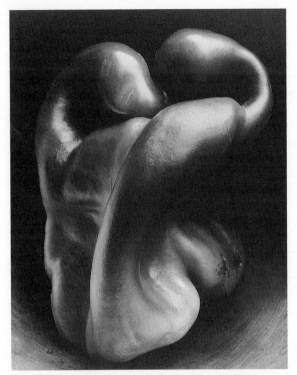

Edward Weston, (American, 1886–1958). *Pepper, 1930.*
Photograph, gelatin silver print. Sheet: 24.1 × 19.2 cm (9 ½ ×
7 ⁹⁄₁₆ in.). Photograph © The Lane Collection. Photograph
courtesy Museum of Fine Arts, Boston. Weston used long time
exposures for his peppers, ranging from six minutes to fifty. In
an entry dated 24 April 1930 he repeated in his journal, which he
called *Daybook,* a statement that he had written for a museum:
"Clouds, torsos, shells, peppers, trees, rocks, smoke stacks, are
but interdependent, interrelated parts of a whole, which is life.
–Life rhythms felt in no matter what, become symbols of the
whole." And on 8 August 1930 he wrote, "It is a classic, com-
pletely satisfying—a pepper—but more than a pepper: abstract,
in that it is completely outside subject matter . . . this new pepper
takes one beyond the world we know in the conscious mind."

Weston's *Pepper #30* (1930), placed against a mysterious black back-
ground and softly lit from the side (see above), makes us think of the ways
that the ever-changing curves and bulges of common vegetables repeat
the sensual, intertwined limbs of the human body. By moving close to the
isolated object and carefully controlling the lighting, Weston assumes an

aesthetic rather than a botanical approach. The picture would not be very successful as an illustration for a book on the various species of peppers and their reproductive structures; it does not present the kind of visual information that we have grown to expect from such illustrations.

In other cases, the distinctions between the artistic photograph and the documentary photograph are less clear from internal evidence. Many nineteenth-century photographs that were originally conceived as records of buildings or machinery have struck recent viewers as beautiful and expressive of a personal vision. The turn-of-the-century French photographer Eugène Atget earned his living selling standard-size prints of eighteenth-century Parisian architecture and rapidly disappearing street vendors to antiquarians, libraries, cartoonists, and illustrators. By the time of Atget's death in 1927, avant-garde artists were struck by the uncanny stillness and radiant light of many of his photographs and began collecting them as the work of a naive genius. As tastes have changed and the intended functions of photographic images have been forgotten or ignored, our understanding of photography has also shifted from the functional or documentary to the aesthetic. In writing about photographs, you should be aware of the ways that the passage of time and the changes in context transform what photographs mean. We do not respond to a framed photograph on the walls of a museum in the same way that we respond to that photograph reproduced in *Life* magazine.

At various points in the history of the medium, photographers have pointedly taken past or contemporary paintings or drawings as models for artistic photographs. They introduced Rembrandtesque lighting into portraits or contrived figure compositions imitating Raphael or Millet. In the late nineteenth century, to distinguish their works from the flood of easily made snapshots of family outings, self-proclaimed art photographers used soft focus and extensive hand manipulation of negatives and prints to make photographs that looked like charcoal drawings. These *pictorialists*, whose goal was to elevate photography to the rank of serious art by imitating the look of that art, were condemned in the early twentieth century by such photographers as Alfred Stieglitz (1864–1946), who argued that the best photographs were those that were honest to the unique properties of camera vision. (There was, however, little recognition that these properties were themselves changing as equipment and processes changed.)

Whereas modern photographers have rarely tried to legitimize their practice by literally copying famous paintings, they have often reintroduced manual manipulations and elaborate staging. A **manipulated photograph** is one in which either the negative or the positive (i.e., the print) has been altered by hand or, more recently, by computer. Negatives may be scratched, drawn on, or pieced together; positive prints may be hand-tinted or have

their emulsions (the coating on the paper that contains the light-sensitive material) smeared with a brush. Computer-aided processes are now often used to manipulate images. For instance, images from old magazines can be put into digital form and combined and colorized on a computer, allowing the artist, in David Hockney's words, "to work on photographs the way a draftsman might" (*Aperture*, 1992). Yasumasa Morimura, one of the most ingenious makers of manipulated pictures, uses computer technology to create composite photographs of famous paintings with images of himself—usually costumed in the appropriate period or semi-nude. Thus, for his *Portrait (Nine Faces)*, he used a computer to blend parts of his own face into the nine faces (including the face of the corpse) of Rembrandt's *The Anatomy Lesson*. A **fabricated photograph** is one in which the subject has been constructed or staged to be photographed. In a certain sense, all still lifes are fabricated photographs. More recently, photographers coming out of art school backgrounds have choreographed events or crafted environments to challenge our belief in photographic truth or question conventions of representation. For example, Thomas Demand constructs elaborate, three-dimensional models based on photographs of actual historical places, such as the Oval Office in the White House (2008), solely for the purpose of photographing them. Or consider the work of Gregory Crewdson: he works like a movie producer with a crew of lighting and stage technicians to construct elaborate scenarios whose uncanny effects and carefully choreographed actors invoke mystery. Such scenes are photographed multiple times using largeformat film cameras; selected color negatives are then digitally scanned, manipulated, and combined to constitute a single finished print.

Digital photography, in which light strikes an image sensor called a charge-coupled device (CCD) and is translated into a series of electronic signals, has now become the dominant mode of commercial photography and is rapidly replacing film (or "wet") photography for artists as well. Digital files can be easily manipulated using computer software such as Photoshop and printed with colored inks on various sizes of paper and other materials. There is no negative involved in digital prints and no way to prove that an image (or part of an image) was shot from life rather than made in the computer. Inkjet prints are also fugitive, and stored image files may degrade through time or become unreadable thanks to the planned obsolescence of software and hardware.

Although many people fear that digital photography undermines the very definition of the photograph as a permanent record of reality, all photographs, as we have seen, differ from human perceptions of the world. What the digital revolution has initiated, however, is an explosion in amateur photographic printing and virtually costless shooting, where errors can be deleted with the push of a button. With greater experimentation in the

manufacture of digital cameras, which initially borrowed their formatting and vocabulary from film cameras ("contrast," "portrait format," "white balance"), we can expect the next generation of digital photographic artists to explore new modes of vision as far removed from film photography as film was from drawing.

When we turn to analyze a photograph, many of the questions on drawing and painting—for example, those on composition and color—also apply. But because of the different ways that photographs are produced, their peculiar relationship to the physical world as it existed at some point in the past, and their multiple functions, we need to expand our questions to reflect these special concerns.

Our first concern in analyzing a photograph is **identification of the work** (much of this information is often provided by a wall label or photo caption). Who took the photograph? Was it an individual or a photographic firm (usually identified on the negative or in a stamp or label)? Was the positive print produced by the same individual (or firm) who exposed the negative? If the photographer is unknown, can the photograph be assigned to a country or region of production?

What is the **title** of the work? Was the photograph given a title by its creator(s) in the form of an inscription on the negative or positive? Or was the title added by later viewers? What does the title tell you about the intended function of the photograph? Did the photographer identify the **date** of the work? When was the exposure made? When was the positive print made?

What type of **photographic process** was used to produce the negative? The positive? On what sort of paper was the positive printed? Are these processes typical for the period? Why do you think the photographer chose these particular processes?

Analysis of a photographic work also involves looking at its **physical properties.** What are the dimensions of the photograph? Are these typical for the techniques chosen? What effect does the **size** of the work have on the viewer's analysis of it? Is the photograph printed on paper or on some other type of material, such as metal or silk? If the image is on paper, is the paper matte, glossy, or somewhere in between? What is the color of the print? Has it been hand-tinted or retouched? How do the physical properties of the print influence the viewer's reaction? Is the print damaged, torn, abraded, faded? Has the paper been trimmed or cropped? If the image is on metal, has there been corrosion, tarnishing, or other damage that alters your appreciation of the image? Are there signs in the print of damage to the negative?

Briefly describe the **subject** of the photograph. Is it a traditional subject—a landscape, a still life, a portrait, a genre, an allegorical or

historical scene, or a documentary? Do the figures or objects in the picture seem arranged by the photographer or caught "as they were"? Are props included? To what extent did the photographer fabricate or create the image by physically constructing, arranging, or interacting with some or all of its components? How does this affect the viewer's response?

In addition, the many **formal properties** of a photograph are relevant to an analysis. If the work is considered as a **two-dimensional** composition, how is the subject represented? Which are the most important forms and where are they located on the picture's plane? Is the composition balanced or unbalanced? How does your eye read the photograph? What did the photographer leave out of the frame? What happens along the edges of the photograph? How obvious and important is the two-dimensional composition?

If the work is considered as a **three-dimensional** composition, where is the main activity taking place—in the foreground, the midground, the background, or a combination of these areas? How did the photographer define (or not define) the three-dimensional space? How can you describe the space—as shallow or deep, static or dynamic, claustrophobic or open, rational or irrational? How important is the three-dimensional composition?

Look for the photographer's choice of **vantage point** and **angle of vision.** How near or far does the main subject appear? Does the photograph draw the viewer's attention to where the photographer was located? How does the position from which the picture was taken contribute to the mood or content of the image? What is the angle of vision? How does it compare with "normal" vision? Is there lens distortion? Why do you think the photographer chose the lens he or she did?

Examine the **detail** and **focus** of the work. Can you characterize the overall focus? Where are the areas of sharp focus? Soft focus? What is the **depth of field** (i.e., the minimum and maximum distances from the camera that are in sharp focus)? How did the photographer use focus to convey meaning? Is the image detailed or grainy? How does the detail or grain contribute to or detract from the image?

What sort of **lighting** was used? Was the photograph taken out-of-doors or inside, in natural or artificial light (or in some combination of the two)? How did the season or time of day affect the lighting conditions? Where is the main light source? The secondary light source? Was a flash used? How can you characterize the lighting—as harsh, subtle, flat, dramatic, magical, or what? What effects do you think the photographer was trying to achieve through the use or control of light?

Consider also **contrast** and **tonal range.** Within the black-and-white print, what is the range of light and dark? Where are the darkest and lightest areas? Does the print have high contrast, with large differences in tone

from light to dark, or does it have low contrast, with many shades of gray? What overall effect do contrast and tone create?

What **exposure time** did the photographer choose? How does the length of the exposure influence the image? Do any blurs or midaction motions signal the passage of time? How does the length of the exposure add or detract from the image?

Taking into consideration the preceding points, what do you think the photographer was trying to say in this image? What aspects of the subject did the photographer want to accentuate? What was the photographer's attitude toward the subject? What does the photograph convey to you today—about a place, a time, a person, an event, or a culture?

Video Art

Video art originated in 1965, when Nam June Paik (musician, sculptor, filmmaker) used the Sony Portapak, the first portable videotape system, to record from a taxi the visit of Pope Paul VI to New York. He then showed the tapes at a New York café frequented by artists. The announcement for the screening said, "Some day artists will work with capacitors, resistors, and conductors just as they work today with brushes, violins, and junk." Video art is a medium, like oil painting or photography, not a style; the color can be intense or washed out, the images can move or be still, the recorded material can be spontaneous (as in television news coverage) or highly scripted (as in a sitcom), the work can celebrate popular culture or it can be critical of it. It uses the technology of commercial television but for purposes regarded as artistic rather than commercial. Some examples were mentioned on page 2 of this book, notably Mona Hartoum's *Corps Etranger,* a video in which Hartoum passes a fiber-optic video camera through her bodily orifices.

The monitor showing the tape may itself be part of a larger work, in which case the whole can be considered a sculpture. Thus, Paik's *Electronic Superhighway* (1995), 15 feet tall and 32 feet long, uses neon to represent a map of the United States, and within what might almost be called a neon drawing are set dozens of television monitors and laser disk images. Two other works by Paik: In *TV Buddha* (1982) the monitor records the live camera's image of the motionless stone head of a Buddha who appears to be contemplating his own image on the monitor; in *Video Fish* (1975), five tanks with live fish are in front of five monitors with video tapes of swimming fish. Thus, the tanks seem to be monitors and the monitors seem to be tanks, and the whole (like *TV Buddha*) stimulates the viewer to meditate on relationships between reality and representation and, indeed, to meditate on the relationships between meditation and technology.

In writing about video art, consider

- the visual impact (e.g., the work as sculpture)
- the use of sound (music, talk, or noise usually is part of the work)
- the context (Is the work shown in a museum—and if so, in one of the galleries or in the cafeteria—or on the street? If the work is shown on a screen in your home, how does this context relate to the video?)
- the political implications (much video art satirizes bourgeois interests)
- the connections with earlier art history (e.g., with documentary film, or with surrealism)

For statements by video artists, see *Video Art: An Anthology,* edited by Ira Schneider and Beryl Korot (1976). For an exhibition catalog with images and useful essays, see *Video Art* (1975; no editor, but essays by David Antin and others). See also Doug Hall and Sally Jo Fifer, eds., *Illuminating Video* (1990), and Michael Rush, *Video Art* (2003).

Another Look at the Questions

As the preceding discussion of various kinds of art has shown, there are many ways of helping yourself to see. In short, you can stimulate responses (and understanding) by asking yourself two basic questions:

- *What is this doing?* Why is this figure here and not there? Why is the work in bronze rather than in marble? Or put it this way: What is the artist up to?
- *Why do I have this response?* Why do I find this landscape oppressive but that landscape inviting, this child sentimental but that child fascinating? That is, how did the artist manipulate the materials in order to produce the strong feelings that I experience?

The first of these questions (*What is this doing?*) requires you to identify yourself with the artist, wondering, perhaps, why the artist chose one medium over another, whether pen is better than pencil for this drawing, or watercolor better than oil paint for this painting.

Sometimes artists tell us what they are up to. Van Gogh, for example, in a letter (11 August 1888) to his brother, helps us to understand why he put a blue background behind the portrait of a blond artist: "Behind the head instead of painting the ordinary wall of the mean room, I paint infinity, a plain background of the richest, intensest blue that I can contrive, and by the simple combination of the bright head against the rich blue background, I get a mysterious effect, like a star in the depths of an azure

sky." But remember, you cannot assume that the artist's stated intention has been fulfilled in the work itself.

The second question (*Why do I have this response?*) requires you to trust your feelings. If you are amused or repelled or unnerved or soothed, assume that your response is appropriate and follow it up—but not so rigidly that you exclude the possibility of other, even contradictory feelings. (The important complement to "Trust your feelings" is "Trust the work of art." The study of art ought to enlarge feelings, not merely confirm them.)

Almost any art history book that you come across will attempt to answer questions posed by the author. For example, in the introduction to *American Genre Painting: The Politics of Everyday Life* (1991), Elizabeth Johns writes:

> Two simple questions underscore my diagnosis: "Just whose 'everyday life'
> is depicted?" and "What is the relationship of the actors in this 'everyday
> life' to the viewers?"

The book contains her answers.

Indeed, as we saw when we quoted Evelyn Welch on page 78, art historians typically ask the questions "How?" "What?" "Why?" and "Who?"—and offer answers.

✍️ A RULE FOR WRITERS:

Generate ideas by asking yourself questions—and in this process do not hesitate to go back over the same ground. Good writing depends on good thinking, and good thinking keeps reexamining its conclusions.

5

WRITING A COMPARISON

If you really want to see something, look at something else.

—Howard Nemerov

Everything is what it is and not another thing.

—Bishop Joseph Butler

COMPARING AS A WAY OF DISCOVERING

Analysis frequently involves comparing: Things are examined for their resemblances to and for their differences from other things. Strictly speaking, if one emphasizes the differences rather than the similarities, one is contrasting rather than comparing, but we need not preserve this distinction; we can call both processes *comparing*.

Although your instructor may ask you to write a comparison of two works of art, the *subject* of the essay is the *works*, or, more precisely, the subject is the thesis you are advancing—for example, that one work is later than the other or is more successful. Comparison is simply an effective, analytical *way* to show some of the qualities of the works. We usually can get a clearer idea of what X is when we compare it to Y—provided that Y is at least somewhat like X. Comparing, in short, is a way of discovering, a way of learning, and ultimately a way of helping your reader to see things your way.

In the words of Howard Nemerov, quoted at the top of this page, "If you really want to see something, look at something else." But the "something else" can't be any old thing. It has to be relevant. For example, in a course in architecture you may compare two subway stations (considering the efficiency of the pedestrian patterns, the amenities, and the aesthetic qualities), with the result that you may come to understand both of them more fully; but a comparison of a subway station with a dormitory, no matter how elegantly written, can hardly teach the reader or the writer anything. Similarly, a Pop artist such as Andy Warhol and an Abstract Expressionist such as Jackson Pollock are so different that a comparison can hardly illuminate either. It probably would be like comparing a horse and a bird: Horses have four feet, whereas birds have two. If you keep in mind the principle that a comparison should help you and your reader to

132

learn, you will not (unless you are kidding around) make useless comparisons, such as "What do Winnie the Pooh and Alexander the Great have in common?" "Same middle name."

Art historians almost always use comparisons when they discuss authenticity: A work of uncertain attribution is compared with undoubtedly genuine works on the assumption that an inauthentic work, when closely compared with genuine works, will somehow be markedly different, perhaps in brush technique, and thereby shown probably not to be genuine (here we get to the thesis) despite superficial similarities of, say, subject matter and medium. (This assumption, though widely held, can be challenged: A given artist may have produced a work with unique characteristics.)

Comparisons are also commonly used in dating a work, and thus in tracing the history of an artistic movement or the development of an artist's career. The assumption here is that certain qualities in a work indicate the period, the school, perhaps the artist, and even the period within the artist's career. Let's assume, for instance, that there is no doubt about who painted a particular picture and that the problem is the date of the work. By comparing this work with a picture that the artist is known to have done, say, in 1850, and with yet another that the artist is known to have done in 1870, one may be able to conjecture that the undated picture was done, say, midway between the dated works, or that it is close in time to one or the other.

The assumptions underlying the uses of comparison are that an expert can recognize not only the stylistic characteristics of an artist but can also identify those that are permanent and can establish the chronology of those that are temporary. In practice these assumptions are usually based on yet another assumption: A given artist's early works are relatively immature; the artist then matures, and if there are some dated works, we can with some precision trace this development or evolution. Whatever the merits of these assumptions, comparison is a tool by which students of art often seek to establish authenticity and chronology. Again, the comparison is not made for the sake of writing a comparison; rather, it is made for the sake of making a point.

TWO WAYS OF ORGANIZING A COMPARISON

We can call the two ways of organizing a comparison *block-by-block* (or, less elegantly but perhaps more memorably, *lumping*) and *point-by-point* (or *splitting*). When you compare block-by-block, you say what you have to say about one artwork in a block or lump, and then you go on to discuss

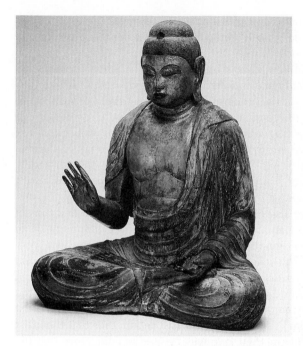

Shaka nyorai, The Historical Buddha. Sakyamuni Buddha. Japanese, late Heian period, late 10th-early 11th century. Cherry with polychrome and gold; single woodblock construction, 83 cm (32 ¹¹⁄₁₆ in.) (height of figure). Museum of Fine Arts, Boston. Denman Waldo Ross Collection, 09.72. Photograph © 2013 Museum of Fine Arts, Boston.

the second artwork, in another block or lump. When you compare point-by-point, however, you split up your discussion of each work, more or less interweaving your comments on the two things being compared, perhaps in alternating paragraphs, or even in alternating sentences.

Here is a miniature essay—it consists of only one paragraph—that illustrates lumping. The writer compares a Japanese statue of a Buddha with a Chinese statue of a bodhisattva (page 135). (A Buddha has achieved enlightenment and has withdrawn from the world. A bodhisattva—in Sanskrit the term means "enlightened being"—is, like a Buddha, a person of very great spiritual enlightenment, but unlike a Buddha, a bodhisattva chooses to remain in this world in order to save humankind.) The writer's point here is simply to inform the museum-goer that all early East Asian religious images are not images of the Buddha. The writer says what she has to say about the Buddha, all in one lump, and then in another lump says what she has to say about the bodhisattva.

> The Buddha, recognizable by a cranial bump that indicates a sort of supermind, sits erect and austere in the lotus position (legs crossed, each foot with the sole upward on the opposing thigh), in full control

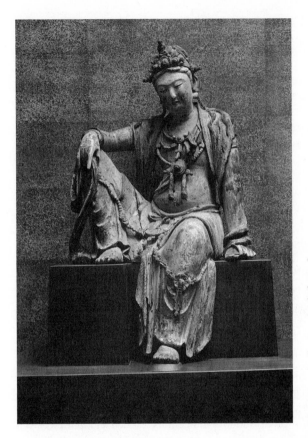

Guanyin, Chinese, Song Dynasty, 12th century. Wood with traces of polychrome and gilt. Overall: 141 × 88 × 88 cm (55 ½ × 34 ⅝ × 34 ⅝ in.). Museum of Fine Arts, Boston. Gift of Hervey E. Wetzel, 20.590. Photograph © 2013 Museum of Fine Arts, Boston.

of his body. The carved folds of his garments, in keeping with the erect posture, are severe, forming a highly disciplined pattern that is an outward expression of his remote, constrained, austere inner nature. The bodhisattva, on the other hand, sits in a languid, sensuous posture known as "royal ease," the head pensively tilted downward, one knee elevated, one leg hanging down. He is accessible, relaxed, and compassionate.

The structure is, simply, this:

The Buddha (posture, folds of garments, inner nature)

The bodhisattva (posture, folds of garments, inner nature)

If, however, the writer had wished to split rather than to lump, she would have compared an aspect of the Buddha with an aspect of the bodhisattva, then another aspect of the Buddha with another aspect of

the bodhisattva, and so on, perhaps ending with a synthesis to clarify the point of the comparison. The paragraph might have read like this:

> The Buddha, recognizable by a cranial bump that indicates a sort of supermind, sits erect and austere, in the lotus position (legs crossed, each foot with the sole upward on the opposing thigh), in full control of his body. In contrast, the bodhisattva sits in a languid, sensuous posture known as "royal ease," the head pensively tilted downward, one knee elevated, one leg hanging down. The carved folds of the Buddha's garments, in keeping with his erect posture, are severe, forming a highly disciplined pattern, whereas the bodhisattva's garments hang naturalistically. Both figures are spiritual, but the Buddha is remote, constrained, and austere; the bodhisattva is accessible, relaxed, and compassionate.

In effect the structure is this:

The Buddha (posture)

The bodhisattva (posture)

The Buddha (garments)

The bodhisattva (garments)

The Buddha and the bodhisattva (synthesis)

When you offer an extended comparison, it is advisable to begin by indicating your focus, that is, by defining the main issue or problem—for instance, the kind of ivory, the subject matter, the treatment of space, and the style of the carving suggest that *this* piece is fourteenth-century French and *that* piece is a modern fake—and also by indicating what your principle of organization will be.

Caution: Splitting is well suited to short essays, say from one to three paragraphs, or for occasional use within longer essays, but if it is relentlessly used as the organizing principle of a longer essay, it is likely to produce a ping-pong effect. The essay may not come into focus—the reader may not grasp the point—until the writer stands back from the seven-layer cake and announces, in the concluding paragraph, that the odd layers taste better. In your preparatory thinking, splitting probably will help you to get certain characteristics clear in your mind, but you must come to some conclusions about what these add up to before writing the final version. The final version should not duplicate the preliminary thought processes; rather, since the point of a comparison is to make a point, it should be organized so as to make the point clearly and effectively.

Lumping, especially if the essay is not longer than two or three paragraphs, will often do the trick. After reflection you may decide that although there are superficial similarities between X and Y, there are essential differences; in the

finished essay, then, you probably will not wish to obscure the main point by jumping back and forth from one work to the other, working through a series of similarities and differences. It may be better to announce your thesis, then discuss *X*, and then *Y*.

Whether in any given piece of writing you should compare by lumping or by splitting will depend largely on your purpose and on the complexity of the material. Lumping is usually preferable for long, complex comparisons, if for no other reason than to avoid the Ping-Pong effect, but no hard-and-fast rule covers all cases here. Some advice, however, may be useful:

If you split, in rereading your draft:

- *Ask yourself if your imagined reader can keep up with the back-and-forth movement.* Make sure (perhaps by a summary sentence at the end) that the larger picture is not obscured by the zigzagging.
- *Don't leave any loose ends.* Make sure that if you call attention to points 1, 2, and 3 in *X*, you mention all of them (not just 1 and 2) in *Y*.

If you lump, do not simply comment first on *X* and then on *Y*.

- *Let your reader know where you are going,* probably by means of an introductory sentence.
- *Don't be afraid in the second half to remind the reader of the first half.* It is legitimate, even desirable, to connect the second half of the comparison (chiefly concerned with *Y*) to the first half (chiefly concerned with *X*). Thus, you will probably say things like "Unlike *X*, *Y* shows. . ." or "Although *Y* superficially resembles *X* in such-and-such, when looked at closely *Y* shows. . . ." In short, a comparison organized by lumping will not break into two separate halves if the second half develops by reminding the reader how it differs from the first half.

✍ A RULE FOR WRITERS:

When you write a comparison you are not merely making two lists. Rather, you are making a point, arguing a thesis. Indeed, it is almost always a good strategy to introduce the comparison with a thesis sentence, a sentence that states the *point*.

Again, the point of a comparison is to call attention to the unique features of something by holding it up against something similar but significantly different. If the differences are great and apparent, a comparison is a waste of effort. (Blueberries are different from elephants. Blueberries do

not have trunks. And elephants do not grow on bushes.) Indeed, a comparison between essentially and obviously unlike things will merely confuse, for by making the comparison, the writer implies that there are significant similarities, and readers can only wonder why they do not see them. The essays that do break into unrelated halves are essays that have no focus and that make uninstructive comparisons: The first half tells the reader about five qualities in El Greco; the second half tells the reader about five different qualities in Rembrandt. You will notice in the following student essay that the second half occasionally looks back to the first half.

SAMPLE ESSAY: A STUDENT'S COMPARISON

This essay, by an undergraduate, discusses one object and then discusses a second. It lumps rather than splits. It does not break into two separate parts because at the start it looks forward to the second object, and in the second half of the essay it occasionally reminds us of the first object.

 When you read this essay, don't let its excellence lead you into thinking that you can't do as well. The essay, keep in mind, is the product of much writing and rewriting. As Rebecca Bedell wrote, her ideas got better and better, for in her drafts she sometimes put down a point and then realized that it needed strengthening (e.g., with concrete details) or that—come to think of it—the point was wrong and ought to be deleted. She also derived some minor assistance—for facts, not for her fundamental thinking—from books, which she cites in footnotes.

 Brief marginal annotations have been added to the following essay in order to help you appreciate the writer's skill in presenting her ideas.°

<div align="right">Rebecca Bedell</div>

<div align="right">FA 232 American Art</div>

Title is focused and, in "Development," implies the thesis	John Singleton Copley's Early Development: From *Mrs. Joseph Mann* to *Mrs. Ezekial Goldthwait*
Opening paragraph is unusually personal but engaging, and it implies the problem the writer will address	Several Sundays ago while I was wandering through the American painting section of the Museum of Fine Arts, a professorial bellow shook me. Around the corner strode a well-dressed mustachioed member of the art historical elite, a gaggle of note-taking students

°Rebecca Bedell, John Singleton Copley's Early Development: From *Mrs. Joseph Mann to Mrs. Ezekial Goldthwait*. Copyright 1981 by Rebecca Bedell. Used by permission of the author.

following in his wake. "And here," he said, "we have John Singleton Copley." He marshaled his group about the rotunda, explaining that, "as one can easily see from these paintings, Copley never really learned to paint until he went to England."

A walk around the rotunda together with a quick leafing through a catalog of Copley's work should convince any viewer that Copley reached his artistic maturity years before he left for England in 1774. A comparison of two paintings at the Museum of Fine Arts, *Mrs. Joseph Mann* of 1753 (Figure 1) and *Mrs. Ezekial Goldthwait* of ca. 1771 (Figure 2), reveals that Copley had made huge advances in his style and technique even before he left America; by the time of his departure he was already a great portraitist. Both paintings are half-length portraits of seated women, and both are accompanied by paired portraits of their husbands.

Thesis is clearly announced

The portrait of Mrs. Joseph Mann, the twenty-two-year-old wife of a tavern keeper in Wrentham, Massachusetts,[1] is signed and dated "J. S. Copley 1753." One of Copley's earliest known works, painted when he was only fifteen years old, it depicts a robust young woman staring candidly at the viewer. Seated outdoors in front of a rock outcropping, she rests her left elbow on a classical pedestal and she dangles a string of pearls from her left hand.

Brief description of the first work

The painting suffers from being tied too closely to its mezzotint prototype. The composition is an almost exact mirror image of that used in Isaac Beckett's

Relation of the painting to its source

[1]Jules David Prown, *John Singleton Copley* (Cambridge: Harvard University Press, 1966), I: 110.

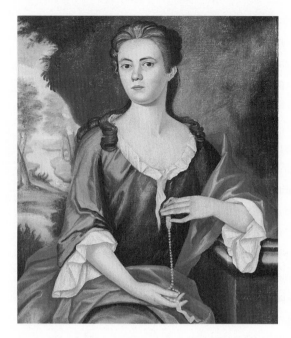

Figure 1. John Singleton Copley, American, 1738–1815. *Mrs. Joseph Mann (Bethia Torrey)*, 1753. Oil on canvas, 91.44 × 71.75 cm. (36 × 28 ¼ in.). Museum of Fine Arts, Boston. Gift of Frederick H. Metcalf and Holbrook E. Metcalf, 43.1353. Photograph © 2013 Museum of Fine Arts, Boston.

Figure 2. John Singleton Copley, American, 1738–1815. *Mrs. Ezekiel Goldthwait (Elizabeth Lewis)*, 1771. Oil on canvas, 127.32 × 101.92 cm (50 ⅛ × 40 ⅛ in.). Museum of Fine Arts, Boston. Bequest of John T. Bowen in memory of Eliza M. Bowen, 41.84. Photograph © 2013 Museum of Fine Arts, Boston.

mezzotint after William Wissing's *Princess Anne* of ca. 1683.[2] Pose, props, and background are all lifted directly from the print. Certain changes, however, were necessary to acclimatize the image to its new American setting. Princess Anne is shown provocatively posed in a landscape setting. Her blouse slips from her shoulders to reveal an enticing amount of bare bosom. Her hair curls lasciviously over her shoulders and a pearl necklace slides suggestively through her fingers as though, having removed the pearls, she will proceed further to disrobe. But Copley reduces the sensual overtones. Mrs. Mann's bodice is decorously raised to ensure sufficient coverage, and the alluring gaze of the princess is replaced by a cool stare. However, the suggestive pearls remain intact, producing an oddly discordant note.

First sentence of paragraph is both a transition and a topic sentence: the weakness of the painting

The picture has other problems as well. The young Copley obviously had not yet learned to handle his medium. The brush strokes are long and streaky. The shadows around the nose are a repellent greenish purple, and the highlight on the bridge was placed too far to one side. The highlights in the hair were applied while the underlying brown layer was still wet so that instead of gleaming curls he produced dull gray smudges. In addition, textural differentiation is noticeably lacking. The texture of the rock is the same as the skin, which is the same as the satin and the grass and the pearls. The anatomy is laughable: There is no sense of underlying structure. The arms and neck are the inflated tubes so typical of provincial portraiture. The left

Concrete details support the paragraph's opening assertion

[2]Charles Coleman Sellers, "Mezzotint Prototypes of Colonial Portraiture: A Survey Based on the Research of Waldon Phoenix Belknap, Jr.," *Art Quarterly* 20 (1957): 407–68. See especially plate 16.

earlobe is missing, and the little finger on the left hand is disturbingly disjointed. Light too appears to have given Copley trouble. It seems, in general, to fall from the upper left, but the shadows are not consistently applied. And the light-dark contrasts are rather too sharp, probably due to an overreliance on the mezzotint source.

Transition ("Despite its faults") and statement of idea that unifies the paragraph

Despite its faults, however, the painting still represents a remarkable achievement for a boy of fifteen. In the crisp linearity of the design, the sense of weight and bulk of the figure, the hint of a psychological presence, and especially in the rich vibrant color, Copley has already rivaled and even surpassed the colonial painters of the previous generation.

Transition ("about seventeen years later") and reassertion of central thesis

In *Mrs. Ezekial Goldthwait,* about seventeen years later and about four years before Copley went to England, all the early ineptness had disappeared. Copley has arrived at a style that is both uniquely his own and uniquely American; and in this style he achieves a level of quality comparable to any of his English contemporaries.

Brief description of the second picture

The substantial form of Mrs. Goldthwait dominates the canvas. She is seated at a round tilt-top table, one hand extended over a tempting plate of apples, oranges, and pears. A huge column rises in the right-hand corner to fill the void.

Biography and (in rest of paragraph) its relevance to the work

The fifty-seven-year-old Mrs. Goldthwait, wife of a wealthy Boston merchant, was the mother of fourteen children; she was also a gardener noted for her elaborate plantings.[3] Copley uses this fertility theme as a unifying element in his composition. All the forms are plump and heavy, like Mrs. Goldthwait herself.

[3]Prown, 76.

The ripe, succulent fruit, the heavy, rotund mass of the column, the round top of the table—all are suggestive of the fecundity of the sitter.

The most obvious characteristic of the work

The painting is also marked by a painstaking realism. Each detail has been carefully and accurately rendered, from the wart on her forehead to the wood grain of the tabletop to the lustrous gleam of the pearl necklace. As a painter of fabrics Copley surpasses all his contemporaries. The sheen of the satin, the rough, crinkly surface of the black lace, the smooth, translucent material of the cuffs—all are exquisitely rendered.

"But" is transitional, taking us from the obvious (clothing) to the less obvious (character)

But the figure is more than a mannequin modeling a delicious dress. She has weight and bulk, which make her physical presence undeniable. Her face radiates intelligence, and her open, friendly personality is suggested by the slight smile at the corner of her lips and by her warm, candid gaze.

Brief reminder of the first work, to clarify our understanding of the second work

The rubbery limbs of Copley's early period have been replaced by a more carefully studied anatomy (not completely convincing, but still a remarkable achievement given that he was unable to dissect or to draw from nude models). There is some sense for the underlying armature of bone and muscle, especially in the forehead and hands. And in her right hand it is even possible to see the veins running under her skin.

Further comparison, again with emphasis on the second work

Light is also treated with far greater sophistication. The chiaroscuro is so strong and rich that it calls to mind Caravaggio's *tenebroso*. The light falls almost like a spotlight onto the face of Mrs. Goldthwait, drawing her forward from the deep shadows of the background, thereby enhancing the sense of a psychological presence.

Reassertion of the thesis, supported by concrete details

Copley's early promise as a colorist is fulfilled in mature works such as *Mrs. Goldthwait*. The rich, warm

red-brown tones of the satin, the wood, and the column dominate the composition. But the painting is enlivened by a splash of color on either side—on the left by Copley's favorite aqua in the brocade of the chair, and on the right by the red and green punctuation marks of the fruit. The bright white of the cap, set off against the black background, draws attention to the face, while the white of the sleeves performs the same function for the hands.

Summary, but not mere rehash; new details

Color, light, form, and line all work together to produce a pleasing composition. It is pleasing, above all, for the qualities that distinguish it from contemporary English works: for its insistence on fidelity to fact, for its forthright realism, for the lovingly delineated textures, for the crisp clarity of every line, for Mrs. Goldthwait's charming wart and her friendly double chin, for the very materialism that marks this painting as emerging from our pragmatic mercantile society. In these attributes lie the greatness of the American Copleys.

Further summary, again heightening the thesis

Not that I want to say that Copley never produced a decent painting once he arrived in England. He did. But what distinguishes the best of his English works (see, for example *Mrs. John Montressor* and *Mrs. Daniel Denison Rogers*)[4] is not the facile, flowery brushwork or the fluttery drapery (which he picked up from current English practice) but the very qualities that also mark the best of his American works—the realism, the sense of personality, the almost touchable textures of the fabrics, and the direct way in which the sitter's gaze engages the viewer. Copley was a fine, competent painter in England, but it was not the trip to England that made him great.

[4]Prown, plates.

[NEW PAGE]

Works Cited

Prown, Jules David. *John Singleton Copley*. 2 vols. Cambridge: Harvard University Press, 1966.

Sellers, Charles Coleman. "Mezzotint Prototypes of Colonial Portraiture: A Survey Based on the Research of Waldon Phoenix Belknap, Jr." *Art Quarterly* 20 (1957): 407–68.

✔ Checklist for Writing a Comparison

Have I asked myself the following questions?

❏ Is the *point* of the comparison clear? (Examples: to show that although X and Y superficially resemble each other, they are significantly different; or, to show that X is better than Y; or, to illuminate X by briefly comparing it to Y.) Phrases like "Despite these differences" and "A less conspicuous but still significant resemblance" are signs that critical thinking is at work, that a point is being made.

❏ Are all significant similarities and differences covered?

❏ Is the organization clear? If the chief organizational device is lumping, does the second half of the essay connect closely enough with the first so that the essay does not divide into two essays? If the chief organizational device is splitting, does the essay avoid the Ping-Pong effect? Given the topic and the thesis, is it the best organization?

❏ If a value judgment is offered, is it supported by evidence?

6

WRITING AN ENTRY IN AN EXHIBITION CATALOG

> I do not know any reading more easy, more fascinating, more delightful
> than a catalogue.
>
> —Anatole France

KEEPING THE READER IN MIND

Today most exhibition catalogs—catalogs that accompany exhibitions
aimed at the general public are written by specialists who ought to speak
both to their colleagues and to a more general public. An exhibition cat-
alog is not a catalogue raisonné (from the French, literally "reasoned
catalog"), which is a catalog aimed at specialists. A catalogue raisonné is
not based on an exhibition; rather, it seeks to give all the relevant factual
information about every work by an artist or every work in a particular
medium by an artist. Thus, in addition to commenting on each work, a
catalogue raisonné seeks to record every known owner and every exhibi-
tion in which the work appeared. A catalogue raisonné is aimed at art
historians, dealers, and collectors, but an exhibition catalog is aimed at a
larger audience, the museum-going public.

The author of an exhibition catalog, therefore, should present the lat-
est scholarship *in a reader-friendly way*, and indeed some authors—usually
curators or academicians—succeed admirably. But many authors of exhibi-
tion catalogs fail to engage the general public, often for a simple reason:
They write for themselves or for their colleagues, and they do not bother,
when they draft or revise, to envision any other audience.

How else can one account for the fact that—to take a fairly recent example,
in a handsome catalog called *Art of the First Cities: The Third Millennium BC
from the Mediterranean to the Indus* (2003)—one reads (page 281) that a "pin
with flanged head" was found along with "a silver pin with pyriform head"?
You don't know what "pyriform" means? (You might guess that it is related to
"pyre" and "pyromaniac" and, therefore, means "flame-shaped," but this guess
would be mistaken.) In this same catalog—filled with excellent illustrations of

wonderful objects—you will also find that #63 in the exhibition is described (page 114) as a "Cosmetic box lid inlaid with a lion attacking a caprid." Readers with a bit of Latin can guess that a caprid is some sort of goat—a goat is the sign of Capricorn—but that will only be a guess because "caprid" is not defined in any of the standard college dictionaries. In reading catalogs one routinely finds words like "caprid," "felly" (the rim of a wheel), and "protome" (a bust), words unknown to many highly educated people, and indeed "protome," like "caprid," is not defined in any of the chief college dictionaries.

It would be inaccurate to say that the persons who wrote entries with these words were trying to impress their readers, because the authors almost surely were not thinking about an audience when they wrote. When queried, a few authors of comparable entries huffily said that they would not dumb-down their writing. Yet why these authors think they are dumbing-down their writing if they say "pear-shaped"—that's what pyriform means—instead of "pyriform," or "rim of a wheel" instead of "felly" is a mystery.

That these writers have not bothered to think about writing for a nonspecialized audience is puzzling, but the further mystery is this: Why do they use such language when writing for themselves? The profession of art history necessarily has developed specialized terms, for instance, "baroque" and "perspective," and these terms must be used in some discussions, just as "shortstop" and "double play" must be used in talking about baseball, but what possible realm of discussion requires "pyriform" instead of "pear-shaped"?

✍ A RULE FOR WRITERS:

In drafting and writing a catalog entry—as in all of your other writing—use technical terms only when necessary, and, since a catalog is usually designed for the general reader, make sure that you define the terms clearly.

Entries in catalogs vary greatly in length—some entries may be only a few sentences, while others may run two or three pages. The heading of an entry usually includes the following material:

- artist's name and dates if known, for instance:

 Greek (fifth century BC)
 Jackson Pollock (American, 1912–56)

- title of the work or, for untitled works, a brief description:

 The Last Supper
 Plaque with Lion-Headed Eagle

- material:

 bronze
 oil on canvas

- dimensions, height preceding length (width), usually given in inches and often also in centimeters, in one of two forms:

 H. 1 3/8 in. (4.2 cm.); W. 2 1/8 in. (5.4 cm)
 1 3/8 × 2 1/8 in. (4.2 × 5.4 cm)

- condition:

 Left forearm restored

- owner (and sometimes provenance, i.e., list of previous owners, beginning with the first known owner and ending with the last); if you are writing an entry as an exercise, your instructor probably will expect only that you give the name of the current owner, as in the second of these two examples:

 S. Yabumoto; Matthias Komor; Emily Andrews; Museum of Fine
 Arts, Boston
 Museum of Fine Arts, Boston

- exhibitions, if the catalog aims at completeness (again, your instructor probably will not expect such a list):

 Fogg Museum 1996; Detroit Institute of Arts, 1997; Brooklyn
 Museum, 2009

- bibliographical material, that is, references to relevant publications. Usually this information is given in the form of a brief reference to a work that is fully cited in the bibliography at the rear of the catalog. Sometimes in the catalog entry the citation is introduced by the word "literature"; if there are two or more works by the author, the date of the appropriate work is given:

 Literature: Jackson 2011

Headings with material of this sort are fairly standard from one catalog to another, but when it comes to the discussion that constitutes the body of the entry, there are enormous differences. For instance, a catalog dealing with material from the ancient world or the medieval world will probably contain a larger number of technical words—words that need to be briefly explained—than a catalog of American folk art or a catalog of a painter of the twentieth century. Similarly, a catalog of Islamic silver or Buddhist painting or Yoruba sculpture probably will have to introduce the reader to a larger number of new concepts than will a catalog devoted to Winslow Homer.

Instructors who ask students to write an entry for a catalog will provide a general idea of the length of the entry (e.g., "about 500 words," "about 1,500 words"), and it is then up to the student to apportion the space. What does the reader of a catalog want and deserve to get? Most entries in a catalog say something about the following aspects:

- **the subject** (for instance, the birth of the Buddha, the myth of Leda and the Swan, the historical associations of the landscape depicted, the biography of the person whose portrait is painted)
- **the technique of manufacture**—usually not necessary for a painting or drawing, but necessary if the work is a ceramic, bronze, or other manufactured material
- **the conditions of production** (for whom was the work produced? is it part of a larger group?)
- **the meaning,** and how the meaning is conveyed (for instance, the significance of the gesture a figure makes, the significance of the color of the clothing a figure wears, the implications of the symmetry or asymmetry or of the thickness or thinness of the paint)
- **the way in which the work fits into the artist's development,** or (for an anonymous work) how the work fits into the period
- **the way in which the work fits into the subject of the exhibition.** An entry on Grant Wood's *American Gothic* in an exhibition of European influences on American painting of the first half of the twentieth century ought to be somewhat different from an entry on the same painting in an exhibition of, say, "American Realism," or in a one-man exhibition of Wood.

Perhaps most important of all, a good entry in a catalog conveys

- **the inherent value of the work**—for instance its historical importance, its beauty, its richness of meaning, or whatever. In short, the entry helps the reader and viewer to understand why the work is worth looking at and is worth reading about. In fact, a good entry should help the reader to *see* the work more clearly, more fully. It should make the reader want to return to the exhibition to take another look at the work (or if the exhibition is no longer available, the entry should make the reader take a second and closer look at the reproduction of the work in the catalog), and cause the reader to say mentally, "Ah, I hadn't noticed that. That's *very interesting.*"

The only way to learn to write an entry for a catalog is to read a number of catalogs, get an idea of what they do—and then do *that,* but (equally important) do *not* do any of the annoying things that you may encounter. An example of what not to do: In *Art of the First Cities* (2003), the catalog that

we glanced at earlier in this chapter, the entry on the handsome *Kneeling Bull Holding a Vessel* (#13) begins (page 43):

> The subject of animals engaged in human activities held particular meaning for the people living in the mountains and the lowlands to the east of Uruk at the turn of the third millennium BC.

Fine; we now are eager to learn what the "particular meaning" of this beautiful, curious sculpture is. We are all ears, all eyes, all mind, but, oddly, the rest of the entry disappoints us because it says not a word about meaning, other than that "the function of these small sculptures is unclear." If *this* is all that the author can tell us about the meaning of the work, why did the entry begin by asserting that the motif of "animals engaged in human activities held particular meaning for the people"? It should have begun by saying something like this: "The motif of animals engaged in human activities is common, so it probably held particular meaning for the people, but we don't know what that meaning was."

There are countless excellent catalogs; your instructor can recommend examples, but here are a few titles, chosen almost at random:

Barnet, Peter, ed. *Images in Ivory: Precious Objects of the Gothic Age* (Detroit: Detroit Institute of Arts, 1997)

Cikovsky, Nicolai, Jr., et al. *Winslow Homer* (Washington: National Gallery of Art, 1995)

Evans, Helen C., ed. *Byzantium and Islam: Age of Transition, 7th–9th century* (New York: Metropolitan Museum of Art, 2012.

Herbert, Robert L., et al. *Georges Seurat 1859–1891* (New York: Metropolitan Museum of Art, 1991)

LaGamma, Alisa. *Art and Oracle: African Art and Rituals of Divination* (New York: Metropolitan Museum of Art, 2000)

Morse, Anne Nishimura, ed. *Drama and Desire: Japanese Paintings from the Floating World, 1690–1850* (Boston: MFA Publications, 2007).

Tinterow, Gary. *Master Drawings by Picasso* (Cambridge, Mass.: Fogg Museum, 1981)

A SAMPLE ENTRY

Because the following entry deals with a Japanese image of the infant Buddha, a subject unfamiliar to most Americans,

- it inevitably spends a fair amount of time sketching the background, but
- it also looks closely at the work itself, and
- it conveys something of the work's meaning and importance.

What may seem like a puzzling entry in the heading, "Literature: Washizuka No. 25," was clarified in the bibliography at the end of the catalog, which included a publication by Hiromitsu Washizuka, *Transmitting the Forms of Divinity*, where a comparable image was illustrated and discussed in entry 25. Here is the sample entry.

> The Buddha at Birth
> Gilt Bronze
> Asuka Period (542–645), 7th Century
> H. 3 3/8 in. (8.5 cm)
> Freer Gallery
> Literature: Washizuka No. 25

Like Christianity and Islam, Buddhism is rooted in the teachings of an historical figure. Shakyamuni ("Sage of the Shaka Clan," c. 560 BCE–c. 483 BCE), also called the Buddha (Enlightened One) or the Historical Buddha, was born into a princely family in north-central India, in the Himalayan foothills of present-day Nepal. According to semi-historical lore, although within the palace he was shielded from all possible pain, when at the age of twenty-nine he discovered suffering in the outside world he left the royal household in a quest for a better way of life, a different kind of existence. After six years of asceticism he found the Middle Way, a path between the two extremes of self-indulgence and asceticism, which brought enlightenment

The Buddha at Birth. Gilt bronze, Asuka Period (542–645), 7th Century. Height 3 ⅜ in. (8.5 cm.). Freer Gallery of Art, Smithsonian Institution, Washington, D.C.: Gift in honor of Yanagi Takashi, F2005a-b.

(Sanskrit: *bodhi*; Japanese: *bodai*). For the next forty-five years he preached a doctrine that came to be called The Four Noble Truths:

> All existence is characterized by suffering;
> Suffering is caused by desire or craving;
> There is a way to overcome craving;
> The way is the Eight-Fold Path, which involves leading a disciplined, moral life.

According to legend, at his birth the infant Buddha miraculously took seven steps, pointed with one hand to heaven, with the other to earth, and proclaimed, "Between heaven and earth, I alone am honored." This small image shows the smiling infant Buddha making the assertive gestures that announced a new way of perceiving experience. (He smiles because he has discovered a happy way of living.) All religious art, no matter how realistic, calls our attention in one way or another to an idealized world, for in effect religious art tells us that our daily perception of the world is severely limited, and—guided by the religion's teachings—we must see differently, see a different world.

Consider the *un*naturalness of this image: A tiny newborn infant with golden skin (the Buddha's gold skin symbolizes his perfect knowledge) and a full head of hair that is shaped like a natural crown (the cranial protuberance symbolizes his supreme wisdom) stands unaided and makes a confrontational gesture. Although the image is far from realistic, it does catch the supple, undefined body of a child (except for the delightful indication of the spine), and it interestingly contrasts the smooth bodily surfaces with the finely detailed elaborate garment. This paradoxical image—a smiling infant who commands—itself is an embodiment of the challenging idea that there is a world different from our visible world of helpless infants who are born, grow old and sick, and then die.

The Buddha at Birth was produced by the lost-wax method: The image was made in wax, encased in a clay mold with a drain hole, and the mold was then heated. When the melted wax ran out, bronze was poured into the mold through an inlet, filling the space where the wax model had been. After the bronze cooled, the mold was broken to free the bronze image. Details were perhaps refined, and the image was gilded—that is, it was painted with powdered gold dissolved in mercury, and heated until the mercury vaporized, leaving gilt fixed to the surface.

Although Buddhism was introduced to Japan from Korea in the sixth century, the oldest surviving Japanese Buddhist sculptures are, like this one, from the early seventh century. (In later images the face is rounder, less rectangular, and the skirt is longer.) The present sculpture may be the earliest Japanese gilt bronze in the United States, and perhaps the earliest outside of Japan.

The Entry Briefly Analyzed

The first paragraph gives some necessary historical background.

The second paragraph zeroes in on the image, explains the iconography (the pose of this figure), and offers an interesting relevant generalization about religious art.

The third paragraph, beginning "Consider," helps the reader to understand and enjoy this particular image.

The fourth paragraph offers information about how the image was made. This material might equally well have been the substance of the second paragraph, but the writer probably thought it was of less immediate interest to the reader than the iconography and therefore decided to postpone it.

The final paragraph emphasizes the importance of the piece.

✔ Checklist for Writing a Catalog Entry

Have I asked myself the following questions?

- ❑ Details of artist, title, dimensions, material, owner correct?
- ❑ Length of entry appropriate to the assignment?
- ❑ Necessary technical words unobtrusively defined?
- ❑ Nature and significance of the work communicated?

7

WRITING A REVIEW OF AN EXHIBITION

Pleasure is by no means an infallible critical guide, but it is the least fallible.

—W. H. Auden

That which probably hears more nonsense than anything else in the world is a picture in a museum.

—Edmond and Jules de Goncourt

WHAT A REVIEW IS

Your instructor may ask you to write a review of an exhibition at a local museum or art gallery. Like other writing about art, a review should deepen the reader's understanding of art history, or enhance the reader's experience of works of art, or both. It also deepens the *writer's* understanding because (as this book repeatedly suggests) writing is a way of getting and refining ideas. This fact is at the heart of an anecdote: When an art critic was asked what she thought of an exhibition, she said, "I don't know; I haven't written my review yet."

Writing a review requires analytic skill, but a review is not identical to an analysis. An analysis usually focuses on one work or at most a few, and often the work (let's say Picasso's *Guernica*) is familiar to the readers. On the other hand, a review of an exhibition normally is concerned with a fairly large number of works, many of which may be unfamiliar. The first paragraph or two of a review usually provides a helpful introduction, such as the following, in which a student, writing in a college newspaper—that is, a publication aimed at non-specialists—gives some background about African beadwork, a kind of material that she correctly assumes most of her readers are unfamiliar with.

> It is estimated that some eleven million Yoruba people live in the Benin Republic (formerly Dahomey) and in southwestern Nigeria. Yoruba wooden sculpture is world-famous, many examples being in European and American museums, but Yoruba beadwork is sparsely represented, and chiefly by minor examples, though in Africa it sometimes is of enormous importance.

Relatively ordinary and relatively inexpensive beadwork, made of bone or wood or shell can easily be found, worn simply as decoration, as jewelry, but the beadwork of greatest social significance (and of the highest degree of craftsmanship) is the veil worn by the oba, a Yoruba monarch who is regarded as a figure who is so powerful that his look can kill. The beaded veil thus protects the viewer who faces the monarch. Further, oba wears a conical crown covered with beads, the beads further symbolizing the power of his head. The colors of the beads—chiefly red, yellow, and blue—are associated with specific traditional deities, even though the monarch may be a Christian or a Muslim.

In this example, the writer is gently educating her readers, giving the readers—who are assumed to be nonspecialists—information that the readers need. If, however, the student had been writing in a journal such as *African Art,* she would not have provided this elementary information.

If the exhibition is devoted to an artist whose work is likely to be fairly familiar to the readers, for instance work by Monet or Rodin or van Gogh or Norman Rockwell, you will not need to do more in your introduction than to announce the topic—though in an interesting way—and then to get down to business. If, however, the material is relatively unusual, for instance, Japanese calligraphy or prehistoric Inuit carving, you probably will have to educate your reader at the outset.

A review usually includes:

- Description
- Analysis
- Evaluation

A description, you recall, is not the same as analysis;

A *description* tells readers what something looks like: A description in a review tells us how big the exhibition is, how the works are displayed (e.g., crowded together or with plenty of space, on white walls or green, brightly lit or in what John Milton called "a dim religious light"), and it tells us what some of the works look like ("He is a large man, and he fills the canvas");

An *analysis* tells readers how some aspects of the exhibition work, how they interact, how they exert an influence ("The paintings, crowded together, convey a sense of bristling energy"; "The chronological arrangement makes sense, but in this exhibition it unfortunately means that the last objects a viewer encounters are the weakest") and what all parts of the exhibition add up to ("Although the show is chiefly devoted to African ritual objects created between 1880 and 1920, it includes a few recent works, all of which are clearly designed for the contemporary tourist trade. These last are interesting in their own way, but their only connection with the other works is that they were made in Africa.")

An *evaluation* tells readers whether the exhibition was worth doing, how well it has been done, and whether it is worth seeing—and of course these judgments must be supported with evidence.

If you read reviews of art in *Time, Newsweek, The New Yorker, The New Criterion, The Nation,* and *The New Republic,* or a newspaper, you will soon develop a sense of what reviews for a relatively general public normally do. And of course some journals devoted to art include reviews of exhibitions; these reviews will give you an idea of how to write for a specialized audience.

Drafting a Review

In brief, in drafting and revising a review—as in drafting and revising almost any other piece of writing you produce in college—keep asking yourself two questions:

- What do my readers need to know? (You will have to provide the necessary background information.)
- What do I want my readers to think? (You will have to offer evidence that supports the thesis you are arguing.)

Speaking broadly, a review commonly has a structure something like this, though the position of the paragraphs on strengths and on weakness may be reversed:

1. A title that engages the reader, such as "Is Norman Rockwell Under-Rated?" rather than "Norman Rockwell: A Review."
2. An opening paragraph that informs the reader of the subject—the name or names of the artist(s), the time period and subject matter covered—and that establishes the tone of the review (more about tone in a moment). A reviewer may comment on the slightly obscure title of an exhibition, explaining, for instance, that "Seeing the Unspeakable: The Art of Kara Walker" is an exhibition of Walker's depictions of slavery. In any case, by the end of the opening, the reader should also sense the reviewer's thesis, the main point.
3. A few paragraphs that go into further detail about the theme, purpose, or idea, or scope embodied in the exhibition, perhaps within the context of related exhibitions; for example, "Unlike last year's show of van Gogh's self-portraits, the current exhibition gives a broad overview. . . ."
4. A paragraph (or two or three) on the installation, including the explanatory wall plaques (if any) and the lighting. Some exhibitions treat the objects as self-sufficient works of art, "form as content,"

perhaps giving them a sort of jewel-case setting with spot ("boutique") lighting, whereas other exhibitions treat the objects as artifacts that encode the values of a culture and display the objects with abundant contextual material such as long labels, wall texts, and brochures. Exhibitions of this second sort commonly avoid spotlights, using instead an overall wash of light. An exhibition that seeks to reproduce or at least to suggest an historical context—for instance, Egyptian objects in a tomb-like setting or standing on sand, or Greek sculpture in a setting of classical columns or Arctic sculptures in a white room (at the Enil collection in Houston) with ambient background sounds of Inuit voices, blowing winds, and cracking ice—is said to be an *environmental installation*. (The Arctic exhibition went so far as to exclude any wall labels.) Remember, the curator has shaped the exhibition by choosing certain works, and the designer has collaborated by displaying them in a certain way. But curators and designers are not entirely free: They must work within a given architecture. Thus, you may also want to comment on the architectural problems that the curator faced. For instance, Robert Hughes in a review (in *Nothing If Not Critical,* page 207) of David Smith's sculpture says, "The National Gallery's East Wing, with its choppy transitions of level, is a confusing place for large sculpture; the background is always in the way." Hughes then goes on to say that Smith's sculpture triumphs over the environment. Reviews often comment, too, on whether the installation of the material helps or hinders the viewer's experience.

5. A few paragraphs on the strengths, if any (for instance, the exhibition presents unfamiliar work, or work that although it is familiar is nevertheless of such high quality that one can see it again and again). If the exhibition includes work by several artists, the reviewer singles out those who are especially interesting.

6. A few paragraphs on the weaknesses, if any (perhaps too much space is devoted to a certain period, or to certain artists, or to certain forms of art, or perhaps too many objects are crowded into the space). If you include such comments make sure that you do not sound smart-alecky.

7. A concluding paragraph in which the reviewer in effect summarizes (but in fresh language) the point—the thesis—that has been emerging throughout the review. A relevant quotation by an artist can often help you write a paragraph that does much more than lamely say, "As I have already pointed out. . . ."

Tone—the writer's personality as the reader perceives it, for example courteous or stuffy or bullying—is largely a product of the writer's attitude toward the subject and toward the readers. The tone of a review, therefore, depends partly on the publication in which it will appear: A review in a scholarly journal will have a different tone from a review in a popular magazine. Unless your instructor has told you to write a review aimed at the readers of a specific journal, imagine that your classmates are your readers, forgetting of course that they may be reviewing the same exhibition you are. Remember, too, it's always productive to treat both your readers and your subject with respect. Be serious but don't be stuffy. (For more on tone, with examples of writings that unintentionally convey off-putting personalities, see pages 197–200.)

Some final tips:

- Read any texts that are on the walls. (You may learn from them—or you may find them intrusive.)
- If a brochure is available at the exhibition, take it, read it after you have walked through the exhibition once, and then walk through the exhibition at least once more. On this second trip, you may want to record (in the form of marginal jottings) your responses to comments made in the brochure. Save the brochure, or buy a catalog if one is available; such material will provide sources for the illustrations in your paper.
- If an audio program is available, listen to it as you go through the exhibition. Take notes on the comments you think are noteworthy—and be sure to acknowledge the program if you use any of the material in your review.
- Take notes while you are at the exhibition; don't assume you will remember titles and dates, or the ways in which works are juxtaposed, or even all of your responses to individual works.
- In your first draft, don't worry about limitations of space. Put down whatever you think is worth saying, and later revise the review to bring it within the established length.
- Express your opinions—subjectivity is inherent—but go easy on such terms as "I think," "I feel," "In my opinion." Express opinions chiefly by calling attention to details that will in effect compel the reader to share your responses.
- If possible, revisit the exhibition after you have revised your draft, so that you can improve the review (probably by adding concrete details) before handing it in.
- Give your review an interesting title: not "A Review of an Exhibition of van Gogh's Self-Portraits" but perhaps "Van Gogh

Looks at Vincent." The final version of the title will probably be almost the last thing you write, but make certain that the final draft of the review fulfills expectations that the title arouses.

- For help in thinking about standards of evaluation, consult Chapter 11, especially pages 229–40.

For a valuable discussion of the ways in which objects have been exhibited, see Victoria Newhouse, *Art and the Power of Placement* (2005).

A Note on Reviewing an Exhibition of Non-Western Art

First, a necessary clarification: The West has pretty much invented the idea of what is and what is not the West: The West includes Europe, the ancient Near East, ancient Egypt, and the Americas (but not the Indian traditions in the Americas). Thus, the concept of "the West" is as much cultural as it is geographic. And non-Western art is defined in terms of Western art; painting and sculpture rank higher than basketry and textiles, which until recently were regarded as works of craft rather than art.

How fully can any of us appreciate the arts of a culture that is remote from our own? Historians of global art ask if there are universal aesthetic criteria that, for instance, allow twenty-first-century Caucasians fully to appreciate pre-Columbian textiles and also sub-Saharan carvings of the nineteenth century. Or, on the other hand, are we inevitable culture-bound? A related question: Do art museums serve as clear glass windows through which we see and understand and enjoy the art of the world, or (something very different) do museums in fact offer the highly focused lenses—we might say narrow views—of curators, thereby imposing Eurocentric views?

Reviewing (like exhibiting) non-Western art, especially sub-Sahara African, Oceanic, Buddhist, Islamic, and pre-Columbian material—works from a culture that is regarded as "the Other"—can be especially challenging. It is perhaps easier to see this challenge in exhibitions than in reviews: If the exhibited material is accompanied by abundant contextual material, for instance music and photomurals showing how the people who produced the works used them in rituals, viewers may complain that the exhibitors are apologizing for it, are condescending to it, or are implying that it lacks universal aesthetic value. If, however, the exhibited material is offered "as art," with little contextualizing material, viewers may complain that it is baffling—or that it is being oversimplified by being deprived of its context.

You may find it appropriate to indicate *why* the material is considered to be "art":

- Beauty of form?
- Excellence of craftsmanship?
- Preciousness of materials?
- Importance within its own culture?
- Influence on Western art (e.g., African sculpture on Picasso, Navajo sand paintings on Jackson Pollock)?

What advice can be given? Only this: Be aware that

- if you give a fair amount of context, of background, readers may mistakenly infer that you are implying that the work is aesthetically weak, but
- if you give relatively little context readers may mistakenly infer that you subscribe to mystical universal values.

When you reread your draft (just as when you read any of your other drafts), imagine yourself in your reader's shoes and consider whether the review is open to these possible objections. Think hard about your assumptions and make whatever revisions seem necessary. The challenge is great, but if you face it you will produce a thoughtful review.

A Note on Reviewing a Highly Controversial Exhibition

Viewed one way, every exhibition is controversial—why *this* material, shown in *this* way?—but with most exhibitions (for instance, van Gogh's self-portraits, or Mary Cassatt's prints, or Chinese ceramics of the Song Dynasty) such questions are asked by very few viewers. Some exhibitions, however, raise questions that may inflame a general public. Exhibitions of this sort are likely to include

- images that have been looted (antiquities illegally excavated and then smuggled out of the country of origin, or paintings stolen from Jews by Nazis and now in the hands of recent purchasers), or
- images showing nudity or sexual acts (especially implying sadomasochism or pederasty), or
- images that seem to some viewers sacrilegious (for instance, Andres Serrano's *Piss Christ* (1987), a photograph of a plastic crucifix submerged in urine mixed with cow's blood, or Chris Ofili's *The Holy Virgin Mary* (1996), a collage executed in part with elephant dung and including images of female genitalia clipped out of pornographic magazines, or
- objects that stir strong patriotic responses (in Scott Tyler's exhibition, viewers were invited to step on an American flag).

Reviews of such exhibitions are likely to become chiefly attacks or defenses, rather than thoughtful analyses. If you are writing about a highly controversial exhibition, be sure to go beyond merely reasserting your preconceptions: Make a diligent effort to understand what the artist is doing.

Let's look briefly at Scott Tyler's work, an installation (i.e., a site-specific work, usually consisting of an ensemble of several units designed for a particular place) created in 1989 by an African American student at the School of the Art Institute of Chicago. (Tyler is also known as Dread Scott Tyler.) The work, in an exhibition of work by minority artists, was titled *What Is the Proper Way to Display a U.S. Flag?* On the wall was the title; beneath the title were photographs showing coffin-draped flags and South Koreans burning an American flag; beneath the photographs, attached to the wall, was a shelf on which rested a blank notebook in which viewers could write their comments; beneath the shelf, on the floor, an American flag extended outward from the wall. Veterans groups were outraged, security at the exhibition had to be heightened, a teacher who walked on the flag was arrested, the matter was taken to court, and Judge Kenneth Gillis dismissed the suit, declaring that no state or federal law had been violated. In the course of his ruling the judge said, "This exhibit is as much an invitation to think about the flag as it is an invitation to step on it."

The judge's words are wise; an exhibition of this sort is an invitation to think, *not* to shout the first thing that comes to one's mind. True, most reviews of such exhibitions probably proceed from strong feelings and are likely to be worded strongly, but if reviewers want to do more than get something off their chests, if they really want to convince their readers that this or that exhibition is outrageous (or, on the contrary, is to be regarded seriously), they will have to do more than express their outrage.

For one thing, reviewers might well begin by examining their own assumptions. Reviewers who write for a right-wing journal (say, *The National Review*) or for a left-wing journal (say, *The Nation*) need not worry about examining their own ideas or about convincing their readers—they are preaching to the choir—but other reviewers are rightly concerned about learning from the exhibition and about communicating their views to persons who may not share them. Such writers want to set forth their viewpoints as effectively as possible, not because they think readers with markedly different views will say, "Yes, of course, you have converted me," but because these writers want their views to be thoughtful and they want them to be given a hearing by readers who may have other views. They want to show that the views they advance in the essay

can be held by a *reasonable* person. Of course, they would like to persuade their readers, but they will settle if the readers, finding some merit in the argument, concede that the writer has offered a reasonable case and that the position can be held by someone who is neither stupid nor hopelessly corrupt.

Consider a reviewer writing about an exhibition that included Andres Serrano's large colored photograph (about five feet tall and three feet wide) called *Piss Christ* (1987), an image showing a crucifix in a luminous rosy-golden glow. (In fact, as mentioned earlier, the photograph is of a plastic crucifix immersed in a Plexiglas tank of the photographer's urine mixed with cow's blood.) Serious reviewers, whatever their final positions, will do more than either rant about blasphemy or enthuse about artistic freedom; they will try to understand the responses of those spectators who were outraged and also of those who found the image impressive, meaningful, and aesthetically successful. In short, they will try to understand the counter-arguments to their own position.

For instance, a reviewer who found the image offensive and ultimately valueless might nevertheless recognize that

- Serrano was brought up in a devout Roman Catholic family;
- Serrano may have wanted to assert that, for believers, Jesus was fully human as well as divine; *Piss Christ* by its title jolts viewers out of unthinking conventional responses to religious images, forcing them to think freshly about the significance of the Incarnation and the Crucifixion;
- blood is commonly shown in images of the Crucifixion, so another bodily fluid also might be used to help describe Jesus' humanity;
- the image is visually attractive, at least until one reads the title or learns what exactly is depicted;
- in our democratic society, artists—like all other people—are entitled to express their ideas freely;
- "artistic freedom" is not just a matter of indulging in the nonsense of artists; our society benefits when art is not censored.

Recognizing that such views have something to recommend them, the reviewer might nevertheless go on to argue, on moral and aesthetic grounds, that the work is trivial and crude (Serrano might at least have said "urine" instead of "piss"), that we need not believe Serrano's comments about his aims and his religion, and that—without disputing Serrano's right to express himself—work that deeply offends many Americans should not be supported by taxpayers' dollars (Serrano had received a grant of $15,000 from the National Endowment for the Arts).

Piss Christ (1987). Andres Serrano © the artist. Courtesy of the artist and Yvon Lambert Gallery.

A reviewer might well argue that protecting an artist's freedom of expression is one thing, but subsidizing the artist with taxpayers' money is a very different thing.

On the other hand, a reviewer who valued the work ought to show awareness of such thoughts as these:

- the title is deeply offensive to many people;
- in the eyes of many people, immersing a crucifix in urine is comparable to the blasphemous act of urinating on a crucifix;
- most viewers cannot be expected to know that the artist may be expressing some thoughts about the human nature of Jesus;
- taxpayers may reasonably argue that although an artist (like everyone else) has the right to express ideas that offend some people, government funds should not be used to support work that either advances or derides religious beliefs.

Having shown some understanding of the counter-arguments, the reasons why viewers might be deeply disturbed by Serrano's image—and having *achieved* this understanding by the process of drafting and writing—the reviewer might then go on to offer arguments to the effect that the image nevertheless has value. Probably the essay will not win many converts, but even readers who remain unconvinced may recognize the good faith of the writer and the complexity of the issue.

A question: If a work of art offends us, and we later hear that the artist's intention was praiseworthy, need we modify our response? (For a brief discussion of *intention*, see pages 23–25.)

Perhaps we can go a bit further and be a bit more specific: The reviewer probably will also examine as fairly as possible

- the work's material and formal properties (what is it made of, how the elements are combined), and the aesthetic impact;
- the context (for instance, social, political, or religious) that the artist or the organizer of the exhibition is working in or drawing on;
- the meaning(s) of the work(s) in their context.

✍ A RULE FOR WRITERS:

Because by writing you hope to educate yourself and then to interest and perhaps even to persuade skeptical readers, especially when you write about a highly controversial topic, you need to show that you understand that intelligent people can hold views other than yours. In short, make certain that your writing reveals that you are informed and that you are a person of good will.

✔ Checklist for Revising a Review

Have I asked myself the following questions?

❑ Is my title informative and engaging? (A comment on the appropriateness of the exhibition's title often provides a good beginning.)

❑ Do the opening paragraphs give my readers the appropriate amount of background? And do they give the reader an idea of my thesis?

❑ Does the review provide the appropriate factual information (e.g., approximate size of the exhibition, concept behind the exhibition, lighting and labeling and other methods of display, freshness of the material). You may even want to consider supplementary material: If the museum shop has in effect mounted a show of relevant stuff (reproductions, books, T-shirts), does this display enhance or degrade the exhibition?

❑ Are the value judgments expressed in the review (both of individual works and of the exhibition as a whole) supported by evidence?

❑ If the review includes an illustration, does this illustration help the readers to see an important point?

❑ If the topic is highly controversial, have I stated at least one other view in a way that would satisfy its proponents and, thus, demonstrated my familiarity with the issue and your fairness?

❑ Is the tone appropriate? (Sarcasm is rarely appropriate.)

❑ Is the review the assigned length?

A SAMPLE REVIEW

Here is a review, about 1,000 words long (the equivalent of four double-spaced typed pages), of an exhibition by Mark Rothko (1903–1970), an abstract expressionist painter born in a part of Russia that today is Latvia. Rothko came to the United States as a child and became a naturalized citizen in 1938. This exhibition, showing works from the artist's entire career, opened at the National Gallery of Art, in Washington, D.C., and then went to the Whitney Museum in New York. The reviewer saw the exhibition in both venues and, thus, is able to make some interesting comparisons about the installation. Because the review appeared in *Art Journal* (Spring 1999), a publication concerned with contemporary art, read by artists and art historians, the reviewer can allude to other artists without even briefly identifying them; she knows that her readers know who these people are.

Before reading the review, look at some good color reproductions of Rothko's work. you can find them by typing his name into a search engine such as Google or Yahoo. The National Gallery of art has a particularly good site that was prepared for the exhibition; just type "NGA Rothko" and go on from there. Strictly speaking, the site is <*http://www.nga.gov/ feature/rothko/rothkosplash.html*>

MARK ROTHKO
*Phyllis Tuchman**

Jeffrey Weiss, Exh. cat, Washington, D.C.: National Gallery of Art and New Haven: Yale University Press, 1998. Texts by John Gage, Carol Mancusi-Ungaro, Barbara Novak, Brian O'Doherty, Mark Rosenthal, and Jessica Stewart, 374 pp., 120 color ills., 50 b/w. $65.

*Phyllis Tuchman, "Mark Rothko Rising," *Art Journal*, Spring, Vol. 58, No. 1, 1999. Copyright 1999 Phyllis Tuchman. Reprinted by permission of the author.

Exhibition schedule: National Gallery of Art, Washington, D.C., May 3–August 16, 1998; Whitney Museum of American Art, New York, September 10–November 29, 1998; Musee de l'Art Moderne de la Ville de Paris, January 8–April 18, 1999.

The Mark Rothko retrospective, which opened at the National Gallery of Art in Washington, D.C., and was next on view at the Whitney Museum of American Art in New York, was astonishingly beautiful. And people responded accordingly. Answering to a call comparable to "Build a ball field and they will come," the crowds descended on this spectacular display. Whenever I visited the exhibition, which featured about 110 paintings and works on paper the artist made between 1936 and 1969, a year before he died at the age of sixty-six, the galleries were filled. Abstract art is once again ascendant; artists, as well as others, appear to care passionately about how it is made, what it can address, and its ability to communicate the highest values of life in a nonrepresentational, visual language.

Exhibiting his work regularly from the forties onward, Rothko never lacked critical attention during his lifetime or after his death. Besides the retrospective mounted at The Museum of Modern Art in 1961 when he was fifty-seven, Rothko represented the United States in 1958 at the Venice Biennale and in 1959 at Documenta II in Kassel. Moreover, during the fifties and early sixties, when the work of Americans was rarely seen abroad, his art traveled to places as far-flung as Berlin, Paris, Caracas, Calcutta, and Madrid.

While there have been other in-depth survey exhibitions and several books and catalogues devoted to Rothko's art during the more than three decades since his suicide, the magnificence of this latest retrospective came as a surprise to many. Thanks to Jeffrey Weiss, associate curator of twentieth-century art at the National Gallery, this body of work will never again look the same. The author of *The Popular Culture of Modern Art* and co-curator of the National Gallery and the Boston Museum of Fine Art's exhibition "Picasso: The Early Years, 1892–1906," this talented art historian turns out to have quite an eye, as well as a searching intellect. Weiss's discriminating selection from Rothko's oeuvre, more than anything else, set this group of canvases and drawings apart from those seen previously.

At the Whitney, Rothko's representational pictures from the thirties and forties benefited from their proximity to the new fifth-floor galleries displaying the permanent collection. Having a

context within which to view these awkward, not quite resolved canvases shed further light on the period in which they were executed. Following the artist's own example, a number of critics averred that these tentative works never should have been exhibited (years after their making, Rothko tried to distance himself from these canvases and never referred to or exhibited them). However, Weiss brought a fresh eye to bear on them, choosing paintings with strong blocks of color serving as backgrounds. They do indeed suggest possibilities the artist later went on to develop.

Another group of works, the late acrylics on paper mounted on canvas from 1969, were also broadly criticized for being unresolved and possibly unfinished. It was suggested that they, too, should never have been shown. But consider this scenario. Rothko's art of the thirties was influenced by what the then-young artist saw being done around him. Eventually, as a mature painter, he hit his stride, and one work generated another. But there came a moment when he realized he was an older "contemporary" amid a new emergent generation. So, he again glanced at what was being created by others.

Where decades earlier, his eyes, which he depicted in a self-portrait from 1936 as nuggets of blue, had turned toward older artists, they now rested on what artists fifteen or twenty years younger, some of whom were Minimalists, were doing. Surrounding Rothko's greatest paintings of the late fifties and early sixties with both earlier and later work reveals the ways in which he was affected by the periods in which he flourished. It also adds a touch of poignancy to this retrospective.

Still, it is Rothko's gift for color that we treasure most. He used a range of blues and tangerines, as well as shades of chartreuse and saffron, the way Mozart arranged a musical score with the instruments of a symphony orchestra. With consummate grace, this Russian-born, Yale-educated artist used his palette as if it were a keyboard. And his paintings react to different viewing circumstances the way a concerto is altered by the interpretation of its conductor, the company, and the hall in which it is performed. At the National Gallery, where the rectangular galleries seemed narrower, the walls darker, and the lights lower than they were at the Whitney, sensations of color rather than individual paintings swept over viewers. For instance, in a room where canvases with orange predominating hung along one wall and others with blue were across from these, peripheral vision took hold. It was as if

your left eye saw one hue and your right eye perceived the other set of tones.

At the Whitney it was easier to focus on each individual picture. The works seemed a bit less mysterious, and you could easily concentrate on how Rothko had actually executed them. You could readily parse how the artist put one color on top of another and perhaps one or two others on top of those. The complexities of his art were never more evident.

Because of how the exhibition was installed, the way one group of works led into another possessed a clarity that revealed Rothko's appeal to the Minimalists who followed his lead. "The verticals," Donald Judd wrote about one of his predecessor's paintings in the September 1963 issue of *Arts Magazine,* "are simultaneously areas, color, light, and volume—which is intrinsic to Rothko's successful work." The multiforms from the late forties, with their patches of color scattered across the canvases, have an unexpected liveliness (and make evident that the artist was as much influenced by Ad Reinhardt as he was by Clyfford Still at this point). As stacks of various hues grow larger and more expansive, the emotional range of these abstractions amazes. You become aware as well of how the artist applied pigments to his flat surfaces with broad arm movements, delicate flicks of the wrist, rubbing motions, and a swoosh from time to time. As you look, uniformity gives way to the discovery of scores of irregularities. Eventually blocks of chocolate and maroon become as dense and smooth as ice. During the early sixties, a void rather than a luminous glow entered Rothko's paintings. Curtains of black took over; and in the darkened room at the National Gallery in which the canvases from the mid-sixties hung, you felt the artist's pain and were brought to tears as if this were the tragic end of a long, arduous adventure.

Soon after the retrospective opened in New York, its excellent publication was joined by David Anfam's exemplary catalogue raisonne of the artist's works on canvas. A British scholar who has organized several Rothko exhibitions and written books on Abstract Expressionism as well as on Franz Kline, Anfam has spent years pulling everything together. The plates, which reproduce more than eight hundred works spanning a truncated lifetime, are almost all illustrated in color on heavy stock. Wonder how Weiss's selections stack up against the rest of the artist's oeuvre? Consult this book. But be assured, the answer is quite well. While Weiss's text situates Rothko's oeuvre within an absorbing cultural

context, Anfam has introduced all sorts of new art historical sources. Suggesting the Russian-born artist was more city-oriented than previous authors have, Weiss creates a new way to distinguish Rothko's urban achievements from those of, say, Jackson Pollock and Willem de Kooning during their "landscape" years in the Springs, just outside of East Hampton on Long Island. Moreover, John Gage's essay on Rothko's painting practices in the retrospective's catalogue also can be applied to the stunning canvases of Still because the two had so much in common. Solely focused on his subject's output, Anfam is more limited in his orientation. Since he is very good with what he does, Anfam should be read in tandem with Weiss. Rothko, who would complain bitterly to almost total strangers such as myself that he had begun to feel "old-fashioned," would be delighted that unlike his colleagues he is now the subject of all sorts of books devoted to his art and the big picture.

8

VIRTUAL EXHIBITIONS: WRITING TEXT PANELS AND OTHER MATERIALS

When anything new comes along, everyone, like a child discovering the world, thinks that they've invented it, but you scratch a little and you find a caveman scratching on a wall is creating virtual reality in a sense. What is new here is that more sophisticated instruments give you the power to do it more easily. Virtual reality is dreams.

—Morton Heilig (attributed)

Although papers such as formal analyses, comparisons, and research papers are the most frequently assigned kinds of writing, in an intermediate or an advanced course your instructor may require you to prepare some of the kinds of written material that accompany any museum exhibition. Imagine that you, or that you and others in a group, have been invited to present an exhibition in a museum.

Or, more precisely, you may be asked to prepare a **virtual exhibition** (also called an **online exhibition** or a **cyber exhibition**)— an exhibition that viewers might see not in a brick-and-mortar museum but on a computer at home or in a dormitory room. **Globalization**—the worldwide effect of economic processes and the worldwide adoption of local institutions, for instance a McDonald's in Tokyo, and a sushi bar in Topeka—means that today the art of almost any culture may be exhibited almost anywhere. But when thinking of possible topics for your virtual exhibition, bear in mind that your virtual audience, whose ideas of art may well be based on Greek sculpture and paintings by van Gogh, probably will make little out of an exhibition of the body-painting and scarification of the Nuba people from Sudan, or of an ornamented canoe from Micronesia. Viewers of such exhibitions probably need extra help.

KINDS OF EXHIBITIONS

We have already seen (pages 154–55, 159) that, at the extremes, an exhibition may fall into one of two types:

- An exhibition may emphasize each object as an independent work of art, showing it in a relatively neutral setting as something to be enjoyed aesthetically (we can call it a **fine arts exhibition**), or, at the other extreme,
- an exhibition may be highly didactic, emphasizing each object as a cultural artifact (a **cultural** or **ethnic exhibition**), showing it as something to be understood—with the help of abundant commentary—as part of a larger context, for instance as a piece of evidence that reveals how the people in a particular time and place (especially in the non-Western world) lived their lives.

We have seen, too, that the fine arts exhibition may be criticized for detaching objects (say, wine vessels or priests' staffs, as well as paintings and sculptures) from their cultural context, and the cultural exhibition, loaded with contextual videos and text-panels that tell the viewer how each object functioned in its original context, may be criticized for neglecting inherent aesthetic values and for turning the museum into a textbook. Most exhibitions in museums probably are somewhere in between these two extremes.

There is more. Exhibitions that go beyond the usual display of aesthetic objects rub some people the wrong way. Here is a fairly recent example. The Arthur M. Sackler Gallery in Washington, D. C. (it is part of the Smithsonian Institution) in the spring of 2010 exhibited a Tibetan shrine of the sort that might have been used by a nineteenth-century Tibetan aristocrat, with edge-to-edge Buddhist paintings, and with numerous small statues on shelves in front of the paintings. The catalog, *A Shrine for Tibet*, gives you some idea of the exhibition, but it cannot convey the feel of the exhibition, where low lighting was meant to imitate the illumination that Tibetan yak-butter lamps would have provided, and visitors were invited (but not required) to remove their shoes as an act of devotion when they approached this sacred space. A reviewer in *The Washington Post* (March 21, 2010) said it was "vexing" that a branch of the Smithsonian, whose mission is "the diffusion of knowledge," was propagandizing on behalf of Tibetan Buddhism. "If the National Gallery," he said, "had installed a working Catholic altar, complete with choirboys and chalices, in its current show of sacred Spanish art, we'd have been up in arms."

It's encouraging to know that someone cared enough about the exhibition to be vexed by it. (By the way, would a representation of a Catholic altar in the National Gallery bother you? Why, or why not?)

KINDS OF WRITING ASSIGNMENTS

A curator begins with a proposal that focuses on the central idea of the exhibition. Museum practices vary, but normally this writing is submitted to the chair of the department, then in revised form to the chief curator, then with further revisions to the director of the museum. Other documents are intended for the general public. We will skip the proposal, which ordinarily talks about such matters as the museum's schedule, comparable exhibitions in recent years, costs of borrowing and of installing, and so forth. Because this exercise is intended chiefly to educate *you*, we need not worry about whether (for instance) *Mona Lisa* really is available for borrowing: If you have decided that you need it for your exhibition, you will include it.

What, then, are the writing assignments, the assignments (spread throughout the semester) that will help you to think about art and to learn about art by preparing an exhibition? They probably include:

1. Constructing a **title** for the exhibition.
2. Writing a brief statement—let's say three or four sentences, about 50–75 words—of the basic idea that underlies the exhibition, the response you might give to someone who asked, "What is this exhibition you are working on? What do you hope visitors to the exhibition will take away from it? What is the **Big Idea**?" Be sure that your statement includes a sentence or two that tells the hearer what the exhibition will *look like*, for example, how large the exhibition is (how many objects), and how the objects will be arranged, for instance chronologically or thematically or by media. (At a later stage you will want to get into additional details for an exhibition imagined at a real museum, such as the color of the walls, the level of lighting, and the kinds of lighting—for example, chiefly a diffused wash of lights but also some spotlights.) You may want to specify that it will occupy two galleries in such-and-such a local museum.

 This statement—your Big Idea—probably will become the heart of the introductory wall text. Some of the sentences may become the topic sentences of later wall panels commenting on subsections of the exhibition. Wall panels are important; they

may provide the general public with its first encounter with the ideas inherent in the objects.

3. Writing a somewhat longer **introductory text**, probably about 150–200 words broken down into three or four paragraphs, that will be posted as a wall panel at the point where visitors enter the exhibition. The aim is to help viewers get an overall idea of the exhibition.

4. Writing, for the walls of the galleries, two or three **group texts** (each with perhaps 100–125 words, maybe divided into two or possibly three paragraphs) concerned with groups of works within the exhibition, for instance a panel that comments on the paintings on a single wall, or on the several small sculptures within a single case. The text establishes the context for the objects. If your exhibition concerns ritual objects, like those in *A Shrine for Tibet* mentioned a moment ago, you will want to consider how much cultural context you need to include in your label.

5. Writing—in place of text panels for groups of works—the texts for **group audio-guides** for these units.

6. Writing what the profession calls **tombstone labels** (minimal information concerning date, size, medium) and **chat labels** (brief comments) for half-a-dozen works. (See page 178.)

7. Writing the texts of **one-minute audio-guide comments** for each of three works.

8. Preparing a **floor plan** showing the exact location of each work, whether freestanding or in a Plexiglas case or hanging on a wall. (This job is usually for the museum's exhibition designer with guidance from the curator, and of course for a virtual exhibition there *is no floor*, but if you think about a floor plan it will help you think about what you hope to accomplish by curating the exhibition. Consider creating a floor plan with virtual mock-ups of wall elevations with thumbnail images downloaded from the Internet.)

9. Preparing **a handout for youngsters**.

Let's look briefly at each of these assignments.

1. **The title** will be the first thing that your visitors will read, but it probably will be almost the last thing that you will settle on because you will keep refining it. You want it to be informative and also at least moderately catchy. (Do not forget that museums need revenue, and they rely on exhibitions to attract viewers who buy tickets.)

If the title includes a Big Name, it is already catchy:

> *Monet's Water Lilies*
> *Andy Warhol: The Last Decade*
> *Van Gogh at Arles*

Most of the public—even the museum-going public—probably does not know that van Gogh spent fifteen months at Arles, in southern France, where between February 1888 and May 1889 he painted some of his most famous pictures (for instance, his *Bedroom,* his *Self-Portrait with Bandaged Ear,* and his portraits of the postmaster and the postmaster's wife), but everyone knows the artist's name.

If your exhibition is of less famous material, you may have to do a bit of explaining in the subtitle.

> *Pen and Parchment: Drawing in the Middle Ages*
> *Seductive Subversion: Women Pop Artists, 1958–1968*
> *Awakenings: Zen Figure Painting in Medieval Japan*
> *Images in Ivory: Precious Objects of the Gothic Age*

About the first two of these titles, *Pen and Parchment* and *Seductive Subversion*: Alliteration (repetition of an initial letter, here *p* in the first title, *s* in the second) is a fairly common way of getting attention.

A few points about the last title, *Images in Ivory: Precious Objects of the Gothic Age*, may help you conceive a title for a virtual exhibition.

- *"Precious"* is (in a quiet way) something of a come-on; potential visitors are assured they will see costly goods
- if a subtitle is used, as here, the main title is usually short and punchy (*Images in Ivory*), and the subtitle is usually a bit longer, clarifying the title
- the museum assumed that most museum-goers would have at least a rough idea of what "the Gothic Age" implies
- at an early stage in the planning, the curator thought that the subtitle might be *"Piety and Pleasure,* thereby conveying the idea that some of the works displayed were religious objects but that others were frankly secular. The museum's marketing department, however, nixed the idea—please do not forget that museums must operate within budgets—partly because it feared that the word *piety* might turn off some of the potential audience, and partly because it thought there was something kinky about combining "piety" with "pleasure."

The subtitle of an exhibition often conveys the special angle that the curator is offering. Thus, although the main title of

> *Picasso and Portraiture: Representation and Transformation*

clearly lets viewers know what they can expect, it doesn't suggest the curator's distinctive idea. The subtitle indicates that something special is going on. Admittedly the subtitle does not tell readers exactly what the curator—in this case William Rubin of the Museum of Modern Art—had in mind, but it nevertheless gets our interest. In the introduction to the catalog Rubin says that at the beginning of the twentieth century

> It was assumed that the *raison d'être* of a portrait was to communicate the appearance and personality of the sitter. By redefining the portrait as a record of *the artist's personal responses* to the subject, Picasso transformed it from a purportedly objective document into a frankly subjective one. (13)

There it is. Now, having encountered "transformed," we understand why *Transformation* is in the subtitle: Rubin believes that Picasso transformed the genre of portraiture from an art of observation to an art of expression. And indeed Rubin's choice of material helped him argue his thesis. Whenever possible, he chose to exhibit several portraits of the same person so that viewers would see not so much the changes in the faces wrought by *time* but the changes that (for instance) show *the artist* cooling in his affection for a mistress.

2. Let's now consider the **Big Idea, the brief statement giving the gist of the idea of the exhibition.** Here is such a statement as it appears online at the site of the Museum of Fine Arts, Boston. It describes what was then (early 2010) a current exhibition.

Under the Skin: Tattoos in Japanese Prints

> Tattooing became an important feature of Japanese urban popular culture in the early 19th century, influenced strongly by the success of a series of woodblock prints featuring Chinese martial arts heroes with spectacular tattoos, vividly imagined by the artist Utagawa Kuniyoshi. Tattoo artists copied designs from the prints and invented new designs that were, in turn, depicted in later prints. "Under the Skin: Tattoos in Japanese Prints" explores the social background, iconography, and visual splendor of Japanese tattoos through some seventy prints, postcards, books, and manuscripts that helped carry the art from the streets of 19th-century Japan to 21st-century tattoo shops all over the world.°

Here is a slightly fuller description of another exhibition, from the same museum and at the same time.

Object, Image, Collector:
African and Oceanic Art in Focus

> By juxtaposing pieces from Africa and Oceania selected from private collections with photographs, "Object, Image, Collector" explores the

° *Under the Skin: Tattoos in Japanese Prints* published by the Museum of Fine Arts, Boston. Reproduced by permission.

complex intertwining of the histories of these objects, photography, and collecting. Objects from the African continent and the Pacific came to Europe and the United States during the nineteenth and twentieth centuries. In their places of origin these objects may have served in rituals, denoted prestige, or have been utilitarian in nature, but they became endowed with different meanings after they arrived in the West, eventually metamorphosing from artifacts into works of art in the early decades of the twentieth century. How did this change in focus come about?

In a vibrant visual narrative, "Object, Image, Collector" explores photography's role in the promotion and recognition of African and Oceanic objects as art. Three-dimensional works, among them figurative sculpture, masks, and utilitarian objects selected from twenty-one private Boston-area collections, some displayed in public for the first time, are complemented by images from several important photographic endeavors, among them projects by American modernists Charles Sheeler and Walker Evans. With examples of art books and teaching materials, the exhibition also demonstrates the impact of photographic illustrations on creating a classical canon of African and Oceanic art, and how collectors—and museums—regard them today.[*]

These examples give you an idea of the genre, though in your own statement you will probably omit the sales pitch ("vibrant visual narrative") and the acknowledgments to the donors ("generously supported").

Here is another example of a posting on a museum's Web site, a brief description of an exhibition held at the National Gallery, Washington, D.C., in the spring and summer of 2010. (The choice here of an exhibition of a little-known artist is deliberate.)

Hendrick Avercamp: The Little Ice

In the first exhibition devoted to Dutch landscape artist Hendrick Avercamp (1585–1634), scenes of skating, sleigh rides, and outdoor games on frozen canals and waterways bring to life the lively pastimes and day-to-day bustle of the Golden Age. Displayed in the intimate Dutch Cabinet Galleries, some 14 paintings and 16 drawings capture the harsh winters of the period and the activities they made possible. Avercamp—the first artist to specialize in painting winter landscapes that feature people enjoying themselves on the ice—made the "ice scene" a genre in its own right. Within these winter scenes is a social narrative as well: unencumbered by status, all classes formed one community on the ice. Avercamp was also an outstanding draftsman who made individual figure studies that he utilized not only in his painted work but also in compositional drawings.

[*]*Object, Image, Collector: African and Oceanic Art in Focus* published by the Museum of Fine Arts, Boston. © Museum of Fine Arts, Boston. Reproduced by permission.

The writer has given us a good idea of

- the physical feel of the exhibition ("some 14 paintings and 16 drawings"),
- the sort of thing Avercamp did (winter recreation scenes), and
- the two reasons why we ought to be interested in him ("the first artist to specialize in painting winter landscapes that feature people enjoying themselves on ice," "an outstanding draftsman").

Your instructor may ask you to try your hand at drafting a press release that might appear in a local newspaper or on the museum's Web site.

3. **An introductory text, about 300 words—perhaps five or six paragraphs**—will give the visitor to the exhibition a fuller idea of what to expect. It may even indicate that in the first gallery the visitor will find . . . , in the second gallery . . . , and in the third. . . . Don't worry that some of the wording here may duplicate some of the wording of the shorter statement. We can imagine the shorter statement as a posting on a Web site, the longer statement as a wall panel in a museum. A museum's design department often determines the size of the panels. One other point: The introductory panel, orienting the viewer to the entire exhibition, may use visual material. Thus, the panel for an exhibition of African textiles might include a map showing the areas from which the textiles come, and it might also include line drawings showing weaving techniques.

Note: Because the text of this panel is relatively long, some readers may be discouraged from reading it. Consider making it more reader-friendly by setting off some of the material with bullets. Sentences with such expressions as "Two types of" or "Three factors" usually lend themselves easily to bulleting.

4. Your **group texts** give you a chance to explain why you have juxtaposed these things. A group text often begins with an eye-catching title. For instance, in 2011 at Tufts University, an exhibition entitled *Seductive Subversion: Women Pop Artists, 1958–1968* arranged the material under four headings, one of which was described thus:

Heroes, Heartbreaks, and Thugs

> This section groups together stereotypical images of masculinity such as the businessman, the gangster, the pop singer/idol, the cowboy, and the President, alongside powerful male icons such as Babe Ruth, John Wayne, and King Kong to show how keenly aware women artists were of the pervasiveness of romanticized heroic and "bad boy" images of male power in the mass media, which they felt compelled to critique.

5. If you prepare the **general comments for an audio-guide** instead of the text for wall panels, remember that spoken language is not the same as written language. You do not want to be someone who "talks like a book." The spoken language probably will be a trifle less formal; for instance, the audio-guide may include contractions ("Van Gogh didn't stay long at Arles") whereas the printed material probably will not ("Van Gogh did not stay long at Arles"). After you have drafted your comments, read them aloud and make sure that you feel comfortable speaking them.

6. **Labels** are discussed on pages 309–10. Until fairly recently, most labels gave only minimal information—name of artist, title, date, medium, dimensions—because it was felt that longer labels would distract or overload the viewer. These so-called tombstone labels in effect gave a tight-lipped, minimal answer to the question, "What am I looking at?" In the last few years many museums—much concerned with what administrators call "visitor engagement" or "audience engagement"—have been moving toward somewhat longer, more friendly labels, "chat labels." Usually about fifty or seventy-five words, chat labels go beyond tombstone labels, and they answer a different question: "Why should I care about what I am looking at?"

Here is an example (largely derived from information in Rebecca Bedell's essay, pages 138–45) of a chat label for John Singleton Copley's *Portrait of Mrs. Ezekiel Goldthwait* (page 140). After the tombstone material, the label might say:

> Mrs. Goldthwait, the wife of a wealthy Boston merchant, was known for her skill as a gardener. The abundant fruit on the table is a sign of her horticultural accomplishments and also of her fertility and—to put it tactfully—her physical abundance. The slight smile on her brightly illuminated face suggests that she may offer a piece of fruit to an appreciative visitor. The skillfully painted satin and lace, and indeed the column and the polished table itself convey the prosperity of this merchant's wife, but Copley has also emphasized her engaging warmth.

7. **Brief audio-guide comments on individual works** should be governed by the same consideration mentioned a moment ago in talking about longer comments (item 5): Make certain that you do not sound pompous.

8. The **floor plan** is not for your imagined visitor but for yourself, to make certain that you are aware of how one work relates to the next. *Where* a given work is placed can be immensely important: A classic example is *Winged Victory (Nike) of Samothrace*, a statue at the top of a great stairway in the Louvre in Paris. No museum space—not even the so-called "white cube"—is truly neutral. Whatever the space, it helps to shape a viewer's response to the objects it contains.

Consider the tiny image of *The Buddha at Birth,* illustrated on page 151. This sculpture, only a bit over three inches tall, was exhibited in Washington in the first gallery of an exhibition of Japanese Buddhist art. Visitors entered the small circular gallery—a sort of anteroom about fifteen feet in diameter— and saw, in the center of the room, a gilt-bronze image isolated in a Plexiglas vitrine. Hanging on the surrounding gallery walls were scrolls bearing the words of the Buddha. The effect was stunning: The tiny sculpture— its sacredness doubly emphasized by its *isolation* and by its *central position*—seemed to radiate its spiritual messages throughout the room. A third, obvious, way to emphasize an object is to focus light on it. (On the significance of presentation as meaning, see Victoria Newhouse's book, *Art and the Power of Placement* [2005].)

For a second example of the significance of an exhibition's layout, we can return to *Picasso and Portraiture*. The sequence was chiefly chronological, but if this principle had been strictly adhered to, the exhibition would have ended relatively weakly. The curator wisely avoided an anticlimactic ending by putting all of Picasso's *self*-portraits—and these include some great early works—into the final gallery. The exhibition thus ended with a powerful reaffirmation of its thesis that the portraits are ultimately really all about Picasso. In short, curators are not bound by chronology; the fact that a work is a masterpiece is often good enough reason to violate a chronological arrangement.

9. **Kids' stuff, material for youngsters,** is of various sorts, depending on the ages of the youngsters. (Educators at museums usually distinguish three groups: elementary school students, middle school students, and high school students.) Children are often sent on a treasure hunt in which they are given a list that asks them to locate images of certain kinds of things, such as animals, food, and persons playing games or doing specific kinds of work or wearing crowns. For middle school and for high school students, assignments may include writing short essays.

Exhibitions of armor seem to be sure-fire attractions, perhaps especially for boys but also for many girls. A handout for this material might ask the viewers to think about such things as

- What sort of damage does this weapon do? How would you hold the weapon?
- This armor protects, but does it also greatly reduce ability to move and therefore endanger the wearer? How might you feel if you wore this suit of armor? Confident, but terribly confined?
- Why do you suppose the armor is decorated? After all, the decoration doesn't add protection. Or does what seems to be mere decoration—let's say a shield that shows a cross, or an Islamic helmet with a passage from the Qur'an, Islam's sacred book—

perhaps also offer protection? Or is the armor perhaps *all* deco-
ration, something for show and not really something to be worn
in battle?

For an exhibition of photographic portraits, middle school and high
school students visiting the Museum of Fine Arts, Boston, were asked to
write about these topics:

- What do you think the person portrayed thought about himself or
 herself?
- What do you think the photographer thought about the person?
- If you could meet this person, what questions would you ask?

Let's take another topic, persons playing games, and briefly imagine
an exhibition that shows people playing cards. In fact, in 2011 the
Metropolitan Museum of Art staged an exhibition concerned with
Cézanne's paintings of card players, along with preliminary drawings
as well as earlier Flemish and Dutch etchings. Some of the earlier etchings,
showing card players cheating or behaving raucously associate card
playing with the vices of drinking and gambling. One of Cézanne's
paintings is reproduced on the cover of this book.

One college student, assigned to produce a hand-out for high school
viewers, came up with the following material.

1. What is your favorite game—perhaps a card game, but perhaps
 a computer game? Why do you play it? What pleasures does the
 game offer? Here are some possible responses.

 - the pleasure of concentrating on one thing and making the rest
 of the world disappear for a few moments
 - the pleasure of developing a skill
 - The pleasure of sharing an experience with a fellow player
 - the pleasure of competing and especially of winning, of coming
 out on top
 - the pleasure of killing some time, of pushing away boredom
 - Do you think this painting conveys anything like your own
 response to playing a game? Explain.

 Can you add any reasons for playing a game, especially a card game? If
 you can, what are these additional reasons?

2. Look closely at the painting on the cover, and then write your responses
 to the following questions—perhaps a sentence or two for each.

 - The man at the right is slightly more hunched, and his arms
 extend further over the table than the man at the left. Do you

agree with the suggestion of one scholar that his body suggests he is exerting more physical effort in the act of playing—in the act of thinking about the game—than the man at the left? That is, would you say that playing the game is harder for the man at the right than for the man at the left? (For a notable example of a work of art that uses body language to convey the act of strenuous thinking, see Rodin's statue, *The Thinker*. If you are not familiar with *The Thinker*, you can easily find a reproduction via a search engine.)

- If you agree that the body language of the man at the right suggests something of a strain, are you therefore inclined to say that although he probably is an eager player, he is evidently less at ease playing, probably a sign that he is a less skilled player than his opponent?

- The man at the left smokes a pipe, and he wears a hat that seems stiffer, more precisely shaped, than his opponent's hat. Do you make anything out of these details? Do you think that clothing reveals personality? Support your answer with examples of clothing that you wear—and examples of clothing that you would not be caught dead in. What do you think of the clothing that your teachers wear?

- Cézanne belonged to a prosperous family of bankers. His models for his pictures of card players were peasants, some of whom are known to have been employed on his family's estate. Do you think Cézanne, who was socially far above the peasants who worked for his family, looks down on the two men in this painting? Why do you take the position that you do?

Bibliographic Note: The standard text concerning labels is Beverly Serrell, *Exhibit Labels: An Interpretive Approach* (Walnut Creek, CA.: Alta Mira Press, 1996). If time permits, you may want to look at a collection of essays, *Museums in a Digital Age*, ed. Ross Parry (London: Routledge, 2009). Some of the essays are difficult, but Parry provides helpful introductions. You may find especially useful Jennifer Trant's essay on virtual exhibitions.

9

HOW TO WRITE AN EFFECTIVE ESSAY

I love being a writer. What I can't stand is the paperwork.

—Peter de Vries

Writing is a craft. You have to take your apprenticeship in it like anything else.

—Katherine Anne Porter

A writer is someone for whom writing is more difficult than it is for other people.

—Thomas Mann

Earlier pages have touched on aspects of the writing process, but now is the time for a fuller discussion.

THE BASIC STRATEGY

- Choose a topic and a tentative thesis.
- Generate ideas, for instance, by asking yourself questions.
- Make a tentative outline of points you plan to make.
- Rough out a first draft, working from your outline (don't worry about spelling, punctuation, etc.) but don't hesitate to depart from the outline when new ideas come to you in the process of writing.
- Make large-scale revisions in your draft by reorganizing, or by adding details to clarify and support assertions, or by deleting or combining paragraphs.
- Make small-scale revisions by revising and editing sentences.
- Revise your opening and concluding paragraphs. Make certain that these paragraphs are *interesting*, not mere throat-clearing.
- Have someone read your revised draft and comment on it.
- Revise again, taking into account the reader's suggestions.
- Read this latest version and make further revisions as needed.
- Proofread your final version.

All writers must work out their own procedures and rituals, but the following basic suggestions will help you write effective essays. They assume that you take notes using note-taking software, but you can easily adapt the principles if you prefer taking notes on index cards. If your paper involves using sources, consult also Chapter 13, "Writing a Research Paper."

LOOKING CLOSELY: APPROACHING A FIRST DRAFT

1. **Look at the work or works carefully.**
2. **Choose a worthwhile and compassable subject,** something that interests you and is not so big that your handling of it must be superficial. As you work, shape your topic, narrowing it, for example, from "Egyptian Sculpture" to "Black Africans in Egyptian Sculpture," or from "Frank Lloyd Wright's Development" to "Wright's Johnson Wax Company as an Anticipation of His Guggenheim Museum."
3. **Keep your purpose in mind.** Although your instructor may ask you, perhaps as a preliminary writing assignment, to jot down your early responses—your initial experience of the work—it is more likely that he or she will ask you to write an analysis in which you will connect details and draw inferences. Almost surely you will be asked to do more than report your responses or to write a description of an object; you probably will be expected to support a *thesis*, that is, to make a claim and to support it with evidence. In short, to offer an *argument*. Your thesis might be, for instance, that although the work of art had such-and-such a meaning for its original viewers, it means something very different for viewers today.

Don't expect to have a sound thesis at the very beginning of your work on the essay. The thesis will probably come to you only after you have done some close looking, and have stimulated ideas by asking yourself questions. Almost surely you will see that the initial thesis needs to be modified in the light of evidence that you encounter. In short, your thesis will evolve in the course of thinking about what you are looking at.

Obviously an essay that evaluates a work not only offers a judgment but also supports the judgment with evidence. Yet even a formal analysis presents an argument, holding that the work is constructed in such-and-such a way and that its meaning (or one of its meanings) is communicated by the relationships between the parts.

In thinking about your purpose, remember, too, that your *audience* will in effect determine the amount of detail that you must give. Although your instructor may in reality be your only reader, probably you should imagine

that your audience consists of people pretty much like your classmates—intelligent but not especially familiar with the topic on which you have recently become a specialist.

4. **Keep looking at the art** you are writing about (or reproductions of it), jotting down notes on all relevant matters.

- You can generate ideas by asking yourself questions such as those given on pages 77–131.
- As you look and think, reflect on your observations and record them.
- If you are going to write about an object in a museum that you are visiting, choose an object that is reproduced on a postcard; the picture will help you to keep the object in mind when you are writing in your room. If you can't find a postcard, check the museum's Web site to see if the museum has posted the object.
- When you have an idea, jot it down; don't assume that you will remember it when you begin writing. Note-taking software such as SuperNoteCard works well for this, but many people prefer to use index cards. Sometimes ideas come when we are not actively working; a smartphone can be an ideal tool for taking notes when an idea strikes you.
- Put only one point on each card, and give each card a caption (e.g., Site of *David*); later you can arrange and categorize the cards so that the relevant notes are grouped together.

5. **When taking notes from secondary sources, do not simply copy and paste.**

- Take brief notes, *summarizing* important points and jotting down your own critiques of the material.
- Read the material analytically and thoughtfully, with an open mind and a questioning spirit.
- When you read in this attentive and tentatively skeptical way, you will find that the material is valuable not only for what it tells you but also for the ideas that you yourself produce in responding to it. Be sure, in your notes, to indicate which notes are summaries of the source and which notes are your own responses.

Writing your paper does not begin when you sit down to write a draft; rather, it begins when you write your first thoughtful notes.

6. **Sort out your note cards, putting together what belongs together.** Three separate cards with notes about the texture of the materials of a building, for instance, probably belong together. Reject cards irrelevant to your topic.

7. **Organize your cards into a reasonable sequence.** Your cards contain ideas (or at least facts that you can think about); now the cards have to be put into a coherent sequence. When you have made a tentative

arrangement, review it; you may discover a better way to group your notes, and you may even want to add to them. If so, start reorganizing.

A tripartite organization usually works. For this structure, tentatively plan to devote your opening paragraph(s) to a statement of the topic or problem and a proposal of your hypothesis or thesis. The essay will then take this shape:

- a beginning, in which you identify the work(s) of art that you will discuss, giving the necessary background and, in a sentence or two, setting forth your underlying argument, your thesis
- a middle, in which you develop your argument, chiefly by offering evidence
- a conclusion, in which you wrap things up, perhaps by giving a more general interpretation or by setting your findings in a larger context. (On concluding paragraphs, see pages 222–24.)

In general, organize the material from the simple to the complex in order to ensure intelligibility. If, for instance, you are discussing the composition of a painting, it probably will be best to begin with the most obvious points and then to turn to the subtler but perhaps equally important ones. Similarly, if you are comparing two sculptures, it may be best to move from the most obvious contrasts to the least obvious. When you have arranged your notes into a meaningful sequence of packets, you have approximately divided your material into paragraphs.

8. **Get it down on paper.** Most essayists find it useful to jot down some sort of **outline**, a map indicating the main idea of each paragraph and, under each main idea, supporting details that give it substance. An outline—not necessarily anything highly formal, with capital and lower-case letters and roman and arabic numerals, but merely key phrases in some sort of order—will help you to overcome the paralysis called "writer's block" that commonly afflicts professional as well as student writers. For an example of a student's rough outline, see the jottings on page 58 that were turned into an essay on the sculpture *Seated Statue of Prince Khunera as a Scribe*.

A page of paper with ideas in some sort of sequence, however rough, ought to encourage you that you do have something to say. And so, despite the temptation to sharpen another pencil or to have another cup of coffee or to get some new software, the best thing to do at this point is to follow the advice of Isaac Asimov, author of 225 books: "Sit down and start writing."

If you don't feel that you can work from note cards and a rough outline, try another method: Get something down on paper, writing (preferably on a word processor) freely, sloppily, automatically, or whatever, but allow your ideas about what the work means to you and how it conveys its meaning—rough as your ideas may be—to begin to take visible form. If you are like most people, you can't do much precise thinking until you have committed

to paper at least a rough sketch of your initial ideas. At this stage you are try-ing to find out what your ideas are, and in the course of getting them down on paper you will find yourself generating new ideas. We *think* with words. Later you can push and polish your ideas into shape, perhaps even deleting all of them and starting over, but it's a lot easier to improve your ideas once you see them in front of you than it is to do the job in your head. On paper one word leads to another; in your head one word often blocks another.

Just keep going; you may realize, as you near the end of a sentence, that you no longer believe it. Okay; be glad that your first idea led you to a better one, and pick up your better one and keep going with it. What you are doing is, in a sense, by trial and error pushing your way not only toward clear expression but also toward sharper ideas and richer responses.

REVISING: ACHIEVING A READABLE DRAFT

Revision is "re-vision," "re-seeing" your work, and re-seeing your work almost always means rewriting it extensively. (The Golden Rule: Good writing is *re*writing.) In writing your first draft you were largely concerned with looking into yourself, finding out what you thought about the topic. But now, in revising, you are taking another look, and much of this look should be from a *reader's* point of view because, after all, a reader will be looking at your essay.

1. **Keep looking and thinking,** asking yourself questions that a reader might raise, and keep providing tentative answers, searching for additional material that strengthens or weakens your main point, and take account of it in your outline or draft.

Now is probably the time to think about a title for your essay. It is usu-ally a good idea to let your reader know what your topic is—which works of art you will discuss—and what your approach is, for instance, "A Formal Analysis of *Prince Khunera as a Scribe*," or "Van Gogh's *Self-Portrait as a Priest:* A Psychoanalytic Approach." At this stage your title is still tentative, but thinking about a title will help you to organize your thoughts and to determine which of your notes are relevant and which are not. Remember, the title that you settle on is the first part of the paper that your reader encounters. You will gain the reader's goodwill by providing a helpful, inter-esting title. But be careful not to go too far in an effort to hook the reader. "Whistler's Japanese Mother" (see page 14) is about as far as a writer can safely go.

2. **With your outline or draft in front of you, write a more lucid version,** checking your notes for fuller details. You probably wrote your

draft on a computer, but don't try to revise it now merely by reading the monitor. *Print a hard copy* and revise it with pen or pencil. You need to read the essay more or less as your instructor will read it. True, the process of revising by hand takes more time than revising on a computer, but time is exactly what you need to devote to the process of revision. When you wrote your first draft, you perhaps were eager to pour out words, to find out what you thought, what you knew, what you didn't know, but now, in the revising stage, you need to write slowly, thoughtfully. Later you will type the hand-written revisions into the computer.

In revising an early draft it is probably best to start by concentrating on *large-scale revisions*—reorganization, additions (for instance, you may now see that you need to define a term, or to give an example), and deletions (you may see that some sentences or paragraphs are redundant or irrelevant).

Although it is best to start with large-scale revisions (i.e., with what teachers of composition somewhat grandly call "global revision"), the truth is that when most writers revise, whether they are experienced or inexperienced, they do not proceed methodically. Rather, they jump around, paying attention to whatever attracts their attention at the moment, like a dog hunting for fleas, and that's not a bad way to proceed. Still, here we can say that one might at least plan to work in the following sequence:

- **Introductory matters:** Make sure that your title and opening paragraph(s) give your readers an idea of where you will be taking them. Is your thesis evident?
- **Matters of organization:** If some of your material now seems to be in the wrong place, cut and paste. The Golden Rule: "Put together what belongs together." Is your concluding paragraph conclusive without being merely repetitive?
- **Evidence:** Make sure that your assertions are supported by evidence, and that your evidence is of varying sorts, ranging from details in the works that you are talking about to quotations from appropriate sources.
- **Coherence** in sentences, in paragraphs, and between paragraphs. Usually this is a matter of adding transitional words and phrases (*furthermore, therefore, for instance, on the other hand*).
- **Tone:** Remember, your sentences inevitably convey information not only about your topic but about you yourself. Do the sentences suggest stuffiness? Or on the other hand are they too informal, inappropriately casual?
- **Editorial matters:** Check the spelling of any words that you are in doubt about, check the punctuation, and check the form of footnotes and bibliography (list of works cited).

If you find that some of the points in your earlier jottings are no longer relevant, eliminate them; but make sure that the argument flows from one point to the next. It is not enough to keep your thesis in mind; you must keep it in the reader's mind. As you write, your ideas will doubtless become clearer, and some may prove to be poor ideas. (We rarely know exactly what our ideas are until we set them down on paper. As the little girl said, replying to the suggestion that she should think before she spoke, "How do I know what I think until I see what I say?") Not until you have written a draft do you really have a strong sense of what you feel and know, and of how good your essay may be.

If you have not already made an outline at this stage, it is probably advisable to make one, to ensure that your draft is reasonably organized. Jot down, in sequence, each major point and each subpoint. You may find that some points need amplification, or that a point made on page 3 really ought to go on page 1.

Later you will concern yourself with *small-scale revisions* (polishing sentences, clarifying transitions, varying sentence structure if necessary, checking spelling and documentation).

3. **After a suitable interval, preferably a few days, again revise and edit the draft.** To write a good essay you must be a good reader of the essay you are writing. We're not talking at this stage about proofreading or correcting spelling errors, though you will need to do that later. Van Gogh said, "One becomes a painter by painting." Similarly, one becomes a writer by writing—and by rewriting, or revising. In revising their work, writers ask themselves such questions as

- Do I mean what I say?
- Do I say what I mean? (Answering this question will cause you to ask yourself such questions as, Do I need to define my terms? Add examples to clarify? Reorganize the material so that a reader can grasp it?)

✍ A RULE FOR WRITERS:

Put yourself in the reader's shoes to make sure that the paper not only has an organization but also that the organization will be clear to your reader. If you imagine a classmate as the reader of the draft, you may find that you need to add transitions ("for example," "on the other hand"), clarify definitions, and provide additional supporting evidence.

During this part of the process of writing, read the draft in a skeptical frame of mind. You engaged in critical thinking if you made use of sources.

Apply the same questioning spirit to your own writing. In taking account of your doubts, you will probably unify, organize, clarify, and polish the draft.

- **Unity** is achieved partly by eliminating irrelevancies. These may be small (a sentence or two) or large (a paragraph or even a page or two). You wrote the material and you are fond of it, but if it is irrelevant you must delete it.
- **Organization** is largely a matter of arranging material into a sequence that will assist the reader to grasp the point. *Suggestion:* If you reread your draft and jot down a paragraph outline—a series of sentences, one under the other, each sentence summarizing one paragraph—you can then see if the draft has a reasonable organization, a structure that will let the reader move easily from the beginning to the end.
- **Clarity** is achieved largely by providing concrete details, examples, and quotations to support generalizations, and by providing helpful transitions ("for instance," "furthermore," "on the other hand," "however").
- **Polish** is small-scale revision. Delete unnecessary repetitions, combine choppy sentences into longer sentences, and break overly long sentences into shorter sentences.

If you have written your draft on a word processor, do *not* try to revise it on the monitor. Print the entire draft, and then read it—as your reader will be reading it—page by page, not screen by screen. Almost surely you will detect errors in a hard copy that you miss on the screen. Only by reading the printed copy will you be able to see if, for instance, paragraphs are too long.

After producing a draft that seems good enough to show to someone, writers engage in yet another activity. They edit. **Editing** includes such work as checking the accuracy of quotations by comparing them with the original, checking a dictionary for the spelling of doubtful words, and checking a handbook for doubtful punctuation—for instance, whether a comma or a semicolon is needed in a particular sentence.

✔ Checklist for Revising a Draft

Have I asked myself the following questions?

- ❑ Does the draft fulfill the specifications (e.g., length, scope) of the assignment?
- ❑ Does the draft have a point, a focus?
- ❑ Is the title interesting and informative? Does it create a favorable first impression?

❏ Are the early paragraphs engaging, and do they give the reader a fairly good idea of what will follow, perhaps by naming the works of art and the approach?

❏ Are arguable assertions supported with evidence?

❏ Are your readers kept in mind, for instance, by defining terms that they may be unfamiliar with?

❏ If any quotations are included, are they adequately introduced rather than just dumped into the essay? Are quotations as brief as possible? Might summaries (properly credited to the sources) be more effective than long quotations?

❏ Are *all* sources cited, including Internet material?

❏ Is the organization clear, reasonable, and effective? (Check by making a quick outline.)

❏ Does the final paragraph nicely round off the paper, or does it merely restate—unnecessarily—what is by now obvious?

❏ Does the paper include whatever visual materials the reader needs to see?

PEER REVIEW

Your instructor may encourage (or even require) you to discuss your draft with another student or with a small group of students. That is, you may be asked to get a review from your peers. Such a procedure is helpful in several ways. First, it gives the writer a real audience, readers who can point to what pleases or puzzles them, who make suggestions, who may often disagree (with the writer or with each other), and who frequently, though not intentionally, *misread*. Though writers don't necessarily like everything they hear (they seldom hear "This is perfect. Don't change a word!"), reading and discussing their work with others almost always gives them a fresh perspective on their work, and a fresh perspective may stimulate thoughtful revision. (Having your intentions *misread*, because your writing isn't clear enough, can be stimulating.) But remember, a peer review is useful only if the reviewer is frank. If you are a reviewer, and you cannot bring yourself to tell your friends unpleasant truths, you are not doing your job as a reviewer.

 Note: It's not a bad idea for you to ask *yourself* these questions before you give a draft to a fellow student.

✔ Checklist for Peer Review

Read each draft once quickly. Then read it again and jot down brief responses to the following questions. Remember: Your job is *not* to rewrite the paper but only to offer suggestions that will help the author strengthen it.

Have I asked myself the following questions?

- ❑ What is the essay's topic? Is it one of the assigned topics or a variation of one of them? Is the title appropriate? Does the draft show promise of fulfilling the assignment?
- ❑ Looking at the essay as a whole, what *thesis* (main idea) is stated or implied? If implied, try to state it in your own words.
- ❑ Is the thesis plausible? How might it be strengthened? Is the structure of the essay clear and effective? Does the writer provide adequate guidance, for instance by means of such transitions as "for example," "on the other hand," and "we will see"?
- ❑ Looking at each paragraph separately:
 - ❑ What is the basic point?
 - ❑ How does each paragraph relate to the essay's main idea or to the previous paragraph?
 - ❑ Should some paragraphs be deleted? be divided into two or more paragraphs? be combined? be put elsewhere? (If you outline the essay by jotting down the gist of each paragraph, you will get help in answering these questions.)
 - ❑ Is each sentence clearly related to the sentence that precedes and to the sentence that follows?
 - ❑ Is each paragraph adequately developed? Are there sufficient details to support the generalizations?
 - ❑ Are the introductory and concluding paragraphs effective?
- ❑ Are the necessary illustrations included, and are they adequately identified?
- ❑ Is the writer's tone appropriate?
- ❑ What are the paper's chief strengths?
- ❑ Make at least two specific suggestions that you think will assist the author to improve the paper.

The writer whose work is being reviewed is not the sole beneficiary. When students regularly serve as readers for each other, they become better readers of their own work and consequently better revisers, which is to say that they become better writers. And, as you probably know, learning to write is in large measure learning to read.

✍ A RULE FOR WRITERS:

Good writing is rewriting. (Attributed to Truman Capote)

If peer review is a part of the writing process in your course, the instructor may distribute a sheet with suggestions and questions. The preceding checklist is an example of such a sheet.

PREPARING THE FINAL VERSION

1. **If you have received comments from a reader, consider them carefully.** Even if you disagree with them, they may alert you to places in your essay that need revision, such as clarification.

In addition, if a friend, a classmate, or another peer reviewer has given you some help, acknowledge that help in a footnote or endnote. (If you look at almost any book or any article in *The Art Bulletin,* you will notice that the author acknowledges the help of friends and colleagues. In your own writing follow this practice.) Here are sample acknowledgments from papers by students:

> I wish to thank Anna Aaron for numerous valuable suggestions.

> I wish to thank Paul Gottsegen, Geoff Sandy, and Howard Tse for calling my attention to passages that needed clarification, and Jane Leslie for suggesting the comparison with Orozco's murals at Dartmouth College.

> Emily Andrews called my attention to recent studies of Mayan art.

> I am indebted to Louise Cort for explaining how Shigaraki ceramics were built and fired.

2. **Write, type, or print a clean copy,** following the principles concerning margins, pagination, footnotes, and so on, set forth in Chapter 14.

3. **If you have borrowed any ideas, be sure to give credit,** usually in footnotes, to your sources. Remember that plagiarism is not limited to the unacknowledged borrowing of words; a borrowed idea, even when put into your own words, requires acknowledgment. (On giving credit to sources, see pages 295–96, 327–35.)

4. **Proofread and make corrections.**

In short, ask these questions:

- Is the writing true (do you have a point that you state accurately)?
- Is the writing good (do your words and your organization clearly and effectively convey your meaning)?

All of this adds up to a recipe in a famous Victorian cookbook: "First catch your hare, then cook it."

10

STYLE IN WRITING

Style in writing, as in painting, is the author's thumbprint.

—Mavis Gallant

To me, style is first the outside of content, and content the inside of style, like the outside and inside of the human body—both go together, they can't be separated.

—Jean-Luc Godard

To improve one's style means to improve one's thoughts.

—Friedrich Wilhelm Nietzsche

Have something to say, and say it as clearly as you can. That is the only secret of style.

—Matthew Arnold

PRINCIPLES OF STYLE

Writing is hard work (Lewis Carroll's school in *Alice's Adventures in Wonderland* taught reeling and writhing), and there is no point in fooling ourselves into believing that it is all a matter of inspiration. Many of the books that seem, as we read them, to flow so effortlessly were in fact the product of innumerable revisions. "Hard labor for life" was Joseph Conrad's view of his career as a writer. This labor, for the most part, is not directed to prettifying language but to improving one's thoughts and then getting the words that communicate these thoughts exactly. There is no guarantee that effort will pay off, but failure to expend effort is sure to result in writing that will strike the reader as confused. It won't do to comfort yourself with the thought that you have been misunderstood. You may know what you *meant to say,* but your reader is the judge of what indeed you *have said.* Keep in mind Henri Matisse's remark: "When my words were garbled by critics or colleagues, I considered it my fault, not theirs, because I had not been clear enough to be comprehended."

Many books have been written on the elements of good writing, but the best way to learn to write is to

- do your best,
- show your draft to a friend,
- think about the responses and
- revise accordingly;
- a few days later read your paper *aloud* (you will often catch small errors) and revise as needed;
- hand in the corrected copy, and then
- study the annotations an experienced reader put on your essay.

In revising the annotated passages, you will learn what your weaknesses are in writing. After drafting your next essay, put it aside for a day or so, then reread it, preferably aloud. You may find much that bothers you. (If you read it aloud, you will probably catch choppy sentences, needless repetitions, and unpleasant combinations of words, such as "We see in the sea. . . .") If the argument does not flow, check to see whether (a) your organization is reasonable and (b) you have made it clear to readers by means of adequate transitions, such as "furthermore," "however," and "by way of comparison," so that your readers can easily follow your argument. Do not hesitate to delete interesting but irrelevant material that obscures the argument. Make the necessary revisions again and again if there is time. Revision is indispensable if you wish to avoid (in Somerset Maugham's words) "the impression of writing with the stub of a blunt pencil."

Even though the best way to learn to write is by writing and by heeding the comments of your readers, a few principles can be briefly set forth here. These principles will not suppress your particular voice; rather, they will get rid of static, enabling your voice to come through effectively. You have something to say, but you can say it only after your throat is cleared of "Well, what I meant was" and "It's sort of, well, you know." Your readers do *not* know; they are reading in order to know. This chapter will help you let your individuality speak clearly.

GET THE RIGHT WORD

Denotation

Be sure the word you choose has the right explicit meaning, or denotation. Don't say "carving" when you mean "modeling," or "print" (a hand-produced picture transferred from a printing surface to a piece of paper or cloth) when you mean a photographic reproduction of a painting.

Sometimes the word will depend on your point of view. For many English people, Lord Elgin from 1801 to 1812 "acquired" or maybe "collected" or even "rescued" the mid-fifth-century B.C. Greek sculptures that are now called the Elgin Marbles and are housed in the British Museum, but so far as most Greeks are concerned, Elgin "stole" or "looted" (rather than acquired or collected or rescued) these works, and the works are properly called (in the Greek view) "the Parthenon frieze sculptures," or "the Acropolis sculptures," *not* "the Elgin Marbles."

Connotation

Be sure the word you choose has the right association or implication—that is, the right connotation. Here is an example of a word with the wrong connotation for its context: "Close study will *expose* the strength of Klee's style." "Reveal" would be better than "expose" here; "expose" suggests that some weakness will be brought to light, as in "Close study will expose the flimsiness of the composition."

Sometimes our prejudices blind us to the unfavorable connotations of our vocabulary. Writing about African architecture, one student spoke of "mud huts" throughout the paper; a more respectful term for the same type of building would be "clay house" or "earthen compound." When you submit your paper to a colleague for peer review, urge your reviewer to question your use of words that may have inappropriate connotations.

Concreteness

Catch the richness, complexity, and uniqueness of what you see. Do not write "His expression lacks emotion" if you really mean the expression is icy or indifferent. But concreteness is not only a matter of getting the exact word—no easy job in itself. If your reader is (so to speak) to see what you are getting at, you have to provide some details. Instead of writing "The influence of photography on X is small," write "The influence of photography is evident in only six paintings."

Compare the rather boring statement, "Thirteenth-century sculpture was colored," or even "Thirteenth-century sculpture was brightly painted and sometimes adorned with colored glass," with the following richly detailed sentences:

Concrete

> Color was an integral part of sculpture and its setting. Face and hands were given their natural colors; mouth, nose, and ears were slightly emphasized; the hair was gilded. Dresses were either covered in flowers

or painted in vigorous colors; ornaments, buckles, and hems were high-
lighted by brilliant colors or even studded with polished stones or colored
glass. The whole portal looked like a page from an illuminated manu-
script, enlarged on a vast scale.

> —Marcel Aubert, *The Art of the High Gothic Era,*
> trans. Peter Gorge (New York: Crown, 1965), 60

Similarly, in the following passage notice how detailed Robert Hughes is.
He does not simply tell us that in *The Migration Series* Jacob Lawrence
was concerned with "violence and pathos." He goes on to specify "prisons,
deserted villages, city slums, race riots, labor camps." And when he says that
Lawrence's images are "restrained," he goes on to specify a particular image
of a lynching, and he offers details to support his assertion.

> Lawrence was not a propagandist. He eschewed the caricatural appa-
> ratus of Popular Front Social Realism, then at its hightide in America.
> Considering the violence and pathos of so much of his subject matter—
> prisons, deserted villages, city slums, race riots, labor camps—his images
> are restrained, and all the more piercing for their lack of bombast. When
> he painted a lynching, for instance, he left out the dangling body and the
> jeering crowd: there is only bare earth, a branch, an empty noose, and the
> huddled hump of a grieving woman.
>
> —Robert Hughes, *American Visions* (1997), 456

By means of details, Hughes not only makes us see the pictures but he also
convinces us that he knows what he is talking about.

A Note on the Use of "This" Without a Concrete Reference

Avoid using "this" when you mean "what I have been saying." Your reader
does not know if "this" refers to the preceding clause, sentence, paragraph,
or page.

Imprecise

> She did not begin to paint until she was fifty. Moreover, she did not
> try to sell her work until at least ten years later. This proved to have
> advantages.

To what does "this" refer? That she did not try to sell her work for ten
years? That she did not paint until she was fifty? Both? Perhaps something
even earlier in the paragraph? It turned out that "this" refers to the points

made in the first two sentences quoted, and the student successfully revised the third sentence by providing specific references for "this":

Precise and clear because "this" is made specific

> She did not begin to paint until she was fifty. Moreover, she did not try to sell her work until at least ten years later. This late start and lack of concern for the market proved to have advantages.

A Note on Technical Language and on Jargon

Discussions of art, like, say, discussions of law, medicine, the dance, and for that matter, cooking and baseball, have given rise to technical terminology. A cookbook will tell you to blend, boil, or bake, and it will speak of a "slow" oven (300 degrees), a "moderate" oven (350 degrees), or a "hot" oven (400 degrees). These are technical terms in the world of cookery, and no one objects that it is preposterous to define a hot oven as 400 degrees when everyone knows that a hot day is 90 degrees.

In watching a baseball game we find ourselves saying, "I think the hit-and-run is on," or "He'll probably bunt." We use these terms because they convey a good deal in a few words; like "a hot oven," they are clear and precise. Technical language is illuminating—provided (1) it is used accurately, and (2) the audience is familiar with the language. How can an audience not be familiar with language? New ways of thinking—new systems of thought, such as Structuralism and Queer Theory—produce new language, language that is meaningful to the initiated but puzzling to others. Outsiders may object to such language, but their objections may show only that they are unfamiliar with the language that specialists use when they speak concisely to each other.

On the other hand, technical language is sometimes used, needlessly, in an effort to impress readers rather than to communicate clearly. Such pretentious or even meaningless language is jargon. Consider the following sentences, taken almost at random from an essay by a professor of art history who is writing about American Indian baskets made for whites in the early twentieth century. The sentence comes from a collection of essays called *Unpacking Culture: Art and Commodity in Colonial and Postcolonial Worlds*, ed. Ruth B. Phillips and Christopher B. Steiner (Berkeley and Los Angeles: University of California Press: 1999).

> Native curios were privileged in bourgeois parlor decoration as metonymic representations of the premodern, their significations enhanced by hand-made production and utilitarian function, two aspects of the premodern also valorized in the contemporary American Arts and Crafts Movement. (148)

If you are writing for readers who write like this—people who in a single sentence use words like *metonymic, significations*, and *valorized*—you probably will have to write like this. More sensible readers, however, will see that the passage is preposterously inflated and obscure—it sounds like a parody of critical talk.

The sad thing about such dreadful language is that it muffles the writer's voice; if the writer has any individuality, it is utterly suppressed by this highly conventional language, this torrent of needless technical terms. The jargon prevents the writer from sounding like an interesting human being.

Here is a student's revision of the passage, which makes the same points but in a more engaging style.

> Middle-class whites valued native curios and displayed them in their parlors. Because these objects were handmade and because they had been used in daily life, they stood for a pre-industrial world, a world celebrated also in the contemporary American Arts and Crafts Movement.

Your sense of your audience will tell you whether you want your writing to be like the grotesque original passage or like the second version.

What are the chief differences?

- First, there are differences in vocabulary. Instead of "privileged" and "valorized," the revision says "valued"; instead of "metonymic representations" and "the premodern," it says "stood for" and "a pre-industrial world." In short, the revision is closer to ordinary speech, and the speaker therefore comes across as less preposterous.
- Second (and closely related), the original consists of one long sentence of thirty-eight words—quite a mouthful—whereas the two-sentence revision mercifully lets the speaker and the reader take a breath midway.

True, even the proposed revision is colorless, but the idea of this exercise in revision is to make all of the points of the original in a more reader-friendly way, without adding anything new. Try your hand at a somewhat freer version, adding details that will enliven the passage. Here is one student's contribution:

> Contrary to what one might expect, small objects made by American Indians became a staple of middle-class interior decoration in the late nineteenth and early twentieth centuries. Although the objects were inexpensive, they were valued because in a world in which almost everything else was machine-made, they were handmade, pretty, and often useful.

In writing about art you will, for the most part, use the same language that you use in other courses. You will not needlessly introduce unusual words, but you will use the language of art history *when it enables you to be clear, concise, and accurate.* Some specialized words are known to most native speakers ("etching," "perspective," "still life"); some are known chiefly to highly educated people ("bas relief," "gouache," "vellum"), and some are known only to people who have read a fair amount of critical theory concerning art or literature ("episteme," "poststructuralism," "semiotics"). Obviously readers who for the first time encounter the word "episteme" are aware that they are in new territory, and if the writer has not offered a helpful definition, they either try to understand the word from the context, or they consult a reference work.

Another sort of technical word is more dangerous, a word like "hot," which means one thing when talking about the weather and another thing when talking about an oven. For instance, among the words that look innocent but that recently have acquired highly technical meanings in discussions of art are "appropriation," "code," "discourse," "erasure," and "fetish." How technical? "Fetish" gets a two-and-a-half-page discussion in *Artwords* (1997), a dictionary of current critical terms by Thomas Patin and Jennifer McLerran, and it gets eleven pages in *Critical Terms for Art History,* 2nd ed. (2003), ed. Robert S. Nelson and Richard Shiff.[*] If you encounter these words in a book or in a lecture, and if you think that they are impressive ways of saying something that otherwise sounds commonplace, do *not* use them in your own writing. After all, in an essay you wouldn't (or shouldn't) speak of a "preliminary overall strategizing concept" when "plan" will do. On the other hand, if indeed you understand the specialized use of certain terms, and if they strike you as the best way to make your point, of course you can use them—though if you are writing for a general public, you will have to clarify them.

While we are speaking of writing for the general public, what do you think the public made of these opening sentences in a brochure accompanying an exhibition entitled *Performing Images, Performing Race,* shown at the Davison Art Center, Wesleyan University, in 2003? The brochure was written by the curator of the exhibition.

> The body is both the physical means of performance and the material
> pretext for ideas about race. Images of human bodies may serve at once
> to depict specific performative acts and to signify racial typicality. Such

[*] Both of these books are concerned more with the vocabulary of current art theory than with the vocabulary of art history.

portrayals can document and foster interlinked acts of looking, of performing, and of thinking about racial identities—of inhabiting them or assigning them to other.

Now, class, here is an open-book quiz:

1. Are you confident that you understand the first sentence, especially the phrase "the material pretext"? If so, paraphrase the sentence, and then decide whether, given the presumed purpose of the brochure—to introduce visitors to the exhibition—the original is better than your paraphrase.
2. If you were writing a brochure for an exhibition, would you take this author's style as a model? Why, or why not?

If you did not enjoy reading the passage, if you found it hard to understand and hard to paraphrase (maybe especially hard because "pretext" probably is *not* used in its ordinary sense of "untrue reason"), if you would not dream of taking this style as a model, give yourself a grade of A.

The Writer's Voice: Tone

Remember, when you are writing, *you* are the teacher. You are trying to help someone to see things as you see them, and it is unlikely that either pomposity or vulgarity will help anyone see anything your way. There is rarely a need to write that Daumier was "incarcerated" or (at the other extreme) "thrown into the clink." "Imprisoned" or "put into prison" will probably do the job best. Be sure, also, to avoid shifts in tone. Consider this passage, from a book on modern sculpture:

Faulty

> We forget how tough it was to make a living as a sculptor in this period. Rare were supportive critics, dealers, and patrons.

Although "tough" is pretty casual ("difficult" might be better), "tough" probably would be acceptable if it were not followed, grotesquely, by the pomposity of "Rare were supportive critics." The unusual word order (versus the normal order, "Supportive critics were rare") shows a straining for high seriousness that is incompatible with "tough."

Nor will it do to "finagle" with an inappropriate expression by putting it in "quotes." As the previous sentence indicates, the apologetic quotation marks do not make such expressions acceptable, only more obvious and more offensive. The quotation marks tell the reader that the writer knows

he or she is using the wrong word but is unwilling to find the right word. If for some reason a relatively low word is the right one, use it and don't apologize with quotation marks.

The lesson? As Buffon said two hundred years ago, "The style is the man," to which we can add "or the woman." And, as E. B. White said a few decades ago, "No writer long remains incognito."

✍🏻 A RULE FOR WRITERS:

The words that you put on the page will convey an image of you to the reader; make sure that the image is favorable.

Repetition

Although some repetitions—say, of words or phrases like "surely" and "it is noteworthy that"—reveal a tic that ought to be cured by revision, don't be afraid to repeat a word if it is the best word. Notice that in the following paragraph the writer does not hesitate to repeat "Impressionism," "Impressionist," "face," and "portrait" (three times each) and "portraiture" and "photography" (twice each).

Effective

> We can follow the decline of portraiture within Impressionism, the art to which van Gogh assumed allegiance. The Impressionist vision of the world could hardly allow the portrait to survive; the human face was subjected to the same evanescent play of color as the sky and sea; for the eyes of the Impressionist it became increasingly a phenomenon of surface, with little or no interior life, at most a charming appearance vested in the quality of a smile or a carefree glance. As the Impressionist painter knew only the passing moment in nature, so he knew only the momentary face, without past or future; and of all its moments, he preferred the most passive and unconcerned, without trace of will or strain, the outdoor, summer holiday face. Modern writers have supposed that it was photography that killed portraiture, as it killed all realism. This view ignores the fact that Impressionism was passionately concerned with appearances, and was far more advanced than contemporary photography in catching precisely the elusive qualities of the visible world. If the portrait declines under Impressionism it is not because of the challenge of the photographer,

but because of a new conception of the human being. Painted at this time, the portraits of van Gogh are an unexpected revelation. They are even more surprising if we remember that they were produced just as his drawing and color was becoming freer and more abstract, more independent of nature.

—Meyer Schapiro, *Vincent van Gogh*
(New York: Abrams, 1952), 16–17*

When you repeat words or phrases, or when you provide clear substitutes (such as "he" for "van Gogh"), you are helping the reader to keep step with your developing thoughts.

An ungrounded fear of repetition often produces a vice known as *elegant variation*. Having mentioned "painters," the writer, fearful of repeating the word, then speaks of "artists," and then (more desperately) of "men and women of the brush." This use of synonyms is far worse than repetition; it strikes the reader as silly. Or it may be worse than silly. Consider:

Confusing

> Corot attracted the timid painters of his generation; bolder artists were attracted to Manet.

The shift from "painters" to "artists" makes us wonder if perhaps Manet's followers—but not Corot's—included etchers, sculptors, and others. Probably the writer did *not* mean any such thing, but the words prompt us to think in the wrong direction.

Be especially careful not to use variations for important critical terms. If, for instance, you are talking about "nonobjective art," don't switch to "abstract art" or "nonrepresentational art" unless you tell the reader why you are switching.

The Sound of Sense, the Sense of Sound

Avoid jingles and other repetitions of sound, as in these examples:

Annoying

> The reason the season is autumn . . .
> Circe certainly . . .
> Michelangelo's Medici monument . . .
> The peculiar power of Pollock's paintings . . .

These irrelevant echoes call undue attention to the words and thus get in the way of the points you are making. But wordplay can be effective when it contributes to meaning. For example, in this sentence:

Effective

> The walls of Sian both defended and defined the city.

The echo of "defended" in "defined" nicely emphasizes the unity in this duality.

WRITE EFFECTIVE SENTENCES

Economy

Short sentences are not always concise:

> The picture is small in size.

The sentence is short but wordy because "in size" adds nothing to the meaning.

Say everything relevant, but say it in the fewest words possible. Consider the following sentence:

Wordy

> There are a few vague parts in the picture that give it a mysterious quality.

This sentence can be written more economically:

Revised

> A few vaguely defined parts give the picture a mysterious quality.

Nothing has been lost by the deletion of "There are" and "that." An even more economical version could be formulated:

Further Revised

> A few vague parts add mystery to the picture.

The original version says nothing that the second version does not say, and it says nothing that the third version—nine words against fifteen—does not say.

If you find the right nouns and verbs, you can often delete adjectives and adverbs. (Compare "a mysterious quality" with "mystery.") Something

is wrong with a sentence when you can delete words and not sense the loss. A chapter in a recent book begins:

Wordy

> One of the principal and most persistent sources of error that tends to bedevil a considerable proportion of contemporary analysis is the assumption that the artist's creative process is a wholly conscious and purposive type of activity.

Well, there is something of interest here, but it comes along with a lot of hot air. Why that weaseling ("*tends to* bedevil," "*a considerable* proportion"), and why "type of activity" instead of "activity"? Those spluttering *p*'s ("principal and most persistent," "proportion," "process," "purposive") are a giveaway: The writer has not sufficiently revised his writing. It is not enough to have an interesting idea; the job of writing requires *re*writing, revising. The writer of this passage should have revised it—perhaps on rereading it an hour or a day later—and produced something like this:

Revised

> One of the chief errors bedeviling much contemporary criticism is the assumption that the artist's creative process is wholly conscious and purposive.

Possibly the author thought that a briefer and clearer statement would not do justice to the complexity of the main idea, but more likely he simply neglected to reread and revise. The revision says everything that the original says, only better.

Here are some wordy phases, with their concise equivalents:

the reason is because	because
because of the fact that	because
due to the fact that	because
for the reason that	because
in spite of the fact that	although
at that point in time	then
it is possible that there might be	possibly

And here are four words that almost always can be eliminated:

definitely	truly
really	very

When we are drafting an essay we sometimes put down what is more than enough. There's nothing wrong with that—anything goes in a

draft—but when we revise we need to delete the deadwood, for instance the redundancies. Here is part of a descriptive entry from an exhibition catalog:

Redundant

> A big black bird with a curved beak is perched on a bare, wintry branch that has lost all its leaves.

If the branch is "bare," it has lost its leaves. No need to write it twice.

Unlike repetition, which often provides emphasis or coherence (for example, "government of the people, by the people, for the people"), redundancy can always be eliminated. Compare the following redundant expressions with the concise versions:

Redundant	*Concise*
future plans	plans
red in color	red
round in shape	round
small in size	small
glossy in appearance	glossy
basic fundamentals	fundamentals
resulting effect	result
connected together	connected
very unique	unique
throughout the entire article	throughout the article
elements common to both of them	common elements

Wordy Beginnings

Wordy beginnings can be especially deadly, for instance sentences that begin "There is" or "There are":

> There is evidence to show that some African symbolic motifs were unchanged over long periods.

Revised

> Evidence shows that some African symbolic motifs were unchanged over long periods.

Even better would be a more precise opening, such as "Much evidence shows," or "A few bits of evidence show," or whatever is the case.

Passive Voice

The **passive voice** (wherein the subject receives the action) is a common source of wordiness. *Example:* In general, do not write "The sculpture was carved by Michelangelo" (the subject—"the sculpture"—receives the action—"was carved"). Instead, use the **active voice,** in which the subject acts on the object: "Michelangelo carved the sculpture" (the subject—"Michelangelo"—acts—"carved the sculpture"). Even though the revision is a third shorter, it says everything that the longer version says. Often the passive is needlessly vague, as in "It is believed that . . ." when the writer means "Most people believe" or "Most art historians believe. . . ."

Notice the overuse of the passive voice in the following passage, the opening paragraph of an essay on the classical aspects of a library at a women's college:

> A person walking by Jackson Library (1908–13) is struck by its classical design. The symmetry of the façade is established by the regularly spaced columns of the Ionic order on the first story of the building, and by pilasters on the second level. In the center of the lower tier are two bronze doors: On the left door a relief is seen, depicting Sapientia (Wisdom), and on the right is seen the image of Caritas (Charity). The Greco-Roman tradition is furthered by the two bronze statues on either side of the entrance. On the left is Vesta (goddess of the hearth) and on the right Minerva (goddess of wisdom). Through the use of classical architecture and Greco-Roman images, an image is conveyed—one which Charleston College hopes to create in its women.

Although the paragraph is richly informative it is sluggish and eerily life-less, chiefly because the writer keeps using the passive voice: *A person . . . is struck by; symmetry . . . is established by; a relief is seen; on the right is seen; tradition is furthered by; an image is conveyed.*

Converting some or all of these expressions into the active voice will greatly improve the passage. (A second weakness, however, is the monotony of the sentence structure—subject, verb, object. Notice that in the revision, sentences are more varied. Many versions are possible; try your hand at producing one.)

Revised

> Walking by Jackson Library (1908–13), one notices the classical design. Regularly spaced columns of the Ionic order on the first story, and pilasters on the second, establish the symmetry of the façade. In the center of the lower tier are two bronze doors: On the left door a relief depicts Sapientia (Wisdom), and on the right Caritas (Charity).

A bronze statue on each side of the entrance (Vesta, goddess of the hearth, on the left, and Minerva, goddess of wisdom, on the right) furthers the Greco-Roman tradition. Charleston College hopes, through the use of classical architecture and Greco-Roman sculpture, to inspire in its women particular ideals.

Yet the passive voice has its uses as, for instance, when (1) the doer is unknown ("The picture was stolen Monday morning") or (2) is unimportant ("Drawings should be stored in light-proof boxes") or (3) is too obvious to be mentioned ("The inscription has never been deciphered").

In short, use the active voice rather than the passive voice unless you believe that the passive especially suits your purpose.

Parallels

Use parallels to clarify relationships. Few of us are likely to compose such deathless parallels as "I came, I saw, I conquered," but we can see to it that coordinate expressions correspond in their grammatical form. A parallel such as "He liked to draw and to paint" (instead of "He liked drawing and to paint") neatly says what the writer means. The following wretched sentence seems to imply that "people" and "California and Florida" can be coordinate:

Faulty

> The sedentary Pueblo people of the southwestern states of Arizona and New Mexico were not as severely affected by early Spanish occupation as were California and Florida.

This sort of fuzzy writing is acceptable in a first or even a second draft, but not in a finished essay.

Variety

You probably have been told that you should vary your sentence structure, and you probably have read essays in which the sentences (and the reader) suffered because the structure was, over and over, subject/verb/object. Here is another example of the sort of monotonous writing no one wants to read:

> Van Gogh wrote several letters to his brother Theo that contain material relevant to the painting of his bedroom. Van Gogh wrote on October 14, 1888, "I have just slept sixteen hours at a stretch, and it has restored me completely." Van Gogh wrote two days later, telling Theo that he had painted a picture of his bedroom, "suggestive of **rest** or sleep in general." Van Gogh wrote the next day, "This afternoon I finished the canvas representing the bedroom."

What is wrong here, however, is not so much that the sentence structure is repeated as that the words "Van Gogh wrote" begin—maddeningly—four consecutive sentences. If we change the second occurrence to "On October 14, 1888, he wrote," the third occurrence to "Two days later he wrote," and the fourth to "On the next day he again mentioned the picture," the passage becomes readable:

> Van Gogh wrote several letters to his brother Theo that contain material relevant to the painting of his bedroom. On October 14, 1888, he wrote, "I have just slept sixteen hours at a stretch, and it has restored me completely." Two days later he wrote, telling Theo that he had painted a picture of his bedroom, "suggestive of *rest* or sleep in general." On the next day he again mentioned the picture: "This afternoon I finished the canvas representing the bedroom."

If you vary the beginnings of your sentences, and use pronouns as substitutes for earlier nouns, readers probably will not complain that the structure of your sentences is monotonous.

✍ A RULE FOR WRITERS:

Do not repeat the same words in the same position in more than two consecutive sentences unless you are doing so for emphasis. Similarly, do not begin consecutive paragraphs with the same words ("This painting is . . .") unless you have a good reason.

Subordination

A word about short sentences: They can, of course, be effective ("Rembrandt died a poor man"), but unless what is being said is especially weighty, short sentences seem childish. They may seem choppy, too, because the periods keep slowing the reader down. Consider these sentences:

Choppy

> He was assured of government support. He then started to dissociate himself from any political aim. A long struggle with the public began.

There are three ideas here, but they are not worth three separate sentences. The choppiness can be reduced by combining them, subordinating some parts to others. In **subordinating,** make sure that the less important element is subordinate to the more important. In the following example the

first clause ("As soon as he was assured of government support"), summarizing the writer's previous sentences, is a subordinate or dependent clause; the new material is made emphatic by being put into two independent clauses:

Revised

> As soon as he was assured of government support, he started to dissociate himself from any political aim, and the long struggle with the public began.

The second and third clauses in this sentence, linked by "and," are coordinate—that is, of equal importance.

We have already discussed parallels ("I came, I saw, I conquered") and pointed out that parallel or coordinate elements should appear as such in the sentence. The following line gives van Gogh and his brother Theo equal treatment:

> Van Gogh painted at Arles, and his brother Theo supported him.

This example is a **compound sentence**—a sentence composed of two or more clauses that can stand as independent sentences but that are connected with a coordinating conjunction such as *and, but, for, nor, yet;* or with a correlative conjunction such as *not only . . . but also;* or with a conjunctive adverb such as *also* or *however* (these require a semicolon); or with a colon, semicolon, or (rarely) a comma.

A **complex sentence** (an independent clause and one or more subordinate clauses), however, does not give equal treatment to each clause; whatever is outside the independent clause is subordinate, less important. Consider this sentence:

> Supported by Theo's money, van Gogh painted at Arles.

The writer puts van Gogh in the independent clause ("van Gogh painted at Arles"), subordinating the relatively unimportant Theo. Notice, by the way, that emphasis by subordination often works along with emphasis by position. Here the independent clause ("van Gogh painted at Arles") comes after the subordinate clause; the writer appropriately puts the more important material at the end—that is, in the more emphatic position.

Had the writer wished to give Theo more prominence, the passage might have run:

> Theo provided money, and van Gogh painted at Arles.

Here Theo stands in an independent clause, linked to the next clause by "and." Each of the two clauses is independent, and the two men (each in an independent clause) are now of approximately equal importance.

If the writer wanted instead to deemphasize van Gogh and to empha-
size Theo, the sentence might read:

> While van Gogh painted at Arles, Theo provided the money.

Here van Gogh is reduced to the subordinate clause ("While van Gogh painted
at Arles") and Theo is given the dignity of the only independent clause ("Theo
provided the money"). (Notice again that the important point is also in the
emphatic position, near the end of the sentence. A sentence is likely to sprawl
if an independent clause comes first, preceding a long subordinate clause of
lesser importance, such as the sentence you are now reading.)

A brief example will further clarify this business of not putting weak
material at the end of a sentence:

Weak

> The evidence supporting this Freudian interpretation is weak for the
> most part.

Improved

> For the most part, the evidence supporting this Freudian interpretation
> is weak.

But note: You need not worry about subtle matters of emphasis while
you are drafting your essay. When you reread the draft, however, you may
feel that certain sentences dilute your point, and it is at this stage that you
should check to see if you have adequately emphasized, by subordination
and by position, what is important.

✍ A RULE FOR WRITERS:

Gain emphasis not by using italics and exclamation marks but by putting
the right words into the right clauses.

WRITE UNIFIED AND COHERENT PARAGRAPHS

A paragraph is normally a group of related sentences that explores one idea
in a coherent (organized) way.

Unity

If your essay is some five hundred words long—about two double-spaced
typewritten pages—you probably will not break it down into more than

four or five parts or paragraphs. (But you *should* break your essay down into paragraphs—that is, into coherent blocks that give the reader a rest between them. One page of typing is about as long as you can go before the reader needs a slight break.) A paper of five hundred words with a dozen paragraphs is probably faulty not because it has too many ideas but because it has too few *developed* ideas. A short paragraph—especially one consisting of a single sentence—is usually anemic; such a paragraph may be acceptable when it summarizes a highly detailed previous paragraph or group of paragraphs, or when it serves as a transition between two complicated paragraphs, but usually summaries and transitions can begin the next paragraph.

The unifying idea in a paragraph may be explicitly stated in a **topic sentence.**

- Most commonly, the topic sentence is the first sentence, forecasting what is to come in the rest of the paragraph,
- or it may be the second sentence, following a transitional sentence. In either case, it prepares the reader for the rest of the paragraph.
- Less commonly, it is the last sentence, summarizing the points that the paragraph's earlier sentences have made. In paragraphs of this sort, the writer usually sets forth descriptive details and then concludes the paragraph with a summary or a generalization—essentially an argument—that is based on the details.

Here, from a student's essay, is an example of a paragraph with a topic sentence at the *end* of the paragraph. (For Munch's *The Scream*, see page 91.)

> In Edvard Munch's *The Scream* (1896), the little boats seem to rest easily on the water but the wavy lines of the sky suggest the heavens are agitated, and the anguished figure in the center seems surrounded by and assaulted by conflicting lines. At the right, verticals crash into horizontals, and at the left, the diagonals define a walkway that either recedes with frightening rapidity or crashes forward into the viewer's space. Munch seems to do everything possible to unnerve the viewer.

Topic sentences are useful to writers as well as to readers. They help writers to develop ideas and they help readers to follow the argument.

Every paragraph, however, does not need to contain a topic sentence. But if a paragraph does not contain a topic sentence, it must contain a **topic idea**—an idea that holds the sentences together although it has not been explicitly stated. Here is an example, based on the preceding example:

> In Edvard Munch's *The Scream* (1896), the little boats seem to rest easily on the water but the wavy lines of the sky suggest agitation, not rest. The viewer almost experiences the feelings of the anguished

figure in the center, who seems surrounded by and assaulted by conflicting lines. At the right, verticals crash into horizontals, and at the left, the diagonals define a walkway that either recedes with frightening rapidity or crashes forward into the viewer's space.

✍ A RULE FOR WRITERS:

Make certain that an idea—explicit or implicit—unites the sentences of each paragraph.

If your paragraph has only one or two sentences, you probably have not adequately developed its idea.

A paragraph can make several points, but the points must be related, and the nature of the relationship must be indicated so that there is, in effect, a single unifying point. Here is a satisfactory paragraph about the first examples of Egyptian sculpture in the round. (The figures to which the author refers are not reproduced here.)

Unified

> Sculpture in the round began with small, crude human figures of mud, clay, and ivory (Fig. 4). The faces are pinched out of the clay until they have a form like the beak of a bird. Arms and legs are long rolls attached to the slender bodies of men, while the hips of the women's figures are enormously exaggerated. A greater variety of attitudes and better work-manship are found in the ivory figurines which sometimes have the eye indicated by the insertion of a bead (Fig. 4). It is the carving of animals, however, such as the ivory hippopotamus from Mesaeed in Fig. 4, or the pottery figure (Fig. 6) which points the way toward the rapid advance which was to be made in the Hierakonpolis ivories and in the small carvings of Dynasty I.
>
> —William Stevenson Smith, *Ancient Egypt*, 4th ed.
> (Boston: Museum of Fine Arts, 1960), 20

Smith is talking about several kinds of objects, but his paragraph is held together by a unifying topic idea. The idea is this:

> Although most of the early sculpture in the round is crude, some pieces anticipate the later, more skilled work.

Notice, by the way, that Smith builds his material to a climax, beginning with the weakest pieces (the human figures) and moving to the best pieces (the animals).

The beginning and especially the end of a paragraph are usually the most emphatic parts. A beginning may offer a generalization that the rest of the paragraph supports. Or the early part may offer details, preparing for the generalization in the later part. Or the paragraph may move from cause to effect. Although no rule can cover all paragraphs (except that all must make a point in an orderly way), one can hardly go wrong in making the first sentence either a transition from the previous paragraph or a statement of the paragraph's topic. Here is a sentence that makes a transition and states the topic:

> Not only representational paintings but also abstract paintings have a kind of subject matter.

This sentence gets the reader from subject matter in representational paintings (which the writer has been talking about) to subject matter in abstract paintings (which the writer goes on to talk about).

Consider the following two effective paragraphs on Anthony Van Dyck's portrait of Charles I (see page 214).

Unified

> Rather than begin with an analysis of Van Dyck's finished painting of Charles I, let us consider the problem of representation as it might have been posed in the artist's mind. Charles I saw himself as a cavalier or perfect gentleman, a patron of the arts as well as the embodiment of the state's power and king by divine right. He prided himself more on his dress than on robust and bloody physical feats. Van Dyck had available to him precedents for depicting the ruler on horseback or in the midst of a strenuous hunt, but he set these aside. How then could he show the regal qualities and sportsmanship of a dismounted monarch in a landscape? Compounding the artist's problem was the King's short stature, just about 5 feet, 5 inches. To have placed him next to his horse, scaled accurately, could have presented an ungainly problem of their relative heights. Van Dyck found a solution to this last problem in a painting by Titian, in which a horse stood with neck bowed, a natural gesture that in the presence of the King would have appropriate connotations. Placing the royal pages behind the horse and farther from the viewer than the King reduced their height and obtrusiveness, yet furnished some evidence of the ruler's authority over men. Nature also is made to support and suitably frame the King. Van Dyck stations the monarch on a small rise and paints branches of a tree overhead to resemble a royal canopy. The low horizon line and our point of view, which allows the King to look down on us, subtly increase the King's stature. The restful stance yet

inaccessibility of Charles depends largely upon his pose, which is itself
a work of art, derived from art, notably that of Rubens. Its casualness is
deceptive; while seemingly at rest in an informal moment, the King is
every inch the perfect gentleman and chief of state. The cane was a royal
prerogative in European courts of the time, and its presence along with
the sword symbolized the gentleman-king.

Just as the subtle pose depicts majesty, Van Dyck's color, with
its regal silver and gold, does much to impart grandeur to the paint-
ing and to achieve a sophisticated focus on the King. The red, silver,
gold, and black of his costume are the most saturate and intense of
the painting's colors and contrast with the darker or less intense col-
oring of adjacent areas. Largely from Rubens, Van Dyck had learned
the painterly tricks by which materials and textures could be vividly
simulated, so that the eye moves with pleasure from the silvery silken
sheen of the coat to the golden leather sword harness and then on to
the coarser surface of the horse, with a similar but darker combination

Anthony Van
Dyck, *Portrait of
Charles I Hunting,*
c. 1653. Oil on
canvas, 8' 1 × 6' 11"
(2.7 × 2.1 m). Inv
1236. Musees des
Louvre, Paris.
Photographer:
RMN-Grand
Palais/Art
Resource, NY.

of colors in its coat and mane. Van Dyck's portrait is evidence that, whatever one's sympathy for the message, the artist's virtuosity and aesthetic can still be enjoyed.

—Albert E. Elsen, *Purposes of Art,* 3rd ed.°
(New York: Holt, 1972), 221–222

Let's pause to look at the structure of these two paragraphs. The first begins in effect by posing a question (What were the problems Van Dyck faced?) and then goes on to discuss Van Dyck's solutions. This paragraph could have been divided into two, the second beginning "Nature also"; that is, if Elsen had felt that the reader needed a break, he could have provided it after the discussion of the king's position and before the discussion of nature and the king's pose within nature. But in fact a reader can take in all of the material without a break, and so the topic idea is "Van Dyck's solutions to the problem."

The second paragraph grows nicely out of the first, largely because Elsen begins the second paragraph with a helpful transition, "Just as." The topic idea here is the relevance of the picture's appeal through color; the argument is supported with concrete details, and the paragraph ends by pushing the point a bit further: The colors in the painting not only are relevant to the character portrayed but also have a hold on us.

Coherence

A kit containing all of the parts for a model airplane has unity—it does not contain any parts for a battleship—but it does not have coherence, since it is just a lot of loose pieces rather than an ordered whole. Make sure that your paragraphs have not only unity but also coherence. You need to connect or relate each sentence to the preceding and the following sentences, so that (from the reader's point of view) your writing *flows,* making a steady, intelligible argument. Transitions let your reader know what is up ahead and around the bend.

Nothing is wrong with obvious **transitions** such as *moreover, furthermore, in addition* (these transitions indicate amplification); *but, on the contrary, however, nevertheless, although* (these transitions indicate contrast or concession); *in short, briefly, in other words* (restatement); *finally, therefore, to sum up* (conclusion). But (this transition that tells you to expect some sort of change of direction) transitions should not start every sentence (they can be buried thus: "Degas, moreover, . . ."), and transitions need not appear anywhere in the sentence.

The point is not that transitions must be explicit but that the argument must proceed clearly. The gist of a paragraph might run thus:

> Speaking broadly, there were in Japan two traditions of portraiture. . . . The first. . . . The second. . . . The chief difference. . . . But both traditions. . . .

It is not enough to give the reader pieces of information; rather, sentence by sentence you have to indicate how the pieces are connected.

Consider the following lucid paragraph from an essay on Auguste Rodin's *Walking Man:*

Coherent

> *L'Homme qui marche* is not really walking. He is staking his claim on as much ground as his great wheeling stride will encompass. Though his body's axis leans forward, his rearward left heel refuses to lift. In fact, to hold both feet down on the ground, Rodin made the left thigh (measured from groin to patella) one-fifth as long again as its right counterpart.

> —Leo Steinberg, *Other Criteria* (New York: Oxford, 1972), 349

Auguste Rodin, 1840–1917, Walking Man, *L'homme qui marche*, 1877. Bronze, 71¾". Rodin Museum, Paris. Photographer: Foto Marburg/Art Resource, NY.

Notice how easily we move through the paragraph: The figure "is not. . . . He is. . . . Though. . . . In fact. . . ." These little words take us neatly from point to point so that the paragraph flows.

Here are some of the most common transitional words and phrases, categorized by their function:

amplification or likeness: similarly, likewise, and, also, again, second, third, in addition, furthermore, moreover, finally

comparison: likewise, similarly, in the same manner

consequence or cause and effect: thus, so, then, it follows, as a result, therefore, hence

contrast or concession: but, on the contrary, on the other hand, by contrast, of course, however, still, doubtless, nevertheless, granted that, conversely, although, admittedly

emphasis: chiefly, equally, indeed, even more important

example: for example, for instance, as an example, specifically, consider as an illustration, that is, such as, like

place: in the foreground, further back, in the distance

restatement: in short, that is, in effect, in other words

time and sequence: afterward, first, second, next, then, as soon as, later, until, when, finally, last, at last

summary (conclusion): finally, in short, therefore, thus, to sum up

Signals such as these will help your readers know where you are taking them.

✍ A RULE FOR WRITERS:

A paragraph should make a main point; all of the sentences in the paragraph should contribute to this point, and signals—notably *transitions*—should help the readers to see where you are taking them.

How Long Should a Paragraph Be?

Although a paragraph can contain any number of sentences, two is probably too few, and ten might be too many. It is not a matter, however, of counting sentences; paragraphs are coherent blocks, substantial units of your essay, and the spaces between them are brief resting-places allowing the reader to take in what you have said. One double-spaced, word-processed page of writing (approximately 250 words) is about as much as the reader can take before requiring a slight break. On the other hand, a single page with half a dozen paragraphs is probably faulty because the reader is too often interrupted with needless pauses and because the page has too few *developed* ideas: An assertion is made, and then another, and another. These assertions are unconvincing because they are not supported with detail.

A short paragraph can be effective when it summarizes a highly detailed previous paragraph or group of paragraphs, or when it serves as a transition

between two complicated paragraphs, but unless you are sure that the reader needs a break, avoid thin paragraphs. A paragraph that is nothing but a transition can usually be altered into a transitional phrase or clause or sentence that starts the next paragraph.

Short paragraphs usually leave readers feeling unsatisfied, even annoyed. Consider these two consecutive paragraphs from a draft of a student's essay on Leonardo da Vinci's *Mona Lisa:*

> Leonardo's *Mona Lisa*, painted about 1502, has caused many people to wonder about the lady's expression. Different viewers see different things.
>
> The explanation of the puzzle is chiefly in the mysterious expression that, Leonardo conveys. The mouth and the eyes are especially important.

Sometimes you can improve a sequence of short paragraphs merely by joining one paragraph to the next, But unsatisfactory short paragraphs usually cannot be repaired so simply: The source of the problem is usually not that sentences have been needlessly separated from each other, but that generalizations have not been supported by details or that claims have not been supported by evidence. Here is the student's revision, strengthening the two thin paragraphs of the draft.

> Leonardo's *Mona Lisa*, painted about 1502, has caused many people to wonder about the lady's expression. Doubtless she is remarkably lifelike but exactly what experience of life, what mood, does she reveal? Is she sad, or gently mocking, or uncertain or self-satisfied, or lost in daydreams? Why are we never satisfied when we try to name her emotion?
>
> Part of the uncertainty may of course be due to the subject as a whole. What can we make out of the combination of this smiling woman and that utterly unpopulated landscape? But surely a large part of the explanation lies in the way that Leonardo painted the face's two most expressive features, the eyes and the mouth. He slightly obscured the corners of these, so that we cannot precisely characterize them: although on one viewing we may see them one way, on another viewing we may see them slightly differently. If today we think she looks detached, tomorrow we may think she looks slightly threatening.

This revision is not simply a padded version of the earlier paragraphs; it is a necessary clarification of them, for without the details the generalizations mean almost nothing to a reader.

✍ A RULE FOR WRITERS:

Remember: A paragraph consisting of only a sentence or two or three—unless it serves chiefly as a transition—is probably underdeveloped, and a paragraph longer than a page is probably too long for a reader's comfort.

Introductory Paragraphs

Vasari, in *Lives of the Painters* (1550, 1568), tells us that Fra Angelico "would never take his pencil in his hand till he had first uttered a prayer." All writers can easily understand his hope for divine assistance. Beginning a long poem, Lord Byron aptly wrote, "Nothing so difficult as a beginning." Of course, your job is made easier if your instructor has told you to begin your analysis with some basic facts: identification of the object (title, museum, museum number), subject matter (e.g., mythological, biblical, portrait), and technical information (material, size, condition). Even if your instructor has not told you to begin thus, you may find it helpful to start along these lines. The mere act of writing *anything* will probably help you to get going.

Still, almost all writers—professional as well as student writers—find that the beginning paragraphs of their drafts are false starts. Blaise Pascal shrewdly noted that "The last thing one discovers in composing a work is what to put first." In your finished paper the opening cannot be mere throat clearing. It should be interesting and informative. Don't take your title ("Space in Manet's *A Bar at the Folies-Bergère*") and merely paraphrase it in your first sentence: "This essay will study space in Manet's *A Bar at the Folies-Bergère*." There is no information about the topic here, at least none beyond what the title already gave, and there is no information about you either—that is, there is no sense of your response to the topic, such as might be present in, say,

> The space in *A Bar at the Folies-Bergère* is puzzling; one at first wonders where the man is standing, whose reflection we see in the upper right.

This brief opening illustrates a surefire way to begin:

- **Identify the artwork(s)** you will discuss.
- **Suggest your thesis** in the opening paragraph, moving from a generalization ("The space in the picture is puzzling") to some supporting details ("we are unsure of the position of the man whose reflection we see").

- **Adopt an engaging tone**, an interesting human voice. Do *not* begin with such a flat opening as "In this essay I will demonstrate," or "This paper will show. . ."

Such an introduction quickly and effectively gets down to business; especially in a short paper, there is no need (or room) for an in-depth introduction.

Notice in the following example, the opening paragraph from an essay on Buddhist art in Japan, how the writer moves from a "baffling diversity" to "one major thread of continuity."

Effective Opening

> Amid the often baffling diversity which appears in so much of the history of Japanese art, one major thread of continuity may be traced throughout the evolution of religious painting and sculpture. This tradition was based on the great international style of East Asian Buddhist imagery, which reached its maturity during the early eighth century in Tang China and remained a strong influence in Japan through the thirteenth century.
>
> —John Rosenfield, *Japanese Arts of the Heian Period: 794–1185* (New York: Japan Society, 1967), 23

Similarly, in the next example, the paragraph moves from a general comment about skin-clinging garments to an assertion of the thesis (the convention is exaggerated in English Neoclassical art), and this thesis is then supported with concrete details.

Effective Opening

> The pictorial and sculptural custom of clothing the nude in skin-clinging dress has many and often-copied Classical precedents, but the erotic emphasis of this convention seems exaggerated in English art of the Neoclassic period more than at other times and places. The shadowy meeting of thighs, the smooth domes of bosom and backside, are all insisted on more pruriently through the lines of the dress than they were by contemporary French artists or by Botticelli and Mantegna and Desiderio da Settignano, who were attempting the same thing in the Renaissance—or, indeed, than by the Greek sculptors. The popular artists Rowlandson and Gillray naturally show this impulse most blatantly in erotic cartoons and satirical illustrations, in which women have enormous bubbly hemispheres fore and aft, outlined by the emphatically sketched lines of their dress.
>
> —Anne Hollander, *Seeing Through Clothes*
> (1978), 118[*]

[*]From *Seeing Through Clothes* by Ann Hollander, copyright © 1975, 1976, 1978 by Anne Hollander. Used by permission of Viking Penguin, a division of Penguin Group (USA) LLC. 1978, p. 118.

Here are three other effective ways to begin an essay:

- **Use a quotation** (notice the use of a quotation from Vasari, on page 219, at the beginning of this section on introductions). A quotation by the artist about whom you are writing may be especially stimulating.
- **Use an interesting relevant fact,** such as "Grant Wood's *American Gothic* (1930) seems to be so American a painting that it comes as a surprise to learn that it is indebted to European sources."
- **Ask a provocative question,** such as "Why shouldn't we consider Titian's *Venus of Urbino* (1538) a pornographic picture?" or "Does it make a difference if the subjects of Grant Wood's *American Gothic* (1930) are a father and daughter rather than a husband and wife?"

Sample Revised Introductory Paragraph

~~The formal elements of a work of art combine to form a dominant impression that contributes significantly to the understanding of the work's meaning.~~ Two sculptures *of seated figures* ~~located~~ in the Boston Museum of Fine Arts provide good examples of ~~this principle.~~ *the principle that in a work of art, form as well as subject matter establishes the meaning.* Dating form the Fourth Dynasty of Old Kingdom Egypt (2613–2494 B.C.) ~~is~~ a foot-high statue of Prince Khunera. ~~This sculpture,~~ originally placed in his burial site at Giza, depicts the prince sitting cross-legged like a scribe. The yellow limestone sculpture is somewhat chipped and cracked but is generally intact, ~~as is~~ the second work of art, the Bodhisattva of Compassion, also known as Avalokiteshvara. *C*arved from a black stone called schist, ~~the Bodhisattva~~ was made in Bihar, in eastern India, in the mid-tenth century A.D. *The Bodhisattva is more than twice the size of the prince, but* ~~Although more than twice the size of the prince, he sits in a similar~~ *the essential differences are conveyed chiefly by elements of* ~~position. However, both the body language and the overall impression~~ *design.* ~~sion conveyed by the two sculptures differ greatly. Skillful use of the formal elements of design gives~~ *conveys* Prince Khunera a sense of eternal stillness *, whereas* ~~and~~ the Bodhisattva of Compassion *conveys* a sense of

movement and accessibility, ~~making~~ each impression correspond s
with the religious meaning and purpose of the object.

> Student's revision of the opening paragraph of a draft of an essay comparing two sculptures. ☞ The student probably deleted the first sentence because she realized she was lecturing—at length—about a point that her readers would regard as obvious. In the revision she takes what is essential from the first sentence of the draft and incorporates it into the next sentence, thus getting a stronger opening sentence. ☞ In the original version the second sculpture (the Bodhisattva) is weakly introduced by being tacked on to the end of a sentence about the first sculpture (the prince); in the revision the Bodhisattva rightly gets its own sentence. ☞ The sprawling last sentence of the original paragraph is, in the revision, converted into two sentences, allowing the paragraph to end more emphatically.

 A RULE FOR WRITERS:

The introductory paragraph usually identifies the works and indicates the writer's thesis, but whatever it says, it must be interesting.

Concluding Paragraphs

The preceding discussion of opening paragraphs quotes Lord Byron: "Nothing so difficult as a beginning." But Byron went on to add, "Unless perhaps the end."

In conclusions, as in introductions, try to say something interesting. It is not of the slightest interest to say "Thus we see . . . " and then go on to echo the title and the first paragraph. There is some justification for a summary at the end of a long paper because the reader may have half-forgotten some of the ideas presented thirty pages earlier, but a paper that can easily be held in the mind needs something different. A good concluding paragraph does more than provide an echo of what the writer has already said. It may round out the previous discussion, normally with a few sentences that summarize (without the obviousness of "We may now summarize"), but usually it also draws an inference that has not previously been expressed, thus setting the previous material in a fresh perspective. A good concluding paragraph closes the issue while enriching it. You can often get ideas for a good concluding paragraph by asking yourself, "What are the implications?" Your response to this question probably will help you to write a paragraph that goes beyond restating your earlier material.

Consider the following example, the concluding paragraph of an essay by a student (Jane Holly) on small gilt bronzes (2 or 3 inches tall) of the Buddha Shakyamuni, produced in Japan in the seventh century A.D. For an example of such an image, see pages 214–15.

Effective Ending

Small gilt bronzes of the type that we have been discussing are almost unknown outside of Japan, and they are rare even in Japan. Temples do not have them, since they are too small for public worship, and museums rarely display them, since the casual viewer would pass them by, thinking of them as trifles. When we think of a Japanese Buddha, we probably call to mind some enormous figure, such as the seated Great Buddha at Kamakura—about thirty-four feet tall—which is known throughout the world because airlines often use pictures of it on travel posters. But these small gilded images, doubtless commissioned by wealthy people for use in small shrines in their homes, are by no means trivial. They were obviously made with extreme care, and gilding was a costly, time-consuming process, so the bronzes must have been highly valued. Today, as familiarity with East Asian art increases in America, we are beginning to see the beauty and importance of these physically small but spiritually great works.

Pretty much the same technique is used at the end of Elsen's second paragraph on Van Dyck's *Charles I* (pages 214–15), where the writer moves from a detailed discussion of the picture to the assertion that the picture continues to attract us.

Don't feel that you must always offer a conclusion in your last paragraph. When you have finished your analysis, it may be enough to stop—especially if your paper is fairly short, let's say fewer than five pages. If, for example, you have throughout your paper argued that a certain Japanese print shows a Western influence in its treatment of space, you need scarcely reaffirm the overall thesis in your last paragraph. Probably it will be conclusion enough if you just offer your final evidence, in a well-written sentence, and then stop.

Because all writers have to find out what they think about any given topic, and have to find the strategies appropriate for presenting these thought to a particular audience, I hesitate to offer a do-it-yourself kit for final paragraphs, but the following simple devices often work:

- End with quotation, especially a quotation that amplifies or varies a quotation used in the opening paragraph.
- End with some idea or detail from the beginning of the essay, thus bringing the essay full circle.

- End with a new (but related) point, one that takes your discussion a step further.
- End with an allusion, say to a historical or mythological figure or event, putting your topic in a larger framework.
- End with a glance at the readers—not with a demand that they mount the barricades, but with a suggestion that the next move is theirs.

If you adopt any of these devices, do so quietly; the aim is not to write a grand finale, but to complete or round out a discussion.

All essayists will have to find their own ways of ending each essay; the five strategies suggested are common, but they are not for you if you don't find them useful. And so, rather than ending this section with rules about how to end essays, I suggest how not to end them:

✍ **A RULE FOR WRITERS:**

Don't merely summarize, don't say "in conclusion" (it sounds stuffy), don't introduce a totally new point, and don't apologize.

✔ Checklist for Revising Paragraphs

Have I asked myself the following questions?

❑ Does the paragraph *say* anything? Does it have substance?

❑ Does the paragraph have a topic sentence? If so, is it in the best place? If the paragraph doesn't have a topic sentence, might one improve the paragraph?

❑ If the paragraph is an opening paragraph, is it interesting enough to attract and to hold a reader's attention? If it is a later paragraph, does it easily evolve out of the previous paragraph—perhaps by means of a transitional word or phrase such as "Furthermore" or "On the other hand"—and lead into the next paragraph?

❑ Does the paragraph contain some principle of development, for instance, from cause to effect, or from general to particular?

❑ What is the purpose of the paragraph? Do I want to summarize (introduced with a transition such as "In short"), or to give an illustration ("For example"), or to concede a point ("Admittedly," "Granted")? Does the paragraph fulfill my purpose and will my purpose be clear to my reader?

❑ If the paragraph is long—let's say, a full page of typing or more—is it trying to do too much? If I divide it into two or even three paragraphs, will I be helping my reader?

❑ If the paragraph is very short—perhaps just a sentence or two—is the point adequately developed? (The chief acceptable use of a one-sentence paragraph is to serve as a transition after a fairy long and complicated discussion.)

❑ Is the closing paragraph effective and not merely an unnecessary restatement of the obvious?

A NOTE ON TENSES

In talking about an artist's life, you will probably use forms of the past tense ("Georgia O'Keeffe *was born* in Sun Prairie, Wisconsin. She *taught* in Texas"). But in speaking about works of art themselves it is usually best to use the present tense: "Her work *hangs* in many museums," "This painting *shows* her at her best," "The blue *is* intense," "The barn *is* white," "She *denied* that she used sexual symbolism, but her pictures nonetheless *contain* sexual symbols."

Some instances can go either way. Compare these two sentences:

> Her usual motifs *are* Southwestern, such as desert flowers and bleached bones.
> Her usual motifs *were* Southwestern, such as desert flowers and bleached bones.

The first sentence uses the present tense because the writer is thinking of the works as enduring presences—they are here right now, and the motifs are Southwestern. The second sentence uses the past tense because the writer is telling us about what O'Keeffe *did*—she often chose Southwestern motifs. What a writer cannot do, however, is to shift back and forth. If you write, "Her usual motifs *were* Southwestern," you almost surely can*not* write in your next sentence, "She often *paints*. . . ."

Of course, you can use the *narrative present* (also called the *historic present*): "Gothic carvers delight in ornament," "Van Gogh usually applies the pigment boldly." (This device is commonly said to add vitality to the narrative.) But if you use the narrative present—and it often sounds odd—be consistent. If you write, "Gothic sculptors *delight* in ornament; they *carved* abundant tendrils, and they *fill* every corner," you will needlessly disturb your readers, who will wonder why you use a past tense ("carved") between two verbs in the present tense ("delight" and "fill").

11

ART-HISTORICAL RESEARCH

Research is formalized curiosity. It is poking and prying with a purpose.
—Zora Neale Hurston

The past is a foreign country: they do things differently there.
—L. P. Hartley

Facts explain nothing. On the contrary, it is facts that require explanation.
—Ursula K. Le Guin

A problem adequately stated is a problem on its way to being solved.
—R. Buckminster Fuller

I have yet to see any problem, however complicated, which, when you looked at it in the right way, did not become still more complicated.
—Poul Anderson

It is sometimes argued that there is a clear distinction between *scholarship* (or *art-historical research*) and *criticism.* In this view, scholarship gives us information about works of art (especially concerning how they were perceived in their original contexts), and it uses works of art to enable us to understand the thought of a period; criticism gives us information about the critic's feelings, especially the critic's evaluation of the work of art. Art history, it has been said, is chiefly fact-finding, whereas art criticism is chiefly fault-finding. And there is some debate about which activity is the more worthwhile. The historical scholar may deprecate evaluative criticism as mere talk about feelings, and the art critic may deprecate scholarly art-historical writing as mere irrelevant information. But before we further consider the relationship between historical scholarship and criticism, we should think briefly about a third kind of activity, *connoisseurship.*

Connoisseurship

Connoisseurs focus on workmanship—lines, patterns, colors—identifying and evaluating originals from copies, dating works, and distinguishing the good from the less good. (The usual assumption is that the genuine objects exhibit greater aesthetic integrity, and that the better objects exhibit

greater skill.) Speaking metaphorically, we can say that the connoisseur identifies the handwriting of the artist, asserting, for instance, "Rembrandt around 1650." Erwin Panofsky, in *Meaning in the Visual Arts* (1955), suggests that the connoisseur differs from the art historian not so much in principle as in emphasis; the connoisseur's opinions (e.g., "Rembrandt around 1650"), like the historian's, are verifiable. The difference (Panofsky says) is this: "The connoisseur might be defined as a laconic art historian, and the art historian as a loquacious connoisseur" (page 20). But elsewhere in his book Panofsky distinguishes between art history on the one hand and, on the other, "aesthetics, criticism, connoisseurship, and 'appreciation'?" (pages 249–50). Perhaps we can retain Panofsky's definition of the connoisseur as a "laconic art historian" and say that the connoisseur's specialty is a sensitivity to artistic traits, an awareness of the ways an artist handles materials in order to produce a work.

We can say, too, that the art historian possesses the knowledge of the connoisseur—a knowledge of what is genuine and of when it was made—and then goes on (by analyzing forms and by relating them chronologically) to explain the changes that have occurred in the ways that artists have seen.

Connoisseurship today has been widely censured, especially by leftist historical scholars who sometimes characterize themselves as practitioners of the New Art History (see pages 227, 249–50). These scholars, concerned largely with art as a revelation of the social and political culture that produced it, see connoisseurship as an arid activity that chiefly serves rich people. Thus, T. J. Clark in the first chapter of his *Image of the People* (1973) dismisses connoisseurship as "barren" because it is unconcerned with the artist as a person reacting within a given society (pages 12–13). In the eyes of the New Art History, connoisseurship concentrates on minutiae, evades confronting the social implications of art, fosters the elitist implications of art museums, bolsters the art market by authenticating works for art dealers and collectors, and asserts the validity of such mystical and elitist concepts as "taste" and "intuition" and "quality."

Even a new sort of connoisseurship, relying on scientific tests of pigments, paper, patination, and so forth, has been criticized along the same grounds. Scientific study is intended to clear matters up, but persons skeptical of connoisseurship argue that highly technical reports serve chiefly to enhance the mystique of art. On the other hand, many connoisseurs (they are found chiefly in museums and in dealers' shops rather than in colleges and universities) believe that art historians tend to be insufficiently concerned with works of art as things of inherent worth and overly concerned with art as material for the study of political or intellectual history. But let us now further consider the relationship between the art historian and the art critic.

History and Criticism

The **art historian** is sometimes viewed as a sort of social scientist, reconstructing the conditions and attitudes of the past through documents. (The documents, of course, include works of art as well as writings.) In studying Cubism, for example, the supposedly dispassionate art historian does not prefer one work by Braque to another by Braque, or Picasso to Braque, or the other way around. The historian's job, according to this view, is to explain how and why Cubism came into being. Art history, it is regularly said, is concerned with *why* objects look the way they do. Thus, as we have seen (pages 14–18), *Whistler's Mother* (to use the popular title) looks the way it does because Whistler was familiar with newly fashionable (in England and Europe) Japanese prints.

In pursuing their attempts to explain why things look the way they do, art historians engage in various activities, especially,

- visual analysis (formal analysis)
- examination of written documents
- study of the social context, especially the conditions of production (not only conditions in the workshop, but also the market for which the work was designed)
- scientific examination, for instance, the analysis of paper or of pigments in order to determine the date of production

For art historians, it is usually said, value judgments are considered irrelevant.

The **art critic,** on the other hand, is supposedly concerned not with verifiable facts but with his or her aesthetic responses and especially with value judgments. Sometimes these judgments can be reduced to statements such as "This work by Braque is better than that work by Picasso," or "Picasso's late works show a falling-off," and so on. But even when critics are not so crudely awarding As and Bs and Cs, acts of evaluation lie behind their choice of works to discuss. Intrigued by a work, they usefully call our attention to qualities in it that evoke a response, helping us to see what the work has to offer us. That is, (1) they offer a considered response, revealing elements in the work so that (2) we can better experience the work. In the words of the novelist D. H. Lawrence, criticism offers "a reasoned account of the feelings" produced by a work. In short, they offer *evidence*— arguments—to support their opinions.

The art historian E. H. Gombrich, in "Art and Scholarship," in *Meditations on a Hobby Horse,* 2nd edition (London: Phaidon, 1963), describes the connection between (1) the critic's response, (2) the critic's formulation of that response in words, and (3) the reader's response to

those words thus: "Critics . . . know how to use words to articulate their sensations and they let us profit in our own sensibility by teaching us differentiations" (page 11).

We will return to this topic later, when we consider "Historical Scholarship and Values" (pages 241–43).

ACCOUNTING FOR TASTE

Is it "all a matter of taste"? A cartoon shows a frog dining in a restaurant with a waiter standing nearby. The caption: "Waiter, there's a fly in my soup. My compliments to the chef."

Before we consider taste let's pause to think about evaluation in general. When we say, "This is a great picture," are we in effect saying only "I like this picture"? Are we merely *expressing our taste* rather than *pointing to something out there*, something independent of our tastes and feelings? And if we are expressing only our taste, there is nothing to discuss, because, as the saying goes, *De gustibus non est disputandum* ("There is no disputing matters of taste"). Another saying along the same line: "Beauty is in the eye of the beholder."

Consider three sentences:

1. It's raining outside.
2. I like vanilla.
3. Of Cézanne's three versions of *The Card Players,* the one in the Louvre is the best.

If you are indoors and you say that it is raining outside, a hearer may ask for verification of this assertion about something outside. Why do you say what you said? "Because Jane just came in, and she's drenched," or "Because I just looked out of the window." If, on the other hand, you say that you like vanilla, it's almost unthinkable that anyone would ask you why. No one expects you to justify—to offer a reason in support of—an expression of taste.

Now consider the third statement, that the Louvre version of *The Card Players* is the best of the three paintings. (This assertion is made by Meyer Schapiro, in his *Paul Cézanne,* [1952], on page 88.) Does this assertion resemble the assertion about the weather, or does it resemble the assertion about vanilla? The answer is the weather, because it would have been entirely reasonable for someone to ask Schapiro *why* he said the Louvre version is the best. And in fact in his book Schapiro goes on to give his reasons. He says the Louvre version is the most monumental and the most

varied, and he supports these assertions by pointing to particular details. His statement evaluating the three pictures asserts something that we can discuss, in a way that we cannot discuss the expression of a personal preference for vanilla. We can, so to speak, hold a mental conversation with Schapiro, offering our own views in response to his.

We might begin by thinking about *why* he might value monumentality and variety. We may conclude that Schapiro's values are merely subjective, or we may conclude (at the opposite pole) that these qualities indeed are present in all the works that are valued by virtually all persons who think carefully about the issue. Or (a middle position) we may conclude that although certain qualities are widely esteemed, it becomes evident that it is only certain groups in certain historical periods that esteem them. (This last view is called socio-historical relativism.) These are issues that can be discussed, can be argued. We can offer *reasons,* and some reasons are more plausible than others.

Consider this passage about Picasso's *Les Demoiselles d'Avignon* (see page 35 for a reproduction):

> *The Young Ladies of Avignon,* that great canvas which has been so frequently described and interpreted, is of prime importance in the sense of being the concrete outcome of an original vision, and because it points to a radical change in the aesthetic basis as well as the technical processes of painting. In itself the work does not bear very close scrutiny, for the drawing is hasty, and the colour unpleasant, while the composition as a whole is confused and there is too much concern for effect and far too much gesticulation in the figures The truth is that this famous canvas was significant for what it anticipated rather than for what it achieved.
>
> —Frank Elgar and Robert Maillard, *Picasso,* trans. Francis Scarfe
> (1956), 56–58; quoted in Monroe Beardsley, *Aesthetics*
> (1958), 454

Notice that Elgar and Maillard evaluate the painting on at least two very different grounds:

- **historical significance** (the picture is important because it is "original" and it altered the history of painting) and
- **aesthetic merit** or **inherent worth** (the picture is not very important because "the drawing is hasty," the color is "unpleasant," "the composition . . . is confused," "there is too much concern for effect," and there is "far too much gesticulation in the figures").

Probably if Elgar and Maillard were pressed they would go on to explain—by pointing to details—what they meant by saying that the drawing was "hasty," the color "unpleasant," and so forth. Certainly a reader feels

that the authors *ought* to be able to support their views or they shouldn't have asserted them. In our mental conversation with Elgar and Maillard we might begin by asking *why* hastiness is a weakness? Aren't there drawings and paintings that impress us because they seem spontaneous? Conversely, aren't there highly finished works that we censure because they seem fussy or labored? In short, *is* evidence of hastiness a weakness and *is* evidence of great care a virtue? That's worth thinking about. And what about "gesticulation"? As we think about this critical comment, we may conclude that the writers have not adequately supported their assertions. When we read criticism we expect to hear *arguments*, not merely unsupported assertions.

Let's look at another passage of evaluative writing, a paragraph in which the architect Paul M. Rudolph talks about Falling Water or Fallingwater (1936–1938), a house Frank Lloyd Wright designed as the weekend retreat for a department store magnate:

> Fallingwater is that rare work which is composed of such delicate balancing of forces and counterforces, transformed into spaces thrusting horizontally, vertically and diagonally, that the whole achieves the serenity which marks all great works of art. This calmness, with its underlying tensions, forces and counterforces, permeates the whole, inside and out, including the furnishings and fittings The thrusts are under complete control, resulting in the paradox of a building full of movement: turning, twisting, quivering movement—which is, at the same time, calm, majestic and everlasting.
>
> —"Fallingwater,"*Global Architecture* 2 (1970)

Rudolph, in love with "underlying tensions, forces and counterforces," is barely concerned with how well Falling Water works as a house. Is it noisy? (Yes.) Damp and hard to heat? (Yes.) Can one see and enjoy the waterfall from inside? (No.) Do the cantilevered terraces tilt because Wright put too little steel into the support beams? (Maybe.) Rudolph does not ask these questions because he does not care about how the house functions. In fact, he goes on to suggest that "the mark of an architect is how he handles those spaces that are not strictly functional." In short, Rudolph's values (at least in this essay) have to do chiefly with the resolution of forces, little to do with functionalism, and nothing to do with economics or politics. Another critic—the client, for instance—might evaluate the house in terms of livability. (Le Corbusier said, "A house is a machine for living in." How well does this machine work?) And still another critic—a Marxist, perhaps— might evaluate the building as a ridiculously expensive toy designed for a millionaire. These and other critics would come up with a far less favorable evaluation.

Frank Lloyd Wright, 1869–1959, *Falling Water,* the Edgar J. Kaufmann House, 1936–1938. Bear Run, Pennsylvania. The house is cantilevered out over a stream. Modern Design/Alamy.

In the preceding pages we saw critics setting forth criteria: Schapiro valued monumentality and variety in Cézanne's *The Card Players,* Elgar and Maillard regarded hastiness as a fault, Rudolph valued "underlying tensions" but also said that "serenity . . . marks all great works of art." In Chapter 1 we glanced at a common question, "Is it art?" Now we will look at some responses to another common question, "Is it good?" Let's take a brief survey of some theories of value that have been common in discussions of Western art.*

*Rudolph's mention of "serenity" is significant because a good deal of Western writing about art focuses on pleasure. But some other cultures produce objects in accordance with other criteria. Suzanne Preston Blier, in *African Vodun: Art, Psychology, and Power* (Chicago: University of Chicago Press, 1995), quotes a Fon-speaking West African sculptor who says, "One makes things that will cause fear" (page 59). For introductory material on non-Western topics such as "Eskimo Aesthetics," "Navajo Aesthetics," "Aztec Aesthetics," and "Yoruba Aesthetics," see Richard L. Anderson, *Calliope's Sisters: A Comparative Study of Philosophies of Art,* 2nd ed. (2004). There has been little study of such topics, and the findings are deeply contested, but Anderson's bibliography is valuable.

We will briefly look at evaluations based on the following criteria:

1. Truth
2. Instrumental value (or utility)
3. Ideology
4. Intrinsic aesthetic merit
5. Expressiveness
6. Sincerity
7. Technique
8. Originality
9. Historical importance

Truth as a Criterion: One view holds that art should be true. At its simplest, perhaps, this means that art should present images that closely resemble what we see when we look at the world around us. Legend has it that in the fourth century B.C. two Greek painters competed. Zeuxis's picture showed a boy holding grapes painted so realistically that live birds sought to peck at them. Confident that he had won, Zeuxis asked the other candidate, Parrhasius, to push aside the curtain that covered his painting. Parrhasius then pointed out that the curtain was not a curtain but was a painting of a curtain. Zeuxis had deceived stupid birds, but Parrhasius had deceived a human being, so Zeuxis conceded defeat.

In the following passage, which stands for countless similar passages, the writer praises Mary Cassatt because she has observed reality closely:

> Not mother love but baby love became her subject. Her grasp of baby anatomy became perfect, and startling, even a little ugly, in its truth. In the pastel *Mathilde Holding a Baby Who Reaches Out to the Right,* of 1889, she caught the touching discrepancy between a baby's soft, limp lower body and its hard, horizontal arms—the soft massive release downward, the nervous angular, unarticulated still movement outward and upward.
> —Adam Gopnik, "Cassatt's Children," *New Yorker*
> (March 22, 1999), 119

Closely connected to this sense of realism as "optically accurate representations" is the view that realism involves depicting real objects—let's say, human beings and horses—as opposed to mythological objects (nymphs, gods, and winged horses). A desire for realism of this sort underlies such statements as Diderot's characterization of Boucher ("So much imagination, illusion, magic, and facility! . . . That man is capable of everything—except the truth" [1761]) and Zola's reaction to Corot ("If M. Corot would kill, once and for all, the nymphs and replace them with peasants, I should like him beyond measure" [1866]).

Much of the hostility that critics express when they discuss Norman Rockwell is rooted in the idea that Rockwell presents an unrealistic—false—view of America. Until late in his career, Rockwell's America was all white and all nice, a world populated with cute kids, shy adolescents, concerned parents, kindly policemen, and shaggy dogs with floppy ears. Critics acknowledged Rockwell's technical skill—they praised his ability to record accurately the surface appearances of people and objects—but they usually complained that his work was sentimental, the presentation of an overly sweet, simplified view of life. On the other hand, Rockwell claimed that he was revealing truths to his viewers: "I showed the America I knew and observed to others who might not have noticed it."

The demand for a realistic view of life can find even unretouched photographs deficient in reality. Thus, Allan Sekula, a critic with a Marxist approach, wants artists to present important economic and social truths. He finds inadequate the liberal sentiments usually associated with documentary photographers such as W. Eugene Smith. What Sekula wants is a politically sophisticated art (in this case, a documentary photograph) that reveals to the viewer what Sekula takes to be the truth about capitalism:

> For all his good intentions, for example, Eugene Smith in *Minamata* provided more a representation of his compassion for mercury-poisoned fisherfolk than one of their struggle for retribution against the corporate polluter. I will say it again: the subjective aspect of liberal aesthetics is compassion rather than collective struggle. Pity, mediated by an appreciation of "great art," supplants political understanding.
>
> —Allan Sekula, *Photography Against the Grain* (1984), 67

For Sekula it is not enough for a picture to have formal beauty (say, the "underlying tensions" that Paul Rudolph valued in Falling Water) or for a picture to evoke compassion. A work of art is a window on the non-art world, and it must also reveal and convey political understanding. "I am arguing, then," Sekula says, "for an art that documents monopoly capitalism's inability to deliver the conditions of a fully human life" (page 74).

Instrumental Value and Ideology: In talking about art and truth—whether we are holding the work of art up against the truth as it is given by a religious system (for instance, Christianity) or by a secular system (for instance, Marxism)—we are saying that the value of the work depends on something outside of the work itself, something *extrinsic* to the work, here the external world, seen through Christian eyes or seen through Marxist eyes. Art, in this view, has a *cognitive* role: It gives us knowledge. Critics who hold this position say that a good work of art has *instrumental value;* the work is an *instrument,* improving us spiritually, morally, or socially.

Most religious art, for example, in its original context—that is, until it is removed from sacred space and put into a museum or a private collection, where it becomes as object to be admired as art—is instrumental. (We have already seen [page 30] that the Archbishop of Westminster regards Piero della Francesca's *The Baptism of Christ* as "a way into prayer.") In some faiths, images are regarded not just as representations of a deity but also as places in which the deity actually resides: The worshipper seeks to connect with the deity in order to gain some sort of power, for instance, to become fertile or to defeat an enemy. Christian theologians, aware that the second of the Ten Commandments prohibits the creation of graven images, have usually said that the prohibition is against the creation of images of the sort just mentioned—idols, we might call them, objects that are worshiped as gods. The images (sculptures and paintings) that are acceptable to Christianity are venerated, not worshiped, but these too are commonly defended on instrumental grounds. Pope Gregory the Great at the end of the sixth century said that images are the books of the illiterate; from such images as pictures in a stained glass window in a church the illiterate Christian could learn the biblical stories, and by gazing on an image of Christ suffering on the cross, the illiterate could better grasp Christ's great love for humanity. Such images are not idols that are worshiped but it is said that they nevertheless do work a sort of magic, producing a change in the viewer and thus in the world. Similarly, it is held that the architecture of churches, mosques, and temples can, by virtue of its proportion and its lighting, elevate the spirit of the worshipper. In short, in this view, physical seeing of material things is transformed into the spiritual perception of God.

Like religious art, much feminist art is said to have instrumental value: In this instance, the art is usually said to heighten female consciousness, to empower women. Judy Chicago, creator of *The Dinner Party* (1974–1979) on her Web site (*www.judychicago.com*) affirms her "commitment to the power of art as a vehicle for intellectual transformation and social change and to women's right to engage in the highest level of production." In one of her books Chicago explicitly connects her work with medieval images:

> I firmly believe that if art speaks clearly about something relevant to people's lives, it can change the way they perceive reality. In a similar way medieval art had been used to teach the Bible to illiterate people. Since most of the world is illiterate in terms of women's history and contributions to culture, it seemed appropriate to relate our history through art, particularly through techniques traditionally associated with women— china-painting and needlework.
>
> —*The Dinner Party: A Symbol of Our Heritage* (1979), 12

Judy Chicago, *The Dinner Party,* 1979, looking from Wing Three, featuring Virginia Woolf and Georgia O'Keefe place settings. Brooklyn Museum, Gift of The Elizabeth A. Sackler Foundation, 2002.10. Photographer: © 2013 (photo) Donald Woodman/Artists Rights Society (ARS), New York. Art © 2013 Judy Chicago/Artists Rights Society (ARS), New York.

The Dinner Party, a mixed-media installation that fills a large room, consists of a triangular table, each side of which is 48 feet long. (Chicago supervised some four hundred artists, mostly women, who worked for five years on the project.) On the white tile floor are inscribed, in gold, the names of 999 distinguished women who, so to speak, provided the foundation for the accomplishments of the thirty-nine distinguished women for whom the triangular table is set. (The triangle is an ancient symbol of female sexuality and power.) On the table are thirty-nine 14" sculpted dinner plates for the diners, who range from ancient goddesses and the Egyptian Queen Hatshepsut (1503–1482 B.C.) to mid–twentieth-century women such as Georgia O'Keeffe and Virginia Woolf. The plates, decorated with painted butterflies or flowers that evoke images of female genitalia, rest on woven embroidered runners with motifs of the period in which the diner lived. All of this, again, is said to have been created for the purpose of heightening the viewer's awareness of the accomplishments of women. (For responses to *The Dinner Party,* see *Sexual Politics* [1996], ed. Amelia Jones.)

In practice, the instrumental view usually comes down to evaluating the **ideology** of the work, arguing that a work embodying such-and-such ideas is (depending on the critic's own ideology) good or bad. Allan Sekula's comment about Eugene Smith, quoted on page 234, is an example of criticism based on instrumental value.

But *does* art really make anything happen? Answer vary; among those who most vigorously hold that the arts do exert a great effect are those who see the arts chiefly as dangerous. Some two thousand five hundred years ago Plato was no lover of the arts—he argued that they nourish the passions, a very bad thing in the eyes of a rational philosopher—and today's newspaper probably has a report of someone who argues that some image in a current exhibition is in fact pornography and that it will corrupt young viewers.

Intrinsic Aesthetic Merit as a Criterion: In contrast to value systems that judge the work in terms of something extrinsic to the work—such as the real world, as we see it or as it is understood by (say) Christians or by Marxists, or the artist's sincerity or insincerity, as conjectured by the critic—we can place **formalism.** Formalism holds that *intrinsic* qualities—qualities within the work, having no reference to the outside world—make it good or bad. We have seen Paul Rudolph praise Falling Water because of its "delicate balancing of forces and counterforces" and because "the whole achieves the serenity which marks all great works of art."

Are there patterns that are inherently pleasing, patterns that in themselves afford aesthetic pleasure to the viewer? The implication here is that all members of our species are hardwired to receive this kind of pleasure. Euclid, the Greek mathematician of the third century B.C., defined one pattern that has come to be called *the golden section,* a pattern much discussed in the Renaissance—for instance, by Leonardo—and unquestionably used by later artists such as Claude Lorrain (1600–1682) and Richard Wilson (1714–1782). A line or rectangle is divided into two unequal parts, so that the ratio of the smaller is to the larger as the ratio of the larger is to the whole. This proportion, roughly, is 3 to 5; thus (again, roughly), 3 is to 5 as 5 is to 8. In a landscape, the painter might divide the canvas vertically, giving us classical ruins in the smaller portion and an expansive landscape in the larger portion. Or the line might be conceived horizontally, dividing the canvas into an upper and a lower portion. In a landscape painting or photograph, the horizon might be located so that the sky occupied the larger rectangle, the land the smaller.

Whether the golden section does offer aesthetic pleasure is still a matter of controversy—and if it does, does it do so for people of all cultures?—but the point here is merely to explain the idea that in the formalist view, a work offers

pleasure by means of its form. If you have ever rearranged objects on a mantel, or even straightened a picture on a wall, you know that some patterns are (at least for you) more pleasing than others. Formalist critics, taking issue with the position that we must judge a work only by the standards of the work's own age, hold that all great works are closely related because of common qualities.

One additional point: Although most formalist critics suggest that the work is not to be judged by anything outside of itself, some formalists do hold instrumentalist positions, claiming for instance that works of art help us to see reality better, or that they are valuable because by means of their harmony they induce mental harmony in the viewer. "Music," William Congreve said (but perhaps we can extend his remark to any work of art), "has charms to soothe a savage breast," and indeed some racetracks pipe music into the stables to soothe the high-strung horses.

Modernist critics, active chiefly from about 1950 to the mid-1970s, were primarily committed to abstract art and the apparently impersonal no-frills architecture of the International Style epitomized in the work of Mies van der Rohe. They tended to assume, as formalist critics, that a work of art is self-sufficient, pure, the product of a genius and, therefore, opposed to popular culture, and it need not—indeed should not—be seen as a reflection of the social context. It now seems evident, however, that admirers of the International Style were espousing—whether they knew it or not—not intrinsic aesthetic merit, but a capitalist celebration of business efficiency. For the modernist, the significant artist was highly original, a member of the avant-garde, a genius who produced a unique work that marked an advance in the history of art—a sort of artistic Thomas Edison or Henry Ford. Not surprisingly, modernist critics tended to practice formal analysis.

A reaction against the modernist critics of the mid-twentieth century probably was inevitable, and it took the name of **postmodernism** (familiarly called *pomo*). Postmodernist critics (active from about 1970 to the present) argue that the supposedly dispassionate old-style art historians are, consciously or not, committed to the false elitist ideas that universal aesthetic criteria exist and that only certain superior things qualify as "art." For postmodernists, modernist art and modernist criticism are all dressed up with nowhere to go. Here is the way Tom Gretton puts it:

> For most art historians "art" does not designate a set of types of object—all paintings, sculptures, prints and so forth—but a subset arrived at by a more or less openly acknowledged selection on the basis of aesthetic criteria. But aesthetic criteria have no existence outside a specific historical situation; aesthetic values are falsely taken to be timeless.
>
> —Tom Gretton, "New Lamps for Old," in *The New Art History*, ed.
> A. L. Rees and Frances Borzello (1986), 64

Behind a good deal of postmodernist criticism stand the writings of the architects Robert Venturi and Denise Scott-Browne, who see modernism, with its emphasis on formal beauty, as narcissistic. In place of Mies van der Rohe's "Less is more," they say, "Less is a bore." Postmodern critics, seeing the artist as deeply implicated in society, reject formal analysis and tend to discuss artworks not as beautiful objects produced by unique sensibilities but as works that exemplify a society's culture, especially its politics. This approach is discussed (see pages 51, and 249) in comments on deconstruction and on the New Art History.

Other Criteria: We have not exhausted the criteria that critics may offer. Some critics value art for its **expressiveness.** In this view, artists express themselves, setting forth their inner life. In Jackson Pollock's words, "Painting is a state of being . . . self-discovery. Every good artist paints what he is." And again, Pollock, "I want to express my feelings rather than illustrate them." It may be healthful for artists to express themselves, but what is the value for viewers? The usual answer is that the work of art gives viewers (if the expression is successful) new states of feeling. Thus, Jonathan Fineberg in *Art Since 1940,* 3rd edition (2011) says of Eva Hesse—for an example of her work, see page 104— "In Hesse's case, her drive to find form (in whatever material seemed most evocative) for her profound emotional struggles presses the viewer irresistibly into identifying with her discovery of herself in the objects she created" (page 297).

Critics who value art for its expressiveness are likely to talk about the artist's **sincerity,** faithfulness to his or her vision, and so on. Skeptics, however, may ask how we can know if the artist indeed was sincere and faithful. Do we turn to the artist's letters, for instance, or to statements made in interviews, in order to validate the sincerity of the work? True, we can turn to documents if we are talking about modern artists, and we can agree that much of the interest in modern art is in the artist's highly personal response to experience, but what about older artists who have left us little or nothing besides the works themselves? How do we know if the cave paintings at Lascaux, the sculptures from the Parthenon, and *Mona Lisa* are sincere? And can't a very bad artist be utterly sincere?

Still other critics may especially value **technique.** We have only to look at the perfection of the potting of, say, a Chinese porcelain—the uniformity of the color, the almost unbelievable thinness of the clay—to see value in the work. The commonly heard complaint against much modern art, "Any two-year-old could do that," is a complaint about the apparent lack of skill. In valuing technique (skillful execution) we may, when speaking of

paintings, be getting back to realism: "Look how the painter has caught the texture of fur here, and the texture of silk there. And just look at the light reflecting on that glass of wine!"

Originality and **influence on later art** are yet other values. The first artist to do something gets extra credit, so to speak, even if on other grounds the work is not exceptional. Here we recall Elgar and Maillard's praise (page 230) of Picasso's *Les Demoiselles d'Avignon* as "the concrete embodiment of an original vision." In this vein, the sculptor Richard Serra has said (*New York Times,* 11 August 1995, C1) that he inclines to "evaluate artists by how much they are able to rid themselves of convention, to change history." Monet's late paintings of water lilies were for several decades regarded as of no interest and were unsaleable, but fairly recently they have been hailed as precursors of Abstract Expressionism, and their prices have soared. Conversely, an artist who pretty much keeps doing the same thing may be put down as unimaginative, even though each work may be excellent when judged by other criteria.

The distinction between the *fine arts* and the *crafts* is usually rooted in this emphasis on originality. The artist supposedly has a unique vision, whereas the craftsperson executes—with considerable skill—a routine job, making a table or a quilt or a ceramic pot. Today most people who think about this issue either elevate craftspersons to the level of artists or, on the other hand, demystify artists—they take away the element of alleged genius or at least inspired individuality—and see artists as "art workers."

Arguing about Values

Even this very brief survey of conflicting values offers enough to indicate why some philosophers (including some professors of art history) doubt that objective evaluation is possible. And one can see why they say that such terms as "beautiful" and "ugly" are not really statements about artworks but are simply expressions of feelings, mere emotional responses, high-class grunts of approval or sighs of despair. (However, as we saw on pages 23–25, some philosophers of art insist that the real existence of a work is indeed in the observer's response, not in its material makeup of paint on canvas or a mass of bronze.)

Probably most people today would agree that there are no inflexible rules by which we can unerringly judge all works. Still, the preceding paragraphs seek to convince you that discussions of artistic value are not merely subjective, not just expressions of personal opinion.

When we are deeply moved by an artwork, we want others to feel equally excited, and so we point to details, evidence, we offer *arguments* to convey *why* we care about the work. (After all, most instructors do not include just any old thing in their syllabus; rather, they choose specific works because they believe these works embody particular qualities.) When we

offer our opinions about works that excite us, sometimes others agree with us immediately; sometimes we have to offer further analysis; and sometimes, no matter how precise and passionate our arguments, we fail to convince our audience. Then it becomes their turn, and the discussion and debate proceed. Our own responses may sharpen or even radically change. Fine; this is part of why art, and critical conversations about art, can be richly rewarding. But good critics recognize a duty to set forth their feelings in (to repeat D. H. Lawrence's words) a *reasoned* account. If we really believed that "It's all a matter of personal preference," we would not bother to offer reasons, and we would not bother to pay alleged experts to teach courses in art.

If you want some fun while thinking about what makes a work of art good or bad, visit the Web site of the Museum of Bad Art, *www.glyphs. com/moba*, or just enter "Museum of Bad Art" into a Web search engine, or visit the museum itself, in the concrete basement (next to the men's room) of the community theater in Dedham, Massachusetts.

✍ A RULE FOR WRITERS:

When you draft an essay, and when you revise it through successive drafts, imagine that you are explaining your position to someone who, quite reasonably, wants to hear the reasons that have led you to your conclusions.

HISTORICAL SCHOLARSHIP AND VALUES

The root of much historical writing, like that of critical writing, is also a feeling or intuition—a hunch perhaps that a stained glass window in a medieval cathedral may be a late replacement, or that photography did not influence the paintings of Degas as greatly as is usually thought. The historian then follows up the hunch by scrutinizing the documents and by setting forth— like the critic—a reasoned account.

It is doubtful, then, that historical scholarship and aesthetic criticism are indeed two separate activities. To put it a little differently, we can ask if scholarship is really concerned exclusively with verifiable facts or, on the other hand, if criticism is really concerned exclusively with unverifiable responses (i.e., only with opinions, especially with reports about aesthetic responses). If scholarship limited itself to verifiable facts, it would have little to deal with; the verifiable facts usually don't go far enough.

Suppose that a historian who is compiling a catalog of Rembrandt's work, or who is writing a history of Rembrandt's development, is confronted

by a drawing attributed to Rembrandt. External documentation is lacking: No letter describes the drawing, gives a date, or tells us that the writer saw Rembrandt produce it. The historian must decide whether the drawing is by Rembrandt, by a member of Rembrandt's studio, by a pupil but with a few touches added by the master, or is perhaps an old copy or even a modern forgery. Scholarship (e.g., a knowledge of paper and ink) may reveal that the drawing is undoubtedly old, but questions still remain: Is it by the master or by the pupil or by both?

Even the most scrupulous historians must bring their critical sense into play and offer conclusions that go beyond the verifiable facts—conclusions that are ultimately based on an evaluation of the work's quality, a feeling that the work is or is not by Rembrandt and—if the feeling is that the work *is* by Rembrandt—a sense of *where* it belongs in Rembrandt's chronology. Art historians try to work with scientific objectivity, but because the facts are often inconclusive, much in their writing is inevitably (and properly) an articulation of a response, a rational explanation of feeling that is based on a vast accumulation of experience.

Another example: A historian's decision to include in a textbook a discussion of a given artist or school of art is probably a judgment based ultimately on the feeling that the matter is or is not worth discussing, is or is not something of importance or value. And the decision to give Vermeer more space than Casper Netscher is an aesthetic decision, for Netscher was, in his day, more influential than Vermeer. Indeed, art history has worked along these lines from its beginnings in *Lives of the Most Excellent Painters, Sculptors and Architects* by Giorgio Vasari (1511–1574). Vasari says that he disdained to write a "mere catalog," and that he did not hesitate to "include [his] own opinion" everywhere and to distinguish among the good, the better, and the best.

On the other hand, even critics who claim that they are concerned only with evaluation, and who dismiss all other writing on art as sociology or psychology or gossip, bring some historical sense to their work. The exhibitions that they see have usually been organized by scholars, and the accompanying catalogs are often significant scholarly works; it is virtually impossible for a serious museum-goer not to be influenced, perhaps unconsciously, by art historians. When, for example, critics praise the Cubists for continuing the explorations of Cézanne and damn John Singer Sargent for contributing nothing to the development of art, they are doing much more than expressing opinions; they are drawing on their knowledge of art history, and they are echoing the fashionable view that a work of art is good if it marks an advance in the direction that art happens to have taken. (One can in fact point out that there are so many trends, one can doubt that art is going in any particular direction.)

Probably it is best, then, not to insist on the distinction between scholarship and criticism, but to recognize that most writing about art is a blend of both. True, sometimes a piece of writing emphasizes the facts that surround the work (e.g., sources, or the demands of the market), showing us how to understand what people once thought or felt; and sometimes it emphasizes the reasons why the writer especially values a particular work, showing the work's beauty and significance for us. But on the whole the best writers on art do both things, and they often do them simultaneously.

12

SOME CRITICAL APPROACHES

Aesthetics is for me as ornithology must be for the birds.
>—Barnett Newman, interview of 1972

The way we see things is affected by what we know or what we believe.
>—John Berger, *Ways of Seeing*, 1972

Ask a toad what beauty is, the Beautiful? He will answer you that it is his she-toad.
>—Voltaire, *Philosophical Dictionary*, 1764

Most of this book thus far has been devoted to writing about what we perceive when we look closely at a work of art, but it is worth noting that other kinds of writing can also help a reader to see (and therefore to understand better) a work of art. For example, one might discuss not a single picture but, say, a motif: Why does the laborer become a prominent subject in nineteenth-century European painting? Or: Why do Europeans and Americans on the whole put a much higher value on nineteenth-century African art than they do on African art of the second half of the twentieth century or the early twenty-first century? Essays of this sort usually involve analyzing artworks in terms of their context, the world around them. The larger context may be, for instance, the artist's life, or it may be the religious or political world in which the artist moved, or it may be the world of those persons who created the market for the artist's goods.

This chapter sketches some of the chief methodologies or ways of approaching art—for instance, by setting art in its historical context or by examining the psychology of the artist—but it is important to understand that these approaches are not mutually exclusive. Its not a question of one method *or* another; art historians use all of the tools they feel comfortable with. There are times when, so to speak, one stands back from the work, and times when one gets up close, times when one uses a telescope and

times when one uses a microscope. What follows is an introduction to some of the methodologies or sets of principles that art historians have found helpful when they study art.°

SOCIAL HISTORY: THE NEW ART HISTORY AND MARXISM

Discussions of subject matter may be largely **social history** (art seen in a context of social relations), wherein the aesthetic qualities of the work of art (as well as such matters as whether a work is by Rembrandt or by a follower) may be of relatively little importance. Social historians assume that every work (if carefully scrutinized) tells a story of the culture that produced it. Thus, Michael Baxandall in *Painting and Experience in Fifteenth Century Italy* (1972) implies his approach in the first line of his Introduction: "A fifteenth-century painting is the deposit of a social relationship." Similarly, Gary Schwartz, in *Rembrandt: His Life, His Paintings* (1985), says that his intention is to study Rembrandt as "an artistic interpreter of the literary, cultural, and religious ideas of a fairly fixed group of patrons" (page 9).

°For a collection of writings about art, from Vasari (sixteenth century) to Griselda Pollock (late twentieth century), see *Art History and Its Methods,* ed. Eric Fernie (London: Phaidon, 1995). Fernie also includes a thoughtful, readable glossary (about forty pages) of terms ranging from *art* and *avant garde* through *typology* and *vocabulary,* with mini-essays on each term. Jonathan Harris's *Art History: The Key Concepts* (2006) offers lucid mini-essays (about a page or two apiece) on several hundred terms, from "abstract expressionism" to "zeitgeist." For brief discussions (with excellent suggestions for further reading) of twenty-six theorists including Karl Marx, Sigmund Freud, Judith Butler, Jacques Derrida, Michel Foucault, Edward Said, and Gayatri Chakravorty Spivak, see Jae Emerling, *Theory for Art History* 2005).

Inevitably, new critical approaches bring new critical terms. A few terms, such as *cultural materialism, deconstruction, Orientalism, postcolonialism,* and *text,* are used in the present chapter, but dozens of others are now in use, some (such as *discourse, text,* and *queer theory*) whose meanings are not as simple as they seem to be at first glance. The only way to understand these terms is to read a good deal of contemporary criticism, thereby absorbing the terms within their contexts, but considerable help can be found in a work mentioned in the preceding chapter, Thomas Patin and Jennifer McLerran, *A Glossary of Contemporary Art Theory* (1997). The *Glossary* offers definitions ranging from two or three sentences to a page or two. For essays (not always models of clarity) on such newly popular terms as *gaze, postcolonialism,* and *simulacrum,* see *Critical Terms for Art History,* 2nd ed., ed. Robert S. Nelson and Richard Shiff (2003).

Useful online glossaries are *Artlex* and Robert J. Belton's *Words of Art.*

Notice the interest in patrons. Much social history is interested in patronage, confronting such questions as "Why did portraiture in Italy in the late fifteenth century show an increased interest in capturing individual likeness?" and "Why did easel painting (portable pictures) come into being when it did?" The social historian usually offers answers in terms of who was paying for the pictures. Obviously a Renaissance duke or the wealthy wife of a nineteenth-century businessman wanted images very different from those wanted by the medieval church.

Let's consider what the social historian's point of view may reveal if we scrutinize, say, French "**Orientalist**" paintings—nineteenth-century pictures of North Africa (e.g., Algeria and Morocco) and the Near East by such artists as Delacroix and Gérôme, painted for the middle-class European market. We might find that these paintings of part of the Islamic world, such as Gérôme's *The Slave Market* (see page 247), do not simply depict locales; rather, the paintings also depict the colonialist's Eurocentric view that this region is a place of laziness, savagery, and abundant sexuality (beautiful slaves, male and female). The pictures offered viewers (or at least some of them) voyeuristic pleasure by providing images of carnal creatures, and at the same time the pictures allowed the viewers comfortably to feel that the region was badly in need of European law and order and the work ethic.

In short, the pictures can be seen as European constructions that justify colonialism, for instance, the French occupation of Algeria (1830) and the British occupation of Egypt (1882). Even Matisse's pictures of bare-breasted odalisques reclining on cushions and staring blankly can reasonably be said, by today's standards, to embody the colonialist's views, or at least the early twentieth-century bourgeois male's views of North Africa and of women as sensuous and passive beings waiting to be enlivened by the white male who gazes at the pictures. And, of course, white males were the chief purchasers. (We will return to this idea—that *the gaze* of the viewer implies power over the depicted subject—when we discuss images of female nudes as viewed by males later in the chapter.)*

*For a survey of views concerning Orientalism, see John M. MacKenzie, *Orientalism: History, Theory and the Arts* (Manchester: Manchester University Press, 1995). MacKenzie offers a vigorous defense of the view that these pictures do *not* denigrate the Islamic world. For a severe view of the Orientalists, see Linda Nochlin's essay, "The Imaginary Orient," *Art in America* May 1983: 118t, reprinted in her book *The Politics of Vision* (New York: Harper, 1989), 33–59. See also Rodger Benjamin, *Orientalist Aesthetics* (Berkeley: University of California Press, 1997); *The Orientalists: Delacroix to Matisse: The Allure of North Africa and the Near East,* ed. Mary Anne Stevens (1984); and (on Victorian photographs) James R. Ryan, *Picturing Empire* (1997).

Jean-Leon Gérôme, *The Slave Market*, c. 1867. 1955.53, oil on canvas, 33 ³/₁₆"× 24 ³/₁₆". © Sterling and Francine Clark Art Institute, Williamstown, Massachusetts/The Bridgeman Art Library. Gerald M. Ackerman, writing in *Arts Magazine* 60 (March 1986): 79, says that this picture of a slave market "could only be seen as abolitionist." Richard Leppert, in *Art and the Committed Eye* (Boulder: Westview, 1996), 239, emphatically disagrees: "We are *not* invited by Gérôme to gaze at this image in order to critique slavery; we are invited to look and to salivate, all the while saying out loud to anyone within earshot, 'Tsk, tsk.'"

Orientalism, European colonialism or imperialism, multiculturalism, identity politics, whiteness studies, and the ways in which colonized people are depicted and indeed are changed by colonization are the concern of **postcolonial theory.** The term *postcolonial,* coined in the 1980s, is a bit odd; it chiefly means something like "studies in the light of our new awareness of colonialism." Postcolonial studies in art history are especially concerned with "pictorial colonialization," that is, with the ways in which

Caucasian colonial powers have depicted (especially in the nineteenth century) persons of color in the colonies as "other," for instance, as disorderly, female, and irrational (especially erotic)—in short negatively—whereas they have depicted the West as orderly, male, and rational—in short, positively. This division, widely accepted a century ago, is no longer acceptable. In the words of Griselda Pollock, in *Avant-garde Gambits, 1888–1893: Gender and the Color of Art History* (1992), "In a post-colonial era, no Westerner can be complacent about the late nineteenth-century conjunction of aesthetics, sexuality and colonialism" (page 9).

Further, the cultures of both the colonizer and the colonized inevitably intermingle to some degree, with the results that hybrid cultures develop; the colonized in some degree adapt to the colonizers, and the colonizers in some degree adapt to the colonized. At this point we should note that the term **global art history** sometimes refers merely to works of art created throughout the world—anonymous Polynesian decorated shields as well as drawings by Picasso—but "global art history" and especially **globalization** chiefly refer to a contemporary theory that is shaped by an awareness of Western colonial interactions with other traditions. The effects of colonialism can be seen in earlier centuries—for instance, a "traditional" Navajo blanket is made of wool from sheep descended from those brought to the New World by the Spaniards, and its zigzag pattern probably goes back (through Mexican shepherds who derived it from Spain) to the Moors of North Africa—but writers concerned with globalization tend to concentrate on the influences on local communities of widespread economic forces.*

Whereas the formalist critic emphasizes the uniqueness of each work, for the social historian a work of art (like a religious, legal, or political system) is a creation deeply implicated in the values of the culture that produced and consumed it. Indeed, some critics avoid the words "art" and "creation" on the grounds that they smack of individualism. To call something (let's say an image of the Buddha) a work of art is allegedly to take it out of its original context—out of the world in which it was a vital thing—and in effect to steal it and put it into a museum of the mind, where it becomes lifeless.

In this view, the concept of "art" is a modern idea that wrongly values only the sensuous work, whereas in reality the work is a "text" or "production" whose attractive surface is a mask. The student, by resisting its aesthetic seductions and perhaps by "reading against the grain" (a common

*For readings concerned with globalization and with hybrid art, see Jonathan Harris, ed., *Globalization and Contemporary Art* (2011). For encyclopedia-like definitions (ranging from about half a page to six pages) of some 140 terms such as *black Atlantic, colonialism, hybridity,* and *third world,* see Bill Ashcroft, Garreth Griffiths, and Helen Tiffin, ed., *Post-Colonial Studies: The Key Concepts,* 2nd ed. (2007).

expression referring to the attempt to get at what the artist may have tried to hide or may have been unaware of), "interrogates" or "demystifies" or "deconstructs" the work. The approach, which denies that the individual artist establishes the meaning of a work, is called **deconstruction.**

The study of the social and political history of art, especially of matters of class, gender, and ethnicity, in a context of Marxist, feminist, and psychoanalytic theory, and most especially when conducted in a somewhat confrontational manner, is sometimes called the **New Art History** to distinguish it from the earlier art history that was concerned chiefly with such matters as biography, connoisseurship (attribution and evaluation), history of style, and iconography (symbolic meanings of subjects). In the eyes of the New Art History, traditional art history was elitist and was marked by gender and class bias.

Briefly, in this view, art history was:

- Too much concerned with issues of connoisseurship and the art market, such as (a) Which Old Master (almost always a white male) created the work? and (b) How good is it, i.e., How much is it worth?
- Too little concerned with ethical issues such as (a) Are we paying adequate attention to the achievements of women, people of color, colonized people, and people with sexual interests other than our own? and (b) Do we recognize that the art market—by means of which an African or a pre-Columbian religious sculpture ends up in an American museum or on the mantelpiece in a rich American home—deprives nations of their cultural heritages?

The new approach, dating from about 1970, was summed up decades ago in Kurt Forster's "Critical History of Art, or Transfiguration of Values?" published in *New Literary History* (1972). Dismissing the traditional art history, Forster argued that because its practitioners admired the objects they studied, these art historians could not study them critically—that is, they could not see that the objects served the vested interests of the classes in power. Calling for a new approach, Forster argued that "the only means of gaining an adequate grasp of old artifacts lies in the dual critique of the ideology which sustained their production and use, and of the current cultural interests that have turned works of art into a highly privileged class of consumer and didactic goods" (pages 463–464).

In this view, because the work is implicated (or "imbricated") in the economic and cultural demands of the world in which the artist worked, we must examine these demands, i.e., the circumstances in which art is produced and consumed. And we must also examine ourselves—taking account of the influences of such factors as our race, class, and sex—in order

to understand why we regard certain works as of special value. That is, art historians must realize that their understanding of the past depends in part on their own social situation. Our responses to a work are not universal spiritual responses; rather, these responses are a matter of cultural conditioning.

This kind of analysis, which studies a work (often called a "text") in terms of the conditions of its production and reception, is commonly called **cultural materialism** or **cultural criticism.** The interest is less in aesthetic judgment than in moral or political judgment, especially in matters of race, gender, and class. Thus, cultural materialists, influenced by Karl Marx (1818–1883) and especially by the theoretical writings of Michel Foucault (1926–1984), are far less likely to ask, "Is this work by Rembrandt or by a follower?" (a question of connoisseurship that probably gets into matters of quality) than they are to ask, "What is the social system that caused people to value productions of this sort?" and, "How does this object sustain—or undermine—the prevailing power relations?" and, "Why do we today value this work?"

For instance, confronted with a Renaissance painting of an angel facing a young woman above whose head is a halo—a depiction of the Annunciation (the announcement by the angel Gabriel to the Virgin Mary, "You shall conceive and bear a son, and you shall give him the name Jesus")—cultural materialists are likely to be less interested in the ostensible subject matter than in an Oriental rug on a table ("In sixteenth-century Europe, rugs of this sort were expensive and conveyed high status, and therefore they were much coveted by the aristocracy and the wealthier members of the bourgeoisie"). Similarly, for a cultural historian, a portrait painting tells the viewer more about the society in which the sitter lived than about the sitter's personality.

A chief goal of the New Art History, then, is to unearth or reconstruct the often neglected, forgotten, or unperceived ideological assumptions or cultural values or social meanings that inform artworks. Cultural studies are especially concerned with struggles for power and usually concentrate on disempowered groups, notably women and people of color.

A related concern is to show that works of art not only reflect ideology—and therefore are far more than mere examples of beauty—but also actively participate in ideological conflicts. In this view, every work is political; in effect it says to the viewer, "See things *this* way, not some other way." Whether or not the men and women who fashioned the works were politically aware, the works produce political actions.°

°For a collection of essays along these lines, see *The New Art History,* ed. A. L. Rees and Frances Borzello (1986). Another good place to begin is Emma Barker, ed., *Contemporary Cultures of Display* (1999), in a series called *Art and its Histories.* For a judicious survey, see Jonathan Harris, *The New Art History: A Critical Introduction* (2001).

The interest in patrons (essentially, *"who* paid for it, and *why?"*) is only one aspect of the social historian's concern with the production and consumption of art. Other points of interest include the particular artists in any given period and the sorts of training they received. In *Art News* (January 1971), Linda Nochlin, then an assistant professor, asked a fascinating sociological question: "Why Have There Been No Great Women Artists?" (The essay is reprinted in Nochlin's book, *Women, Art, and Power and Other Essays,* 1988.) Nochlin rejected the idea that women lack artistic genius, and instead she found her answer "in the nature of given social institutions." For instance, women did not have access to nude models (an important part of the training in the academies), and women, though tolerated as amateur painters, were rarely given official commissions. And, of course, women were expected to abandon their careers for love, marriage, and the family. Furthermore, during certain periods, women artists were generally confined to depicting a few subjects. In the age of Napoleon, for example, they usually painted scenes not of heroism but of humble, often sentimental, domestic subjects such as a girl mourning the death of a pigeon.

The social historian assumes that works of art carry ideas and that these ideas are shaped by specific historical, political, and social circumstances. The works are usually said to constitute ideologies of power, race, and gender. Architecture especially, being made for obvious uses (think of castles, cathedrals, banks, museums, schools, libraries, homes, malls), often is usefully discussed in terms of the society that produced it. (Architecture has been called "politics in three dimensions.")

Social historians whose focus is **Marxism** examine works of art as reflections of the values of the economically dominant class and as participants in political struggles. Works of art themselves do some sort of economic or political work—they commemorate the dead, or serve as intermediaries with the gods, or display the power of their owners. For Marxists this work usually is, at bottom, the reinforcement of the class ideology. In this view, the meanings and value of a work can be understood only by putting it into the social situation that produced it.° In the words of Nicos Hadjinicolaou, in *Art History and Class Struggle* (1978), "Pictures are often the product in which the ruling classes mirror themselves" (page 102).

°See Janet Wolff, *The Social Production of Art* (New York: St. Martins, 1981). Among important Marxist writings on art are John Berger, *Ways of Seeing* (1972), T. J. Clark, *The Painting of Modern Life* (1985), and Terry Eagleton, *The Ideology of the Aesthetic* (1990). For a comment about Marxism and the evaluation of art, see page 247. For sourcebooks of readings, see Berel Lang and Forrest Williams, eds., *Marxism and Art* (1972) and Andrew Hemingway, ed., *Marxism and the History of Art: From William Morris to the New Left* (2006).

Of course, the mirror is not really a mirror but a presentation of the ways in which the ruling classes wish to be seen. For instance, the land-owners whose wealth is derived from the soil, or more precisely from the agricultural labor of peasants, may present themselves as in harmony with nature, or as the judicious and loving caretakers of God's earth. Artworks thus are masks; their surface is a disguise, and the Marxist art historian's job is to discover the underlying political and economic significance. Other artworks, instead of reinforcing a society's dominant values, work the other way; that is, they subvert the values, but in either case art is part of an ideo-logical conflict. As John Tagg says in *Grounds of Dispute* (1992, page 43), the question a Marxist asks of an artwork is not "What does it express?" but "What does it *do*?" Not surprisingly, Marxists sometimes call the people who produce works of art *art workers* rather than *artists,* just as prostitutes are now sometimes called *sex workers* to emphasize that their work *is* work, and that they labor not for their own pleasure but for that of others.

In short, the Marxist art historian, fundamentally concerned with social inequality, is likely to address the following questions:

- What was the social status of the patron?
- What was the social status of the artist?
- What ideology shaped the work?
- Where was the work displayed, and for what purpose?

Where does beauty come in? To the question, "Why does this work give me pleasure?" the Marxist historian—or at least Hadjinicolaou—replies in this way:

> Aesthetic effect is none other than the pleasure felt by the observer when he recognizes himself in a picture's visual ideology. It is incumbent on the art historian to tackle the tasks arising out of the existence of this recognition. . . . This means that from now on the idealist question "What is beauty?" or "Why is this work beautiful?" must be replaced by the materialist question, "By whom, when and for what reasons was this work thought beautiful?"
> —Nicos Hadjinicolaou, *Art History and Class Struggle* (1978), 182–183

GENDER STUDIES: FEMINIST CRITICISM AND GAY AND LESBIAN STUDIES

Gender studies, a comprehensive field including feminist and gay and lesbian historical scholarship and criticism, attempts to link all aspects of cultural analysis concerning sexuality and gender. These methodologies

usually assume that although our species has a biologically fixed sex division between male and female (a matter of chromosomes, hormones, and anatomical differences), the masculine and feminine roles we live out are not "natural" or "essential" or "innate" but are established or "constructed" by the society in which we live. Society—or cultural interpretation—it is argued, exaggerates the biological sexual difference (male, female) into gender difference (masculine, feminine), producing ideals and patterns of gender (masculinity, femininity) and of sexual behavior (e.g., the idea that heterosexuality is the only natural behavior).

It is argued that in our patriarchal society (literally "rule by fathers," less literally "rule by males)—parents, siblings, advertisements and so forth teach us that males are masculine (strong, aggressive, rational) and that females are feminine (weak, nurturing, irrational), and we (or most of us) play male or female roles in a social performance, "constructing" ourselves into what society expects of us. Simone de Beauvoir, an early exponent of the feminist theory of gender, in *The Second Sex* (1949) puts it this way: a "Woman" is constructed as "Man's Other," thus "one is not born a woman; one becomes one." Because (according to the view that gender is socially constructed) ideals and patterns change from one time or culture to another, analysis based on an awareness of the social construction of gender can help the viewer better understand works of art by or about men and women, heterosexual and homosexual.°

Unfortunately, this useful distinction between *sex* (biological) and *gender* (cultural, socially constructed), developed in the mid-twentieth century, was soon eroded by the popular press, which uses *gender* simply as a fancy-sounding word for *sex*, as in "Classrooms in some schools are separated by gender," or "Artists of both genders are represented."

Feminist art history and criticism begins with the fact that men and women are different. As we have just seen, some writers believe the difference is chiefly "essential"—for instance, women menstruate and bear children—and that certain qualities in works of art by women are the natural expression of their biology, independent of race, class, and culture. Others, however, believe the difference is chiefly "constructed," a matter not of biology but of the roles women occupy in society. And of course, in this view the art of men is also an expression of the social roles men occupy. In Mary D. Garrard's words,

°See *Gender and Art*, ed. Gill Perry (New Haven: Yale University Press, 1999). On the essentialist/constructionist issue, see also Amelia Jones's introductory essay in an exhibition catalog, *Sexual Politics* (Berkeley and Los Angeles: University of California Press, 1996), edited by Jones. Jones's catalog is largely devoted to Judy Chicago's installation, *The Dinner Party*, a work discussed in this book on pages 235–36.

The definitive assignment of sex roles in history has created fundamental differences between the sexes in their perception, experience and expectations of the world, differences that cannot help but be carried over into the creative process where they have sometimes left their tracks.

—*Artemisia Gentileschi: The Image of the Female Hero in Italian Baroque Art* (1989), 202

One can make further distinctions, arguing, for instance, that the experiences of women of color differ from those of white women, but here we will concern ourselves only with the most inclusive kind of feminist writing. This writing is especially interested in two topics:

• How women are portrayed in art and
• Whether women (because of their biology or socialization or both) create art and see art differently from men.

The first topic is centered on subject matter: How do images of women (chiefly created by men) define "being female"? Are women depicted as individuals with their own identity or chiefly as objects for men to consume? The second topic, woman as artists and viewers of art, is closely related to the first. It is probably true that (at least until recently) in a world of predominantly male-created public works of art, the implied viewer is male. Consider pictures of nude females. To use language introduced on pages 79–80, the bearer of the *gaze* (and, therefore, the one who wields the power) is male; the eroticized object of the gaze, the "powerless Other," is female. (Erotic gazing is sometimes called *scopophilia*, "pleasures of the eye," a word borrowed from Freud.) The nude woman may be unaware that she is being spied on—perhaps she is about to bathe—or she may be aware, in which case she may be shielding her breasts or her genitals, an action that only emphasizes her vulnerability. In any case, the female nude is an object created largely for the enjoyment of men. The male artist, it is said, constructs images of the female body that satisfy male viewers.

Why, one can ask, do some heterosexual women take pleasure in some images of female nudity? Here are three of the many answers that have been offered: (1) these women, socialized by a patriarchal culture (i.e., deceived or coerced into accepting male ideologies), may negate their own experience and identify with the heterosexual, masculine, voyeuristic, penetrating gaze; (2) some female viewers may narcissistically identify themselves with the female images depicted (this explanation is sometimes used to account for images of female nudity found in advertising directed toward women); (3) "being female is only one aspect of a woman's experience," and although it may sometimes determine her response as a viewer, at other times it may not. (This third view is offered by Carol Ockman, in *Ingres's Eroticized Bodies*, [1995].)*

*For more about the gaze, see Marcia Pointon, *Naked Authority: The Body in Western Painting, 1830–1908* (1990).

Guerrilla Girls, *Do women have to be naked to get into the Met. Museum?*, 1989. Poster, ink and color on paper. Private collection. Courtesy of Guerrilla Girls. © Guerrilla Girls, www.guerrillagirls.com. Since 1985 a group of women, wearing gorilla masks, have put up posters and issued other materials calling attention to the under-representation of women in the art world. The image on this poster is based on Ingres's *Grande Odalisque* (1814), a painting that few viewers would deny offers an eroticized woman as the object of the gaze. Interestingly, the painting was commissioned by a woman, Queen Caroline Murat.

To turn to women as artists: Are the images created by women different from those created by men?

- In working in the "masculine" genre of the female nude, does a female artist (e.g., Suzanne Valadon) produce images that significantly differ from the images produced by males working in the same artistic milieu? (The images produced by males are usually said to be passive objects, constructed by male desire.)
- Are there certain genres in which women chiefly worked?
- Are certain traits that are said to characterize the works of many women artists—e.g., sentimentality—not weaknesses but strengths, evidence of a distinct way of resisting the male status quo?*

*On the issue of differences in the approaches of male and female artists, see Judy Chicago and Edward Lucie-Smith, *Women and Art; Contested Territory* (1999).

Some writers have emphasized connections between events in the lives of women artists and their work. For instance, we know that Artemisia Gentileschi was raped by one of her father's apprentices. Some scholars have suggested that Gentileschi's depiction of Judith, the beautiful widow who according to the Bible saved the Hebrews by beheading Holofernes, an Assyrian general, was Gentileschi's way of taking revenge on men. Other writers, however, have pointed out that the subject was painted by men as well as by women, and still others have expressed uneasiness over the tendency to interpret the work of women in terms of their lives. Mary D. Garrard, in the *New York Times* (22 September 1991), calls attention to the implications in some biographical studies when she says that the art of women is often seen in personal terms whereas the art of men is seen in universal terms.

A glance at certain writings about Frida Kahlo (1907–1954), the politically radical painter, supports Garrard's comment. Kahlo suffered greatly, both physically (at the age of eighteen she was partly paralyzed by a horrendous traffic accident in which her spine was fractured, her pelvis was crushed, and one foot was broken) and mentally (her husband, the painter Diego Rivera, was notoriously unfaithful). Discussions of Kahlo's work usually emphasize the connection of the imagery with her suffering, and they tend to neglect the strong political (Marxist and nationalistic) content.

Speaking of "strong" ideas, keep in mind that such words as *strong, seminal, potent,* and *powerful,* when used to describe artworks, are not gender-neutral but are loaded in favor of male values. Indeed, much of the language of art criticism—*masterpiece* is another example—tends to put women and their work at a disadvantage. *The Guerrilla Girls' Bedside Companion to the History of Western Art,* a book that appropriately describes itself as "a wildly entertaining and much-needed corrective to traditional art history," quotes (page 41) a telling example by the art historian James Laver:

> Some women artists tend to emulate Frans Hals, but the vigorous brush strokes of the master were beyond their capability. One has only to look at the work of a painter like Judith Leyster to detect the weakness of the feminine hand.

Today we rub our eyes in amazement that such stuff passed as serious art history.

It is easy to see why many art historians now argue that the traditional distinction between "fine art" or "high art" (a portrait of Henry VIII by Holbein) and "decorative art" or "low art" (a quilt by an anonymous woman) masquerades as a universal truth but is really a patriarchal concept designed

to devalue female creativity. The battle seems now to have been won: The Whitney Museum of American Art in 2003 presented an exhibition entitled *The Quilts of Gee's Bend,* consisting of sixty quilts made by African-American women between 1930 and 2000 in a rural community, Gee's Bend, Alabama. The museum's newsletter for March–May 2003 described the material thus:

> Originally created for practical use in the home, the quilts were often made from the fabrics of daily life. Reflecting a painterly approach to working with textiles, the quilts are outstanding examples of a great American art form. . . . (10)

Before, say, 1970, it would have been inconceivable for a publication of a major art museum (other than a museum devoted to folk art) to speak of quilts as "a great American art form," and to say that they reflect "a painterly approach."*

Earlier in this chapter (page 251) we quoted Linda Nochlin, and we can end this short discussion of feminist art history by quoting another passage from her writing:

> Feminist art history is there to make trouble, to call into question, to ruffle feathers in the patriarchal dovecotes. It should not be mistaken for just another variant of or supplement to mainstream art history. At its strongest, feminist art history is a transgressive and anti-establishment practice, meant to call many of the major precepts of the discipline into question.
>
> —*Women, Art, and Power and Other Essays* (1988), xii

*Examples of feminist criticism and historical scholarship can now be found in almost all journals devoted to art, but they are especially evident in *Women and Art, Woman's Art Journal,* and *Women's Art.* For collections of feminist essays, see Norma Broude and Mary D. Garrard, eds., *Feminism and Art History* (1982); Arlene Raven, Cassandra L. Langer, and Joanna Frueh, eds., *Feminist Art Criticism* (1988); Norma Broude and Mary D. Garrard, eds., *The Expanding Discourse: Feminism and Art History* (1992); and *Feminism–Art–Theory: An Anthology, 1968–2000,* ed. Hilary Robinson (2001). For a survey of feminist art history, see Thalia Gouma-Peterson and Patricia Mathews, "The Feminist Critique of Art History," *Art Bulletin* 69 (1987): 326–357; and the follow-up by Norma Broude, Mary D. Garrard, Thalia Gouma-Peterson, and Patricia Mathews, "An Exchange on the Feminist Critique of Art History," *Art Bulletin* 71 (1989): 124–127. For a valuable survey of feminist methods and themes, see Lisa Tickner, "Feminism, Art History, and Sexual Difference," *Genders* 3 (1988): 92–129. For a listing of feminist writing about art—including more than a thousand items, with brief summaries—see Cassandra Langer, *Feminist Art Criticism: An Annotated Bibliography* (1993).

In brief feminist art historians—who need not be female—usually ask questions (in addition to How are women portrayed? and Do women see art differently from men?) of this sort:

- Did the artist's sex determine the kind of training he or she had?
- Is the subject matter of the work especially associated with male or with female artists? Why?
- Is the subject matter especially associated with male or with female patrons? Why?

Gay and lesbian art criticism, following feminist criticism, operates from the principle that varieties of sexual orientation make important differences in how artists portray the world, love, and eros, and in how viewers receive and interpret those images.*

Like feminist criticism and history, gay and lesbian art history faces certain questions of definition and scope. Most broadly, it is concerned with

- art *about* gay men and lesbians (or, more generally, homosexuality and bisexuality in all their various forms),
- art *by* gay and lesbian artists, and
- art *addressed to* homosexual audiences (e.g., advertising images in mass media).

"Gay art" is not synonymous with erotic art or pornography. It can include, for example, genre scenes of gay life (by, e.g., Francis Bacon, David Hockney), portraits of famous individuals who were gay or lesbian (Bernice Abbott's photographs of the literary lesbians of Paris between the two world wars), political art around issues of concern to lesbians and gay men (AIDS posters), and mythological or historical subjects (Jupiter and his cupbearer Ganymede, the lesbian Greek poet Sappho).

Gay and lesbian art writing looks at homosexuality as both "text" and "context": as subject matter, and also as a factor that may help to shape the desires of a patron, the work of an individual artist, or its reception by various audiences. It asks about differences or parallels in the ways that love, sexuality, gender, and daily life are depicted by heterosexuals and homosexuals, and it seeks to uncover distinctive expressions of gay and lesbian experience that have, in the past, often been suppressed or misunderstood (Caravaggio's mythologized portraits of Roman adolescent boys, Rosa

*Except for the last paragraph (p. 261), this discussion of gay/lesbian/queer criticism is by James M. Saslow (Queens College and the Graduate Center, City University of New York), author of numerous studies including *Ganymede in the Renaissance* (1986) and *Pictures and Passions: A History of Homosexuality in the Visual Arts* (1999).

Bonheur's self-representation in male clothing). It should be emphasized, however, that not all art by gay people (or by heterosexuals) can be reduced to biographical illustration.

While biography and psychology are important tools for understanding some art by gays and lesbians, gay art history and criticism are linked equally closely to both political and social history. Political because, throughout much of Western history at least, homosexual expression, when not silenced altogether, has often been forced to operate indirectly, in a sort of code that requires inside knowledge to be understood. Moreover, images of homosexual life have been created by heterosexuals seeking to propagate negative attitudes toward their subject, which need to be placed in historical perspective (e.g., a 16th-century Flemish print recording the public burning of men convicted of the sin of sodomy).

In confronting such images, it is important to avoid projecting the moral attitudes of one's own time back onto earlier art. One should not assume, for example, that all cultures "naturally" condemn homosexuality; rather, one should try to discern what artists were trying to say about it within their own cultural framework. Gay criticism is thus closely linked to social history, because interpreting art about gay experience requires a knowledge of attitudes about sex and gender in various societies. Not only attitudes, but even the very definitions of sexual identities and roles have varied greatly throughout history. "Homosexuality" is itself a modern Western term, and vase-paintings of male adolescents addressed to classical Greek men (who were generally what we would now call bisexual), or woodblock prints showing two women making love in Ming China (where no equivalent of our contemporary lesbian culture existed), need to be interpreted in terms of the categories of sexual experience and the social patterns of those cultures.*

Most of this discussion has focused on iconography (see pages 254–59); there is little to suggest any distinctive formal traits that might constitute a "gay style" before the emergence of self-conscious homosexual subcultures in the 18th century. However, in visual terms, the issue of the *gaze*, adopted from feminist criticism, is important in gay and lesbian analysis as well. The "gaze" refers to the act of looking itself, including how it is established within works of art and what kind of outside viewer is implied. Students should ask such questions of pictures as "Who is doing the looking?" and

*Two excellent recent surveys integrating images and historical context are Louis Crompton, *Homosexuality and Civilization* (2003) and Robert Aldrich, ed., *Gay Life and Culture: A World History* (2006).

"Who is being looked at?" Consider, for example, the multiple possible meanings of a male figure when he is painted or viewed by various kinds of individuals:

- a heterosexual male artist or viewer, for whom the sitter is primarily an object for impersonal study and a traditional subject in drawing class
- a gay man, for whom the subject also has a potential erotic interest and perhaps some significant personal connection (e.g., Michelangelo's drawings of ideal men presented to his beloved, Tommaso de' Cavalieri)
- a heterosexual woman, who, like a gay man, may also be erotically or emotionally interested in the male body
- a lesbian, who, like a heterosexual man, has no erotic interest in the sitter, but who might feel political or cultural kinship (e.g., Romaine Brooks's portrait of Jean Cocteau)

Since the 1980s, many critics, historians, and artists have defined themselves as "queer" rather than gay/lesbian. In one sense, the postmodern category of "queer" serves as an umbrella term for a more inclusive range of minority sexual identities, often abbreviated LGBTQ (lesbian, gay, bisexual, transgender, queer). More fundamentally, however, it questions the very notion of individual identity as something innate and fixed that provides a shared basis for a minority subculture. As we saw on page 253, such scholars critique the idea of an inherent self as "essentialist," emphasizing instead how desire is formed, expressed, and perceived by multiple and shifting cultural forces. To those who condemn minority sexualities as "unnatural," they reply that nothing is natural, and that even ostensibly "normal" people frequently break arbitrary social conventions.* Lesbian artist Deborah Kass has painted a multiple image of actress Barbra Streisand from a film where she impersonated a male rabbinical student, titled *Triple Silver Yentl: My Elvis.* Gay/lesbian critics would view it mainly as an image of the artist's lesbian desire; queer critics would see an example of how mass media paint everyone's mental canvas, and how Yentl's gender is superficial and temporary.

In reality, we are all an unstable amalgam of innate desires and cultural conditioning, of *both* body and mind, nature and nurture. To be "queer" is to stand outside one's own cultural box, to view the values, practices, and images of any culture from a skeptical distance: "What does this picture want to make

*For the fundamentals of queer theory, see Whitney Davis, "'Homosexualism,' Gay and Lesbian Studies, and Art History," in *The Subjects of Art History*, eds. Mark A. Cheetham, Michael Ann Holly, and Keith Moxey (1998); Annamarie Jagose, *Queer Theory: An Introduction* (1996); and *Feminism Meets Queer Theory,* Elizabeth Weed and Naomi Schor (1997). It should be mentioned that much more work has been done on gay (male) art history than on lesbian art history.

me think? Why?" That task is more urgent for an artist or viewer who is part of a problematic minority, but it faces anyone who wishes to understand art engaged with the culturally charged topic of sexual orientation.

Indeed, the topic is so culturally charged that a few students, confronted with works that strongly challenge their values, such as Robert Mapplethorp's homoerotic photographs, respond not with gasps or giggles but with inflammatory language (*fags, dyke art*). This book has several times affirmed the importance of listening to one's initial responses, but it has also affirmed the importance of examining these responses in an effort to enlarge experience—in short, in an effort to educate oneself. Don't let preconceptions—whether about art or about morality—bar you from trying to understand images that may seem subversive.

BIOGRAPHICAL STUDIES

Biographical writing, glanced at in the preceding comments on gender criticism, need not be rooted in gender. True, one might study the degree to which Picasso's style changed as he changed wives or mistresses, but one could also study his changes in style as he changed literary friends—Apollinaire affecting Picasso's Cubism, Cocteau his Neoclassicism, and Breton his Surrealism. In fact, John Richardson's multivolume biography is built on a remark by Picasso: "My work is like a diary. To understand it, you have to see how it mirrors my life." Thus, in the second volume of *A Life of Picasso* (1977), pages 19–20, Richardson argues that the distorted faces of *Les Demoiselles d'Avignon* (page 35 in the present text) are partly indebted to Picasso's deteriorating relationship with his mistress, Fernande Olivier.

Speaking broadly, we can say that biographical studies are of two sorts, those that emphasize the individual artist's genius ("the life of") and those that emphasize the artist's social context ("the life and times of"). The first kind is as old as Vasari, whose *Lives of the Artists* (1550) is traditionally said to be the first modern example of art history. Vasari emphasizes the mysterious genius of the individual artist (in Renaissance Italy, all were white and almost all were males): Giotto was a child prodigy who later was able to draw a perfect circle freehand, Michelangelo was a God-like creator, etc. The second kind of biographical study, emphasizing the social context, is very different; it sees the artist not as a mysterious genius, a creative power, but as a team player, someone aided by (for example) the artists of the past and fellow-artists, assisted by patrons and by apprentices in the studio, efficiently producing a commodity in response to the market.

As for the charge that biographies depend at least in part on the chance survival of written documents, defenders of life-and-times biographical studies argue that they set the works of art in their original historical and

authorial contexts, and are concerned with the issues that most concerned the artists themselves—such things as "Who is paying?" and "How is the workshop organized?" Still, readers may feel that the traditional biographical-historical approach to art history tends to reduce art to its alleged historical determinants, and it conveys very little sense of why we today value these earlier works of art.

PSYCHOANALYTIC STUDIES

Many of today's biographical studies can be called **psychoanalytic studies.** Such writings follow in the tradition of Sigmund Freud's *Leonardo da Vinci: A Psychosexual Study of Infantile Reminiscence* (1910), which seeks to reconstruct Leonardo's biography and psychic development by drawing on certain documents and, especially, by analyzing one of Leonardo's memories (for Freud, a fantasy) of an experience while he was an infant. Thus, it seems that Leonardo had two "mothers," a biological mother (a peasant woman) and a stepmother (the woman who was Leonardo's father's wife). In accord with this information, Freud sees in *The Madonna, Child, and St. Anne* Leonardo's representation of himself as the Christ Child, the peasant woman as St. Anne, and the stepmother as the Madonna. St. Anne's expression, in Freud's analysis, is both envious (of the stepmother) and joyful (because she is with the child whom she bore).

In a 1931 letter Freud wrote that an artist's entire repertory might be traced back to "the experience and conflicts of early years," and most psychoanalytic studies of artists have followed Freud in concentrating on early experiences. But there are exceptions; one example is Henry Adams's psychoanalytic essay (in *Art in America,* February 1983) on Winslow Homer, which argues that the works are related to crises in Homer's life. For instance, *The Life Line* and *The Undertow,* two pictures that show men rescuing women, are said to reveal Homer's love for his mother and his desire to rescue her from death. While we are talking about Homer, Nicolai Cikovsky, Jr., in *Winslow Homer* (1996) says that "The sharks in *The Gulf Stream,* for example, circling the helpless boat with sinuous seductiveness, can be read as castrating temptresses, their mouths particularly resembling the *vagina dentata,* the toothed sexual organ that so forcefully expressed the male fear of female aggression" (page 379). In reading psychoanalytic interpretations, it is well to remember a comment attributed to Freud: "Sometimes a cigar is just a cigar."

Psychoanalytic interpretations of works of art, then, are likely to see the artwork as a disguised representation of the artist's mental life, and

especially as a manifestation of early conflicts and repressed sexual desires. The assumption is that the significant "meaning" of the work is the personal meaning that it had (consciously or unconsciously) for the artist. However, as we have seen (pages 23–25), this view is not popular today.

Further, in some psychoanalytic studies the works of art almost disappear. Many pages have been written about why van Gogh cut off the lower part of his left ear and took it to a brothel, where he gave it to a prostitute with the request that she "keep this object carefully." Among the theories offered to explain van Gogh's actions are the following: (1) Van Gogh was frustrated by the engagement of his brother, Theo, and by his failure to establish a working relationship with Paul Gauguin. He first directed his aggression toward Gauguin, and then toward himself. (2) Van Gogh identified himself with prostitutes as social outcasts. He had written that "the whore is like meat in a butcher shop," and so now he treated his body like a piece of meat. (3) He experienced auditory hallucinations, and so he cut off a part of his ear, thinking it was diseased.*

Still, if the job of the art historian is (as is commonly said) to explain not only what works of art meant in their own time but also to explain *why works of art look the way they do,* one can hardly dismiss biographical information. To take a single example: The paintings that Claude Monet made of his garden in the second decade of the twentieth century and in the first few years of the third decade look very different from his earlier paintings of a comparable subject: The whites of earlier paintings became yellow, the blues and greens tended to become purple, and the forms were less clearly defined. In 1912 Monet was diagnosed with cataracts (a disease in which the lenses of the eyes are covered with an opaque film), and in 1923 he had an operation on one eye. Because in subsequent years his paintings became closer to his earlier work, it seems reasonable to think that the work of, say, 1920–23 is what it is because of Monet's impaired sight, and that the later work shows the effect of the operation. Other explanations for the distinctive appearance of the 1920–23 paintings are conceivable—perhaps he was experimenting with a new style—but the medical explanation seems plausible.

Although most psychoanalytic studies of art have been concerned with the process of artistic creation (the study of Winslow Homer is an example), in recent years psychoanalysis has been interested in a second area, the

*On van Gogh, see William M. Runyan, *Life Histories and Psychobiography* (1982), 38–41. For a survey (somewhat dated but nevertheless valuable) of psychoanalytic scholarship and art, see Jack Spector, "The State of Psychoanalytic Research in Art History," *Art Bulletin* 70 (1988): 49–76. On Leonardo, see Bradley L. Collins, *Leonardo, Psychoanalysis, and Art History* (1997).

source of the perceiver's aesthetic enjoyment. Studies of this topic, often couched in terms of *the gaze*, are primarily concerned with how differences in pleasure are linked to differences in gender and class. (See pages 264 and 254.)

ICONOGRAPHY AND ICONOLOGY

One kind of highly specialized study that keeps the image in view is **iconography** (Greek for "image writing, i.e., writing about images"), or the identification of images with specific symbolic content or meaning. In Erwin Panofsky's words, iconography is concerned with "conventional subject matter," the iconographer showing us that certain forms are (for example) particular saints or gods or allegories. An iconographic study might point out that a painting by Rembrandt of a man holding a knife is not properly titled either *The Butcher* or *The Assassin,* as it used to be called; rather, an iconographer might argue, it depicts St. Bartholomew, who, because he was skinned alive with a knife, is regularly depicted with a knife in his hand. (Saints, often hold an **attribute**—that is, some object that serves to identify them. St. Peter, e.g., holds keys, in accordance with Jesus's words to Peter, as reported in Matthew 16.19: "I will give you the keys of the kingdom.")°

But is every image of a man holding a knife St. Bartholomew? Of course not, and if, as in Rembrandt's painting, the figure wears contemporary clothing and has no halo, skepticism is warranted. Why can't the picture be of an assassin—or of a butcher or a cook or a surgeon? But a specialist in the thought (including the art) of the period might point out that the identification of this figure with St. Bartholomew is reasonable on two grounds. First, the picture, dated 1661, seems to belong to a series of pictures of similar size, showing half-length figures, all painted in 1661, and at least some of these surely depict apostles. For example, the man with another man at his right is Matthew, for if we look closely, we can see that the trace of a wing protrudes from behind the shoulder of the accompanying figure, and a winged man (or angel) is the attribute or symbol of Matthew. In another picture in this series a man leaning on a saw can reasonably be identified as Simon the Zealot, who was martyred by being sawn in half. Second, because

°In addition to saints, pagan gods and also personifications often hold or wear attributes. Thus, Jupiter holds a thunderbolt, Hercules wears a lion's skin, Death holds a scythe, and Justice holds scales (weighing competing claims). An animal may also identify or symbolize a person or deity: A lion may stand for St. Mark or St. Jerome, an eagle for Jupiter or St. John.

the Protestant Dutch were keenly interested in the human ministry of Christ and the apostles, images of the apostles were popular in seventeenth-century Dutch art, and it is not surprising that Rembrandt's apostles look more like solid citizens of his day than like exotic biblical figures. In short, to make the proper identification of an image, one must understand how the image relates to its contemporary context.

The study of iconography—the study of the ideas that the artist conveyed through the subject matter—is not limited to the study of artists of the past. Scholars who write about the Mexican painter Frida Kahlo (1907–1954), for instance, call attention to her use of Christian, Aztec, and Marxist images. They point out that in her *Self-Portrait with Thorn Necklace and Hummingbird* (1940),

- the thorn necklace alludes not only to the crown of thorns placed on Jesus' head—Kahlo as guiltless sufferer—but probably also alludes to the mutilation that Aztec priests inflicted on themselves with thorns and spines.
- The hummingbird, sacred to Huitzilopichtli, god of the sun and of war, is an Aztec symbol of the souls of warriors who died in battle or on a sacrificial stone.

Or take another of Kahlo's self-portraits, *Marxism Will Give Health to the Sick* (1954), painted a few months before she died (see page 266). As noted earlier in this chapter, in her youth Kahlo had been partly paralyzed by a traffic accident. In this picture she shows herself strapped in an orthopedic corset but discarding her crutches, although one of her legs had been amputated in the year before she painted this picture. (The painting is in the tradition of an *ex-voto*, a picture given to a church in fulfillment of a vow made by someone who prayed to a saint for help, and whose prayer was answered, for instance, by a miraculous cure. Such pictures customarily show the saint at the top and the recipient of the miracle in the center; for Kahlo, Karl Marx is contemporary humanity's savior.) In the upper right, Marx strangles an eagle with Uncle Sam's head (i.e., Marxism destroys American imperialistic capitalism). Below Uncle Sam are red rivers—presumably rivers of the blood of America's victims—and a shape that probably represents the mushroom cloud of an atomic bomb. At the top left, the dove of peace counterbalances the wicked eagle. Beneath the dove a globe shows Russia, from which flow not rivers of blood but blue rivers, rivers of life-giving, cleansing water. Kahlo, holding a red book (Marx's teachings), is supported by large hands (great power) near Marx; in one of the hands is an eye, a symbol of knowledge (Marx sees all and understands all).

Frida Kahlo, *Marxism Will Give Health to the Sick*, 1954. Oil on masonite, 30" × 24". Collection of the Frida Kahlo Museum. Art © 2013 Banco de Mexico Diego Rivera and Frida Kahlo Museums Trust, Mexico, D.F./Artists Rights Society (ARS), New York.

The Tehuana dress that Kahlo wears in this picture also appears in several of her other paintings. Janice Helland, speaking of this dress in another painting, explains the iconography:

> This traditional costume of Zapotec women from the Isthmus of Tehuantepec is one of the few recurring indigenous representations in Kahlo's work that is not Aztec. Because Zapotec women represent an ideal of freedom and economic independence, their dress probably appealed to Kahlo.
>
> —"Aztec Imagery in Frida Kahlo's Paintings,"
> *Woman's Art Journal* 11 (Fall 1990–Winter 1991): 9–10

Helland cites three references supporting her interpretation of the Tehuana dress.

Iconology (Greek for "image study") seeks to relate the symbolic meanings of objects and figures in art to (in the words of Erwin Panofsky) "the political, poetical, religious, philosophical, and social tendencies of the

personality, period or country under investigation" (*Studies in Iconology*, 1939, reprinted 1967, page 16). That is, iconology interprets an image for evidence of the cultural attitudes that produced what can be called the meaning or content of the work. For instance, iconology can teach us the significance of changes in pictures of the Annunciation, in which the angel Gabriel confronts Mary. These changes reveal cultural changes. Early paintings show a majestic Gabriel and a submissive Virgin. Gabriel, crowned and holding a scepter, is the emblem of sovereignty. But from the fifteenth century onward the Virgin is shown as Queen of the Angels, and Gabriel, kneeling and thus no longer dominant, carries a lily or a scepter tipped with a lily, emblem of the Virgin's purity. In this example, iconology—the study of iconography—calls to our attention evidence of a great change in religious belief. In short, iconology tells us *why* images mean what they mean. (Panofsky, who introduced the terms, later dropped "iconology" and preferred to speak only of "iconography" and "iconographical interpretation.")

The identification of images with symbolic content is not, of course, limited to images in Western art. Here is a brief passage discussing a veranda post for a palace, carved by an African sculptor, Olowe (c. 1875–1938), whom John Pemberton III calls "perhaps the greatest Yoruba carver of the twentieth century." The post (see page 268) shows a seated king wearing a conical beaded crown that is topped by a bird whose beak touches the crown. Beneath the king are a kneeling woman (a junior wife) and a palace servant, and behind the king is the senior queen. Pemberton says:

> When the crown . . . is placed upon his head by the senior queen, his destiny (ori) is linked to all who have worn the crown before him. The great bird on the crown refers to "the mothers," a collective term for female ancestors, female deities and for older living women, whose power over the reproductive capacities of all women is held in awe by Yoruba men. Referring to the cluster of birds on his great crown, the Orangun-Ila said: "Without 'the mothers,' I could not rule." Thus, the bird on the Ogoga's crown and the senior queen, whose breasts frame the crown, represent one and the same power—the hidden, covert, reproductive power of women, upon which the overt power of Yoruba kings ultimately depends. . . .
>
> —John Pemberton III, "The Carvers of the Northeast," in
> Henry John Drewal and John Pemberton III *Yoruba: Nine Centuries*
> *of African Art and Thought* (1989), 210*

Until fairly recently, discussions of African art rarely went beyond speaking of its "brute force," its "extreme simplifications," and its influence on Picasso and other European artists. But it is now recognized that African

*Reprinted by permission of the Museum for African Art.

Olowe of Ise, 1860–1938, Nigeria (Yoruba), Veranda Post of Enthroned King and Senior Wife (Opo Ogoga), 1910–14, wood, pigment. H: 65 in (165 cm). Formerly collection of Amy and Elliot Lawrence.

art, like the art of other cultures, expresses thought—for instance, ideas of power such as prestige, wealth, and fertility—in material form. In short, the forms of African art embody worldviews. (See, for example, Suzanne Preston Blier, *The Royal Arts of Africa*, [1988].)°

This discussion of iconography has spoken of "the proper identification of an image." Here we have a clue to the chief assumption held by most people who study iconography: a work of art is a unified whole, and

°By the way, the term "African art" may have a highly restricted meaning. It commonly is used to refer to material produced only in the sub-Sahara area, i.e., it excludes the art of the Maghreb (Algeria, Morocco, Tunisia), Egypt, and Sudan, and it sometimes excludes art showing European influences.

its meaning is what the creator took it to be or intended it to be. in our discussion of meaning (pages 23–26), however, we saw that many art historians today (especially those associated with the New Art History) do not accept this assumption.°

Bibliographic Note: Several introductory books offer surveys of the chief methods used to study art history.

Barrett, Terry. *Why Is That Art? Aesthetics and Criticism of Contemporary Art.* New York: Oxford University Press, 2008.

D'Alleva, Anne. *Methods and Theories of Art History.* London: Laurence King, 2005.

Hatt, Michael, and Charlotte Klonk. *Art History: A Critical Introduction to Its Methods.* Manchester: Manchester University Press, 2006.

Minor, Vernon Hyde. *Art History's History.* 2nd ed. Upper Saddle River, NJ: Prentice Hall, 2001.

Pooke, Grant, and Diana Newall. *Art History: The Basics.* New York: Routledge, 2008.

Preziosi, Donald, ed. *The Art of Art History: A Critical Anthology.* New York: Oxford University Press, 1998.

°For a discussion of the strengths and limitations of iconographic studies, see the excellent introduction to Brendan Cassidy, ed., *Iconography at the Crossroads* (Princeton: Index of Christian Art, 1993). See also Roelof van Straten, *An Introduction to Iconography* (1994).

13

WRITING A RESEARCH PAPER

Read not to contradict, and confute; nor to believe and take for granted;
nor to find talk and discourse; but to weigh and consider. Some books
are to be tasted, others to be swallowed, and some few to be chewed and
digested: that is, some books are to be read only in parts; others to be read
but not curiously; and some few to be read wholly, and with diligence and
attention.

—Francis Bacon

If we knew what we were doing, it wouldn't be called research.

—Albert Einstein

Writing . . . keeps me from believing everything I read.

—Gloria Steinem

Because a research paper requires its writer to collect the available evidence—
usually including the opinions of earlier investigators—one sometimes hears
that a research paper, unlike a critical essay, is not the expression of personal
opinion. But such a view is unjust both to criticism and to research. A criti-
cal essay is not a mere expression of personal opinion; to be any good it must
offer evidence that supports the opinions, thus persuading the reader of their
objective rightness. And a research paper is largely personal because the
author continuously uses his or her own judgment to evaluate the evidence,
deciding what is relevant and convincing. A research paper is not merely an
elaborately footnoted presentation of what a dozen scholars have already said
about a topic; it is a thoughtful evaluation of the available evidence, and so it is,
finally, an expression of what the author thinks the evidence adds up to.° Joan
Didion's comment about writing applies to research papers as well as to other

°Because footnotes may be useful or necessary in a piece of writing that is *not* a research
paper (such as this chapter), and because I want to emphasize the fact that a thoughtful research
paper requires more than footnotes, I have put the discussion of footnotes in Chapter 14
"Manuscript Form" (pages 307–44).

forms: "Writing is the act of saying *I*, of imposing oneself on other people, of saying *listen to me, see it my way, change your mind.*"

You may want to do some research even for a paper that is primarily critical. Consider the difference between a paper on the history of Rodin's reputation and a paper offering a formal analysis of a single work by Rodin. The first of these, necessarily a research paper, will require you to dig into books and magazines and newspapers to find out about the early response to his work; but even if you are writing a formal analysis of a single piece, you may want to do a little research into, for example, the source of the pose. The point is that writers must learn to use source material thoughtfully, whether they expect to work with few sources or with many.

Although research sometimes requires one to read tedious material, or material that, however interesting, proves to be irrelevant, those who engage in research feel, at least at times, an exhilaration, a sense of triumph at having studied a problem thoroughly and at having arrived at conclusions that at least for the moment seem objective and irrefutable. Later, perhaps, new evidence will turn up that will require a new conclusion, but until that time, one may reasonably feel that one knows *something*.

A CONCISE OVERVIEW

- Allow plenty of time. This paper will probably take more time than you think it will. For instance, even if you settle on a topic and a thesis fairly early, almost surely these will change somewhat in the course of your research, and you will have to do further research.
- Formulate a question that you will then try to answer, for instance, "In what ways did Japanese art influence Whistler?" or "What arguments can be made for returning the Elgin marbles to Greece?" or "Is there any pattern of development in van Gogh's self-portraits?"
- *The Dictionary of Art,* ed. Jane Turner, or your textbook may provide you with the titles of the first sources you will consult. If you have difficulty finding sources, speak to your instructor and to your college librarian.
- When you take notes, check your transcriptions of verbatim quotations for accuracy, and be sure to record your sources accurately so that you won't have to waste time at the last minute retrieving sources in order to verify quotations or to supply missing page numbers.
- Organize your notes—this is easy if you have used a computer— and then sketch a rough outline (thus indicating the sequence) of the topics you plan to cover in your essay.

- When you convert your written notes into a first draft, get your ideas down onto paper without worrying about spelling and punctuation, or even about neat transitions and effective opening and closing paragraphs. Later, when you revise, you will be concerned with such matters.
- If you quote a source, do not assume that the quotation is self-explanatory. Indicate *why* you are quoting it, and what you make out of it: "Alpers has shown"; "Nelson takes a different view"; "McCormick proved"; "Clark insisted." In short, provide an informative lead-in, something more helpful than "says."
- Acknowledge all sources that you found helpful, including those that you do not quote directly but nevertheless use. Keyboard the citations into the draft.
- When you revise your draft, keep your readers in mind: Provide the necessary background information and definitions of terms, and reorganize the material if necessary. Provide appropriate signposts ("Before we can examine X, we should first . . .") so that your readers are aware of the organization.
- Keep your thesis in view. You are not simply offering a bunch of quotations; you are arguing a point.
- Edit the final version, checking the grammar, punctuation, and spelling.

PRIMARY AND SECONDARY MATERIALS

The materials of most research are conventionally divided into two sorts, primary and secondary. The *primary* materials or sources are the subject of study, and the *secondary* materials are critical and historical accounts already written about these primary materials. For example, if you want to know whether Rodin was influenced by Michelangelo, you will look at works by both sculptors, and you will read what Rodin said about his work as a sculptor. In addition to studying these primary sources, you will also read secondary material such as modern books on Rodin. There is also material in a sort of middle ground: what Rodin's friends and assistants said about him. If these remarks are thought to be of compelling value, especially because they were made during Rodin's lifetime or soon after his death, they can probably be considered primary materials. And for a work such as Rodin's *Monument to Balzac* (1897), the novels of Balzac can be considered primary materials.

If possible, draw as heavily as you can on primary sources. If in a secondary source you encounter a quotation from Leonardo or Mary Cassatt or whomever—many artists wrote a good deal about their work—do not be satisfied with this quotation. Check the original source (it will probably be cited in the secondary source that quotes the passage) and study the quotation in its original context. You may learn, for instance, that the comment was made so many years after the artwork that its relevance is minimal.

FROM SUBJECT TO THESIS

First, a subject. No subject is undesirable. As G. K. Chesterton said, "There is no such thing on earth as an uninteresting subject; the only thing that can exist is an uninterested person." Research can be done on almost anything that interests you, though you should keep in mind two limitations.

- First, materials for research on recent works may be extremely difficult to get hold of, since crucial documents may not yet be in print and you may not have access to the people involved.
- Second, materials on some subjects may be unavailable to you because they are in languages you can't read or in publications that no nearby library has.

So you probably won't try to work on the stuff of today's news—for example, the legal disposition of the works of a sculptor whose will is now being contested; and (because almost nothing in English has been written on it) if you can't read Japanese you won't try to work on the date of the introduction into Japan of the image of the Buddha at birth. But no subject is too trivial for study: Newton, according to legend, wondered why an apple fell to the ground.

You cannot, however, write a research paper on subjects as broad as Buddhist art, Michelangelo, or the Asian influence on Western art. You have to focus on a much smaller area within such a subject, and you will have to have a *thesis*, a point, an argument, a controlling idea, a claim that you will be making. Rebecca Bedell's essay on the American painter John Singleton Copley is not simply a survey of Copley's work or a comparison of two portraits, but an argument, that is, a developed presentation of the evidence supporting a thesis. In her second paragraph (page 139) Bedell states the thesis:

Copley reached his artistic maturity years before he left for England.

The essay as a whole argues on behalf of the point she states in her thesis sentence.

Suppose you are interested in the Asian influence on Western art. You might narrow your topic so that you concentrate on the influence of Japanese prints on van Gogh or Mary Cassatt or Whistler (it may come as a shock to learn (as you now know, from having read pages 14–18) that the famous picture commonly called *Whistler's Mother* is indebted to Japanese prints), or on the influence of calligraphy on Mark Tobey, or on the influence of Buddhist sculpture on Jo Davidson. Your own interests will guide you to the topic—the part of the broad subject—that you wish to explore, and you won't know what you wish to explore until you start exploring. Research requires searching, and at the outset you can't be sure of what you will find. Picasso has a relevant comment: "To know what you want to draw, you have to begin drawing. If it turns out to be a man, I draw a man."

Of course, even though you find you are developing an interest in an appropriately narrow topic, you don't know a great deal about it; that's one of the reasons you are going to do research on it. Let's say that you happen to have a Japanese print at home, and your instructor's brief reference to van Gogh's debt to Japanese prints has piqued your interest. You may want to study some pictures and do some reading now. As an art historian (at least for a few hours each day for the next few weeks), at this stage you think you want to understand why van Gogh turned to Japanese art and what the effect of Japanese art was on his own work. Possibly your interest will shift to the influence of Japan on van Gogh's friend, Gauguin, or even to the influence of Japanese prints on David Hockney in the 1970s. That's all right; follow your interests. Exactly what you will focus on, and exactly what your *thesis* will be, you may not know until you do some more reading. But how do you find the relevant material?

✔ Checklist for a Thesis Sentence

Have I asked myself the following questions?

- ❑ Does the sentence make a claim rather than merely offer a description?
- ❑ Is the claim arguable rather than self-evident, universally accepted, and of little interest?
- ❑ Can evidence be adduced to support the claim?
- ❑ Is the claim narrow enough to be convincingly supported in a paper written within the allotted time and of the assigned length?

FINDING THE MATERIAL

You may already happen to know of some relevant material that you have been intending to read—perhaps titles listed on a bibliography distributed by your instructor—or you can find the titles of some of the chief books by looking at the bibliography in such texts as H. W. Janson's *History of Art*, 8th edition (2011), Spiro Kostof's *History of Architecture*, 2nd edition (1995), Monica Blackman Visonà, *A History of Art in Africa*, 2nd edition (2008), Craig Clunas, *Art in China*, 2nd edition (2009), or Penelope Mason's *History of Japanese Art*, 2nd edition (2005). If such books do not prove useful and you are at a loss about where to begin, consult

- your instructor or the reference librarian
- your library's home page on the Web (to find it, Google the name of your college and the word "library," for example "Tufts University library"). Here you will find a gateway, portal, or other access to your library's print and online materials as well as to its services including contact with a librarian via e-mail, or live chat, or a social networking site.
- the appropriate guides to articles and book reviews in journals
- the reference books listed in the following pages

You can find library resources from anywhere using your personal electronic devices, such as desktop and laptop computers, iPad and other tablets, cell phones and iPhones, that provide internet access. To access online journals (ejournals) and online books (ebooks) you will need a login password from your campus IT (information technology) service.

The Library Catalog and Delivery and Discovery Services

The library catalog is an online database that you can search from a box on the library's home page. It is primarily used to look for books and the titles of journals/periodicals. The search box usually is pre-set for keyword searching but usually has an Advanced Search link nearby to let you search by author, title, or subject. Start with a keyword search such as "art and Japan*" or "prints and Japan*" or "Japanese art" or "Japanese prints" (the* is a truncation symbol that directs the computer's search engine to look for variants of Japan—Japanese, Japan's). Look through the list of results for a

*The following discussion of library materials is the work of Ruth Thomas (Mugar Memorial Library, Boston University).

title that seems relevant to your topic, click on the title, and note the subjects that the Library of Congress has determined best describe the book's main topics. Click on one of the subjects to retrieve more titles of books on the same subject. Another way to find similar books is to click on the book's call number; the results will be listed in the same order the books are arranged on the library's shelves in the stacks because one function of the call number is to bring together books on the same subject. If you want to see all the books your library has on van Gogh, do a keyword search for "van Gogh" (use quotation marks to keep *van* and *Gogh* next to each other). Note that the "official" subject heading is "Gogh, Vincent van."

Discovery and Delivery Services. Many libraries are replacing or complementing the traditional (also called local, classic, or legacy) library catalog described above with discovery and delivery services that let you do a single-point or one-stop search for books and other materials in your library's collections, including online articles and ebooks; for "open-access" materials from sources such as Project Gutenberg and DOAJ (Directory of Open Access Journals); and for many other digital and Web resources. You can usually determine which search box on your library's home page is for the traditional catalog and which search box is for the discovery service by the latter's name, for example, SuperSearch, OneSearch, Discovery, Summon, or statements such as "Find Books and Articles" or "Search Your Library and Beyond." Searching is a three-step process: search, discover, and refine.

Search—Type your keyword(s) in the single search box on your library's home page. Or click on Advanced Search for an additional two or three search boxes plus some limiters such as language, book, or article. Put a phrase in quotes, for example, "Japanese prints." Use the truncation symbol° for word variants such as Japan's, Japanese, Japan. Click the search button.

Discover—The results of your search will be displayed as short citations to books, articles, and other materials. Chances are good that your "discovered" results will number in the hundreds or thousands. They will be sorted by relevance. Relevancy ranking, which means placing at the top of the screen results that are relevant because of frequency of access or "popularity," may not work for your art topic because other disciplines, such as social sciences or medicine, have a larger number of users who skew the relevancy (frequency) results. Therefore, you may have to limit or refine the results to retrieve the citations that are genuinely relevant to your art topic.

Refine—A panel to the left of your list of citations will give you options for refining these results: books, peer-reviewed articles, subject, collection (e.g., JSTOR), author, language, publication date, resource type, journal title, and the like. Of these, *subject* is one of the most important and should include an art-related subject, such as "art & art history," painting (art). If you are starting your research by looking for books, refine the results by limiting to books.

Tip—It is easy to keep a record of all the books and articles you want to read at a later time by exporting the citations to a bibliographic management program such as RefWorks or Endnote. They will store your selected citations, let you access them later, and turn them into a bibliography for your paper. Alternatively, you can e-mail citations to yourself from most online databases.

Getting the material—The citations in your search results will indicate how to actually get the books, articles, and so forth that you have selected. A book citation will provide your library's call number for that book. If it is an ebook, there will be a link labeled "view online" or a similar phrase. Many of the articles you select will be available online by clicking on the title or a "view online" link. If an article is not available online, the library catalog or discovery service will provide a call number for the journal that published the article and you will need go to the library to get it. For books and articles your library does not have in any format—print, electronic, microform— you can use the library's interlibrary loan (ILL) service. ILL requests generally can be made online from your library's home page. If you need ILL help, contact a librarian.

In addition to the books owned by your library, you can find out if there are other books on your topic by searching FirstSearch WorldCat (if your library subscribes) or WorldCat.org (for free). Some libraries have a WorldCat link right on their home pages. Libraries that belong to a consortium of libraries often let you request a book online from another member library via the WorldCatLocal citation. WorldCat is a union database that contains records not only for books but also for visual and archival materials, periodicals, and even Internet resources and tells you what libraries own them. Google Books (www.books.google.com) lets you search for books and the contents of some books by topic keyword, but copyright restricts Google from making available the entire book or chapters of the book. Google helps you find out what library has the book by clicking on its title and then the link "Find in a library," which takes you to WorldCat.org.

Browsing in Encyclopedias, Books, and Book Reviews

Having checked the library catalog or discovery service and written down the relevant information (author, title, call number) or e-mailed or exported the citations to RefWorks or Endnote, you can begin to browse in the books, or you can postpone looking at the books until you have found some relevant articles in journals. For the moment, let's postpone the journals.

You can get an admirable introduction to almost any aspect of art by looking at a magisterial thirty-four-volume work, *The Dictionary of Art,* edited by Jane Turner (1996), now available online as *Grove Art. Online. The Dictionary* contains 41,000 articles, arranged alphabetically, on artists, forms, materials (e.g., amber, ivory, tortoise shell, and hundreds of other materials), movements, sites, theories, and so on. The articles, which range from a few hundred words to several thousand words (e.g., 8,500 on *abstract art),* include illustrations, cross-references to other articles in *The Dictionary,* and bibliographic references. The index in volume 34 will guide you to appropriate articles on your subject. Your library may subscribe to its online version, *Grove Art Online,* which contains more than 45,000 articles. You can browse an alphabetical list of articles or an index of topics or do a keyword search. New articles and image links are added frequently.

More specialized encyclopedias also can be useful at the beginning. For a topic such as early Christian symbolism, the *New Catholic Encyclopedia* (fifteen volumes, 2nd edition, 2003, available in print and online) is especially valuable. But on this subject see also *The Oxford Companion to Christian Art and Architecture* (1996).

Let's assume that you have glanced at some entries in an encyclopedia, or perhaps have decided that you already know as much as would be included in such an introductory work, and you now want to investigate the subject more deeply. Put a bunch of books in front of you and choose one as an introduction. How do you choose one from half a dozen? Partly by its size—choose a fairly thin one—and partly by its quality. Roughly speaking, it should be among the more recent publications, or you should have seen it referred to (perhaps in the textbook used in your course) as a standard work on the subject. The name of the publisher is at least a rough indication of quality: A book or catalog published by a major museum, or by a major university press, ought to be fairly good.

When you have found the book that you think may serve as your introductory study,

- read the preface to get an idea of the author's purpose and outlook
- glance at the table of contents to get an idea of the organization and coverage

- scan the final chapter or, if the book is a catalog of an exhibition, the last few pages of the introduction, where you may be lucky enough to find a summary
- look through the index, which should tell you whether the book will suit your purpose by showing you what topics are covered and how much coverage they get

If the book still seems suitable, browse in it.

At this stage it is acceptable to trust one's hunches—you are only going to scan the book, not buy it or even read it—but you may want to look up some book reviews to assure yourself that the book has merit, and to be aware of other points of view. Countless reviews of art books are published not only in journals devoted to art (e.g., *Art Bulletin, Art Journal, Burlington Magazine*) but also in journals devoted to historical periods (*Renaissance Quarterly, Victorian Studies*), in newspapers and magazines, and, online, in *CAA.reviews <www.caareviews.org>*, 1998—(if your library has a subscription). There are four especially useful indexes to book reviews:

Book Review Digest (published from 1905 onward)
Online: *Book Review Digest Plus* (1983–)
 Book Review Digest Retrospective (1905–1982)

Book Review Index (1965 onward; available online)

Art Index (1929 onward)
Online: *Art Full Text Index* (1984–)
 Art Index Retrospective (1929–1984)

Humanities Index (1974 onward)
Online: *Humanities Full Text* (1984–)
 Humanities and Social Science Retrospective (1907–1984)

Book Review Digest includes brief extracts from the reviews, chiefly in relatively popular (as opposed to scholarly) journals. Thus, if an art book was reviewed in *The New York Times Book Review,* or in *Time* magazine, you will probably find something (listed under the author of the book) in *Book Review Digest.* Look in the volume for the year in which the book was published, or in the next year. But specialized books on art will probably be reviewed only in specialized journals on art, and these are not covered by *Book Review Digest.*

You can locate reviews by consulting *Book Review Index* (look under the name of the author of the book if your library has only the print index) or by consulting *Art Index,* Scholarly reviews sometimes appear two, three, or even four years after the publication of the book, so for a book published in 1985, if your library does not have *Book Review Index* online, you probably will want to consult issues for as late as 1989. To find book

reviews in *Art Index* online, search by author or title of the book and limit to Document Type—Book Review. *Humanities Index* online works the same way as *Art Index* online but covers different journals for an interdisciplinary approach. Book reviews are published in journals, so there will be a link from *Art Index* online and *Humanities Index* online to the full text of your book review if your library has a subscription to the ejournal.

When you have located some reviews, read them and then decide whether you want to scan the book. Of course, you cannot assume that every review is fair, but a book that on the whole gets good reviews is probably at least good enough for a start.

By quickly reading such a book (take few or no notes at this stage), you will probably get an overview of your topic, and you will see exactly what part of the topic you wish to pursue.

Subscription Databases Indexing Published Material

An enormous amount of material on art is published in books, magazines, and scholarly journals—too much for you to look at randomly as you begin a research project. But databases can help you sort through this vast material and locate books and articles relevant to your research topic. Check your library's Web site for links to the database versions.

If your library has a discovery service (described above), your search results will include journal articles but you may find it easier to search the individual art-related databases or a group of art-related databases. The most widely-used databases for art research are:

Readers' Guide Full Text Mega (1983—)
Readers' Guide Retrospective (1890–1982)

Art Full Text (1984—)
Art Index Retrospective (1929–1983)

BHA: Bibliography of the History of Art and RILA: International Repertory of the Literature of Art (1975–2007)

IBA: International Bibliography of Art (after 2007)

A&HCI: Arts and Humanities Citation Index (1975—)

ABM: ARTBibliographies MODERN (1969—)

API: Architectural Periodicals/Publications Index (1978); article citations also available on the RIBA (Royal Institute of British Architects) web catalog.

Avery Index to Architectural Periodicals (1934—)

Index to Nineteenth-Century American Art Periodicals

The descriptions of art-related databases that follow are brief. You may want to check a database's help or information pages to find out more about its coverage, contents, and how to use it. You may also want to check on spellings of artists' names, geographic place names, or art vocabularies in the Getty Research Institute's *Union List of Artist Names (ULAN)*, the *Getty Thesaurus of Geographic Names (TGN)*, and the *Art and Architecture Thesaurus (AAT)*. They are also online at http://www.getty.edu/research/tools/vocabularies/index.html

Readers' Guide indexes more than a hundred of the most familiar magazines—such as *Atlantic, Nation, Scientific American*, and *Time*. Probably there won't be much for you in these magazines unless your topic is something like "Van Gogh's Reputation Today," or "Popular Attitudes Toward Surrealism, 1930–1940," or "Jackson Pollack as a Counter-Culture Hero of Fifties America," or some such thing that necessarily draws on relatively popular writing.

Art Index, A&HCI, BHA, RILA, and *ARTbibliographies MODERN* index many scholarly journals—for example, journals published by learned societies—and to bulletins issued by museums. These are the "peer reviewed" or "refereed" articles your professor will require you to include in your research. **Art Index** covers some popular magazines, so remember to limit your results to Scholarly (Peer Reviewed) Journals.

Art Index and Art Index Retrospective index articles in about three hundred journals, bulletins, and yearbooks; it does not include books, but you can limit your search to Document Type=book reviews or, after your results download, check the Source Types box "Book Reviews."

Some citations include abstracts or summaries of the articles. You also can search for illustrations using Document Type=Art Reproduction or selecting the field: Physical Description and typing "illustration" in the search box.

BHA: Bibliography of the History of Art includes **RILA (Repertory of the Literature of Art)** and covers European and American visual arts material published between 1975 and 2007. It does not cover ancient Western, Asian, Indian, Islamic, African or Oceanic art, or American art before the arrival of the Europeans except in books and articles about their influence on Western art. **BHA** provides citations of books, journal articles, exhibition catalogs, and doctoral dissertations with abstracts in French or English. Articles published after 2007 are indexed in **IBA: International Bibliography of Art**.

ARTbibliographies MODERN used to cover art from 1800, but beginning in 1989 it limited its coverage to art from 1900. It now provides abstracts or brief annotations of journal articles concerned with art of the twentieth and twenty-first centuries, and of exhibition catalogs and books.

Index to Nineteenth-Century American Art Periodicals contains citations to 27,000 articles in 42 periodicals published in the United States during the 19th century. Topics covered are artists and illustrators, painting, sculpture, drawing, photography, architecture and design, exhibitions and sales, location, and collecting.

A&HCI: Arts and Humanities Citation Index lists articles and references cited in articles. To find illustrations of specific works of art, such as Picasso's *Guernica*, choose Cited References Search, then Cited Work. In the column labeled Volume, ILL appears next to citations. Cited references can be from any year.

API: Architectural Periodicals Index continued by **Architectural Publications Index** covers about five hundred journals, mainly on architecture and design in Great Britain.

Avery Index to Architectural Periodicals indexes more than one thousand journals on architecture and design, archaeology, city planning, interior design, and historic preservation of the Americas, Europe, Asia, and Australia.

JSTOR (Journal Storage) is a database of journals you can search and browse. It contains the full text of all articles published in a specific journal from the first year of its publication, even if it was 1800—very useful because few indexes cover material going back that far. It currently has 190 art and art history journals and continues to add titles. If your library has a discovery service, as described above, it will automatically include JSTOR journals in its search.

Google is another approach to finding articles and books. Use Google Scholar (scholar.google.com) for more relevant results. Before you begin your search, it is worth your time to set preferences for direct connections to your library. On Scholar's home page, click on Scholar Preferences. If you are on campus and your library participates, you will see its name listed in Library Links. If you are off campus, you can type in your library's name in the Find Library search box. To find more libraries in your area, type in the name of your city. Remember to click the "Save Preferences" button.

Next, click on "Advanced Scholar Search" and limit your search to articles in Social Sciences, Arts, and Humanities. When you get your search results, notice that many citations include the link, "Find Online at (your library)." Sometimes the link does not display; click on the title anyway, and you may find you have access.

Google Scholar retrieves many articles from JSTOR. To make sure your results include current articles, limit your Scholar search by date, for example, between 2008 and 2014. Current articles will be pushed up to the first to or three results pages.

Major newspapers also cover art topics such as reviews of art books, art exhibitions, and architecture as well as interviews with artists and architects. Major newspapers are available online; check your library's catalog or discovery service. The full-text database *Lexis/Nexis* contains the newspapers of many large and medium-sized U.S. and international cities from about 1980. The *New York Times* is available from 1985 to the present from *Academic OneFile* and from 1980 in *LexisNexis Academic,* which provides abstracts only from 1969 to 1980. For earlier years, see if your library has *ProQuest Historical Newspapers: The New York Times (1851–2007).* Other cities' newspapers available in the ProQuest Historical Newspapers program are Atlanta, Baltimore, Boston, Chicago, Cincinnati, Detroit, Hartford, Indianapolis, and Los Angeles; there also are collections of Black Newspapers and American Jewish Newpapers. If your library does not have any of these online, check to see if there are print indexes to microfilmed newspapers such as *The New York Times Index* from 1851.

Online databases return results sorted chronologically starting from the most current. If you collect titles of materials published in the last five years, you will probably have as much as you can read. These articles will probably incorporate the significant points of earlier writings. But of course it depends on the topic; you may have to—and want to—go back fifty or more years before you find a useful body of material.

Other Guides

There are a great many reference books, not only general dictionaries and encyclopedias, but also **dictionaries of technical words,** for example, Ralph Mayer, *The HarperCollins Dictionary of Art Terms and Techniques,* 2nd edition, 1991; **dictionaries of symbolism** (James Hall's *Dictionary of Subjects and Symbols in Art,* 2nd edition, 2008; and **encyclopedias of special fields** (*Encyclopedia of Twentieth Century Architecture,* ed. Stephen Sennott, 2004). Many of these books are now available both in print and online. For example, see if your library has a subscription to *ORO: Oxford Reference Online;* it includes such titles as *The Oxford Dictionary of American Art and Artists* (Ann Morgan, 1st edition, 2007); *A Dictionary of Architecture and Landscape Architecture* (James Curl, 2nd edition, 2000); *The Oxford Dictionary of Art* (Ian Chilvers, 3rd edition, 2004); *A Dictionary of Modern Design* (Jonathan Woodham, 1st edition, 2004);

A *Dictionary of Modern and Contemporary Art* (Ian Chilvers and John Glaves-Smith, 2nd edition, 2009); *The Oxford Companion to the Photograph* (Robin Lenman, 1st edition, 2005; and several others in the art and architecture collection. You can search them individually or as a group.

Hall's *Dictionary* is devoted chiefly to classical and biblical themes in Western art: If you look up the Last Supper, you will find two detailed pages on the topic, explaining its significance and the various ways in which it has been depicted since the sixth century. You will learn that in the earliest depictions Christ is at one end of the table, but later Christ is at the center. A dog may sit at the feet of Judas, or Judas may sit alone on one side of the table; if the disciples have haloes, Judas's halo may be black.

James Hall has also written a broader book, this one including Asian material: *Illustrated Dictionary of Symbols in Eastern and Western Art* (1994). The most extensive coverage of symbolism, however, drawing on anthropologic studies throughout the world, is Jean Chevalier and Alain Gheerbrant, *Penguin Dictionary of Symbols*, 2nd ed., trans. John Buchanan-Brown (1996). Also useful is Hans Biedermann, *Dictionary of Symbolism*, trans. James Hulbert (1994).

For definitions of chief terms and for brief biographies, see *The Oxford Dictionary of Art* (in print and online, 3rd edition (2004), edited by Ian Chilvers; and *Grove Art Online (Dictionary of Art* in print). *The Dictionary of Women Artists* (1997), edited by Delia Gaze, is a two-volume work covering all periods. For artists of the twentieth century, the best general reference works are *Contemporary Artists,* 5th edition (2002), and *A Dictionary of Modern and Contemporary Art* (Ian Chilvers and John Glaves-Smith, 2nd edition, 2009). The database *Gale Biography in Context* provides selected biographical information from a variety of sources, including St. James Press full-text reference works such as *Contemporary Artists* (5th edition, 2001), *Contemporary Designers* (3rd edition, 1999), *Contemporary Photographers* (3rd edition, 1996), and *Contemporary Women Artists* (1999); newspapers and magazines; academic journals (some citations only); images; Web sites; primary sources, such as American Decades Primary Sources (full text), 2004; and further resources. The Tate (four British galleries) has an online glossary (http://www.tate.org.uk/collections/glossary/) of 300 terms mostly illustrated; for additional glossaries, see the works cited in a footnote above, page 245.

There are also subject bibliographies—books that are entirely devoted to listing (sometimes with comment) publications on specific topics. For example, Yvonne M. L. Weisberg and Gabriel P. Weisberg's *Japonisme* (1990) lists and comments on more than seven hundred books, articles, exhibition catalogs, and unpublished dissertations concerning the Japanese influence on

Western art from 1854 to 1910. Similarly, Nancy J. Parezo, Ruth M. Perry, and Rebecca S. Allen's *Southwest Native American Arts and Material Culture* (1991) lists more than eight thousand references, including books, journals, exhibition catalogs, and dissertations. Wolfgang Freitag, *Art Books: A Basic Bibliography of Monographs on Artists,* 2nd edition (1997), provides lists of books for more than two thousand international artists.

How do you find such reference books? The best single volume to turn to—though it getting a bit dated—is Lois Swan Jones, *Art Information and the Internet: How to Find It, How to Use It* (1999).

Among other useful guides to the numerous books on art are these:

> Donald L. Ehresmann, *Fine Arts: A Bibliographic Guide to Basic Reference Works, Histories, and Handbooks,* 3rd edition (1990).

> Etta Arntzen and Robert Rainwater, *Guide to the Literature of Art History* (1980), covers material only to 1977; it is supplemented by the next title in this list.

> Max Marmor and Alex Ross, *Guide to the Literature of Art History 2* (2005), covers the period 1978 to roughly 2000, with some more recent titles. It includes updated material as well as chapters on such topics as patronage and collecting, and cultural heritage law and policy.

What about reference books in other fields? The best guide to reference books in all sorts of fields is

> *Guide to Reference Books,* ed. Robert Balay, 11th ed. (1996).

There are guides to all these guides: *reference librarians.* When you don't know where to turn to find something, turn to the librarian. Often these librarians have written research guides that include the most recent print and online reference works.

Finally, if you are interested in learning about new bibliographic tools, keep an eye on current issues of a journal devoted to such matters: *Art Documentation* (1982–). You can find citations to these articles in the online database, *BHA,* and in *Art Index.*

ART RESEARCH AND THE WORLD WIDE WEB

After you use print indexes and electronic subscription databases to find scholarly research material published in periodicals and books, you may want to supplement it with resources available on the Web. You may be able to find primary sources such as photographs, images, audios and

transcripts of interviews, diaries, letters, original works of art, historical and government documents, literature and books no longer in copyright, material associated with museum and gallery exhibitions, and finding aids for archival material. You also can find an enormous amount of secondary sources, information, and discussions on topics, artists, and works of art. Your understanding of how to search for and evaluate the material collected on the Web will help you locate and identify it more easily and effectively. Some examples of primary sources are:

BBC audio interviews with eight contemporary painters
http://www.bbc.co.uk/bbcfour/audiointerviews/professions /painters.shtml

Archives of American Art Oral History Interviews
http://www.aaa.si.edu/collections/oralhistories/

More than Words: Illustrated Letters from the smithsonian's Archive of American Art http://www.aaa.si.edu/exhibitions/illustrated-letters

Art-Related Directories

These directories are metasites or gateways, which provide subject-arranged lists of links to other sites. Some provide annotations. Some let you both **search** by your own keywords and also **browse** their lists of subjects, artists, nationalities, themes, and media. Among the most comprehensive and well organized are:

Art History Resources on the Web
http://witcombe.sbc.edu/ARTHLinks.html

ArtSource
http://www.ilpi.com/artsource/welcome.html

World Wide Arts Resources
http://wwar.com

Museum Directories

Virtual Library Museums Pages
http://icom.museum/vlmp/

World Wide Arts Resources
http://www.com/categories/Museums/

Finding, Viewing, and Downloading Images

Image searching on the Web can be done using Web search engines, direc-
tories of sites containing images, and directly in imagebases. The following
Web resources can help get you started. If you intend to download images,
look for copyright permission statements, usually located on the Web site's
opening page.

AMICA (Art Museum Images from Cartography Associates)
 Digital images of works of art held in museums.
 Subscription database; check your institution's online resources.

American Memory (Library of Congress)
 http://memory.loc.gov/ammem/index.html
 Free access to more than nine million items that document U.S.
 history and culture, organized into more than 100 thematic
 collections.

Art Museum Image Gallery
 Subscription database of art of different cultures and
 contemporary and modern artists.

Artcyclopedia
 http://www.artcyclopedia.com/
 Free search by artist, title, or museum; browse artists by
 name, medium, subject, nationality, gender, or art movement.

ARTstor Digital Library
 Subscription database images in the arts, architecture,
 humanities, and sciences from outstanding international
 museums, photographers, libraries, scholars, and photo
 archives. Images may be found using your library's
 discovery service.

Bridgeman Art Library
 http://www.bridgemanart.com/
 Archive of reproductions of art works.

Google Art Project
 http://www.googleartproject.com/
 Partners with museums to present selected images.

Grove Art Online (Oxford Art Online)
 Subscription database of the Dictionary of Art with links to
 images of artworks on your topic.

WorldImages
 http://worldimages.sjsu.edu/
 Browse or use Portfolio List of eight hundred thematic collections.

Many museums have put images of objects in their collections on their Web sites. To find them, look for a link to Collections or to Search and/or Browse Collections. Your college's art history department may have its slide library online; on its Web site (or on your library's Web site), look for a link to Digital Collections or Visual Resources Collection.

Evaluating Web Sites

The Internet has introduced such different standards for publication that assumptions about authorship, accountability, and documentation previously taken for granted—for instance, that published material has been submitted to specialized referees, who have approved it—may no longer apply. National museums and libraries generally have exemplary Web presentations, because they already have well-documented, comprehensive collections and a public mission to make their holdings accessible. Many private museums in this country and abroad document the images they display accordingly. In addition, educational institutions have seen the Web as an opportunity to build digital image archives for teaching and research. Not that institutional authorship is always preferable; some museums limit their Web sites to publicity materials for temporary exhibitions, while many of the best art sites are created by individual scholars in the field. In the final analysis, *you* are responsible for the quality of information in a research paper, and your use of material from the Internet increases your obligation to evaluate and verify sources.

A Word about Wikipedia. Your instructors may caution you about using Wikipedia, the free Web encyclopedia with articles contributed by anonymous volunteers. Although it often provides a useful overview of a topic as well as links to relevant sites and references to published, articles vary greatly in quality. Pay attention to the references in an article, and follow those original sources. If there are none, the entire Wikipedia article could be suspect. Processes to improve quality, for example, peer review, article assessment, and featured article review standards, have been implemented. Wikipedia's page on "Researching with Wikipedia," (http://en.wikipedia .org/wikipedia:Researching_with_Wikipedia) includes some tips on evaluating its articles.

Other resources for evaluating websites are:

Evaluating Web Pages: Techniques to Apply and Questions to Ask.
University of California, Berkeley.
http://www.lib.berkeley.edu/TeachingLib/Guides/Internet/Evaluate.html

Elizabeth E. Kirk, *Evaluating Information Found on the Internet.*
http://guides.library.jhu.edu/evaluatinginformation

✔ Checklist for Evaluating Web Sites

The anonymity of many Web sites, the tendency to substitute corporate for individual identity, and the preeminence given to the address rather than to the creators of Web files all complicate the task of evaluating the site you have located and the source of its authority for your topic. Consider these questions in determining an art site's value for your paper:

❑ Who produced the site (a museum, a teacher, a commercial entity, a student)? What is the intended audience?

❑ Is it authoritative enough to cite? Sites consisting of review materials for an art history course probably will not offer information of sufficient depth for writing a paper, nor will an online tour of a museum collection. They are the equivalent of a class handout or a museum label.

❑ Are the sources of information indicated and verifiable? If they are not, be cautious.

❑ Is the information you have located unique? If the site is based on research papers or scholarly books, go to those sources, which will offer more substance and detail.

❑ Are the reproductions accurate and documented? Compare them to a slide or a print from a book.

❑ What is the likely permanence of the materials you are viewing? Are they promotional or part of a course assignment—something that might be gone by the time your reader tries to retrieve it?

❑ Does the purpose of the site fit the reason you are citing it? Some sites are created for long-term reference; others present current information or ephemeral events. Citing online materials for an architectural competition makes sense if you are writing about that competition, but a museum's current exhibitions page is probably not a reliable source for an image of an artist's work.

❑ Can the information contained on the Web site be confirmed by other sources?

❑ When was the site or page made available? Has it recently been revised?

Referencing Web Pages

Once you have satisfied yourself about the quality and appropriateness of your sources, how should you cite them? Reference formats for print publications have been adopted and modified to cite electronic sources (see pages 291–92). The problem is that Web sites themselves are not documented accordingly. Unfortunately, there is no standardized title page for Web sites. Nor is there a header or footer format that provides all of the necessary

information (even conventions for URLs are changing). Nor are browsers configured to record precisely the information you will need to write a proper citation. And the very nature of hypertext, which allows you to move from site to site, not just from the beginning to the end of the one with which you began, can make it easy to lose track of the path you followed. Keeping in mind certain procedures when you begin your research may save countless hours of trying to retrace your steps when you want to prepare footnotes or a bibliography.

✔ Checklist for Electronic Documentation

Have I asked myself the following questions?

The documentation you need for a reference probably will have to be gathered from various places on the site. Before leaving a site, make sure you have recorded these facts:

❏ Author and institution hosting the site. When no author is indicated, record the webmaster or e-mail address to be contacted about the page.

❏ Title of the page(s) you are referencing and URL. If a title is not provided, record the file name (everything behind the last forward slash in the URL).

❏ For digital images, the identifying information: artist, title, date, owner or location (as in "Kyoto National Museum, Japan"), and URL.

❏ Name of the site to which the pages you want to cite belong, especially if it is an extensive one.

❏ Revision date for the page or site, if stated, and the date you viewed it.

❏ Before leaving the site, ask yourself: If the site moves or reorganizes its Web pages (in other words, if the URL changes), have I provided enough information for a reader to find this page with the help of a search engine?

❏ For an e-mail, if the communication is personal, simply identify the author and say "personal communication." but if it is a distribution list or a Listserv, cite the author, the author's e-mail address, the subject, and the date of publication and the type of communication.

Not all of this information may be available or necessary for every citation you make, but it will save time in the end to record everything you can find at the outset.

✍ A RULE FOR WRITERS:

When you use a source from the World Wide Web, you need to acknowledge and cite it, just as you do when you use a print source.

Citations for Electronic Materials

A Footnote or Endnote Reference for a Site

> 1. Nigel Strudwick, *Egyptology Resources,* The Isaac Newton Institute for Mathematical Sciences, Cambridge University, 1994, revised 2001, *http://www.newton.cam.ac.uk/egypt/*, 7 July 1998.

A reference should begin with the author's name, *first name first*, followed by the title of the site, underlined or in italics. The name of the institution hosting the site (equivalent to the publisher of a book) follows, then the date the site was posted and most recently revised, if available; otherwise, "n.d." Next comes the URL, which consists of the protocol "http" and address (everything following the double slashes), underlined or in italics. Finally, record the date on which you consulted the site. If the host's identity is not displayed on the front or home page of the site, usually it can be deciphered from the domain name. Entering the first part of the address—up to the first single slash—will take you to the domain in question. In this case "newton" stands for the Isaac Newton Institute for Mathematical Sciences, "cam" for Cambridge University, "ac" for academic institution (the type of domain), and "uk" for United Kingdom (the country).

A Footnote or Endnote Reference for an Online Exhibition

> 2. Ecole nationale supérieure des beaux-arts, Paris, *The Prix de Rome Contests in Painting,* Ministry of Culture and Communication, France, n.d., *http://www.culture.gouv.fr/ENSBA/Rome.html*, 8 July 1998.

Online exhibitions often do not identify the curators or contributors, as do printed exhibition catalogs; in such cases the name of the museum or institution sponsoring the event will suffice. When the dates of the exhibition are provided, they should be listed after the institution's name.

A Footnote or Endnote Reference for a Digital Image

> 3. Jan Van Eyck, *The Arnolfini Portrait,* 1434, National Gallery, London, in *The National Gallery: The Collection: The Sainsbury Wing, http://www. nationalgallery.org.uk/paintings/jan-van-eyck-the-arnolfini-portrait*, 15 January 1999.

For a digital reproduction, the artist's name is followed by the title. Then comes the date ("n.d." when the work is undated) and collection. Note that the address of the page on which the image is found is included, because it is likely that a search could find the Web page but not the image file linked to it.

For bibliographies, changes are necessary in the order of the author's name (last name first) and the punctuation. In bibliographic format, the above entries should be listed as follows:

Reference to a Site in a Bibliography

> Strudwick, Nigel. *Egyptology Resources.* The Isaac Newton Institute for Mathematical Sciences, Cambridge University, 1994, revised 2001. *http://www.fitzmuseum.cam.ac.uk/er/.* 7 July 1998.

Reference to an Online Exhibition in a Bibliography

> Ecole nationale supérieure des beaux-arts, Paris. *The Prix de Rome Contests in Painting.* Ministry of Culture and Communication, France. *http://www.culture.gouv.fr/ENSBA/Rome.htmll. 8 July 1998.*

Reference to a Digital Image in a Bibliography

> Eyck, Jan van. *The Arnolfini Portrait,* 1434. National Gallery, London. In *The National Gallery: The Collection: The Sainsbury Wing. http://www. nationalgallery.org.uk/paintings/jan-van-eyck-the-arnolfini-portrait. 15 January 1999.*

Further instructions can be found in *The Chicago Manual of Style,* 16th (2010), Chapters 16 and 17. See also Janice R. Walker and Todd Taylor, *The Columbia Guide to Online Style* (1998), with updates at Andrew Harnack and Eugene Kleppinger, *Online! A Reference Guide to Using Internet Sources, http://www.bedfordstmartins.com/online/index.html,* plus the related book, 3rd edition, 2003. The direct link to the page of citation styles is *http://www.bedfordstmartins.com/online/citex.html.*

KEEPING A SENSE OF PROPORTION

Keep in mind the boundaries of the assignment.

- What is the *length* of the essay? How much *time* did the instructor give you in which to do it?
- *How many sources* did the instructor suggest that you should use? Did the instructor refer to specific kinds of sources that the paper should include—scholarly books and/or articles, other primary texts (published statements by artists, interviews with museum personnel)?
- What are the *proportions* of the essay? How much should consist of formal analysis, and how much of historical research and context?

For a **short paper,** say two to five pages, in which you treat one or two works in a historical context, it may be sufficient if you look at two or three

standard reference works. In them you will find some basic ideas—overviews of the period—and you can think about your selected works within these contexts.

For a paper of **medium length,** say five to ten or twelve pages, you almost surely will want to go beyond basic references. You probably will want to look into some of the works that these references cite, and your instructor presumably has given you enough time to look at them.

- Pay attention to *when* the books or articles were published; the most recent publications may not be the best, but they probably will give you a good sense of current thinking, and they will guide you to other recent writings.

For a **long paper,** say fifteen to twenty-five pages, you will have to go beyond basic references and also beyond a few additional specialized sources. Your instructor almost surely will expect you to have read widely, so at the outset you may want to do a "subject" search in the online catalogs of your own library. But your library, unless it is a major research library, may not contain some work that, according to reference books, is especially important. Or even if your library does contain this title, it may appear as merely one more title in a long list, and you may not be aware of its importance. Before doing a search, then, consider the possibility of first checking reference books and compiling a short bibliography of titles that they cite. Then begin by looking at the titles especially recommended in reference books. If your library does not have some of these titles, request them by interlibrary loan.

How do you know when to stop? There is no simple answer. And almost everyone who has written a research paper has thought, "There still is one more source that I need to consult before I start drafting my paper." (In this respect the writer of a research paper is like a painter; it has been said painters never finish paintings, they just abandon them.) In the midst of a busy semester you need to make choices and to budget your time.

- Stop when you have acquired the historical knowledge that strengthens your analyses of works of art—the knowledge that deepens your understanding of the works, and the knowledge that is sufficient for you to meet the specifications of the assignment.
- The paper should be *your* paper, a paper in which you present a thesis that you have developed, focusing on certain works. By using secondary resources you can enrich your analysis, as you place yourself in the midst of the scholarly community interested in this work or group of works. But keep a proper proportion between your thinking—again, the paper is *your* paper—and the thinking set forth in your sources.

READING AND TAKING NOTES

As you read, you will find references to other publications, and you will jot these down so that you can look at them later. It may turn out, for example, that a major article was published twenty years ago and that the most recent writing about your topic is a series of footnotes to this piece. You will have to look at it, even though common sense had initially suggested (incorrectly, it seems) that the article would be out of date.

A few words about reading sources:

- Before assiduously taking notes from the first paragraph onward, or highlighting long passages, it is usually a good idea to scan a work in order to get a sense of the thesis. You may, for instance, find an early paragraph that states the thesis, and you probably will find a concluding paragraph that offers a summary of the evidence that supports the thesis. Having gained from this preview a general idea of the content of the work, you can now highlight sparingly while you read the material carefully and critically.

- Reading critically does not mean reading hostilely, but it does mean reading thoughtfully, continually asking yourself whether the assertions are adequately supported with evidence. Be especially sure to ask what can be said against assertions that coincide with your own beliefs. One can almost say that the heart of critical thinking is a willingness to face objections to one's own beliefs.

- When the book or journal you are reading is your own, the best way to read critically—interactively rather than passively—is to annotate it, jotting down brief responses ("but see . . . ," "?" and so forth) in the margins. If you highlight, try to confine yourself to brief passages; there is no point in highlighting whole pages. If you don't own the source, don't annotate it and don't highlight it. Either photocopy or scan it, if it is fairly brief, and then mark up your copy—consider reducing the copy so that you will have ample margins for your comments—or take notes on a computer, in a notebook, or on 4 × 6-inch cards. If you take notes on a computer, avoid simply creating a single word processor document with all the notes. Instead, use a note-taking application such as NoteTaker (AquaMinds Software), Circus Ponies Notebook (Circus Ponies Software), SuperNoteCard, or the Notebook feature in Microsoft Word, or a dedicated writer's program such as CopyWrite (Bartas Technologies) or Ulysses (The Blue Technologies Group). Such software is designed to allow you take notes on separate pages and easily search, index, and reorder the notes. If you prefer handwritten

notes, 4 × 6 cards have an advantage over a notebook in that they can be easily moved around. Whether you are taking notes on the computer or by hand, the ability to reorder your notes allows you to organize your paper before writing even a first draft.

Here are guidelines for note-taking:

1. **If you take notes on 4 × 6 cards, write on one side of the card only;** material on the back of a card is usually neglected when you come to write the paper. If your notes from a source on a particular point run to more than one card (say, to three), number each card: 1 of 3, 2 of 3, 3 of 3. Use 4 × 6 cards because the smaller cards (3 × 5) are too small for summaries of useful material, and the larger cards (5 × 7) invite you to put too much material on one card.

2. **If you take notes on a computer, you will need to be somewhat disciplined so as not to take overly long notes.** Fortunately, many note-taking programs allow a custom page size to be defined; choosing a small notebook page size can help avoid overly long summaries.

3. **Write summaries rather than paraphrases;** write abridgments rather than restatements, because restatements may turn out to be as long as or longer than the original. There is rarely any point to paraphrasing; generally speaking, either quote exactly (and put the passage in quotation marks, with a notation of the source, including the page number or numbers) or summarize, reducing a page or even an entire article or chapter of a book to a single 4 × 6 card or to a few sentences or, even better, to a few phrases.

Even when you summarize, indicate your source (including page numbers) on the card or notebook page, so that you can give appropriate credit in your paper. If you are using bibliographical software such as EndNote (Thomson) or Sente (Third Street Software) and note-taking software, you need only link the relevant bibliographical entry to your notes.

4. In your summary you will sometimes quote a phrase or sentence—putting it in quotation marks—but **quote sparingly.** You are not doing stenography; rather, you are assimilating knowledge and you are thinking, so for the most part your source should be digested rather than engorged whole. Thinking now, while taking notes, will also help you later to avoid plagiarism. If you mindlessly copy material at length when you take notes, later when you are writing the paper you may be tempted to copy it yet again, perhaps without giving credit. **Never paste anything from a source (online or other) without enclosing it in quotation marks and citing the source,** even in your notes. Similarly, if you photocopy pages from articles or books and then merely underline some passages, you probably will not be thinking; you will just be underlining. But if you make a

terse summary in your note-taking software or on a note card, you will be forced to think and to find your own words for the idea. Repeat: Although you have summarized, and the words are your own, if you use this material in your paper you still need to give credit to your source, so be sure to cite the source in your notes.

Most of the direct quotations that you copy should be

- effectively stated passages (these will add color to your essay), or
- passages that constitute strong evidence (these will add authority), or
- passages that do both.

Quotations of the first sort may refresh readers by letting them hear a voice other than your own; quotations of the second sort offer weight, material that cannot be easily overlooked.

Be sure not to let your paper degenerate into a string of quotations. This point is especially important now, given the ease of copying and pasting information from a Web browser into a word processor or notebook software. Your notebook software should not be merely a repository for notes; it should be a place to organize your own thoughts and ideas and transform them into the outline of a paper.

5. If you quote but omit some material within the quotation, be sure to indicate the omission by an ellipsis, or three spaced periods. Added words must be enclosed within square brackets. (On omissions and additions, see page 326.) Check the page number you have recorded on your card.

6. **Never copy a passage by changing an occasional word,** under the impression that you are thereby putting it into your own words. Notes of this sort may find their way into your paper, your reader will sense a style other than your own, and suspicions of plagiarism may follow. And indeed you *are* plagiarizing if the ideas and the sentence-structures are from your source, even though you acknowledge the source. How can you be plagiarizing if you acknowledge a source? Easy. True, the words are your own (you have changed "The figures in the foreground" to "The people up front," and you have changed "In most pictures of this sort" to "In many pictures of this type") but you have merely paraphrased your source, *not* integrated it into your own thinking. It is worth saying yet again that you should either quote exactly, and enclose the words within quotation marks, or summarize drastically. In both cases, be sure to give credit to your source. (For a detailed discussion of plagiarism, see pages 327–33.)

7. **Jot down your own responses to the note.** For example, you may want to say, "Baker made same point 5 yr earlier." But make certain that later you will be able to distinguish between these comments and the notes summarizing or quoting your source. A suggestion: Surround all

comments recording your responses with double parentheses, thus: ((. . .)). Alternatively, if you are taking notes on a computer, italicize or change the font of all comments.

8. If you are taking notes on 4 × 6 cards, in the upper corner of each note card, **write a brief key**—for example, "van G's *Portrait of Tanguy*"— so that later you can tell at a glance what is on the card. See the sample note card below on this page. Things to notice are: A brief heading at the top identifies the subject to the card; the quotation is followed by the page citation; the writer's own response to the quotation is enclosed within double parentheses so that it cannot be confused with the writer's notes summarizing the source.

If you are taking notes on the computer, the advantage of note-taking software over a word processor is that you can associate a keyword (or many keywords) with each page in your notes. You can then easily look at all note pages relating to a specific topic.

9. **Record the title of your source accurately.** Index cards were once a great way to record sources, and many art historians continue to use them, but now, with bibliographical software, you can more easily keep track of sources. Software such as EndNote and Sente will even ensure that you use a standard bibliographical format such as this one:

> Patton, Sharon. *African-American Art*. New York: Oxford University Press, 1998.

van G's <u>Portrait of Tanguy</u>
(1887–1888)

Picture includes copies of Japanese prints but <u>not</u> in style of prints:
 lacks characteristic contour lines of J. prints
Why?
 Pollock and Orton claim V's interest is
 in prints' <u>subject matter</u>, not in their style:
 "Attention is drawn to what they depict and not to
 the stylistic character of the woodcuts" (p. 41)

 ((seems to me van G is concerned with their style))

Alternatively, a simple database program such as FileMaker or Microsoft Access, or even spreadsheet software such as Microsoft Excel, can be used for keeping track of sources. However, bibliographical software

allows you to link citations in your paper between your word processor and your bibliography.

If you envision using many sources, bibliographic software or even a simple database enables you to sort and search your references easily. Keeping a list of citations on your computer is a practice that will work adequately for a short paper, but may not scale well to a large research paper with many sources. The great advantage of a database or dedicated bibliographical software is the ease of keeping track of specific fields of information, which you can use to sort or limit the references by title, author, source, or by any of the ideas you have drawn from the source, such as the work of art the source refers to, the artist it discusses, or the dates in history that it covers. For example, when writing a long paper on the sculptures from the Parthenon (the so-called Elgin Marbles), a reference in your database might have the following usable fields:

Author:	John Henry Merryman	Period:	Classical
Title:	Thinking about the Elgin Marbles	Dates:	440–432 BC
Source:	Michigan Law Review	Artist:	Phidias
Cite:	Vol. 83, 1985, pp. 1881–1923	Topic 1:	Classical sculpture
Art:	Greek	Topic 2:	Cultural repatriation

Quote 1: "Elgin removed (or took from the ground where they had fallen or from the fortifications and other structures in which they had been used as building materials) portions of the frieze, metopes, and pediments" (pp. 1883–84).

Quote 2: "Despite national laws limiting the export of cultural property, some of it still finds its way abroad" (p. 1889).

Quote 3: "That, in the end, is what the law and politics of cultural property are about: the cultural heritage of all mankind" (p. 1923).

✔ Checklist for Note-Taking

❑ If in my notes I quote a phrase, sentence, or more, have I quoted accurately, have I put the quoted material within quotation marks, and have I cited the source accurately?

❑ Have I kept in mind the principle that, generally speaking, direct (word-for-word) quotations should be brief, and that longer passages in the source should be *summarized*—but these summaries, like direct quotations, need to be documented with citations?

❑ Have I kept in mind the principle that there rarely is a good reason to paraphrase (as opposed to summarizing) a source—but if for some reason a paraphrase is appropriate, the paraphrase must be explicitly cited as a paraphrase?

❑ Have I cited—that is, given explicit credit—to the sources of *ideas* as well as of quotations?

INCORPORATING YOUR READING INTO YOUR THINKING: THE ART OF SYNTHESIS

A much-quoted passage—at least, teachers of composition often quote it—is by Kenneth Burke (1887–1993), a college drop-out who became one of America's most important twentieth-century students of rhetoric. Burke wrote:

> Imagine that you enter a parlor. You come late. When you arrive, others have long preceded you, and they are engaged in a heated discussion, a discussion too heated for them to pause and tell you exactly what it is about. In fact, the discussion had already begun long before any of them got there, so that no one present is qualified to retrace for you all the steps that had gone before. You listen for a while, until you decide that you have caught the tenor of the argument; then you put in your oar. Someone answers; you answer him; another comes to your defense; another aligns himself against you, to either the embarrassment or gratification of your opponent, depending upon the quality of your ally's assistance. However, the discussion is interminable. The hour grows late, you must depart. And you do depart, with the discussion still vigorously in progress.
>
> *The Philosophy of Literary Form* (Baton Rouge: Louisiana State University Press, 1941), 110–11

When you use sources, you are joining the unending conversation. During the process of reading, and immediately afterwards, as well as when you review your notes, you will want to listen, think, say to yourself something like:

- "No, no, I see things very differently; it seems to me that . . ." or
- "Yes, of course, but on one large issue I think I differ," or
- "Yes, sure, I agree, but I would go further and add . . ." or
- "Yes, I agree with your conclusion, but I hold this conclusion for reasons very different from the ones that you offer."

When using your notes while writing an essay, you almost surely will have to summarize very briefly the idea or ideas you have encountered,

so that your readers will understand the context of your remarks. These ideas may not come from a single source; you may be responding to several sources, for instance to a report and also to some comments that the report evoked. In any case, you will state these ideas briefly and fairly, and will then set forth your thoughtful responses, thereby giving the reader a statement that you hope represents an advance in the argument, even if only a tiny one. That is, you will **synthesize** sources, combining existing material into something new, drawing nourishment from what has already been said (giving credit, of course) and converting it into something new, a view that you think is worth considering.

DRAFTING AND REVISING THE PAPER

There remains the difficult job of writing up your findings, usually in two thousand to three thousand words, or eight to twelve double-spaced typed pages. Here is some advice.

1. **Reread your notes.** If you used note cards, sort them into packets by topic. If you used note-taking software or a writer's project management program such as Ulysses, reorder your notes by topic (this may be made much easier by proper use of keywords). Don't hesitate to reject material that—however interesting—now seems redundant or irrelevant. In doing your research you quite properly took many notes (as William Blake said, "You never know what is enough unless you know what is more than enough"), but now, in looking your material over, you see that some of it is unnecessary and you reject it. Your finished paper should not sandbag the reader; keep in mind the Yiddish proverb, "Where there is too much, something is missing." Of course, do not delete anything; either hide certain note pages if your software allows, or create a backup copy of the complete set of notes before deleting any pages.

After sorting and resorting, you will have a kind of first draft without writing a draft. This business of settling on the structure of your work—the composition of your work, one might say—is often frustrating. Where to begin? Should this go before that? But remember that great artists have gone through greater struggles. If we look at a leaf from one of Raphael's sketchbooks, we find him trying, and trying again, to work out the composition of, say, the Virgin and Child. Nicolas Poussin used a miniature stage, on which he arranged and rearranged the figures in his composition. An X-ray of Rembrandt's *The Syndics of the Cloth Drapers Guild* reveals that he placed the servant in no fewer than four positions (twice at the extreme right, once between the two syndics at the right, and finally in the center)

before he found a satisfactory arrangement. You can hardly expect, at the outset, to have a better grasp of your material than Raphael, Poussin, and Rembrandt had of theirs. What Degas said of a picture is true of a research paper: "A good picture requires as much planning as a crime."

2. **From your rearranged notes or your packets of cards you can make a first outline.** In rearranging your notes into a sequence, and then in sketching an outline (see page 21), you will be guided by your thesis, your point. Without a thesis you will have only a lot of notes, not an essay. (Remember, however, that your thesis—your main point—will probably change somewhat as you collect evidence and think hard about it. A change in thesis may require a change in organization.) This outline or map will indicate not only the major parts of the essay but also the subdivisions within these parts. Do not confuse this type of outline with a paragraph outline (an outline made by jotting down the topic idea of each paragraph); when you come to write your essay, a single heading in your outline may require two or three or more paragraphs.

Don't scorn the most common organization:

- introduction of the works to be studied, and of the thesis (the thesis is your central idea, your main point)
- presentation of evidence, with interpretation relating it to the thesis
- presentation of counterevidence and rebuttal
- conclusion

You may find that this organization doesn't suit your topic or you. Fine, but remember that your reader will need to be guided by some sort of organization that you will have to adopt and make clear.

3. **Write or type your quotations, even in the first draft, exactly as you want them to appear in the final version.** If you took notes on a word processor, just move the quotations from your notes into the paper.

Short quotations (fewer than five lines of prose) are enclosed within quotation marks but are not otherwise set off.

Long quotations are treated differently. Some instructors recommend that you triple space before and after the quotation and single space the quotation. Other instructors recommend that you double space before and after the quotation, indent the entire quotation ten spaces, and double space it. In either case, do not enclose within quotation marks a quotation that is set off as a block.

(For more on quotations, see pages 323–27.)

4. **Include, right in the body of the draft, all of the relevant citations** (later these will become footnotes or endnotes) so that when you come to revise, you won't have to start hunting through your notes to find

who said what and where. If you are using a word-processing program, it will probably allow you to write the footnotes immediately after the quotations, and later it will print them at the bottom of the appropriate pages. Further, most word-processing programs let you add and delete notes while the computer automatically renumbers the notes in the final version. If, however, you are writing by hand, enclose these citations within diagonal lines, or within double parentheses—anything at all to remind you that they will be your footnotes.

5. **Identify works of art as precisely as possible.** Not "Rembrandt's *Self-Portrait*" (he did more than sixty), or even "Rembrandt's *Self-Portrait* in the Kunsthistorisches Museum, Vienna" (they own at least two), but "Rembrandt's *Self-Portrait of 1655,* in the Kunsthistorisches Museum, Vienna," or, more usually, "Rembrandt's *Self-Portrait* (1655, Kunsthistorisches Museum, Vienna)." If the exact date is unknown, preface the approximate date with *ca.,* the abbreviation for *circa,* Latin for "about." Example: ca. 1700. Be sure to identify all illustrations with a caption, giving, if possible, artist, title, date, medium, size, and present location. (See pages 308–10 for more on captions and illustrations.)

6. **Beware of the compulsion to include all of your notes in your essay.** You have taken all these notes, and there is a strong temptation to use them all. But, truth to tell, you now see that many are useless. Conversely, you will probably find as you write your draft that here and there you need to check a quotation or to collect additional examples. Probably it is best to continue writing your draft, if possible; but remember to insert the necessary material after you get it.

7. **Do not let your paper become a string of quotations.** As you revise your draft, make sure that you do not merely tell the reader "X says . . . , Y says . . . , Z says . . ." When you write a research paper

- you are not merely setting the table with other people's dinnerware; you are cooking the meal
- you must have a point, an opinion, a thesis, a controlling idea

You are working toward a conclusion, and your readers should always feel they are moving toward that conclusion (by means of your thoughtful evaluation of the evidence) rather than reading an anthology of commentary on the topic.

8. **When you introduce a quotation, provide a lead-in so the reader can see the use to which you are putting it.** "*A* says" or "*B* writes" is of little help; giving the quotation and then following it with "thus says *A*" is even worse. After all, the authors whom you quote—*A, B, C,* and *D*—were not just writing and saying: They were *arguing, demonstrating,*

showing, supporting their claim, misleadingly implying, or whatever. Similarly, because you are using the quotation in order to make a point, it is usually advisable to let your reader know, by means of a signal phrase, *why* you are quoting;

A concisely states the common view . . .

B calls attention to a significant weakness . . .

Even C admits that . . .

Without offering any proof, D claims that . . .

E gives two reasons for rejecting the idea that . . .

In short, indicate how the quotation fits into your argument. Do not assume that the quotation speaks for itself. (Notice, in the examples just given, that the verbs—for instance "claims," "admits," "rejects"—convey an *argument*, in a way that "says" or "writes" does not.)

 A RULE FOR WRITERS:

Don't merely quote a passage and then move on. Let the reader know, by means of your lead-in and your subsequent comment, how the quotation fits into *your* argument.

Equally important: After giving a quotation, you'll almost surely want to develop (or take issue with) the point made in the quotation.

It is usually desirable in your lead-in to name the author of the quotation, rather than to say something like "One scholar has said . . ." or "Another critic claims that. . . ." In all probability the author whom you are quoting is known in the field and your readers should not have to turn to the footnotes to find out whose words they have been reading.

Remember, too, that a summary of a writer's views may actually be preferable—briefer and more lively than a long quotation. (You'll give credit to your source, of course, even though all of the words in the summary are your own.)

9. **Make sure that you have faced the reasonable objections that might be raised against your thesis,** and that you have given your reader adequate evidence.

10. **Make sure that your conclusion is consistent with everything that precedes it.** Especially check the early part of your essay to see if it raises issues or implies promises that are later neglected.

In brief: You may have noticed while you were doing your research that the most interesting writers persuade the reader of the validity of their opinions in several ways:

- by letting the reader see that the writer knows what of significance has been written on the topic
- by letting the reader hear the best representatives of the major current opinions, whom they correct, modify, or confirm
- by advancing their opinions, and by offering generalizations supported by concrete details
- by fulfilling all expectations that they raise

Adopt these techniques in your own writing.

Your overall argument, then, is fleshed out with careful summaries, with effective quotations, and with judicious analyses of your own, so that by the end of the paper your readers not only have read a neatly typed paper, but they also are persuaded that under your guidance they have seen the evidence, heard the arguments justly summarized, and reached a sound, thoughtful conclusion. They may not become better persons, but they are better informed.

✍ A RULE FOR WRITERS:

Your job is not to report what everyone says but to establish the truth or at least the strong probability of a thesis.

Consider preparing a dual outline of the sort discussed and illustrated on pages 59–60, in which you indicate what each paragraph *says* and what each paragraph *does*. Thus, typical headings of the second sort will include "Introduces thesis," "Supports generalization," "Uses a quotation as support," "Takes account of an opposing view," and "Summarizes two chief views." Then look over your outline to see if each paragraph is doing worthwhile work, and doing it in the right place.

11. **Make sure that in your final version you state your thesis early,** perhaps even in the title (not "Van Gogh and Japanese Prints" but "Van Gogh's Creative Misunderstanding of Japanese Prints"), but if not in the title, almost certainly in your first paragraph.

12. When you have finished your paper **prepare a final copy that will be easy to read.** Keyboard the paper (Times New Roman typeface is recommended), and print a copy from the computer, putting the footnotes or endnotes into the forms given on pages 335–40.

A bibliography or list of works cited—see pages 331–34 (*Chicago Manual* style)—is usually appended to the research paper, partly to add authority to your paper, partly to give credit to the writers who have helped you, and partly to enable readers to look further into the primary and secondary material if they wish. But if you have done your job well, the reader will be content to leave things where you left them, grateful that you have set things straight.

Or straight for a little while; no one expects more. Writers try to do their best, but they cannot hope to say the last word. As Leo Steinberg says, introducing his comment on Velázquez's *Las Meniñas:*

> Writing about a work such as *Las Meniñas* is not, after all, like queuing up at the A&P. Rather, it is somewhat comparable to the performing of a great musical composition of which there are no definitive renderings. The guaranteed inadequacy of each successive performance challenges the interpreter next in line, helping thereby to keep the work in the repertoire. Alternatively, when a work of art ceases to be discussed, it suffers a gradual blackout. (*October* 19 [1981], 48)

✍ A RULE FOR WRITERS:

If students are required to submit papers electronically, find out what formats are required or desired. Most word processing programs can export to a "lowest common denominator" format, but make sure you are submitting your paper in a format that your instructor will be able to read.

✔ Checklist for Reviewing a Revised Draft of a Research Paper

Have I asked myself the following questions?

After you have written a draft and revised it at least once (better, twice or more), reread it with the following questions in mind. If possible, ask a friend to read the draft, along with the questions, or with the peer review checklist on pages 190–92. If your answers or your friend's are unsatisfactory, revise.

❏ Does the draft fulfill the specifications (e.g., length, scope) of the assignment?

❏ Does the draft have a point, a focus?

❑ Is the title interesting and informative? Does it create a favorable first impression?

❑ Are the early paragraphs engaging, and do they give the reader a fairly good idea of what the thesis is and how the paper will be organized?

❑ Are arguable assertions supported with adequate evidence?

❑ Do you keep your readers in mind, for instance by defining terms that they may be unfamiliar with?

❑ Are quotations adequately introduced with signal phrases (for instance, "Richardson has shown," "An opposing view holds"), rather than just dumped into the essay? Are quotations as brief as possible? Might summaries (properly credited to the sources) be more effective than long quotations?

❑ Are quotations adequately commented on, not simply left to speak for themselves?

❑ Are *all* sources cited—not only words, but also ideas—including Internet material?

❑ Is the organization clear, reasonable, and effective? (Check by making a brief outline. Remember that the paper not only must be organized, but also that the organization must be clear to the reader. Check to see that transitions are adequate.)

❑ Does the final paragraph nicely round off the paper, or does it merely restate—unnecessarily—what is by now obvious?

❑ Does the paper include all the visual materials that the reader needs to see?

❑ Is the documentation in correct form?

14

MANUSCRIPT FORM

Accuracy is not a virtue; it is a duty.

—A. E. Housman

Neatness counts.

—Every teacher you have ever had

BASIC MANUSCRIPT FORM

Much of what follows is nothing more than common sense. Unless your instructor specifies something different, you can adopt these principles as a guide to basic manuscript format.

1. **Use 8½ × 11-inch paper of good weight.** Do not use paper torn out of a spiral notebook; ragged edges distract a reader.

2. **If you use a computer, choose Times New Roman, 12 point,** as your font. No 16 point font. No loopy script.

3. **Write on one side of the page only.** Double-space, and make sure that the printed copy is reasonably dark.

4. **Put your name, instructor's name, class or course number, and the date** in the upper right-hand corner of the first page. It is a good idea to put your name in the upper right corner of each subsequent page, so the instructor can easily reassemble your essay if somehow a page gets detached and mixed with other papers.

5. **Center the title of your essay** about 2 inches from the top of the first page. Capitalize the first letter of the first and last words of your title, the first word after a semicolon or colon if you use either one, and the first letter of all the other words except articles (*a, an, the*), conjunctions (*and, but, or,* etc.), and prepositions (*about, in, on, of, with,* etc.), thus:

The Renaissance and Modern Sources of Manet's *Olympia*

(Some handbooks advise that prepositions of five or more letters—
about, beyond—be capitalized.) If you use a subtitle, separate it from the
title by means of a colon:

Manet's *Olympia:* Renaissance and Modern Sources

Notice that your title is neither underlined nor enclosed in quotation marks, but
when your title includes the title of a work of art (other than architecture), that
title is italicized or is underlined to indicate italics.

6. **Begin the essay an inch or two below the title.** If your instruc-
tor prefers a title page, begin the essay on the next page.

7. **Leave an adequate margin**—an inch or an inch and a half—at top,
bottom, and sides, so that your instructor can annotate the paper. Word proces-
sors usually allow you to choose a justified or an unjustified (ragged, uneven)
right-hand margin. If you choose a justified margin, some lines of print will
be stretched out in order to fill the line, and others will be crowded. If your
software cannot convincingly imitate a typeset page, turn off the justification
feature.

8. **Number the pages consecutively,** using arabic numerals in the
upper right-hand corner. If you give the title on a separate page, do not
number that page; the page that follows it is page 1.

9. **Indent the first word of each paragraph** five spaces from the
left margin.

10. **When you refer to a work illustrated in your essay, give the
number of the illustration—called a "Figure"—in parentheses.** (The
illustrations, whether grouped together at the back, or interspersed in the
text at the places where you discuss them, will be numbered consecutively,
Figure 1, Figure 2, etc.)

Vermeer's *The Art of Painting* (Figure 1) is now widely agreed to be an
allegorical painting.

Some instructors want the parenthetic reference to include the location of
the work, thus:

Vermeer's *The Art of Painting* (Vienna, Kunstihistorisches Museum, Figure 1)
is now widely agreed to be an allegorical painting.

Other instructors, however, regard this additional information as intru-
sive and unnecessary, since the information is included in the caption that
accompanies the illustration. Ask if your instructor has a preference.

11. **If possible, insert photocopies of the illustrations, with captions,
at the appropriate places in the paper,** unless your instructor has told you
to put all of the illustrations at the rear of the paper. Number the illustrations
(each illustration is a *Figure*) and give captions that include, if possible, artist

(or, for anonymous works, the culture), title (underlined), date, medium (material out of which the work is made), dimensions (height precedes width), and present location. Here are examples of what museum professionals dryly call *tombstone labels*, that is, labels that offer only minimal facts:

Figure 1. Japanese, *Flying Angel*, second half of the eleventh century. Wood with traces of gesso and gold, 33½' × 15'. Museum of Fine Arts, Boston.

Figure 2. Diego Velázquez, *Venus and Cupid*, ca. 1644–48. Oil on canvas, 3'11⅞' × 5'9¼'. National Gallery, London.

Note that titles of sculpture (here, *Flying Angel*) and of paintings *(Venus and Cupid)* are italicized. Titles of works of architecture (Twin Towers, the White House), however, are *not* italicized. Notice also that in the second example the abbreviation *ca.* (or sometimes *c.*) stands for *circa*, Latin for "about." The English word seems to be—quite reasonably—displacing the Latin.

If there is some uncertainty about whether the artist created the work, precede the artist's name with *Attributed to*. If the artist had an active studio, and there is uncertainty about the degree of the artist's involvement in the work, put *Studio of* before the artist's name.

Six more points about captions for illustrations:

- If you use the abbreviation BC ("before Christ") or AD ("anno domini," i.e., "in the year of our Lord"), do not put a space between the letters.
- BC follows the year (7 BC) but AD precedes the year (AD 10), though AD is acceptable after a century: "In the tenth century AD. . . . "
- The abbreviations BC and AD, derived from Christian history, are falling out of favor and are being replaced with BCE ("before the common era" or "before the current era") and CE ("common era" or "current era"). Both BCE and CE follow the year.
- For a building, give the city (and the country if the city is not well known).
- If an artist's name is likely to be unfamiliar to most viewers and if the spelling does not indicate the pronunciation—Chinese names are examples—consider giving a phonetic equivalent:

Qin Feng (pronounced "chin fung")

- Some instructors may ask you to cite also your source for the illustration, thus:

Figure 3. Japanese, *Head of a Monk's Staff,* late twelfth century. Bronze, 91/4". Peabody Museum, Salem, Massachusetts. Illustrated in John Rosenfield, *Japanese Arts of the Heian Period: 794–1185* (New York: Asia Society, 1967), p. 91.

If, in your source, the pages with plates are unnumbered, give the plate number where you would ordinarily give the page number.

A tombstone label gives a tight-lipped, minimal answer to the question, "What am I looking at?" But in the last few years many museums have been moving toward somewhat longer and more friendly labels—usually between fifty and one hundred words beyond the tombstone information—that answer a different question: "Why should I care about what I am looking at?" Here is an example, largely drawn from information in Rebecca Bedell's essay (page 141), of what is called a *chat label*. After the tombstone material the label might say:

> Mrs. Goldthwait, the wife of a wealthy Boston merchant, was known for her skill as a gardener. The abundant fruit on the table is a sign of her horticultural accomplishments and also of her fertility and—to put it tactfully—her physical abundance. The slight smile on her brightly illuminated face suggests that she may offer a piece of fruit to an appreciative visitor. The skillfully painted satin, lace, and indeed the polished table itself and the column convey the prosperity of this merchant's wife, but Copley has also emphasized her engaging warmth.

12. **If a reproduction is not available**, be sure when you refer to a work to tell your reader where the work is. If it is in a museum, give the acquisition number, if possible. This information is important for works that are not otherwise immediately recognizable. A reader needs to be told more than that a Japanese tea bowl is in the Freer Gallery. The Freer has hundreds of bowls, and, in the absence of an illustration, only the acquisition number will enable a visitor to locate the bowl you are writing about.

13. **Make a photocopy of your essay, or print a second copy** from the computer, so that if the instructor misplaces the original, you need not write the paper again.

14. It's a good idea to **keep notes and drafts,** too, until the instructor returns the original. Such material may prove helpful if you are asked to revise a paper, substantiate a point, or supply a source that you inadvertently omitted.

15. **Fasten the pages of your paper with a staple or paper clip** in the upper left-hand corner. (Find out which sort of fastener your instructor prefers.) Stiff binders are unnecessary; indeed they are a nuisance to the instructor, for they add bulk and they make it awkward to write annotations.

Elliot Erwitt *Museum watching* (1999). Elliot Erwitt/Magnum Photos.

SOME CONVENTIONS OF LANGUAGE USAGE

The Apostrophe

1. To form the possessive of a name, add *'s*, even when the name already ends with a sibilant (*-s, -cks, -x, -z*). Thus:

El Greco's colors
Rubens's models
Mars's armor
Degas's models
Velázquez's subjects
Augustus John's sketches (his last name is *John*)
Jasper Johns's recent work (his last name is *Johns*)

But some authorities say that to make the possessive for names ending in a sibilant, only an apostrophe is added (without the additional *s*)—Velázquez would become Velázquez', and Moses would become Moses'—unless (1) the name is a monosyllable (e.g., Jasper Johns would still become Johns's) or (2) the sibilant is followed by a final *e* (Horace would still become Horace's). Note that despite the final *s* in Degas and the final *x* in Delacroix, these names do not end in a sibilant (the letters are not pronounced), and so the possessive must be made by adding *'s*.

2. Don't add *'s* to the title of a work to make a possessive; the addition can't be italicized (underlined), since it is not part of the title, and it looks odd attached to an italicized word. So, not "*The Sower's* colors" and not "*The Sower*'s colors"; rather, "the colors of *The Sower*."

3. Don't confuse *its* and *it's*. The first is a possessive pronoun ("Its colors have faded"); the second is a contraction of *it is* ("It's important to realize that most early landscapes were painted indoors"). You'll have no trouble if you remember that *its*, like other possessive pronouns such as *ours, his, hers,* and *theirs*, does *not* use an apostrophe.

Capitalization

Most writers capitalize names of sharply limited periods (e.g., Pre-Columbian, Early Christian, Romanesque, High Renaissance, Rococo) and the names of movements (e.g., Impressionism, Minimalism, Symbolism). Most writers do not capitalize "classic" and "romantic"—but even if you do capitalize Romantic when it refers to a movement ("Delacroix was a Romantic painter"), note that you should not capitalize it when it is used in other senses ("There is something romantic about ruined temples").

Many writers capitalize the chief events of the Bible, such as the Creation, the Fall, the Annunciation, and the Crucifixion, and also mythological events, such as the Rape of Ganymede and the Judgment of Paris. Again, be consistent.

On capitalization in titles, see pages 307–08 and 323.

The Dash

Type a dash by typing two hyphens (--) without hitting the space bar before, between, or after. Do not confuse the dash with the hyphen. Here is an example of the dash:

> New York—not Paris—is the center of the art world today.

The Hyphen

1. **Use a hyphen to divide a word at the end of a line.** Because words may be divided only as indicated by a dictionary, it is easier to end the line with the last complete word you can type than to keep reaching for a dictionary. But here are some principles governing the division of words at the end of a line:

- Never hyphenate words of one syllable, such as *called, wrote, doubt, through.*
- Never hyphenate so that a single letter stands alone: *a-lone, hair-y.*
- If a word already has a hyphen, divide it at the hyphen: *pro-choice.*
- Divide prefixes and suffixes from the root: *pro-vide; paint-ing.*
- Divide between syllables. Most words with double consonants should be hyphenated between the double letters: *bal-let, bal-loon.* If you aren't sure of the proper syllabification, check a dictionary.

Notice that when hyphenating, you do not hit the space bar before or after hitting the hyphen.

2. **Use a hyphen to compound adjectives into a single visual unit:** *twentieth-century architects, mid-century architecture* (but "She was born in the twentieth century").

Foreign Words and Quotations in Foreign Languages

1. **Underline (to indicate italics) or italicize foreign words that are not part of the English language.** Examples: *sfumato* (an Italian word for a "blurred outline" or tones seamlessly blended like smoke), *pai-miao* (Chinese for "fine-line work"). But such words as chiaroscuro (in

painting, the use of highlights and shadow to give the appearance of three-dimensionality), minaret (a tall, slender tower on a mosque), and Ming (a Chinese dynasty, 1368–1644) are not italicized because, as their presence in English dictionaries indicates, they have been accepted into English vocabulary. Foreign names are discussed on page 315.

2. **Do not underline or italicize a quotation (whether in quotation marks or set off) in a foreign language.** A word about foreign quotations: If your paper is frankly aimed at specialists, you need not translate quotations from languages that your readers might be expected to know, but if it is aimed at a general audience, translate foreign quotations, either immediately below the original or in a footnote.

3. On **translating the titles of works of art,** and on **capitalizing the titles of foreign books,** see "Titles," pages 322–23.

Left and Right in Describing Pictures

If we say of a certain medieval painting,

With his right hand Jesus makes a gesture of blessing,

there is no ambiguity. But suppose we say

At Jesus's right and left are crucified thieves. The thief at the right, however, seems to be much repainted.

Is the repainted figure "at the right" the figure at *Jesus's* right—that is, the figure on the *left* side of the picture—or is he the figure that *we,* looking at the picture, see at the right side, i.e., to the right of Jesus from our point of view?

There would be no problem if the writer had said, "The thief at Jesus's right," or (on the other hand) "The thief at the right side of the picture. . . ." Sometimes, to avoid ambiguity, writers use the word *proper,* in the nearly archaic sense of "belonging to the being in question":

At Jesus's right and left are crucified thieves. The thief at Jesus's proper right, however, seems to be much repainted.

Here, the word *proper* tells us that the thief in question is unambiguously at Jesus's right—the right from Jesus's own point of view—and thus at the left side of the picture. Incidentally, the Good Thief—good because he accepted Jesus's divinity—was crucified at Jesus's proper right, i.e. to the left from the spectator's point of view.

Names

1. **Arabic names** require caution in alphabetizing in bibliographies. For example, family names beginning with *abu-* are alphabetized under this element, but those beginning with *al-* are alphabetized under the next element. For details, consult *The Chicago Manual of Style,* 16th edition.

2. **Asian names,** in the original language, customarily put the family name first. Thus, the Japanese architect who in the West is known as Kenzo Tange, and whose name is alphabetized under Tange, in Japan is known as Tange Kenzo, and he is addressed as Tange-san (Mr. Tange). Similarly, the Korean-American artist whom we call Nam June Paik is, in Korea, called Paik Nam June, Paik being the family name. Until recently, Chinese, Japanese, and Korean names, when given in English, were given in the Western order, with the family name last ("Kenzo Tange's influence is still great"), but today, in an effort to avoid Eurocentrism, there is a notable tendency to use the original sequence, as in "Tange Kenzo's influence is still great." In a bibliography the name, of course, is alphabetized under *T*, the first letter of the family name. One last (complicated) example: Wu Hung, a historian of Chinese art at the University of Chicago, is Professor Wu, because Wu is his family name. But on his books—even those published in English—his name appears as Wu Hung; i.e., the name is given in the Chinese style. An American student, innocent of Chinese, might think, wrongly, that in a bibliography this author would be alphabetized under *H*. If in preparing a bibliography you are in doubt about which is the family name, ask someone who is likely to know.

3. **Dutch** van, as in Vincent van Gogh, is never capitalized by the Dutch except when it begins a sentence; in American usage, however, it is acceptable (but not necessary) to capitalize it when it appears without the first name, as in "The paintings of Van Gogh." But: "Vincent van Gogh's paintings." Names with *van* are commonly alphabetized under the last name, for example under *G* for Gogh.

4. **French** de is not commonly used when the first name is not given. Thus, the last name of Georges de La Tour is La Tour, *not* de La Tour. But when *de* is combined with the definite article, into *des* or *du,* it is given even without the first name. *La* and *Le* are used even when the first name is not given, as in Le Nain.

5. **Spanish** de is not used without the first name, but if it is combined with *el* into *del,* it is given even without the first name.

6. **Names of deceased persons** are never prefaced with Mr., Miss, Mrs., or Ms.—even in an attempt at humor.

7. **Names of women** are not prefaced by Miss, Ms., or Mrs.; treat them like men's names—that is, give them no title.

8. **First names alone** are used for many writers and artists of the Middle Ages and Renaissance (examples: Dante, for Dante Alighieri; Michelangelo, for Michelangelo Buonarroti; Piero, for Piero della Francesca; Rogier, for Rogier van der Weyden), and usually these are even alphabetized under the first name. Leonardo da Vinci, born near the town of Vinci, is Leonardo, never da Vinci. But do not adopt a chatty familiarity with later people: Picasso, not Pablo. *Exception:* Because van Gogh often signed his pictures "Vincent," some writers call him Vincent.

Except for those artists who are commonly known by their first name, give the **full name** the first time you refer to an artist; in subsequent references give only the last name.

Avoiding Sexist Language

1. Traditionally, the male pronouns *he* and *his* have been used generically—that is, to refer to both men and women ("An architect should maintain his independence"). But this use of *he* and *his* is not sufficiently inclusive and is no longer acceptable. Common ways to avoid this type of sexist language are to use *he or she, she or he, s/he, (s)he, he/she, she/he, his or her,* or *her or his.* Some writers shift from masculine to feminine forms in alternating sentences or alternating paragraphs, and a few writers regularly use *she* and *her* in place of the generic *he* and *his* in order to make a sociopolitical point. But these attempts to avoid using the male pronouns usually call too much attention to themselves. Consider, for example, this grotesque sentence from an article in *Art History* 15:4 (1992), page 545:

> What some music also does (and particularly Wagner) is draw the attentive listener into it, so that s/he finds him- or herself in a close dialectical engagement with something which seems like his- or herself in character but which is neither quite this, nor yet quite alien.

The writer is trying to say something about music, but his attempts to avoid sexist language by writing "s/he . . . him- or herself . . . his- or herself" are so awkward and so conspicuous that the reader notices only them, not the real point of the sentence.

There are other, more effective ways of avoiding sexist writing. Often you can substitute the plural form. For instance, instead of

An architect should maintain his independence.

you can write

> Architects should maintain their independence.

Or you can recast the sentence to eliminate the possessive pronoun:

> An architect should be independent.

2. Think twice before you use *man* or *mankind* in such expressions as "man's art" or "the greatness of mankind." Consider using instead such words as *human being, person, people, humanity,* and *we.* (Examples: "Human beings need art," or "Humankind needs art," or "We need art," instead of "Man needs art.") For *man-made,* consider *artificial, constructed, humanmade, manufactured.*

3. *Layman, craftsman,* and similar words should, when possible, be replaced with such gender-neutral substitutes as *layperson* or *unspecialized people,* and (for *craftsman*) *craftsperson, craftworker,* or probably better, *artisan* or a more specific term such as *fabric artist, basket weaver,* or *woodworker.* Unfortunately there seems to be no adequate synonym for *craftsmanship,* although in some contexts *artistry, technique, technical skill,* or *expertise* will do nicely.

4. Just as you would not without good reason describe van Gogh as "the male painter", you should not use such expressions as "woman painter" or "female sculptor" unless the context requires them.

5. *Reminder:* For some readers, words such as *potent* and *seminal* imply masculine values. (See page 256.)

Avoiding Eurocentric Language

The art history that most Americans are likely to encounter has been written chiefly by persons of English or European origin. Until recently such writing saw things from a European point of view and tended to assume the preeminence of European culture. Certain English words that convey this assumption of European superiority, such as *primitive* applied to African or Oceanic art, now are widely recognized as naive. Some words, however, are less widely recognized as outdated and offensive. For instance, the people whom Caucasians long have called *Eskimo* prefer to be called *Inuit,* and there is no reason why writers should not honor their preference.

Asian; Oriental *Asian,* as a noun and as an adjective, is preferable. *Oriental* (from *oriens,* "rising sun," "east") is in disfavor because it implies a Eurocentric view (i.e., things "oriental" were east of the European colonial powers). Similarly, **Near East** (the countries of the eastern

Mediterranean, Southwest Asia, the Arabian Peninsula, and sometimes northern Africa), **Middle East** (larger than the Near East but variously defined; usually the area in Asia and Africa between and including Libya in the west, Pakistan in the east, Turkey in the north, and the Arabian Peninsula in the south), and **Far East** (China, Vietnam, North and South Korea, and Japan, or these and all other Asian lands east of Afghanistan) are terms based on a Eurocentric view. What is called the Middle East is predominantly Islamic, but it should not be called "the Arab world" because Turks, Kurds, Iranians, Israeli Jews, Christians, and others live there. No brief substitutes have been agreed on for *Near East* and *Middle East*—though *West Asia* is sometimes used—but *East Asia* is now regularly used in place of *Far East*. On Asian names, see page 315.

Eskimo; Inuit *Eskimo* (from the Algonquin for "eaters of raw meat") is a name given by the French to those native people of Canada and Greenland who call themselves *Inuit* (singular: *Inuk*). The Inuit regard *Eskimo* as pejorative, and their preference is now officially recognized in Canada. *Eskimo* is commonly used, however, for Native Americans in Alaska. Still if possible, use a more specific term, such as *Tlinget* or *Haida*.

Far East See *Asian.*

Hispanic The word—derived from *Hispania,* the Latin name for Spain—is widely used to designate not only persons from Spain but also members of the various Spanish-speaking communities living in the United States—Puerto Ricans, Cuban-Americans, and persons from South America and Central America (including Mexican-Americans, sometimes called Chicanos). Some members of these communities, however, strongly object to the term, arguing that it overemphasizes their European heritage and ignores the Indian and African heritages of many of the people it claims to describe. The same has been said of *Latina* and *Latino,* but these terms are more widely accepted within the communities, probably because the words are Spanish rather than English and therefore do not imply assimilation to Anglo culture. Further, *Latina* and *Latino* denote only persons of Central and South American descent, whereas *Hispanic* includes persons from Spain. Note: Many people believe that the differences among Spanish-speaking groups from various countries are so great that *Hispanic, Latino,* and *Latina* are reductive, almost meaningless labels that conjure up an unflattering stereotype. Polls indicate that most persons in the United States who trace their origin to a Spanish-speaking country prefer to identify themselves as *Cuban, Mexican* (or *Chicano*), *Peruvian, Puerto Rican,* and so on, rather than as *Hispanic.*

Inca, Inka *Inka* is now the preferred spelling because it is the spelling used today in Peru's Quechua language to distinguish the sound from the slightly different sound of, say, Cuzco (Qusqu).

Indian; Native American When Columbus encountered the Caribs in 1492, he thought he had reached India and therefore called them *Indios* (Indians). Later, efforts to distinguish the peoples of the Western Hemisphere produced the terms *American Indian, Amerindian,* and *Amerind.* More recently *Native American* and *Indigenous American* have been used, but of course the people who met the European new-comers were themselves descended from persons who had emigrated from eastern Asia in ancient times, and in any case, *American* is a word derived from the name of an Italian. On the other hand, anyone born in America, regardless of ethnicity, is a native American (as opposed to a naturalized American citizen). Further, many Native Americans (in the new, restricted sense) continue to speak of themselves as Indians (e.g., members of the Navaho Indian Nation), thereby making the use of that word acceptable. Although *Indian* is acceptable, use the name of the specific group, such as Hopi or Iroquois or Navaho, whenever possible. In Canada, however, the accepted terms now are *First Nations People* and *First Nations Canadians,* although some of these people call themselves Indians. The words *tribe* and *clan* are yielding to *nation* and *people* (e.g., the Zuni people), but in Canada *band* is widely used. One other point: All of the aboriginal peoples of Canada and Alaska can be called Native Americans, but some of them (e.g., the Inuit and the Aleut) cannot be called Indians.

Inuit; Eskimo See *Eskimo.*

Latina/Latino See *Hispanic.*

Native American See *Indian.*

New World; Western Hemisphere Although half of the earth—comprising North America, Mexico, Central America, and South America—in the late sixteenth century was new to Europeans, it was not new to the people who lived in this half of the world. The term *Western Hemisphere* is preferred to *New World.* On *West,* see page 159.

Primitive Derived ultimately from the Latin *primus,* meaning "first," *primitive* was widely used by anthropologists in the late nineteenth and early twentieth centuries with reference to nonliterate, nonwhite societies, e.g., in Africa south of the Sahara, in Oceania, and in pre-Columbian America. These hunting and gathering or even herding and farming societies were thought to be still in the first stages of an evolutionary process that culminates in "civilization," whose finest flowering was believed to be white industrial society. Even if "primitive" societies were regarded as having certain virtues, for instance, "naturalness" or

"spontaneity," these virtues were viewed with some condescension—the virtues were usually regarded as those of children—and present members of the society were usually thought to have lost them. Although H. Gene Blocker used the word *primitive* in the title of his thoughtful book. *The Aesthetics of Primitive Art* (1994), today most anthropologists agree that the word *primitive* is misleading because it implies not only that the products of a "primitive" society (art, myths, and so on) are crude and simple, but also that such a society does not have a long, evolving, individual history. **Tribal** is often used as a substitute, but this word too contains condescending Eurocentric implications. (The journalists who in newspapers write of "tribal conflicts" in Africa would never speak of "tribal conflicts" in Europe.) *Aboriginal, ethnographic,* and *non-Western* are sometimes used for what was once called "primitive art," but *aboriginal* and *ethnographic* give off a condescending Eurocentric whiff, and *non-Western* inadvertently includes Asian art, for instance Ming porcelains. The misleading term *traditional* seems to be replacing "tribal," but when speaking of the art of individual cultures it is best to use their names (e.g., "Olmec masks," "Yoruba sculpture," "Benin bronzes," "Navaho weaving").

Some ethnographers seem now to be using the word "people," as in "the Sepik River people of New Guinea," but no term has emerged that can usefully and inoffensively be applied when speaking across cultures—and many people would argue that this is a good thing, since any term would necessarily make false connections among diverse, independent cultures.

Primitive is used also in two other senses: (1) to refer to the early stages of a particular school of painters—especially the Netherlandish painters of the late fourteenth and fifteenth centuries, and the Italian painters between Giotto (born ca. 1267) and Raphael (born 1483)—with the false assumption that these early artists were trying to achieve the illusionistic representation that their successors achieved; and (2) to refer to works by artists untrained in formal academies, such as "Grandma Moses" (1860–1961) from upstate New York, who was regarded as preserving a naive, uncorrupted, childlike, charming vision. Paintings by these "primitives" are usually bright, detailed, and flat, with a strong emphasis on design. **Folk art** and **naive art** have long been substitute terms for this last sort of "primitive" art, but **vernacular art** now seems to be the most common term, and its practitioners are usually called **self-taught artists,** a term that includes the makers of functional objects such as baskets, quilts, and toys. If, however, the work is not functional and is highly distinctive, evidently the product

of an individual psyche and not part of a recognizable tradition of art, it may be called **art brut** (French: "raw art" or "unadulterated art," a term coined in 1945 by Jean Dubuffet), **visionary art,** or **outsider art.** The terms *art brut, visionary art,* and *outsider art* are especially used with reference to work produced by people who have had little or no formal training in art and who (unlike traditional folk artists) are largely isolated from the common culture, for instance the insane, religious visionaries, prisoners (see Phyllis Kornfeld, *Cellblock Visions,* 1997), and recluses. Some collectors and students draw a strong line between art brut and folk art, but others do not, seeing "self-taught artist" as a label that embraces the obsessive visionary and the grandmotherly quilter. For the most part, however, the works of outsider artists are usually paintings (often not on canvas but on cardboard, handkerchiefs, and other non-traditional surfaces), carvings, or assemblies of what most people regard as junk. See Colin Rhodes, *Outsider Art* (2000), and for a review of five books on the topic, see N. F. Karlins in *Art Journal* 56:4 (Winter 1997): 93–97. See also James Clifford, *The Predicament of Culture* (1988), Marianna Torgovnick, *Gone Primitive* (1990), and E. H. Gombrich, *The Preference for the Primitive* (2002).

Tribal See *Primitive.*

West See page 159

Spelling

If you are a weak speller, ask a friend to take a look at your paper. If you have written the paper on a word processor, use the spell checker, but remember that the spell checker tells you only if a word is not in its dictionary. It does *not* tell you that you erred in using *their* where *there* is called for.

Experience has shown that the following words are commonly mis-spelled in papers on art. If the spelling of one of these words strikes you as odd, memorize it.

altar (noun)	dimension	recede
alter (verb)	dominant	separate
background	exaggerate	shepherd
connoisseur	existence	silhouette
contrapposto	independent	spatial
Crucifixion	noticeable	subtly
definitely	parallel	symmetry
deity (*not* diety)	prominent	vertical (*not* verticle)

Be careful to distinguish the following:

affect, effect *Affect* is usually a verb, meaning (1) "to influence, to produce an effect on," as in "These pictures greatly affected the history of painting," or (2) "to pretend, to put on," as in "He affected to enjoy the exhibition." Psychologists use it as a noun for "feeling" ("The patient experienced no affect"), and we can leave this word to psychologists. *Effect*, as a verb, means "to bring about" ("He effected this change by turning to new subject matter"). As a noun, *effect* means "result" or "consequence" ("The effect of his work was negligible").

capital, capitol A *capital* is the uppermost member of a column or pilaster; *Capital* also refers to accumulated wealth, or to a city serving as a seat of government. A *capitol* is a building in which legislators meet, or a group of buildings in which the functions of government are performed.

eminent, immanent, imminent *Eminent*, "noted, famous"; *immanent*, "remaining within, intrinsic"; *imminent*, "likely to occur soon, impending."

its, it's *Its* is a possessive ("Its origin is unknown"); *it's* is short for *it is* ("It's an early portrait"). You won't confuse these two words if you remember that possessive pronouns (*his, her, my, yours*, etc.) never take an apostrophe.

lay, lie To *lay* means "to put, to set, to cause to rest" ("Lay the glass on the print"). To *lie* means "to recline" ("Venus lies on a couch").

loose, lose *Loose* is an adjective ("The nails in the frame are loose"); *lose* is a verb ("Don't lose the nails").

precede, proceed To *precede* is to come before in time; to *proceed* is to go onward.

principal, principle *Principal* as an adjective means "leading," "chief"; as a noun it means a leader (and, in finance, wealth). *Principle* is only a noun, "a basic truth," "a rule," "an assumption."

Titles

1. **On the form of the title** of your essay, see pages 307–308.

2. **On underlining titles** of works of art, see the next section, "Italics and Underlining."

3. Some works of art are regularly given with their **titles in foreign languages** (Goya's *Los Caprichos*, the Limbourg Brothers' *Les Très Riches Heures du Duc de Berry*, Picasso's *Les Demoiselles d'Avignon*), and some works are given in a curious mixture of tongues (Cézanne's *Mont Sainte-Victoire Seen from Bibémus Quarry*), but the vast majority are given with English titles: Picasso's *The Old Guitarist*, Cézanne's

Bathers, Millet's *The Gleaners.* In most cases, then, it seems pretentious to use the original title.

4. **Capitalization in foreign languages** is not the same as in English.

> *French:* When you give a title—of a book, essay, or work of art—in French, capitalize the first word and all proper nouns. If the first word is an article, capitalize also the first noun and any adjective that precedes it. Examples: *Le Déjeuner sur l'herbe; Les Très Riches Heures du Duc de Berry.*
>
> *German:* Follow German usage; for example, capitalize the pronoun *Sie* ("you"), but do not capitalize words that are not normally capitalized in German.
>
> *Italian:* Capitalize only the first word and the names of people and places.

Italics and Underlining

1. **Use italics or underlining for titles of works of art, other than architecture:** Michelangelo's *David,* van Gogh's *Sunflowers;* but the Empire State Building, the Brooklyn Bridge, the Palazzo Vecchio. **Monuments** (e.g., the Washington Monument, the Vietnam Veterans Memorial) are usually considered to be architecture rather than sculpture and *therefore* they are *not* italicized.

2. **Italicize or underline titles of journals and books** other than holy works: *Art Journal, Art and Illusion, The Odyssey;* but Genesis, the Bible, the New Testament, the Koran (or, now preferred, the Quran). For further details about biblical citations, see page 327.

3. **Italicize titles of art exhibitions.**

4. **Italicize or underline foreign words,** but use roman type for quotations from foreign languages (see pages 313–14).

QUOTATIONS AND QUOTATION MARKS

If you are writing a research paper, you will need to include quotations, almost surely from scholars who have worked on the topic, and possibly from documents such as letters or treatises written by the artist or by the artist's contemporaries. But even in a short analysis, based chiefly on looking steadily at the object, you may want to quote a source or two—for example, your textbook. The following guidelines tell you how to give quotations and how to cite your sources—but remember, a good paper is not a bundle of quotations.

1. **Be sparing in your use of quotations.** Use quotations as evidence, not as padding. If the exact wording of the original is crucial, or especially effective, quote it directly, but if it is not, don't bore the reader with material that can be effectively reduced either by summarizing or by cutting. If you cut, indicate ellipses as explained in point 5.

You must have a good reason for quoting a passage. For instance,

- the quotation may provide important evidence that supports your argument, or
- it may add authority to your argument, or
- it may represent a view that you are arguing against, or
- it may be so effectively written that it will especially interest your readers, who will be grateful to you for letting them hear this interesting voice.

2. **Identify the speaker or writer of the quotation,** so that readers are not left with a sense of uncertainty. Usually this identification precedes the quoted material (e.g., you write something like "Rosalind E. Krauss argued" or "Clark surprisingly claims"), in accordance with the principle of letting readers know where they are going. But occasionally the identification may follow the quotation, especially if it will prove something of a pleasant surprise. For example, in a discussion of Jackson Pollock's art, you might quote a hostile comment on one of the paintings and then reveal that Pollock himself was the speaker. (Further suggestions about leading into quotations are given on pages 302–03.)

3. **Distinguish between short and long quotations,** and treat each appropriately. *Short quotations* (usually defined as fewer than five lines of prose) are enclosed within quotation marks and run into the text (rather than set off, without quotation marks).

> Michael Levey points out that "Alexander singled out Lysippus to be his favorite sculptor, because he liked the character given him in Lysippus' busts." In making this point, Levey is not taking the familiar view that. . . .

A *long quotation* (usually five or more lines of typewritten prose) is *not* enclosed within quotation marks. To set it off instead, the usual practice is to triple-space before and after the quotation and single-space the quotation, indenting five spaces—ten spaces for the first line if the quotation begins with the opening of a paragraph. (Note: The suggestion that you single-space longer quotations seems reasonable but is at odds with various manuals that tell how to prepare a manuscript for publication. Such manuals usually say that material that is set off should be indented ten spaces and double-spaced. Find out if your instructor has a preference.)

Introduce a long quotation with an introductory phrase ("Jones argues that") or with a sentence ending with a colon ("Jones offers this argument:"). For an example of this use of a colon, see the lead-in to the quotation from Leo Steinberg on page 216.

4. **An embedded quotation** (i.e., a quotation embedded in a sentence of your own) must fit grammatically into the sentence of which it is a part. For example, suppose you want to use Zadkine's comment, "I do not believe that art must develop on national lines."

Incorrect

> Zadkine says that he "do not believe that art must develop on national lines."

Correct

> Zadkine says that he does "not believe that art must develop on national lines."

Correct

> Zadkine says, "I do not believe that art must develop on national lines."

Caution: Do not try to introduce a long quotation (say a longish complete sentence) into the middle of one of your own sentences. It is almost impossible for the reader to come out of the quotation and to pick up the thread of your own sentence. Consider this unfortunate example, in which a writer embeds two complete sentences within his own sentence:

> When Arthur Wesley Dow wrote, "The painter need not always paint with brushes, he can paint with light itself. Modern photography has brought light under control and made it as truly art-material as pigment or clay." in his introduction to the 1921 *Pictorial Photographers of America* catalogue, this country was in the midst of a growing interest in Pictorial photography.
> "Photographs by the Seattle Camera Club,"
> *American Art Review,* 12 (2000): 164.

Even if the period at the end of the inner quotation (after "clay") were replaced by a comma, the writer's own sentence would remain almost impossible to follow. It would be much better to lead into Dow's quotation thus: "In his introduction to a 1921 catalog entitled *Pictorial Photographers of America,* Arthur Wesley Dow wrote," and then (after a colon) to give Dow's two sentences. After the quotation the writer could then begin his own sentence, perhaps along this line: "When Dow was writing, the country was in the midst of a growing interest in Pictorial photography."

5. **The quotation must be exact.** Any material that you add within a quotation must be in square brackets (not parentheses), thus:

> Pissarro, in a letter, expressed his belief that "the Japanese practiced this art [of using color to express ideas] as did the Chinese."

If you wish to omit material from within a quotation, indicate the ellipsis by three spaced periods. If a sentence ends in an omission, add a closed-up period and then three spaced periods to indicate the omission. The following example is based on a quotation from the sentences immediately before this one:

> The manual says that "if you . . . omit material from within a quotation, [you must] indicate the ellipsis. . . . If a sentence ends in an omission, add a closed-up period and then three spaced periods. . . ."

Notice that although material preceded "if you," an ellipsis is not needed to indicate the omission because "if you" began a sentence in the original. (Notice, too, that although in the original *if* was capitalized, in the quotation it is reduced to lowercase in order to fit into the sentence grammatically.) Customarily initial and terminal omissions are indicated only when they are part of the sentence you are quoting. Even such omissions need not be indicated when the quoted material is obviously incomplete—when, for instance, it is a word or phrase.

6. **Punctuation is a bit tricky.** Commas and periods go *inside* the quotation marks; semicolons and colons go *outside* the marks.

Question marks, exclamation points, and dashes go inside if they are part of the quotation, outside if they are your own. Compare the positions of the question marks in the two following sentences.

> The question Jacobs asked is this: "Why did perspective appear when it did?" Can we agree with Jacobs that "perspective appeared when scientific thinking required it"?

7. **Use single quotation marks for material contained within a quotation** that itself is within quotation marks. In the following example, a student quotes William Jordy (the quotation from Jordy is enclosed within double quotation marks), who himself quoted Frank Lloyd Wright (the quotation within Jordy's quotation is enclosed within single quotation marks):

> William H. Jordy believes that to appreciate Wright's Guggenheim Museum one must climb up it, but he recognizes that "Wright . . . recommended that one take the elevator and circle downward. 'The elevator is doing the lifting,' as he put it, 'the visitor the drifting from alcove to alcove.'"

8. **Use quotation marks around titles of short works**—that is, for titles of chapters in books and for stories, essays, short poems, songs, lectures, and speeches. Titles of unpublished works, even book-length dissertations, are also enclosed in quotation marks. But italicize (or underline, to indicate *italics*) titles of pamphlets, periodicals, and books. Underline also titles of films, radio and television programs, ballets and operas, and works of art except architecture. Thus: Michelangelo's *David*, Picasso's *Guernica,* Frank Lloyd Wright's Guggenheim Museum.

Exception: Titles of sacred writings (e.g., the Old Testament, the Hebrew Bible, the Bible, Genesis, Acts, the Gospels, the Quran) are not underlined, not italicized, and not enclosed within quotation marks.

Incidentally, it is becoming customary to speak of the Hebrew Bible or of the Hebrew Scriptures, rather than of the Old Testament, and some writers speak of the Christian Scriptures rather than of the New Testament. The objection to the term "Old Testament" is based on the idea that the Hebrew writings are implicitly diminished when they are regarded as "Old" writings that are replaced by "New" ones. Although "Hebrew Scriptures" is not entirely accurate since some parts of the Scriptures of Judaism are written not in Hebrew but in Aramaic, it is the preferred term by many Jews and by those Christians who are aware of the issue.

To cite a book of the Bible with chapter and verse, give the name of the book (capitalized), then a space, then an arabic numeral for the chapter, a period, and an arabic numeral (*not* preceded by a space) for the verse, thus: Exodus 20.14–15. (The older method of citation, with a small roman numeral for the chapter and an arabic numeral for the verse, is no longer common.) Standard abbreviations for the books of the Bible (for example, 2 Cor. for 2 Corinthians) are permissible in citations.

ACKNOWLEDGING SOURCES

Borrowing Without Plagiarizing

Plagiarism is stealing—stealing words or ideas—and plagiarists are severely punished, usually by being failed in the course, or even by being suspended from the college.

You must acknowledge your indebtedness for material when

1. You quote directly from a work.

2. You paraphrase or summarize someone's words (the words of the paraphrase or summary are your own, but the points are not, and neither, probably, is the structure of the sentences).

3. You appropriate an idea that is not common knowledge.

Let's suppose you want to make use of the second paragraph of Phyllis Tuchman's review of an exhibition of Mark Rothko. Here is her paragraph. (We reprint her entire review on pages 166–69).

> The Mark Rothko retrospective, which opened at the National Gallery of Art in Washington, D.C., and was next on view at the Whitney Museum of American Art in New York, was astonishingly beautiful. And people responded accordingly. Answering to a call comparable to "Build a ball field and they will come," the crowds descended on this spectacular display. Whenever I visited the exhibition, which featured about 110 paintings and works on paper the artist made between 1936 and 1969, a year before he died at the age of sixty-six, the galleries were filled. Abstract art is once again ascendant; artists, as well as others, appear to care passionately about how it is made, what it can address, and its ability to communicate the highest values of life in a nonrepresentational, visual language his work.[*]

1. **Acknowledging a direct quotation.** You may want to use some or all of Tuchman's words, in which case you will write something like this:

> As Phyllis Tuchman says, in her 1999 review of a Mark Rothko exhibition at the National Gallery of Art and the Whiney Museum, "Abstract art is once again ascendant; artists, as well as others, appear to care passionately about how it is made, what it can address, and its ability to communicate the highest values of life in a nonrepresentational, visual language his work."[1]

Notice that the digit, indicating a footnote, is raised, and that it follows the period and the quotation mark. (The form of footnotes is specified on pages 334–40.)

2. **Acknowledging a summary or a paraphrase or summary.** Summaries (abridgments) are usually superior to paraphrases (rewordings, of approximately the same length as the original) because summaries are briefer, but occasionally you may find that you cannot abridge a passage in your source and yet you don't want to quote it word for word—perhaps because it is too technical or because it is poorly written—and you find you

[*]Phyllis Tuchman, "Mark Rothko Rising," *Art Journal,* Spring, Vol. 58, No. 1, 1999. Copyright 1999 Phyllis Tuchman. Reprinted by permission of the author.

want to paraphrase it. Even though you are changing some or all of the words, *you must give credit to the source* because the idea is not yours, nor, probably, is the sequence of the presentation. Here is an example:

Summary

> Phyllis Tuchman, in her review of a Mark Rothko exhibition, says that the popularity of the exhibition is evidence that there is widespread interest in how abstract is made and in its ability to communicate with representational forms.

Not to give Tuchman credit is to plagiarize, even though the words are yours. The offense is just as serious as not acknowledging a direct quotation. And, of course, if you say something like what is given in the following example and you do not give credit, you are also plagiarizing, even though almost all of the words are your own.

Plagiarized Summary

> The Mark Rothko exhibition was amazingly attractive. Visitors responded to this beautiful exhibition, which included more than 100 paintings and some additional works on paper that Rothko created between 1936 and 1969, one year before he died. Abstract art is now again very popular: Members of the general public, as well as artists, are very excited about how abstract art is made, what it is concerned with, and its power to communicate life's most significant values.

Now comes a subtle point: Even if the writer of the previous paragraph had begun the paragraph with something like "As Phyllis Tuchman said," *the paragraph would still be plagiarized.* How, you may ask, can a student be guilty of plagiarism if he or she acknowledges a source? Easily: in this example, the student follows Tuchman's organization and merely finds synonyms for some words. In the first sentence, for instance, "astonishingly beautiful" is turned into "amazingly attractive." That is, the writing is not the student's in any significant sense, as a condensed summary would in fact be. Here the student seems to give credit for an idea, but in fact the writing too is essentially Tuchman's, thinly disguised.

For Tuchman's

> featured about 110 paintings and works on paper

the student gives us

> included more than 100 paintings and also works on paper

and for Tuchman's

> artists, as well as others, appear to care passionately about how it is made, what it can address, and its ability to communicate the highest values of life in a nonrepresentational, visual language his work.

the student gives us

> The general public, as well as artists, seem very concerned about how abstract art is made, what it is concerned with, and its power to communicate life's most significant values by means of visual language.

If Tuchman's sentences had been obscure, for instance if they had used highly technical language, or if they had been confusingly written, it would have been reasonable for the student to paraphrase them (and to tell the reader why a paraphrase was being offered), but in this instance there is no reason to paraphrase Tuchman's sentences. Even though he mentions Tuchman, the student is inappropriately offering as his own writing what is essentially Tuchman's writing.

If the student believed that more than a very brief summary was needed in order to make his point, he either (1) should have quoted Tuchman directly (giving credit), or (2) rethought the whole passage and put it into his own formulation (again giving credit). A mere rewording—a mere paraphrasing—of clear sentences such as Tuchman's is pointless; the only possible point is to take credit for writing that is not one's own.

3. **Acknowledging an idea.** Let us say that you have read an essay in which Seymour Slive argues that many Dutch still lifes have a moral significance. If this strikes you as a new idea and you adopt it in an essay—even though you set it forth entirely in your own words and with examples not offered by Slive—you should acknowledge your debt to Slive. Not to acknowledge such borrowing is plagiarism. Your readers will not think the less of you for naming your source; rather, they will be grateful to you for telling them about an interesting writer.

Similarly, if in one of your courses an instructor makes a point that you do not encounter in your reading and that therefore probably is not common knowledge (*common knowledge* will be defined in the next section), cite the instructor, the date, and the institution where the lecture was delivered.

Caution: Information derived from the Internet must be properly cited. Probably it is best if you do *not* download it into your own working text. Rather, create a separate document file so that later you will recognize it as material that is not your own.

Fair Use of Common Knowledge

When in doubt as to whether to give credit (either in a footnote or merely in an introductory phrase such as "William Bascom says"), give credit. As you begin to read widely in your field or subject, you will develop a sense of what is considered common knowledge. Unsurprising definitions in a dictionary can be considered common knowledge, so there is no need to say "According to Webster, a mural is a picture or decoration applied to a wall or ceiling." (That's weak in three ways: It's unnecessary, it's uninteresting, and it's inexact, since "Webster" appears in the titles of several dictionaries, some good and some bad.)

Similarly, the date of Picasso's death can be considered common knowledge. Few can give it when asked, but it can be found in many sources, and no one need get the credit for providing you with the date. Again, if you simply *know*, from your reading of Freud, that Freud was interested in art, you need not cite a specific source for an assertion to that effect, but if you know only because some commentator on Freud said so, and you have no idea whether the fact is well known or not, you should give credit to the source that gave you the information. Not to give credit—for ideas as well as for quoted words—is to plagiarize.

With matters of interpretation the line is less clear. For instance, almost everyone who has published a discussion of van Gogh's *The Potato Eaters* has commented on its religious implications or resonance. In 1950 Meyer Schapiro wrote, "The table is their altar . . . and the food a sacrament. . . ." In 1971 Linda Nochlin wrote that the picture is an "overtly expressive embodiment of the sacred," and in 1984 Robert Rosenblum commented on the "almost ritualistic sobriety that seems inherited from sacred prototypes." If you got this idea from one source, cite the source, but if in your research you encountered it in several places, it will be enough if you say something like, "The sacramental quality of the picture has been widely noted." You need not cite half a dozen references—though you may wish to add, "first by," or "most recently by," or some such thing, in order to lend a bit of authority to your paper.

"But How Else Can I Put It?"

If you have just learned—say, from an encyclopedia—something that you sense is common knowledge, you may wonder, "How can I change into my own words the simple, clear words that this source uses in setting forth

this simple fact?" For example, if before writing about Rosa Bonheur's painting of Buffalo Bill (he took his Wild West show to France), you look him up in the *Encyclopaedia Britannica,* you will find this statement about Buffalo Bill (William F. Cody): "In 1883 Cody organized his first Wild West exhibition." You cannot use this statement as your own, word for word, without feeling uneasy. But to put in quotation marks such a routine statement of what can be considered common knowledge, and to cite a source for it, seems pretentious. After all, the *Encyclopedia Americana* says much the same thing in the same routine way: "In 1883, . . . Cody organized Buffalo Bill's Wild West." It may be that the word "organized" is simply the most obvious and the best word, and perhaps you will end up using it. Certainly to change "Cody organized" into "Cody presided over the organization of" or "Cody assembled" or some such thing, in an effort to avoid plagiarizing, would be to make a change for the worse and still to be guilty of plagiarism. But you won't get yourself into this mess of wondering whether to change clear, simple wording into awkward wording if in the first place, when you take notes, you summarize your sources, thus: "1883: organized Wild West," or "first Wild West: 1883." Later (even if only thirty minutes later), when drafting your paper, if you turn this nugget—probably combined with others—into the best sentence you can, you will not be in danger of plagiarizing, even if the word "organized" turns up in your sentence.

✍ A RULE FOR WRITERS:

Acknowledge your sources, including computer-generated text

1. if you quote directly and put the quoted words in quotation marks
2. if you summarize or paraphrase someone's material, even though you do not retain one word of your source
3. if you borrow a distinctive idea, even though the words and the concrete application are your own

Notice that *taking notes* is part of the trick; this is not the same thing as copying or photocopying. Photocopying machines are great conveniences but they also make it easy for us not to think; we later may confuse a photocopy of an article with a thoughtful response to an article. The copy is at hand, a few words underlined, and we use the underlined material with the mistaken belief that we have absorbed it.

If you take notes thoughtfully, rather than make copies mindlessly, you will probably be safe. Of course, you may want to say somewhere in your paper that all your facts are drawn from such-and-such a source, but you offer this statement not to avoid charges of plagiarism but for three other reasons: to add authority to your paper, to give respectful credit to those who have helped you, and to protect yourself in case your source contains errors of fact.

✔ Checklist for Avoiding Plagiarism

Have I asked myself the following questions?

❑ In taking notes, did I make certain to indicate when I was quoting directly, when I was paraphrasing, and when I was summarizing, and did I clearly give the source of any online material that I cut and pasted into my notes? (If not, you will have to retrieve your sources and check your notes against them.)

❑ Are all quotations enclosed within quotation marks and acknowledged?

❑ Are all changes within quotations indicated by square brackets for additions and ellipses marks (. . .) for omissions?

❑ If a passage in a source is paraphrased rather than quoted directly or summarized in the paper, is the paraphrase explicitly identified as a paraphrase, and is a reason given for offering a paraphrase rather than quoting directly (for instance, the original uses highly technical language, or the original is confusingly written)?

❑ Are the sources for all borrowed *ideas*—not just borrowed words— acknowledged, and are these ideas set forth in my own words and with my own sentence structure?

❑ Does the list of sources include all the sources (online as well as print) that I have made use of?

Reminder: Material that is regarded as common knowledge, such as the date of Georgia O'Keeffe's death, is not cited because all sources give the same information—but if you are in doubt about whether something is or is not regarded as common knowledge, cite your source.

DOCUMENTATION

As a student, you are a member of a community of writers who value not only careful scholarship and good writing but also full and accurate documentation. Various academic disciplines have various systems of documentation—

the footnote form of professors of literature differs from the footnote form of professors of sociology.

In pages 335–44 you will find the principles set forth in *The Chicago Manual of Style,* 16th edition (2010), the guide followed by most university presses and by many scholarly journals. It is also available online as *The Chicago Manual of Style Online.* Check to see if your college subscribes.

FOOTNOTES AND ENDNOTES (*CHICAGO MANUAL OF STYLE*)

Although this book provides information about how to cite in your notes and in your bibliography such sources as books, journals, and interviews, using the style established by the *Chicago Manual of Style,* 16th edition (2010), your college or university may provide access to software programs or citation tools that will format the citations for you. Such tools as *EndNote* and *RefWorks* allow you efficiently to collect, store, and manage information in your word processor. They will also format in-text citations and the bibliography at the end of your paper (the list of Works Cited) in accordance with the Chicago style, or, indeed, in almost any other style that your instructor may prefer. Check with a reference librarian to see what programs your institution offers.

Kinds of Notes

In speaking of kinds of notes, this paragraph does not distinguish between **footnotes,** which appear at the bottom of the page, and **endnotes,** which appear at the end of the essay; for simplicity, *footnote* will cover both terms. Rather, a distinction is made between (1) notes that give the sources of quotations, facts, and opinions used and (2) notes that give additional comment.

Why use this second type of note? You may wish, for instance, to indicate that you are familiar with an opinion contrary to the one you are offering, but you may prefer not to digress upon it during the course of your argument. A footnote lets you refer to it and indicate why you are not considering it. Or a footnote may contain statistical data that support your point but that would seem unnecessarily detailed and even tedious in the body of the paper. This kind of footnote, giving additional commentary, may have its place in research papers and senior theses, but even in such essays it should be used sparingly, and it rarely has a place in a short analytical essay. There are times when supporting details may be appropriately relegated to a footnote, but if the thing is worth saying, it is usually worth saying in the body of the paper. Don't get into the habit of affixing either trivia or miniature essays to the bottom of each page of an essay.

Footnote Numbers and Positions

Number the notes consecutively throughout the essay or chapter. Although some instructors allow students to group all the notes at the rear of the essay, most instructors—and surely all readers—believe that the best place for a note is at the foot of the appropriate page.

If you use a computer, your software may do much of the job for you. It probably can automatically elevate the footnote number, and it can automatically print the note on the appropriate page.

Footnote Style

To indicate that there is a footnote, put a raised arabic numeral (without a period and without parentheses) after the final punctuation of the sentence, unless clarity requires it earlier. In a sentence about Claude Monet, Camille Pissarro, and Alfred Sisley, you may need a footnote for each and a corresponding numeral after each name instead of one numeral at the end of the sentence, but usually a single reference at the end will do. The single footnote might explain that Monet says such and such in a book entitled—, Pissarro says such and such in a book entitled—, and Sisley says such and such in a book entitled—.

Chicago Manual of Style

Most publications in art follow the principles set forth in the *Chicago Manual of Style,* 16th edition (2010). The chief forms are set forth here.

The first citation of each source, whether a footnote or an endnote, contains all the information that the reader needs to locate the source.

If you are using endnotes, begin the page with the heading "Notes," triple-spaced, and then give the notes in numerical order. Double-space between notes, but single-space the notes themselves.

If you are placing the notes at the foot of the page,

- type a line of five hyphens, and then double-space
- indent five spaces, then type the number of the note (use arabic numbers, with a period after the number). Next, skip one space and type the footnote, single-spacing the note. If the note runs more than one line, begin subsequent lines at the left margin. When you have finished the note, type a period and then
- double-space (to create extra space between the notes); then
- indent five spaces, give the next note, single-spaced, additional lines flush left, ending with a period, but remember that notes are separated by double-spacing.

Your computer can be programmed to format the notes, that is, to draw a line, to double-space and then indent, insert a number, and so forth.

If you are using endnotes rather than footnotes, double-space the endnotes.

For the style of subsequent footnotes and endnotes, see page 334.

Books

First Reference to a Book

> 1. Elizabeh ten Grotenhuis, *Japanese Mandalas: Representations of Sacred Geography* (Honolulu: University of Hawai'i Press, 1999), 153.

Explanation:
- Give the author's name as it appears on the title page, *first name first.*
- Give the title of the book in italics or underlined. (Find out if your instructor has a preference.)
- You need not give a subtitle, but if you do give it (as in this example), separate it from the title with a colon. Capitalize the first letter of each word of the title and subtitle except for articles (*a, an, the*) and prepositions (for instance, *in, on, of*). *Exception:* If an article or a preposition is the first word of the title or the subtitle, it is capitalized.
- Give the publisher's full name, however, omit such words as "Inc." and "Co." You may abbreviate it: Pearson Prentice Hall, for instance, may be given as Pearson.
- Give the name of the city of publication; if the city is not likely to be known, or if it can be confused with another city of the same name (Cambridge, Massachusetts, and Cambridge, England), add the name of the state or country, using an abbreviation.
- Give the page number (here, 153) after the comma that follows the closing parenthesis, with one space between the comma and the page number. Do *not* use "page" or "pages" or "p." or "pp."
- End the note with a period.

If you give the author's name in the body of the text—for instance in such a phrase as "Elizabeth ten Grotenhuis points out that"—do not repeat the name in the footnote. Merely begin with the title:

> 2. *Japanese Mandalas: Representations of Sacred Geography* (Honolulu: University of Hawai'i Press, 1999), 153.

A Revised Edition of a Book

> 3. Rudolf Wittkower, *Art and Architecture in Italy, 1600–1750*, 3rd ed. (Harmondsworth, England: Penguin, 1973), 187.

A Book in More Than One Volume

> 4. Ronald Paulson, *Hogarth: His Life, Art, and Times*, vol. 2 (New Haven, Conn.: Yale University Press, 1971), 161.

The reference here is to page 161 in volume 2. Note that although the abbreviation "vol." is used, "p." is *not* used.

A Book by More Than One Author

> 5. Romare Bearden and Harry Henderson, *A History of African-American Artists from 1792 to the Present* (New York: Pantheon, 1994), 612–13.

- The name of the second author, like that of the first, is given *first name first.*
- If there are more than three authors, give the full name of the first author (first name first), follow it with "and others," a comma, and then give the title.

An Edited or Translated Book

> 6. Ruth Magurn, ed. and trans., *The Letters of Peter Paul Rubens* (Cambridge, Mass.: Harvard University Press, 1955), 238.

> 7. Helmut Brinker and Hiroshi Kanazawa, *Zen Masters of Meditation in Images and Writings*, trans. Andreas Leisinger (Zurich: Artibus Asiae, 1996), 129.

An Introduction or Foreword by Another Author

You may need to footnote a quotation from someone's introduction (say, Kenneth Clark's) to someone else's book (say, James Hall's). If in your text you say, "As Kenneth Clark points out," the footnote will run thus:

> 8. Introduction to James Hall, *Dictionary of Subjects and Symbols in Art*, 2nd ed. (New York: Harper and Row, 1979), viii.

An Essay in a Collection of Essays by Various Authors

> 9. Charles Pellet, "Jewelers with Words," in *Islam and the Arab World*, ed. Bernard Lewis (New York: Knopf, 1976), 151.

As note 9 indicates, when you are quoting from an essay in an edited book,

- begin with the essayist (first name first) and the title of the essay (in quotation marks)
- then give the title of the book (in italics or underlined) and the name of the editor, first name first

References to Material Reprinted in a Book
 Suppose you are using a book that consists of essays or chapters or pages by various authors, reprinted from earlier publications, and you want to quote a passage.

- If you have not given the author's name in the lead-in to your quotation, give the name (first name first) at the beginning of the footnote.
- Then give the title of the essay (in quotation marks) or of the original book (in italics or underlined).
- Then, if possible, give the place where this material originally appeared (you can usually find this information in the acknowledgments page of the book in hand or on the first page of the reprinted material).
- Then give the name of the title of the book you have in hand, in italics or underlined.
- Then give the editor of the collection (first name first), the place of publication, the publisher, the date, and the page number.

The monstrous but accurate footnote might run like this:

> 10. Henry Louis Gates, Jr., "The Face and Voice of Blackness," in *Facing History: The Black Image in American Art, 1710–1940*, ed. Guy McElroy (San Francisco: Bedford Art, 1990); rpt. in *Modern Art and Society*, ed. Maurice Berger (New York: HarperCollins, 1994), 53.

You have read Gates's essay, "The Face and Voice of Blackness," which was originally published in a collection (*Facing History*) edited by McElroy, but you did not read the essay in McElroy's collection. Rather, you read it in Berger's collection of reprinted essays, *Modern Art and Society*. You learned the name of McElroy's collection and the original date and place of publication from Berger's book, so you give this information, but your page reference is of course to the book that you are holding in your hand, page 53 of Berger's book.

Journals and Newspapers

An Article in a Journal with Continuous Pagination Throughout the Annual Volume

> 11. Anne H. van Buren, "Madame Cézanne's Fashions and the Dates of Her Portraits," *Art Quarterly* 29 (1966): 119.

The author's first name is given first; no month or season is given because even though volume 29 contains four issues, pagination from one issue to the next is continuous, so there is only one page 119 in the entire volume. Abbreviations such as "vol." and "p." are *not* used.

An Article in a Journal That Paginates Each Issue Separately

> 12. Christine M. E. Guth, "Japan 1868–1945: Art, Architecture, and National Identity," *Art Journal* 55, no. 3 (1996): 17.

The issue number is given because for this quarterly journal there are, in any given year, four pages numbered 17.

An Article in a Popular Magazine

> 13. Henry Fairlie, "The Real Life of Women," *New Republic*, 26 August 1978, 18.

For popular weeklies and monthlies, give only the date (not the volume number), and do not enclose the date within parentheses.

A Book Review
If a book review has a title, treat the review as an article. If, however, the title is merely that of the book reviewed, or even if the review has a title but for clarity you wish to indicate that it is a review, the following form is commonly used:

> 14. Pepe Karmel, review of *Off the Wall: Robert Rauschenberg and the Art World of Our Time*, by Calvin Tomkins (Garden City, N.Y.: Doubleday, 1980), *New Republic*, 21 June 1980, 38.

A Newspaper
The first example is for a signed article, the second for an unsigned one.

> 15. Bertha Brody, "Illegal Immigrant Sculptor Allowed to Stay," *New York Times*, 4 July 1994, 12.

> 16. "Portraits Stolen Again," *Washington Post*, 30 June 1995, 7.

Note: Even if the title of the newspaper begins with *The*, for example, *The New York Times*, omit *the* in the citation.

Secondhand References

Let's assume you are reading a book (in this case, the fourth volume of a work by William Jordy) and the author quotes a passage (by Frank Lloyd

Wright) that you want to quote in your essay. Your footnote should indicate both the original source if possible (i.e., not only Wright's name but also his book, place and year of publication, etc.), and then full information about the place where you found the quoted material:

17. Frank Lloyd Wright, *The Solomon Guggenheim Museum* (New York: Museum of Modern Art, 1960), 20; quoted in William H. Jordy, *American Buildings and Their Architects* (Garden City, N.Y.: Anchor, 1976), 4:348.

If Jordy had merely given Wright's name and had quoted him but had not cited the source, of course you would be able to give only Wright's name and then the details about Jordy's book.

Subsequent References

When you quote a second or third or fourth time from the same work, use a short form in the subsequent notes. The most versatile form is simply the author's last name, an abbreviated title, and the page number:

18. Wittkower, *Art*, 38.

You can even dispense with the author's name if you have mentioned it in the sentence to which the footnote is keyed, and if the source is the one you have mentioned in the preceding note, you can use "Ibid." (an abbreviation of the Latin *ibidem,* "in the same place") and follow it with a comma and the page number.

19. Ibid., 159.

Although "Ibid." is Latin, customarily it is *not* italicized. If the page is identical with the page cited in the immediately preceding note, do not repeat the page number.

Interviews, Lectures, and Letters

20. Malcolm Rogers, Director, Museum of Fine Arts, Boston, interview by the author, Cambridge, Mass., 12 July 2011.

21. Howard Saretta, "Masterpieces from Africa," lecture at Tufts University, 13 May 2011.

22. Information in a letter to the author, from James Cahill, University of California, Berkeley, 17 March 2011.

Electronic Citations

See page 290.

Bibliography (List of Works Cited)

A bibliography is a list of the works cited or, less often, a list of all references consulted. Normally a bibliography is given only in a long manuscript such as a research paper or a book, but instructors may require a page titled "Bibliography" or "Works Cited" (*not* enclosed within quotation marks) even for a short paper if they wish to see at a glance the material that the student has used.

Bibliographic reference software will automatically formulate your footnotes or endnotes, and your bibliography or List of Works Cited, whether you use the *Chicago Manual of Style* or *MLA Handbook for Writers of Research Papers*. Software programs such as *Papers* by Mekentosj and *Endnote* by Thomson Reuters integrate with your word processor to make tracking and formatting references easy.

Bibliographic Style

First, a few basic principles

- a bibliography is arranged alphabetically by author
- give the author's *last* name first in each entry.
- if a work is by more than one author, it is listed under the first author's name—last name first; the other author or authors are then given with their first names first, thus: Jones, Anne, and Carl Donne
- anonymous works are listed by title at the appropriate alphabetical place, including the initial article, if any (*The, A, An*), but alphabetizing the work under the next word. Thus, the citation for an anonymous book called *The Impressionists* would include the "The," but the book would be alphabetized under "I."
- double-space each entry, beginning flush left, but if the entry runs over the line, indent subsequent lines five spaces
- italicize or underline titles of books (ask if your instructor has a preference)
- enclose within quotation marks parts of books (titles of chapters, essays) and titles of articles in journals
- do not use "p." or "pp." before page numbers
- double-space between entries, so the entire list is double-spaced

A Book by One Author

Calo, Mary Ann. *Distinction and Denial: Race, Nation, and the Critical Construction of the African-American Artist, 1920–40.* Ann Arbor: University of Michigan Press, 2007.

Notice that articles (here *the,* but also *a* and *an*), conjunctions (here *and*), and prepositions (here, *of*) are not capitalized except when they are the first or last word of the title or of the subtitle.

An Exhibition Catalog

An exhibition catalog may be treated as a book, but some journals add "exh. cat." after the title of a catalog. The first example, a catalog that includes essays by several authors, gives the editor's name, which is specified on the title page. The second example is a catalog by a single author.

> Barnet, Peter, ed. *Images in Ivory: Precious Objects of the Gothic Age.* Detroit: Detroit Institute of Arts, 1997. Exhibition catalog.

> Tinterow, Gary. *Master Drawings by Picasso.* Cambridge, Mass.: Fogg Art Museum, 1981. Exhibition catalog.

A Book or Catalog by More Than One Author

> Rosenfield, John M., and Elizabeth ten Grotenhuis. *Journey of the Three Jewels: Japanese Buddhist Paintings from Western Collections.* New York: Asia Society, 1979.

Notice in this entry that although the book is alphabetized under the *last name* of the *first* author, the name of the second author is given in the ordinary way, first name first.

A Collection or Anthology

> Nelson, Robert S., ed. *Visuality Before and Beyond the Renaissance.* Cambridge: Cambridge University Press, 2000.

If a collection has more than one editor, use the following form:

> Nelson, Robert S., and Richard Shiff, eds. *Critical Terms for Art History*, 2nd ed. University of Chicago Press, 2003.

This entry lists the collection alphabetically under the first editor's last name. Notice that the second editor's name is given first name first. A collection may be listed either under the editor's name or under the first word of the title.

An Essay in a Collection or Anthology

> Livingstone, Jane, and John Beardsley. "The Poetics and Politics of Hispanic Art: A New Perspective." In *Exhibiting Cultures: The Poetics and Politics of Museum Display*, ed. Ivan Karp and Steven D. Lavine, 104–20. Washington, D.C.: Smithsonian, 1991.

This entry lists an article by Livingstone and Beardsley (notice that the first author's name is given with the last name first, but the second author's name is given first name first) in a book called *Exhibiting Cultures,* edited by Karp and Lavine. The essay appears on pages 104–120.

Two or More Works by the Same Author

> Cahill, James. *Chinese Painting.* Geneva: Skira, 1960.
>
> ———. *Scholar Painters of Japan: The Nanga School.* New York: Asia House, 1972.

The horizontal line (eight units of underlining, followed by a period and then two spaces) indicates that the author (in this case James Cahill) is the same as in the previous item. Note also that multiple titles by the same author are arranged alphabetically (*Chinese* precedes *Scholar*).

An Introduction to a Book by Another Author

> Clark, Kenneth. Introduction to *Dictionary of Subjects and Symbols in Art,* by James Hall, 2nd ed. New York: Harper and Row, 1979.

This entry indicates that the student made use of Clark's introduction rather than the main body of Hall's book; if the body of the book were used, the book would be alphabetized under *H* for Hall, and the title would be followed by: Intro. Kenneth Clark.

An Edited Book

> Rossetti, Dante Gabriel. *Letters of Dante Gabriel Rossetti.* Edited by Oswald Doughty and J. R. Wahl. 4 vols. Oxford: Clarendon, 1965.

A Book Consisting of Two or More Volumes

> Reid, Jane Davidson. *The Oxford Guide to Classical Mythology in the Arts, 1300–1990s.* 2 vols. New York: Oxford University Press, 1993.

A Journal Article

> Mitchell, Dolores. "The 'New Woman' as Prometheus: Women Artists Depict Women Smoking." *Woman's Art Journal* 12, no. 1 (1991): 2–9.

Because this journal paginates each issue separately, the issue number must be given. For a journal that paginates issues continuously, give the year without the issue number.

A Newspaper Article

> "Museum Discovers Fake." *New York Times*, 21 January 1990.

> Romero, Maria. "New Sculpture Unveiled." *Washington Post*, 18 March 1980.

Because the first of these newspaper articles is unsigned, it is alphabetized under the first word of the title; because the second is signed, it is alphabetized under the author's last name.

Chicago style does not require page numbers for newspapers: Because a newspaper may issue more than one edition on a given day, pagination may change.

A Book Review

> Gevisser, Mark, review of *Art of the South African Townships*, by Gavin Younger, *Art in America* 77, no. 7 (1989): 35–39.

This journal paginates each issue separately, so the issue number must be given as well as the year.

Electronic Sources
> See page 290.

15

WRITING ESSAY EXAMINATIONS

You never know what is enough unless you know what is more than
enough.

—William Blake

Do not on any account attempt to write on both sides of the paper at once.

—W. C. Sellar and R. J. Yeatman

WHAT EXAMINATIONS ARE

The first three chapters of this book assume that writing an essay requires
knowledge of the subject as well as skill with language. Here a few pages
will be devoted to discussing the nature of examinations; perhaps one can
write better essay answers when one knows what examinations are.

A well-constructed examination not only measures learning and think-
ing but also stimulates them. Even so humble an examination as a short-
answer quiz is a sort of push designed to move students forward by coercing
them to do the assigned looking or reading. Of course, internal motivation
is far superior to external, but even such crude external motivation as a
quiz can have a beneficial effect. Students know this; indeed, they often
seek external compulsion, choosing a particular course "because I want to
know something about . . . and I know that I won't do the work on my
own." (Instructors often teach a new course for the same reason; we want
to become knowledgeable about, say, the connections between Matisse and
Picasso, and we know that despite our lofty intentions we may not seriously
confront the subject unless we are under the pressure of facing a class.)

In short, however ignoble it sounds, examinations force students to acquire
knowledge and then to convert knowledge into thinking. Sometimes it is not
until preparing for the final examination that students—returning to museums,
studying reproductions of works of art, rereading the chief texts and classroom
notes—see what the course was really about. Until this late stage the trees
obscure the forest, but now, reviewing and sorting things out—*thinking* about
the facts, the data, and the ideas of others—students see a pattern emerge. The

experience of reviewing material and then of writing an examination, though fretful, can be highly exciting as connections are made and ideas take on life.

Such discoveries about the whole subject matter of a course can almost never be made by writing critical essays on topics of one's own construction, for such topics rarely require a view of the whole. Further, we are more likely to make imaginative leaps when trying to answer questions that other people pose to us than when trying to answer questions we pose to ourselves. (Again, every teacher knows that students in the classroom ask questions that stimulate the teacher to see things and to think thoughts that would otherwise have been neglected.) And although a teacher's question may cause anxiety, when students confront and respond to it on an examination they often make yet another discovery—a self-discovery, a sudden and satisfying awareness of powers they didn't know they had.

WRITING ESSAY ANSWERS

Let's assume that before the examination you have read the assigned material, marked the margins of your books (but not of the library's books), made summaries of the longer readings and of the classroom comments, visited the museums, reviewed all this material, and had a decent night's sleep. Now you are facing the examination sheet.

Here are some obvious but important practical suggestions:

1. **Scan the entire examination before answering the first question.** Get a sense of the whole, and notice how much time is allotted to each question so that you do not spend a disproportionate amount of time on the early questions.
2. In answering each question, take a few moments to **jot down, as a sort of outline or source of further inspiration, a few ideas that strike you** after you have thought a little about the question. You may at the outset realize there are, say, three points you want to make, and unless you jot them down—three key words will do— you may spend all the allotted time on one point.
3. **Reread the question** and then check your outline to make certain that it is fully relevant. Add or delete, as needed.
4. **Answer the question:** If you are asked to compare two pictures, compare them; don't write two paragraphs on the lives of each painter. Take seriously such words as *analyze, compare, define,* and especially *evaluate*.
5. **You can often get a good start if you turn the question into an affirmation**—for example, by turning "In what ways is the painting of

Manet influenced by Goya?" into "Manet influenced Goya in at least three ways." Later in the essay, every now and then it's not a bad idea to repeat a phrase from the question: This practice will insure that you are answering the question, not wandering onto irrelevant byways.

6. **Don't waste time summarizing** at length what you have read unless asked to do so—but, of course, you may have to give a brief summary of a reading in order to support a point. The instructor wants to see that you can *use* your reading, not merely that you have done the reading.

7. **Keep an eye on the clock, and budget your time.** Do not spend more time on a question than the allotted time. In fact, in writing each essay try to spend a few minutes *less* than the allotted time, so that at the end you can review and at least slightly revise your work.

8. **Be concrete. Support your generalizations with evidence.** Illustrate your argument with facts—names of painters or sculptors or architects, titles of works, dates, and brief but concrete descriptions.

9. **Leave space for last-minute additions.** Either skip a page between essays, or write only on the right-hand pages so that when you reread you can add material at the appropriate place on the left-hand pages.

10. **Essentially your essays will be first drafts, but if you have budgeted your time you will have a chance to make brief revisions.** Correct illegible words, add supporting details where necessary, and delete material that now seems irrelevant. Now that you know what you have written, and in what sequence, make certain that the organization will be clear to your reader, for instance **add signposts if necessary,** inserting such things as "First I will consider two widely held views," "Toward the end of the essay I will discuss."

Beyond these general suggestions, it is best to talk about essay examinations by looking at the most common sorts of questions:

- a work to analyze
- a historical question (e.g., "Trace the influence of Japanese art on two European painters of the later nineteenth century"; "Trace the development of Picasso's representations of the Minotaur")
- a critical quotation to be evaluated
- a comparison (e.g., "Compare the representation of space in the late works of van Gogh and Gauguin"; Compare Egyptian and Roman representations of rulers as gods)
- an exhibition proposal

A few remarks on each of these types may be helpful.

1. **On analysis,** see Chapters 3 and 4. As a short rule, look carefully at subject matter, line, color (if any), composition, and medium.

2. A good essay on a **historical question,** like a good lawyer's argument, will offer a nice combination of assertion and evidence; that is, the thesis will be supported by concrete details (names of artists and of works; dates; possibly even brief quotations) which you offer as evidence. A thesis cannot be convincing if in your discussion you do not specify certain works as representative—or as atypical—of certain years. Lawyerlike, you must demonstrate (not merely assert) your point.

3. If you are asked to evaluate a **critical quotation,** read the quotation carefully and in your answer take account of *all* of the quotation. If, for example, the critic has said, "Goya in his etchings usually . . . but in his paintings rarely . . .," you will have to write about etchings and paintings (unless, of course, the instructions on the examination ask you to take only as much of the quotation as you wish).

 Watch especially for such words as *usually, for the most part, never*; that is, although the passage may on the whole approach the truth, you may feel that some important qualifications are needed. This is not being picky; true evaluation calls for making subtle distinctions, yielding assent only so far and no further.

 Another example of a quotation to evaluate: "Picasso's *Les Demoiselles d'Avignon* [illustrated in this book on page 35] draws on several traditions, and the result is stylistic incoherence." A good answer not only will specify the traditions or sources (e.g., Cézanne's *Bathers*, Rubens's *The Judgment of Paris*, Renaissance and Hellenistic nudes, pre-Christian Iberian sculptures, Egyptian painting, African art), calling attention to the passages in the painting where each is apparent, but it also will evaluate the judgment that the work is incoherent. The quotation raises a historical issue (the concern with traditions or sources) and it also raises a critical issue (the concern with incoherence), so a good answer—an A or A– answer, if we may talk about grades—will respond to both issues. The essay might argue, for example, that the lack of traditional stylistic unity is entirely consistent with the newness of the treatment of figures and with the violent eroticism of the subject.

4. **On comparisons,** see Chapter 5. Because lucid comparisons are especially difficult to write, be sure to take a few moments to jot down a sort of outline so that you know where you will be going. You can often make a good start by beginning with the similarities of the two objects. As you jot these down, you will probably find that your perception of the *differences* will begin to be heightened.

In organizing a comparison of two pictures by van Gogh and two by Gauguin:

- You might devote the first paragraph to an introduction, explaining your choice of images (for instance, a portrait and a still life by each), the second paragraph to van Gogh's portrait, the third to his still life, the fourth to Gauguin's portrait, and the fifth to his still life. Your essay will not break into two parts if you announce at the outset that you will treat one artist first, then the other, and if you remind your reader during your treatment of the first artist that certain points will be picked up when you get to the second, and, finally, if during your treatment of the second artist you occasionally glance back to the first.
- Or you might first treat one picture by van Gogh and then one by Gauguin, and then go on, in your next two paragraphs, to treat the second van Gogh painting and the second Gauguin painting.

5. **An exhibition proposal** gives you an opportunity to be highly creative. The examination question might run thus: "Your local museum has just purchased an image of the Buddha [see pages 134 and 154 for examples]. Design a small exhibition—use no more than a dozen objects—that will feature this new acquisition." You might draw entirely on other East Asian images of the Buddha, or you might decide to include some non-Buddhist images, perhaps images of Egyptian deities and also of Jesus. In your essay you will want to explain *how and why* this assembly of images will enhance the visitor's experience in the museum.

 Your instructor may provide guidelines for the virtual exhibition, such as

 - write a wall text (500 words) to be displayed at the entrance to the exhibition
 - write a one-minute audioguide for one work in the exhibition (about 200 words)
 - write museum labels for three objects
 - be sure, perhaps at the beginning or end of your essay, to tell your reader what the display will look like—for instance, the colors of the walls, which objects will be presented singly and which will be grouped within cases. (For some ideas about the implications of display, see pages 29–32, 171.)

If you are given guidelines of this sort, be sure that in your essay you respond to all of them.

✔ Checklist: Writing Essay Examinations

Preliminaries, the Days (or the Night) Before

- ❑ Have I reread the relevant assigned readings, or at least my notes on the readings, and taken another look at the assigned images?
- ❑ Have I reread my classroom notes?
- ❑ Have I discussed possible questions with some classmates, and thought about a variety of responses?

In the Exam Room

Scan the entire examination before you start writing your answer to the first question. (A remark in Question 3 may be useful in your answer to Question 1.)

Be sure not to exceed the time allotted for each question.

- ❑ Have I taken a moment to make a very rough outline, a guide to where I think I will be going?
- ❑ Have I answered the question, rather than wandered off? Have I taken seriously such words as *analyze*, *compare*, and *evaluate*?
- ❑ Have I given supporting details, perhaps some references to other specific works?
- ❑ Have I taken account of what I think are the reader's views, but have I also offered—with supporting details—my own views?
- ❑ Have I taken account of what may be reasonable objections to my views?
- ❑ Have I left space—perhaps by writing on only one page of the two-page spread of the booklet—so that I can revise my essay by inserting material when I reread it?

LAST WORDS

Chance favors the prepared mind.

—Louis Pasteur

Index

Notes

Notes

Notes

Notes

SYMBOLS COMMONLY USED IN ANNOTATING PAPERS

All instructors have their own techniques for commenting on essays, but many make substantial use of the following symbols. When instructors use a symbol, they assume that the student will carefully read the marked passage and will see the error or will check the appropriate reference.

awk	awkward
cap	use a capital letter
choppy	too many short sentences; subordinate (see pages 208–10)
diction	inappropriate word (see pages 194–95)
emph	emphasis is obscured
id	unidiomatic expression
ital	underline to indicate italics (see pages 210, 314, 323)
k	awkward
l	logic; this does not follow
lc	use lowercase, not capitals
mm	misplaced modifier
¶	new paragraph
pass	weak use of the passive voice (see pages 206–07)
ref	pronoun reference is vague or misleading
rep	awkward repetition (see pages 201–02)
sp	misspelling
sub	subordinate (see pages 208–10)
trans	weak transition (see pages 191, 215–17)
wordy	use concise language (see pages 203–05)
ww	wrong word (see pages 194–95)
x	this is wrong
?	really? are you sure? I doubt it (or I can't read this)

BRIEF GUIDE TO INSTRUCTION IN WRITING (CONSULT THE INDEX FOR MANY ADDITIONAL REFERENCES)

Note: For Writer's Checklists, see the inside of the front cover.